WAR BABY / LOVE CHILD: MIXED RACE ASIAN AMERICAN ART

WAR BABY / LOVE CHILD

Mixed Race Asian American Art

Edited by LAURA KINA and WEI MING DARIOTIS

UNIVERSITY OF WASHINGTON PRESS Seattle and London

Funding for this publication was provided by San Francisco State University, The Elizabeth Firestone Graham Foundation, and DePaul University.

University of Washington Press
PO Box 50096
Seattle, WA 98145-5096, USA
www.washington.edu/uwpress

Library of Congress Cataloging-in-Publication Data

War baby / love child : mixed race Asian American art / edited by Laura Kina and Wei Ming Dariotis. — First [edition].
 pages cm
Includes bibliographical references and index.
ISBN 978-0-295-99225-9 (pbk.)
1. Asian American art—20th century. 2. Asian American art—21st century. 3. Asian Americans—Ethnic identity. 4. Racially mixed people—Race identity—United States.
I. Kina, Laura, 1973– editor of compilation. II. Dariotis, Wei Ming, editor of compilation.
N6538.A83W37 2012
704.03'0595013—dc23 2012038294

Contents

Foreword

Too little gets said about art and social life—art's relationship to social movements, art as a response to social life, art as generative of shifting knowledge/power relations, art as essential to self and world.

Is the cart before the horse? In the twentieth century, we wrote histories, analyses, critiques, and even literature about mixed race Asian Americans. We are thankful that in the twenty-first century, Laura Kina and Wei Ming Dariotis place art center stage in *War Baby / Love Child: Mixed Race Asian American Art*.

Within the pages of this book, the analytical and the artistic are complements. The analytical is here to assess, reflect on, and deconstruct both the relationship of the individual to the larger, already structured society and the society in relation to individuals. Art, alternatively, has other tricks in her bag, allowing for the production of objects (what Stuart Hall calls the "exteriorization" of the psyche), objectifications of reworked, reimagined ideas resulting from the subject's experiences of living and being within the world.[1]

One cannot read far into the history of the mixed race experience without noticing the centrality of personal narrative in mixed race Asian American writing, similar to what appears in mixed race Asian American art generally. Sui Sin Far's 1890 essay "Leaves from the Mental Portfolio of an Eurasian" is an early instance of the subject's need to materialize, objectify, concretize, and publicize the experience of mixed race Asian Americanness, exemplifying this seemingly fundamental dimension of mixed race Asian American art.

But art's role in mixed race Asian America has, until now, been understated. In *War Baby / Love Child*, art by and interviews with nineteen artists combine with historical and critical analyses contextualizing this art, these artists, their ideas, and their works in order to reposition art as both necessary and invaluable to understanding self and world, self in world, and world in self.

Alone, we are mere individuals experiencing our own mixed race thoughts and ideas, ideas that result from the profound tension produced from a subject's formlessness at birth and the society's already formed structures of race, social relations, power, and identity, which attempt to mold the subject. The tension produced for individuals facing the incommensurability of their own formlessness as subjects within an overweening, already determined, existing social structure ultimately is relieved by art.

Art is the externalization and objectification of the psychic and, as such, has the potential for an audience, and thus it can play a critical role in community and social life. By psychically repositioning the internalized elements of the society on a daily basis, the subject can experience mixed race cerebrally. But art takes a leap of faith, courageously putting forth reworked, imaginative ideas in public, with the potential of not only generating ideas and other objects but also remaking society.

This collection generously gives us art, the ideas of artists about what they produce, and the ideas of scholars who have worked tirelessly to understand social relations, the positioning of subjects, mixed race, Asia and Asian America, and the United States. Themes of colonialism, love, war, racism, gender, and identity resonate powerfully here as a result.

War Baby / Love Child makes it possible for us to understand how art documents the experience of society, structure, and the history that produced them, as well as to understand art as object that itself creates history, a new society, and, as anterior immanence, the potential for society to enact a new future.

KENT A. ONO
Urbana, Illinois
January 9, 2011

Preface

This volume examines work by mixed race/mixed heritage Asian American artists and maps their cultural productions against larger historical, legal, and social frameworks. Our project starts by triangulating the already inherently interdisciplinary fields of Asian American, Critical Mixed Race, and Visual Cultural studies with the goal of queering the discourses of American history and contemporary art. Through contemporary visual art, cultural analysis, social history, and personal narratives, *War Baby / Love Child: Mixed Race Asian American Art* critically examines the changing faces of Asian America.

The impetus for the title of this book, *War Baby / Love Child*, comes from coeditor Wei Ming Dariotis's experience of growing up mixed Chinese, Greek, Swedish, Scottish, German, English, and Pennsylvania Dutch in the 1970s and 1980s in San Francisco. Her "exotic" looks prompted the question perennially posed to mixed people: What are you?[1] Often accompanying this question is the presumption that mixed Asians fall into one of two stereotypes: either "war babies" or "love children"—brought into existence through U.S. wars in Asia, illicit relationships, or the free love of the post–Civil Rights, post-hippie era. The daughter of a European American father who was a Vietnam War–era conscientious objector and a Chinese immigrant mother, Dariotis is a classic "love child" with hippie parents, but she was always assumed to be a "war baby" because this is has been the dominant narrative of Eurasian identity. For Dariotis, this project, while grounded in examining the history and assumptions behind these stereotypes and the visual and rhetorical tropes that relate to and replace them, is more importantly about developing new theoretical tools based in mixed Asian American art—thus miscegenating, in the sense of transgressing, normalized disciplinary boundaries and discourses.

In the 1990s, Dariotis was relieved to find a sense of community and what she thought would be a clear label for her identity when she was introduced to the word "Hapa."[2] The word "Hapa" (with a capital "H") is an English term derived from the Native Hawaiian word for "mixed" or "part" (as in "hapa haole," i.e., "a person of mixed Native Hawaiian and white heritage"), which mainland Asian Americans have come to use as a kind of ethnic label for people of mixed Asian heritage.[3] In 2007, sparked by an objection to her use of the word "Hapa" raised at a reading at Occidental College, Dariotis began critiquing the way she and others had previously used the word.[4] In contrast, coeditor Laura Kina grew up with the word "hapa" (lowercase,

signifying the way it is used in Hawai'i as opposed to how it is used by mainland mixed Asian Americans). It was not an identity she came to later in life but was always part of how she saw herself, her siblings, and others like her.

Laura Kina is part of the Sesame Street generation for whom being mixed, at least in California and Washington State, where she grew up, no longer was a social transgression but rather was valued for fulfilling ideals of melting-pot multiracial progress. As a multiracial Japanese American with a long family history of U.S. military service, Kina finds war (particularly the Battle of Okinawa and Pearl Harbor) to be a definitive shadow on her identity. Through her paintings, she explores postcolonial histories and the complexities of her identity as the daughter of an Okinawan father from the sugarcane fields of the Big Island of Hawai'i and a Basque, Spanish-French, English, Irish, and Dutch mother with roots in the South, California, and the Pacific Northwest. In two of her series, *Hapa Soap Opera* (2002–5) and *Loving* (2006), Kina constructs a virtual community of mixed people. She has become increasingly curious about what other artists who share similar identity experiences have been doing. Are they also drawn, like she is, to explore these issues in their work? And if so, how do they address form and aesthetics and navigate the role of biography and social history in a contemporary art world fixated on "post-raciality" and moving beyond issues of identity?

Why These Artists and Authors?

The nineteen artists were selected not only for the quality of their work but also for what they have to share about the identities and experiences of mixed Asian Americans, mixed Pacific Islander Americans, and Asian Transracial Adoptees. We looked to include contemporary visual artists, across a wide range of media, who have historic connections to major U.S. wars in Asia and in some cases are actual "war babies"; who are U.S. colonial/postcolonial subjects; who represent pre–Civil Rights era histories of labor migration, mixing, and cosmopolitanism; who are representative of the "biracial baby boom"; and/or who have been key in building visual representations and advancing politics in the mixed race movement. We also sought a diversity of artists in order to highlight the intersections of other identity factors such as gender, age, ethnicity, regional representation, and, to a lesser extent, sexual orientation and religion but recognize that this work is just the starting point: much more needs to be done to properly represent the many diverse communities toward which this volume gestures.

As we worked to select authors for thematic "War Baby," "Discourse of Aloha," and "Love Child" historical- and sociological-context essays, we sought writers who could bring knowledge of the historical and social context of specific ethnic mixes

and the visual culture related to that history. We fortunately found ten scholars interested in taking interdisciplinary approaches; thus, some historians, some visual arts critics, some Critical Mixed Race studies scholars, and some Asian American studies scholars rose to the challenge. The shared commitment to interdisciplinarity, and to writing challenging scholarship in an accessible way, unites this disparate group. Because each author comes from a divergent primary discipline, ranging from ethnic studies to art history to psychology, the style and form of the essays vary. For example, Stephen Murphy-Shigematsu has pioneered methods of narrative therapy and therefore chose to write a short autobiographical story about growing up as a transnational Japanese Eurasian, showing rather than constructing a more traditional academic analysis of World War II and mixed race Japanese Americans, whereas Eleana J. Kim employs comparative visual and contextual analysis in an art historical mode. We sought to balance decolonized methodological approaches by recognizing that many of the authors have lived the experiences of their areas of expertise (e.g., Critical Mixed Race Studies scholar Rudy P. Guevarra, Jr., is Mexican and Filipino, and Wendy Thompson Taiwo is both a scholar and a person of mixed Asian and African American heritage). Though some scholars may be drawn to particular subjects because of their own experiences and identities, one need not be the a priori subject to contribute research written with attention to the nuances of power relationships inherent in scholarship about marginalized populations. Recognizing that diversity is inherently hierarchical, we are pleased that differently mixed race-ed and monoracialized individuals have written with sensitive authority on mixed race Asian American art (e.g., American Studies professor Lori Pierce's scholarship is centered in Pacific Islander and Native Hawaiian Studies, but she happens to *be* African American, while Cathy J. Schlund-Vials is a Vietnam War–era mixed Cambodian transracial adoptee *and* a scholar of Asian American Studies and Jewish American literature whose contribution to this volume is an essay on Vietnamese Amerasians).

Collaboration

This volume emerged as a result of four years (2008–2012) of collaboration: organizing panel discussions, talks, and a major conference to bring together artists and scholars working on visual culture, Asian American studies, and Critical Mixed Race studies.[5] This interdisciplinary project allowed both of us to draw upon our complementary yet quite different areas of expertise. Wei Ming Dariotis coined the book title, conceptualized the structure of the problematized binary of "war baby" and "love child" sections, wrote two original contextual essays, and interviewed five artists. Together we constructed the overall structure of the book, conducted additional

research, edited the entire book, and authored a collaborative introductory essay that theoretically frames this volume. Laura Kina was the primary investigator, developed the "happy Hapa" concept, and led the selection of visual images. She conducted the artist studio visits and interviewed thirteen of the nineteen artists included in this volume (we both interviewed Kip Fulbeck). We used a variety of methods to conduct the interviews (in person, telephone, online video chat, and e-mail), but we always started with a set of scripted questions. All of the interviews were transcribed either by us or by Kina's student research assistant Marco Cortes and included multiple rounds of follow-up questions and collaborative editing by both the artists and us. The scholarly essays were also collaboratively edited by both of us with the authors.

Context

Animated by personal quests and experiences, U.S. and British academic activist-scholars have, since the early 1980s, contributed significantly to the study of mixed race and particularly mixed race Asian American identity formation.[6] They have employed several different monikers to describe this area of antiracist scholarship, including "multiracial," "mixed heritage," "mixed race," and, now, with the advent of deeper critical theoretical frameworks, "critical mixed race." There is an important distinction between this critical and advocacy scholarship and the longer history of research in the humanities, social sciences, and physical sciences (e.g., biology, genetics, etc.), which too often pathologized mixed race and miscegenation. Much of the early antiracist multiracial scholarship was focused within the national boundaries of the U.S. racial paradigm and stemmed from innovative interdisciplinary and multidisciplinary work in ethnic studies and the social sciences (e.g., psychology, social psychology, sociology) and, to a lesser extent, history and philosophy.[7] As we examine the biographies, historical contexts, and cultural productions of mixed race Asian American artists, we do so with attention to transnational flows of identity and history, and, as Andrew Jolivette notes in his keynote address "Critical Mixed Race Studies: New Directions in the Politics of Race and Representation," with particular attention to forming a "critical pedagogy of resistance." Jolivette cautions,

> We are clearly not . . . moving toward that Brazilian or South African model where mixed race equals better race or equals no race. . . . In the same way that African American and American Indian women have articulated a womanist approach in distinction to a feminist approach, so too must we offer an approach that does not limit us to one category or one approach, or the "lowest common denominator." In a womanist

approach one continues to be female, of color, queer, differently abled, immigrant; she can hold all these identities.[8]

Jolivette's comment demonstrates the way in which race is constructed differently in different societies. Over time, the concept of "race" has developed in Europe and in the United States very differently from how it is conceived in places like Brazil, which early in the nation's history valorized racial mixing. One must also consider that the idea of "mixed race" implies that there are indeed separable "races," which is not a biological fact but rather a social construct. G. Reginald Daniel, author of *Race and Multiraciality in Brazil and the United States: Converging Paths?* (2006), further stresses that neither a multiracial identity nor multiracial individuals should be viewed as the final solution to racism and racial inequality, despite the fact that, "many of us believe that multiraciality, when based on egalitarian premises, that is to say, 'critical multiraciality,' has the potential not only to interrogate the essentialized conceptualization of biological race and racial categories but also serve as an addition to the arsenal of tools in the antiracist struggle."[9]

So it is within this context of forming a "critical multiraciality" as part of an "antiracist struggle" in our scholarship that we began to collaborate and lay the groundwork for *War Baby / Love Child*. After having for several years an e-mail and phone relationship born of mutual interest in each other's work, which we each discovered on the Internet, we met in person for the first time in February 2008 at the Multiracial Leadership Retreat.[10] The impetus for this multiauthor volume came from a traveling art exhibition proposal for the DePaul University Art Museum in Chicago and the Wing Luke Museum of the Asian Pacific American Experience in Seattle and subsequently grew with each set of questions we uncovered during the course of our artist interviews and studio visits. Wanting to create a text that moved beyond a typical exhibition catalog, we felt it was necessary to provide the larger historical and social contexts for understanding the art and the artists' interviews.

During 2008–12, when we were collaborating on this book, we saw the emergence of critical mixed race visual cultural studies scholarship focused on popular visual culture and biracial African American art history as well as a wide, deep, and specific range of publications on Asian American art history.[11] Yet, despite the growth in both these fields, few scholars have focused attention on the area of overlap: mixed Asian American artists. Though there have been monographs on mixed Asian artists such as Isamu Noguchi and Li-lan and on mixed race artists such as Adrian Piper, almost no critical scholarly work has been done on mixed Asian American artists as a group within the larger contexts of our histories as mixed Asian Americans. *War Baby / Love Child* builds on this previous scholarship while transgressing disciplinary boundaries.

Acknowledgments

We thank all the *War Baby / Love Child* artists and contributing authors for their art, their life stories, and their critical analyses and expertise. We also thank our friends and family members, as well as our home institutions colleagues, for all of their support.

A big mahalo to the Kina and Aronson mishpocha and Laura Kina's husband, Mitchell Aronson, for taking on more than their share of raising two kids and running a household and family business while Laura worked on this project. Wei Ming Dariotis thanks her Chan, Gin, and Dariotis families, and her family of friends, for their inspiration, love, and support. In particular, she thanks her Yia-yia, Jean Leghorn (1922–2009), for teaching her to love unconditionally and when to call "bullshit."

Laura Kina thanks her former art professors, especially painters Michiko Itatani and Kerry James Marshall, for teaching her the power of representation and DIY spirit. Wei Ming Dariotis appreciates the ethos of academic arts activism and community-engaged scholarship held by San Francisco State University. In particular, she wishes to thank departmental colleagues for support and collaboration: Lorraine Dong, Irene Duller, Mai-Nhung Le, Jonathan H. X. Lee, Isabelle Pelaud, Valerie Soe, Allyson Tintiangco-Cubales, Wesley Ueunten, and Grace J. Yoo.

On this project, we are blessed to have been gifted with the careful mentorship of leading Asian American art historians and curators Alexandra Chang, Mark Dean Johnson, and Margo Machida. Several pioneering scholars in Asian American studies and Critical Mixed Race studies have paved our way, intellectually inspired and personally supported us: G. Reginald Daniel, Camilla Fojas, Kip Fulbeck, Andrew Jolivétte, George Kitahara Kich, Stephen Murphy-Shigematsu, Cynthia Nakashima, Kent A. Ono, Maria P. P. Root, Nitasha Tamar Sharma, Paul Spickard, Teresa Williams-León, and Shawn Wong. We also wish to thank all of the participants of the Critical Mixed Race Studies 2010 conference and our students at DePaul University (in the Mixed Race Art and Identity and Asian American Arts and Culture classes) and San Francisco State University (in the Asian Americans of Mixed Heritage class, the Hapa Club, and the Variations student group) for helping inform this project. Many other colleagues in our departments and across our fields have inspired and supported various aspects of this work—we thank you all.

We would like to thank Laura Kina's DePaul University student research assistant Marco Cortes, for his many hours of transcribing interviews; Rory Padeken, for assistance in editing the bibliography and endnotes; Jacqueline Heckman, for assistance

in editing the preface, introductory essay, and endnotes; Paul Yamada and Cathy J. Schlund-Vials, for their critical feedback on the theoretical framework for this project; Cate Ekstrom and the staff of DePaul's Office of Sponsored Research and Programs and Foundations Relations, for their dedication in helping us fund this project; Belinda Reyes, director of the San Francisco State University College of Ethnic Studies César E. Chávez Institute, for aid in seeking financial support; University of Washington Press director Pat Soden and the acquisition editorial team of Jacqueline Ettinger, Beth Fuget, and Tim Zimmermann, for believing in this project at the early stages and making it a reality; our editor Kathleen Pike Jones and copy editor Laura Iwasaki; and, finally, Kent A. Ono, for authoring a foreword that contextualizes the relationship between the visual arts and multiracial Asian American identity.

Both of us would like to thank the DePaul University Art Museum and the Wing Luke Museum of the Asian Pacific American Experience for supporting this project. Wei Ming Dariotis is pleased to acknowledge support from San Francisco State University's César E. Chávez Institute, spring 2010, and from the Office of Research and Sponsored Programs and the College of Ethnic Studies, spring 2012. At DePaul University, Laura Kina would like to acknowledge the National Endowment for the Arts Art Works grant as well as DePaul University grant funding and fellowships that made this project possible: Office of Research in Academic Affairs 2011 support, 2009–10 Humanities Fellowship, Liberal Arts and Sciences Summer 2010 Research Grant, Liberal Arts and Sciences 2009–10 Student Research Assistant Grants, 2010 University Research Council Grant, and the Presidents' Office of Institutional Diversity and Equity sponsorship of the Critical Mixed Race Studies conference "Emerging Paradigms in Critical Mixed Race Studies," November 5–6, 2010. A grant from San Francisco State University and The Elizabeth Firestone Graham Foundation provided major funding for this book.

LAURA KINA and WEI MING DARIOTIS

Miscegenating Discourses: Critical Contexts for Mixed Race Asian American Art and Identity

LAURA KINA and WEI MING DARIOTIS

FOCUSED ON contemporary visual culture, *War Baby / Love Child: Mixed Race Asian American Art* investigates multivalent constructions of mixed heritage Asian American identity in the United States. As an increasingly ethnically ambiguous Asian American generation comes of age, this book examines—by way of varying degrees and differing registers—how mixed heritage Asian Americans artistically contemplate, engage, and address what Lisa Lowe famously termed "heterogeneity, hybridity, and multiplicity" in their respective artwork.[1] As important, *War Baby / Love Child* draws its various sites of inquiry from critical mixed race studies, illuminating a complex intersection of racialization, war and imperialism, gender and sexuality, and citizenship and nationality. This multiauthor volume features more than thirty works across diverse media by nineteen emerging, midcareer, and established artists who reflect a breadth of mixed heritage ethnoracial and geographic diversity, as well as a variety of artistic styles. Through interviews with the artists grouped with essays by ten leading interdisciplinary Critical Mixed Race and Asian American studies scholars, *War Baby / Love Child* explores the ways in which these artists are navigating and imagining their individual and communal identities against broader art historical, legal, and domestic and transnational social contexts.

"Bridge between Two Worlds"?:
Re-seeing Mixed Heritage Asian American Racial Formation

Set against an imaginary of U.S. imperialism (inclusive of war and colonization in Asia and the Pacific Islands), mixed race Asian Americans likewise reflect dramatic shifts in immigration policy and Civil Rights–era legislation. As many scholars argue, the 1965 passage of the Immigration and Nationality Act, which enabled the en masse entrance of Asian immigrants, has had a profound demographic impact. Equally significant is the 1967 *Loving v. Virginia* Supreme Court decision, which overturned the nation's last antimiscegenation laws. Both immigration law and civil rights cases fore-

3

ground what psychologist Maria P. P. Root dubbed the "biracial baby boom" in her seminal 1992 anthology *Racially Mixed People in America*.[2] Such a boom is evident in the 2010 U.S. Census, wherein more than 9 million Americans (or 2.9 percent of the population) self-identified as more than one race, just behind the largest Asian American group: Chinese. Moreover, Asians remain the fastest growing racialized group (up by 43 percent) in the United States. In the overlap, 2.6 million of 17.3 million Asians identified as Asian plus one or more other races, and a significant population of Asian Americans identified as interethnically mixed.[3] Since the early 1990s, the increasing numbers of mixed heritage Asian Americans, especially on the West Coast, has led to the construction of communities and movements based around a mixed Asian American identity. The concretization of this identity developed through the deployment of the term "Hapa" as an ethnic identifier signifying "mixed Asian."[4] This word has been appropriated from Hawai'i, which has the largest population of mixed Asians proportionally.

Cynthia Nakashima, who coedited *The Sum of Our Parts: Mixed Heritage Asian Americans* with Teresa Williams-León, argues "that the field of Mixed Race studies is a direct outgrowth of Asian American and ethnic studies, borrowing heavily from its texts, its paradigms, and its language."[5] Nakashima further suggests that integrating mixed race perspectives into Asian American Studies is a "necessity . . . simply to remain relevant in the twenty-first century."[6] Such a project would "alter the entire Asian American studies discourse by disrupting the very concept of 'Asian American' itself. Who and what is Asian American, and who gets to decide?"[7] Although integrating more mixed heritage content may subtly begin to shift the paradigms of Asian American Studies, this may also lead to a variation on the model minority myth: mixed Asians representing Asian assimilation into U.S. dominant culture. Countering this requires a rejection of the move to count (either through the census or in other venues) people of mixed heritage as a "multiracial" block with no further differentiation, which promotes a melting-pot multiculturalism that glosses over power relationships in order to celebrate "diversity."

Born in 1976, African American and South Asian Indian American artist Mequitta Ahuja creates art that exemplifies the dynamics and vision of this generation. In her 2009 drawing *Spark* (plate 1), Ahuja focuses on the constructed nature of her self-representation. The camera shutter release cable is clearly visible in her hand as she presents a mirrored self-portrait, bowing deeply, arms thrust out, the sleeves of her Indian kameez open like bird wings. As her head swings down, she unleashes a mass of loose, curly "good hair."[8] At the point in the drawing in which her doubled Afro unites, a psychic explosion ignites. With uncontained hair and wearing a salwar kameez, Ahuja simultaneously signals Black Power pride and Indian ethnicity. None-

theless, the artist's refusal to face the viewer—evident in closed eyes and downturned head—forces *Spark*'s audience to move from an easy reading of ascribed identity to a focus on less tangible modes of mind and energy. As Ahuja summarizes, "The flow from the head became a flow from the mind: a vehicle of infinite possibility."[9] Accordingly, Ahuja's self-portrait complicates notions of hybridity and destabilizes an artificial bifurcation of the psychic whole.

In so doing, Ahuja's *Spark* undermines facile readings of mixed race people as equally divided between two poles. Such polarity corresponds to a problematical reading of multiracial people as a "bridge between two worlds" within the dominant imagination. This connective evaluation carries the essentialized assumption that racialized groups are so deeply divided that interracial unions offer a solution to racial conflict. However, as the artists in this volume underscore, many of their mono-racially divergent parents met through shared economic or social spheres (i.e., attending the same college, mutual friends, allied professions or circumstances).[10] Some, having parents and grandparents of mixed heritage, are multigenerationally mixed; others are transracial adoptees; and some have parents who found homes in communities of color other than their own.

While the experiences and biographies of our interviewees are varied and often diverge significantly from the dominant discourses of mixed Asian identities, the mixed Asian body writ large continues to signify specific histories of Asian Pacific–U.S. collisions: narratives of war, economic and political migration, and colonization. Illustratively, when U.S. photographer Serene Ford returned to her mother's native Vietnam in 2003 to shoot *I'm the Girl Who Survived the War: Photographs from Viet Nam* (plates 2–4), "Amerasian" people would come up to her and say, "Same same, but different."[11] She knew what they were saying. They could tell. She saw people who looked like her; as she says, "a lot of them were still on the streets," and she thought, "Oh god."[12] In these brief encounters, the intersections and differences of race, ethnicity, nationality, and class became visible. Ford's mutual recognition of a shared ethnoracial lineage with Vietnamese Amerasians implies a homecoming—"same same"—but also highlights a larger comparative reading of mixed race people. Her concomitant response of "Oh god" and the Vietnamese qualifier "but different" point to the recognition of the vast chasm of citizenship-based privilege. At the same time, as Asian countries have increasingly entered the economic sphere as superpowers, faces implying "Asian fusion" are increasingly used as a sign of upward mobility and cosmopolitanism with which to "sell the new Asia."[13] Simultaneously fixed to an insider/outsider racial status, mixed race Asian Americans strategically use art as a way of illuminating, according to Homi K. Bhabha's oft-quoted phrase, a "Third Space" in the historic East-West binary (and additional spaces outside of and inter-

secting this binary). Bhabha described this interstitial alterity as "unrepresentable" and constituting "the discursive conditions of enunciation that ensure that meaning and symbols of culture have no primordial unity or fixity; that even the same signs can be appropriated, translated, rehistorized and read anew."[14] This volume expands the framing of hybridity as a liminal discursive, which has come to dominate alternatives to polarities such as theory/practice and First/Third World and Self/Other, to something more akin to mixed heritage Chinese American poet Mei-mei Berssenbrugge's tangible metaphor of "fenestrated capillaries"—blood flowing through many tiny veins, like diverging and converging streams, but veins in which there are windows, providing opportunities to take advantage of the multiple and shifting perspectives.[15] This image is more fluid and multidirectional than the current imagery in mixed race circles of "mixed roots," and it connotes the focus on blood and embodiment in historical discourses of mixed race identity while also acknowledging the water and wave metaphors of early Asian American Studies. Fenestrated capillaries invoke the idea of blood, blood quantum, bloodlines, mixed blood, watering down the blood and the idea of capillary action—a drawing together from multiple disparate sources.

This is a multicentered approach that asks how Critical Mixed Race and Asian American Studies might "fenestrate" these boundaries in such a way as to maintain Asian America while simultaneously reframing it. The window, unlike the lens, is multidirectional, looking both out and in simultaneously; the window provides reflection, implies the home as well as the casement that frames the view. This term offers an apt metaphor for Critical Mixed Race studies, which simultaneously intersects the bloodlines of ethnic studies, critical race theory, and postcolonial, queer, and feminist/womanist discourses while maintaining a sense of their distinctive histories and trajectories.

War Baby / Love Child introduces a heretofore little-mined context for visualizing mixed race Asian American art via the "Third Space" possibilities contained in Asian American art history and mixed race representations. This interstitial site is undeniably shaped by themes in U.S. and mixed Asian American history. Focused on war and concentrated around colonization, and reflective of exclusion and anti-miscegenation laws, this volume attends closely to the aesthetics of form and the physicality of materials of the artworks, individuating the artist's intentions and self-identification against limiting stereotypes. It is also concerned with the impact of audience reception and the ebb and flow of stereotypes of mixed race Asians that mark the artists and artworks, as well as how dominant "post-racial" rhetorics in contemporary art affect the critical reception of these works.

"A Convergence of Multiple Streams": Mixed Race in Asian American Art History

Asian artists in the United States, those born here, those who have come to stay, and those who have traveled here, have individually and collectively been creating their own images for as long as they have been here. However, it was not until the late 1960s, within the context of the Third World Liberation movement and protests against the Vietnam War, that Asian American artists joined together as "Asian Americans" in order to publicly decry racist media imagery and participate in the community arts movement within which to create their own positive, empowered, and corrective imagery en masse (e.g., the Kearny Street Workshop, the Asian American artists' collective founded in 1972 out of the I-Hotel struggle; and Frank Chin's Asian American Theater Workshop, founded in 1973).

In "The Last Asian American Exhibition in the Whole Entire World," Susette S. Min describes the contexts through which the category "Asian American art" developed.

> Emerging out of the Asian American Movement, the naming or categorizing of art as Asian American began as a historical and sociopolitical project. . . . This project gained critical mass as it became visible on the national scene in the late 1980s through the mid-1990s with a series of exhibitions including "The Decade Show: Frameworks of Identity in the 1980s," "1993 Whitney Biennial," "The Curio Shop," and "Asia/America: Identities in Asian American Art," during a period that is now being referred to as the "multicultural" years.[16]

After the 1990s, backlashes against multiculturalism and identity politics meant that organizing exhibitions around identity fell out of favor, and many artists and curators sought to "go beyond" the politics of identity—finding even the idea of "Asian American art" overly essentialized. Parallel to the contemporary visual arts trajectory of post-identity literature, film, theater, performance, and spoken word, by the mid-2000s, arts began to play a crucial role in forming highly visible cultures of multiracial people. Fanshen Cox and Heidi Durrow's annual Mixed Roots Film & Literary Festival at the Japanese American National Museum in Los Angeles, founded in 2008 and held in conjunction with advocacy efforts toward declaring a national Loving Day celebration on June 12, is one such example of these efforts. A transnational stone's throw away, in Vancouver, Asian Canadian artists and community activists organized the inaugural Hapa-Palooza: A Celebration of Mixed Roots Arts and Ideas in 2011, celebrating Vancouver's "identity as a place of hybridity, synergy and acceptance."[17] While these celebrations are not free of the problematics of cele-

bratory representations of multiculturalism, the mixed race body and mixed race art have the potential to destabilize the bifurcation between an uncritical multicultural identity and post-identity solutions by providing a more liminal, fluid reading of art, culture, and racial politics. Mixed race bodies have this potential more than other kinds of multicultural "solutions" because, unlike interracial relationships, which can end, or integrated neighborhoods, which can change from diverse to monoracial, mixed race bodies cannot be separated out. As in playwright Velina Hasu Houston's famous description of her identity as "neopolitan ice cream"—chocolate, strawberry, and vanilla, all mixed together—once it is mixed, you can't remove any part of it.[18] The caveat to this is that mixed race individuals can also racially pass or cover; one need not be mixed in order to create racially and culturally complex art; and other identities can equally engage with liminality (e.g., Queer/LGBTQ, adoptee, desi, and even Asian American identity more generally).

Against the background of these contested contexts, at the inaugural Diasporic Asian Arts Network meeting in 2009, art historian Margo Machida described the current state of Asian American art as "a series of parallel and at times divergent streams that have recently begun to converge."[19] Rather than receding with the waning tide of multiculturalism, critical publications on Asian American art burgeoned at the end of the new millennium's first decade.[20] Asking "What is Asian American art?" scholars conducted primary and archival research and recontexualized Asian American art in multiple ways. Two of the major shifts in the field are at the heart of this project: using diasporic and transnational frameworks rather than hemispheric or nation-bounded contexts and applying Machida's methodology of oral hermeneutics, which she describes as "an exploratory form of dialogic engagement that seeks to share interpretive authority with artists by linking the use of oral history methods with hermeneutical orientation toward textual interpretation."[21]

What has not happened until now in this wave of new scholarship and "convergence of multiple streams" is the centering and critical examination of mixed race Asian American artists with the aim of understanding the important nexus they represent *beyond* individual or exceptional narratives.[22] Oral hermeneutics, which accesses sociological methodologies, carefully balances meta-frameworks and observations with first-person narratives. In the visual arts, the interpretive authority of the critic or art historians has traditionally been given precedence, whereas talking to living artists about their work is often viewed as an unreliable methodology (i.e., the argument that "artists always lie") in favor of the "truthful" historical narratives that can be culled from archives.[23] For artists from underrepresented populations (particularly artists of color, women, and queer artists), inclusion of personal narrative risks their being hypervisible or having their work dismissed as "merely personal" in

contrast to the supposedly "universal" forms of the postmodern, experimental, or abstract. In "Is There an Asian American Aesthetics?" writer Meena Alexander argues, "It is a fiction, a very dangerous one, to think we can play endlessly in the post-modernist fashion, because our ethnicity is located in our bodies and comes in as a pressure to resist this sort of fracturing."[24] Put another way, bodies of color and ethnic bodies are marked by the viewers' presuppositions. The visualized body, as evident in the artwork, is thus read not only for what it presents but also against preexisting stereotypes.[25]

By foregrounding interviews with artists and scholarship that engages personal narrative, as well as art that addresses the mixed Asian body (even those works that are not directly representational or figurative can be read against the bodies of the artists as mixed Asian people), this volume seeks to engage mixed race Asian American art with an understanding of the significance of "positionality" as articulated by ethnic studies, women studies, and queer studies. This understanding can be used to negotiate an analysis that is conscious of and reveals power relationships between critic and artist and within hierarchies of race, gender, class, sexuality, and nationality.

Many of the artists in this volume are invested in representing the mixed race Asian body as both a sutured and a fractured image of racial identity. For example, Kip Fulbeck's portrait of Eric Akira Tate in *The Hapa Project* (2006) (plate 5) presents a confident and friendly frontal headshot of an African American–Japanese man against a white, highly lit, commercial studio backdrop. Despite being portrayed naked from the shoulders up, Tate meets and engages the gaze of the photographer/viewer, and his body appears to be relaxed as a slight smile passes across his face. Tate's body and face embody racial wholeness. Fulbeck complicates this image by co-opting a serial format and the indexical anthropological photographic conventions of portrayals of ethnic and racialized Others that are alternately loaded with nineteenth-century eugenicist or romanticized and exoticized connotations (e.g., Germany's Eugene Fischer's 1913 *Bastardforschung*, Edward S. Curtis's 1907 publication *The North American Indian*). In Fulbeck's typical display of *The Hapa Project*, modestly scaled portraits are hung close together, which emphasizes a comparative reading of the subjects, and in his book rendition of the project, he graphically lists the sitters' races and/or ethnicities next to their portraits. The tensions generated by these anthropological formats create an echo effect as they bounce off the sitters' handwritten, empowered responses to the perennial question, "What are you?" Eric Akira Tate responded, "I am 100% Black and 100% Japanese." His statement acknowledges the historical fractionalization of mixed race identity used to determine "Blackness" or "whiteness" in the context of racist Jim Crow and antimiscegenation laws and to

determine entitlement under the federal government's Bureau of Indian Affairs' blood quantum system. Tate's claiming of multiple 100 percent identities is similar to the mixed Japanese movement toward the term "double"—in opposition to "half"—and thus simultaneously claims racialized wholeness while rejecting the fracturing logic of blood quantum and the one-drop rule.

Hence, the power and importance of the first-person narrative, of seeing oneself reflected in others, holds particular significance for those who have historically been underrepresented and/or misrepresented, or Othered. For those constantly subjected to a kind of fetishized Gaze, first-person narrative is a process of self-determination and self-exploration that often generates a counternarrative.[26] Documentary films such as Deann Borshay Liem's 2000 *First Person Plural*, which explores the complexity of her transracial adoptee identity and family dynamics, fit into the tragic "war baby" genre, but in Borshay's work, the adoptee subject takes agency and tells her own story, in contrast to Gail Dolgin and Vincente Franco's 2002 *Daughter from Danang*, about a Vietnamese mother and her Amerasian daughter torn apart by the war in Vietnam.

Emblematically, the 2010 documentary *One Big Hapa Family*, by Asian Canadian indie filmmaker Jeff Chiba Stearns, makes visible the extent to which autobiographical documentaries can generate historically significant counternarratives. Over the course of the film, Chiba "embarks on a journey of self-discovery to find out why everyone in his Japanese Canadian family married interracially after his grandparents' generation."[27] In addition to portraying a shifting Canadian racial landscape and increased tolerance for "visible minorities," the cinematic protagonist discovers that his family's pattern of outmarriage and assimilation into the dominant white culture reflects the high outmarriage rate of Japanese North Americans generally.[28] Chiba's family structure is specifically related to the treatment of Japanese Canadians during World War II: forced internment and resettlement and internalized racism.[29] Like Chiba, the nineteen mixed heritage Asian artists profiled in *War Baby / Love Child* engage in personal journeys that are inextricably connected to larger histories of globalization, migration, and relocation.

Fluid Stereotypes: "War Baby," "Love Child," and the New "Happy Hapa"

Colonialism has deeply structured globalization, migration, and relocation. As Homi K. Bhabha has argued in "The Other Question: Stereotype, Discrimination and the Discourse of Colonialism," colonialism uses stereotypes as an excuse for the subjugation of supposedly inferior peoples. Stereotypes are nominative iterations constructed to soothe the anxiety of dealing with the incomprehensible Other. He argues that

both positive and negative stereotypes deny rights of ambivalence.[30] The figure of Asians in the American imagination has largely been constructed through racist Yellow Peril and model minority media portrayals of Asians as recognizable "Gangsters, Gooks, Geishas, and Geeks."[31] Portrayals of mixed race Asians, while largely absent, when present as such, are visible only as Eurasian (but not Black Asian, etc.) and totally passive, and this is reinforced through the portrayal of mixed Asians as infants or children, as Kent A. Ono argues with regard to the Irish and Japanese American World War II character Mini in the 1990 film *Come See the Paradise*. When the Eurasian image is present, it exists largely as a struggle to resolve existing stereotypes of the Asian as Other, as in the tragic Eurasian image of being between two worlds, like the Hong Kong–based Eurasian character Han Suyin (played by white actress Jennifer Jones) in the 1955 film *Love Is a Many-Splendored Thing*, or of being eternally bifurcated, "half yella and half white," as Marlon Brando's character says of what his children will be in the classic film *Sayonara* (1957). When the Eurasian is male, the image can be a more threatening symbol of racial betrayal, such as the Eurasian engineer in *Miss Saigon* (originally portrayed by white actor Jonathan Pryce).[32] These positive and negative constructions around ambivalence can be characterized as the images of the Eurasian as "war baby," "love child," and, more recently, the "Happy Hapa."

It was not until the 1990s and early 2000s that mixed Asian American artists, filmmakers, and activists started to gain agency in constructing visual images of Hapas, usually but not always Eurasian, as a distinct identity and subcommunity of Asian Americans and Pacific Islander Americans.[33] Though not all of the following use the term "Hapa," some examples include student activists' formation of the Hapa Issues Forum at the University of California, Berkeley, in 1992; filmmaker Valerie Soe's 1992 interactive video installation *Mixed Blood*; artist-author Kip Fulbeck's work, from his 1991 short film *Banana Split* to his 2006 photographic book and online *Hapa Project*; Reggie Life's 1995 documentary *Doubles: Japan and America's Intercultural Children*, which has a strong Black Asian component; Greg Pak's 2003 *Robot Stories*; and Eric Byler's 2003 film *Charlotte Sometimes* as well as his adaptation of Shawn Wong's 1996 novel *American Knees* into the 2006 film *Americanese*. In *War Baby / Love Child*, we also note that the emergence of a visible virtual Hapa community paralleled the rise of social media networking in the late 1990s to the present. As Athena Asklipiadis of Mixed Marrow, interviewed in Kristen D. Lee's short film *MiXeD mE*, explains, "It had to be online because mixed race people are not a physical community. We don't have a 'Little Hapaland' downtown."[34]

Though we have no clearly defined ethnic enclaves, people of mixed heritage are now widely accepted in most areas of the United States. Nevertheless, it was less than

a generation ago that mixed Asians were assumed to be either by-products of war or of illicit free love. The title of this book, *War Baby / Love Child*, references these historic dyadic stereotypes. Amerasians are the most recent "war babies," who continue to be seen and represented as children of war, at war with themselves, forever infantilized by their public image as the children of U.S. soldiers and hypersexualized Asian and Pacific Islander women. "War babies" symbolize the subjugation of Asian people to U.S. and European power, as in the poem "A Rose of Sharon," by Myung Mi Kim, in which a young Amerasian girl living in Korea describes her mother's rape:

> They say two Big Noses [Americans] threw her out a window. They say her hands were tied, and she had no clothes on.[35]

The trope of the "war baby" continues through U.S. military bases in East Asia and the Pacific and wars in West Asia.[36]

The implication of the term "Amerasian" is that the parents' relationship is one in which the father (presumably white, despite the large numbers of men of color, especially African American men, who serve in the U.S. military) abandoned the mother (presumably Asian) (e.g., Puccini's *Madama Butterfly* [1904], *Miss Saigon* [1989]). The tragic Amerasian/Eurasian trope derives from this racial-gender dynamic, in which the result/child of such a "tragic" narrative must have a tragic identity.

Public Law 97-359 defines "Amerasian" by giving immigration rights to children of U.S. citizens (usually the fathers) who can prove they were born in Korea, Vietnam, Laos, Kampuchea, or Thailand after December 31, 1950, and before October 22, 1982. This law should (but doesn't) include Filipino Amerasians, Japanese Amerasians, Okinawan Amerasians, Guamanian/Chamorro, and Samoan Amerasians. The Vietnamese Amerasian Homecoming Act of 1988 allows Vietnamese Amerasians to immigrate to the United States. They experienced such a lack of acceptance within Vietnamese society because they were "American" that many Amerasians believed they would be accepted in U.S. society as "Americans"; they often erroneously believed that they would be reunited with their fathers, as did their mothers, as depicted in Shawn Hainsworth's documentary *Between Two Worlds* (1998).

The term "love child," while more than two hundred years old, has particular historical associations in a mixed race context. As Katie Roiphe observes, "The word itself dates back to at least 1805. [An] important touchstone in the word's history is . . . the 1968 Diana Ross and the Supremes song 'Love Child,' with the truly transcendent rhyme, 'Love child, never meant to be / Love child, scorned by society' . . . *Love child* is definitely more friendly or tactful than the more Shakespearean *bastard* but it nonetheless cloaks a certain discomfort with the facts."[37] Such "cloaking" is evident in

"love child" stereotypes of tragic mulattoes, tragic mixed breeds, tragic mestizos, and tragic Eurasians, which straddle not only illegitimacy (embodied by the existence of pre-*Loving* antimiscegenation laws) but also the free love of the post–Civil Rights and flowerchild era.[38]

These cultural images of the mid- to late twentieth century might seem outdated at the turn of the twenty-first century, yet the racial shadows of "war baby" and "love child" remain relevant, especially since the United States maintains a strong military presence in or occupies the Pacific Rim (Guam, Hawai'i, Okinawa, South Korea, Samoa) and Afghanistan and Iraq in the region increasingly referred to by academic, military, and business scholars as MENA (Middle East and North Africa).[39] Likewise, the figure of the "love child" has been transformed subversively into a positive (but still stereotypical) image of mixed race people as harbingers of racial harmony—even as "racial saviors." As our popular culture re-creates the image of the mixed race body as a marketable object of desire (e.g., Amerie, Tyson Beckford, Enrique Iglesias, Kristin Kreuk, Maggie Q, Keanu Reeves), such bodies are comparatively read as solutions to a still-unresolved "race problem."[40] Given the reaction to Barack Obama's 2008 election, which made visible what Camilla Fojas calls an "American exceptionalism" (ch. 31, "The Biracial Baby Boom and the Multiracial Millennium") through alleged racial harmony, it is important to examine the social and historical contexts of visual representations of and by mixed Asians, because they necessarily complicate the understanding of racial and artistic discourses beyond mere celebration.

Hawai'i as a multifaceted, contested site figures keenly in this disconnect between racial harmony and racialized subjectivity. As Lori Pierce suggests in chapter 14, "Six Queens," the idea of "American exceptionalism" is particularly funneled through the image of Hawai'i as a multicultural paradise; thus, the association of mixed Asians through the image of the Happy Hapa reinforces the notion of mixed Asians, particularly Eurasians, with the idea that the United States is both racially diverse *and* free of racial tensions. Like these dyadic terms, we utilize the term "Happy Hapa" deliberately so that we may signify the relationship between the discourses that have been constructed around these identities in order to investigate and examine their "emergence and reception."[41] The image of what we term the Happy Hapa represents a simultaneous reclamation of racial pride and a multicultural symbol of undivided wholeness. But this image can also be read as the resolution of societal anxiety over race through the production of beautiful, mixed race (especially white and Asian) children (always infantilized) signaling the supposed assimilation of Asian Americans into the paternalized dominant culture. Images of smiling and ethnically ambiguous children abound on the covers of otherwise serious and scholarly books; Michele Elam, author of *The Souls of Mixed Folk* (2011), aptly critiques these types of images as

"playing a role in the creation of certain restrictive, normative models of mixed race."[42]

This new stereotype of the Happy Hapa is the flip side of the tragic Eurasian. No longer the worst of both worlds, the Happy Hapa embodies the "best" of two imaginaries, living blissfully in a bubble of racial uniqueness, sealed away from complicated histories.[43] "Don't worry, be hapa" is a saccharine phrase seen on T-shirts aimed at Asian and Pacific Islander American and mixed race communities.[44] It replaces the word "Happy" with the appropriated word for mixed Asians: "Hapa." This suggests an anxiety over race—specifically, Asianness—that may somehow be resolved (or evaded) by displaying a mixed Asian identity.[45] T-shirts provide a kind of visible personal narrative, calling attention to the wearers' visual self-presentation, and thus for people of mixed heritage, they can be "a community building tool," as Kimberly DaCosta describes and critiques in *Making Multiracials*.[46] The use of the word "hapa" in this context connects mixed Asians to Hawai'i's racial exceptionalism; thus, "Don't worry, be hapa" implies that mixed Asians can somehow "be" "Hawaiian" instead of worrying about the authenticity of their ethnic identities.

We want to be clear that Asian Americans and Pacific Islander Americans are two differently racialized, pan-ethnic groups. After all, 1980 was the first time Asian Americans and Pacific Islanders were grouped together pan-ethnically in the U.S. Census, and this category persisted until 2000, when the two were disaggregated on the census. In practice, however, across federal government agencies, the two categories remain aggregated.[47] This coupled framing of Asian Pacific American (APA) and Asian Pacific Islander (API) proves to be especially problematic for Pacific Islanders, who are disproportionately underrepresented and economically disadvantaged, and may have contributed to the conflation of Asians and Pacific Islanders that has played out in the use of the term "Hapa" by mixed heritage Asian Americans.[48] The positionality of mixed race and mixed heritage Asian Americans became more solidly located within Asian American communities at least partially through their being named as a coherent, identifiable group through the use of the term "Hapa."[49] As opposed to ethnic-specific terms like Filipino-pan-Latino "mestizo" or Japanese "haafu," "Hapa" has been used as a pan-ethnic term—an ethnic signifier that specifically situates mixed Asian Americans within the pan-ethnic Asian American community. It is understood to be an Asian American–focused term; more than just mixed, it specifically signifies mixed Asian or Pacific Islander. "Hapa" gave mixed heritage Asian Americans a safe space but does so at the expense of Native Hawaiians. In "A Poetics of Ethnicity," Fred Wah writes, "To write (or live) ethnically is also to write (or live) ethically, in pursuit of right value, right place, right home, right otherness."[50] Living "ethnically" means being aware of personal positionality—one's relations to power in

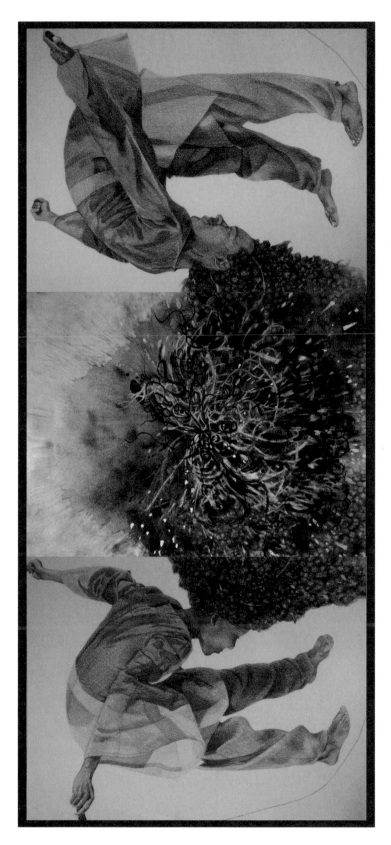

Plate 1. Mequitta Ahuja (American, b. 1976)
Spark, 2009
Waxy chalk on paper
50 x 114 in.
Collection Dr. Anthony Brissett

Plate 2. Serene Ford (American, b. 1975)
Ghost of a Girl, from the series *I'm the Girl Who Survived the War: Photographs from Viet Nam*,
1998–2003
C-print 35mm
20 x 24 in.
Courtesy of the artist

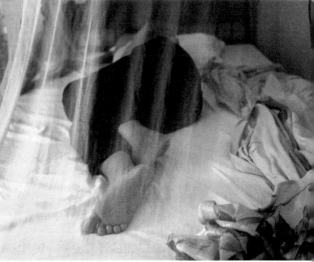

Plate 3. Serene Ford (American, b. 1975)
Mom, from the series *I'm the Girl
Who Survived the War: Photographs from
Viet Nam*, 1998–2003
C-print medium format
20 x 24 in.
Courtesy of the artist

Plate 4. Serene Ford (American, b. 1975)
Mom Sleeping, from the series *I'm the Girl Who
Survived the War: Photographs from Viet Nam*,
1998–2003
C-print medium format
20 x 24 in.
Courtesy of the artist

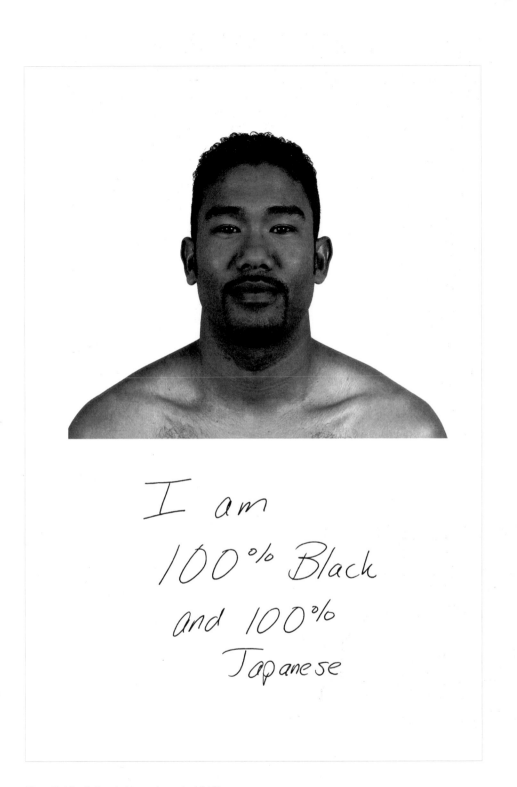

Plate 5. Kip Fulbeck (American, b. 1965)
Selection from *The Hapa Project*, 2006
Digital print
62 x 45 in.
Courtesy of the artist

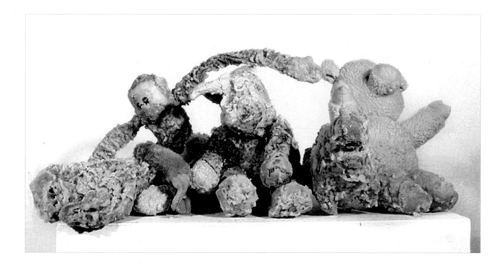

Plate 6. Samia Mirza
(American, b. 1986)
Deep Fry Your Soul, 2007
Stuffed animals, flour,
eggs, cornmeal, oil
Dimensions variable
Courtesy of the artist

Plate 7. Jenifer Wofford (American)
MacArthur Nurses I, 2009
Ink and acrylic on paper
27.5 x 39.5 in.
Courtesy of the artist

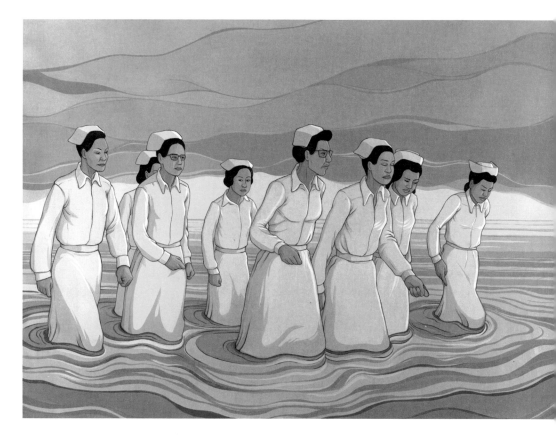

Plate 8. Lori Kay (American, b. 1962)
Heir to Rice, 1999
Bronze, brass, fiber
20 x 16 x 16 in.
Courtesy of the artist

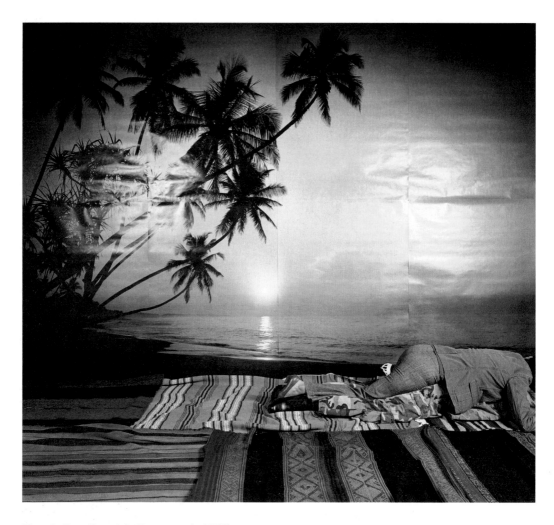

Plate 9. Gina Osterloh (American, b. 1973)
Gina Osterloh (American, b. 1973)
Collapse, from the *Somewhere Tropical* series, 2006
LightJet photograph
36 x 40 in.
Courtesy of the artist

Plate 10. Gina Osterloh (American, b. 1973)
Burnt Out, Died, Got Some Rest #1, from the *Somewhere Tropical* series, 2005
LightJet photograph
40 x 40 in.
Courtesy of the artist

Plate 11. Gina Osterloh (American, b. 1973)
Rapture, from the *Somewhere Tropical* series, 2006
LightJet photograph
36 x 40 in.
Private collection

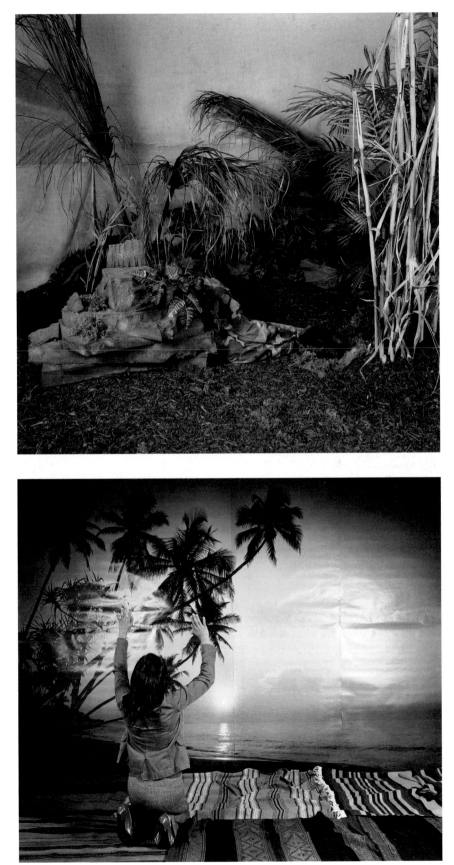

Plate 10

Plate 11

Plate 12. Laura Kina (American, b. 1973)
Hapa Soap Opera #1 (Misty Fujinaga, Sean
Stoops, Laura Kina, Sam Kina, Ian Wan), from
the Hapa Soap Opera series, 2002
Oil on canvas
72 x 48 in.
Courtesy of the artist

(facing page)
Plate 13. Laura Kina (American,
b. 1973)
Issei, from the *Sugar* series, 2011
Oil on canvas
30 x 45 in.
Courtesy of the artist

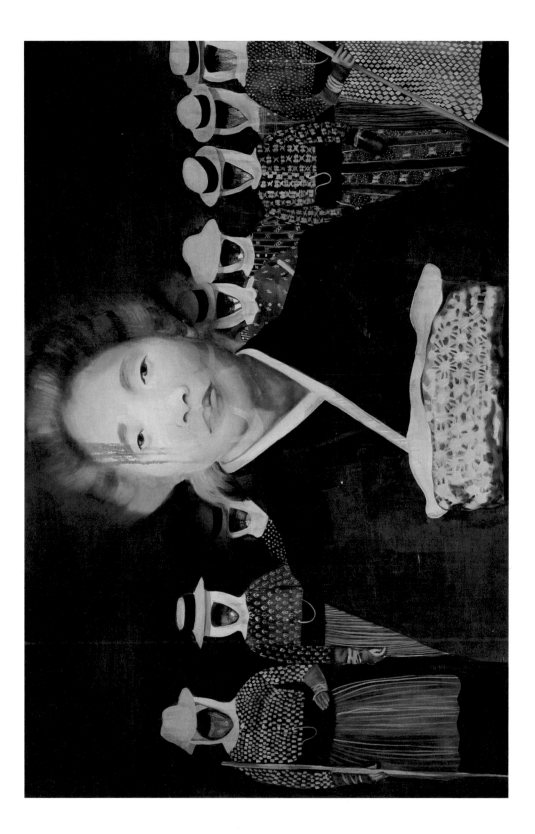

Plate 14. Laurel Nakadate
(American, b. 1975)
Greater New York, 2005
Single-channel video
5 min., 10 sec.
Courtesy of Leslie Tonkonow
Artworks + Projects

This video speaks about small personal tragedies meeting the tragedies of the greater world. It is about exploring the world through chance encounters with strangers, private moments in rooms, telling stories through constructed narratives, and the loneliness of watching the world fall down around you.

(facing page)
Plates 15a–c. Jane Jin Kaisen (South Korean–Danish, b. 1980)
The Woman, the Orphan, and the Tiger, 2010
Single-channel video, DVCPRO 720p
72 min.

By Jane Jin Kaisen in collaboration with Guston Sondin-Kung. Main contributors to the film: Grace M. Cho, Jane Jeong Trenka, Jennifer Kwon Dobbs, Maja Lee Langvad, Soni Kum, Tammy Chu, Nathalie-Mihee Lemoine, Nu Young Nim, Pak Chun Sung, Myung Ki Suk, Rachel, Isabel.
Courtesy of the artist

The film exposes how military and patriarchal violence against women and children became central in international geopolitical negotiations. It creates a strategic genealogy between three generations of women: the former "comfort" women who were subjected to sexual slavery by the Japanese military, women who have been sex workers around U.S. military bases in South Korea, and South Korean international adoptees.

Plate 15a

Plate 15b

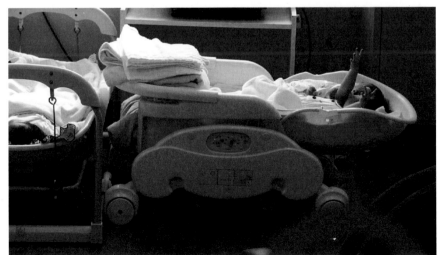

Plate 15c

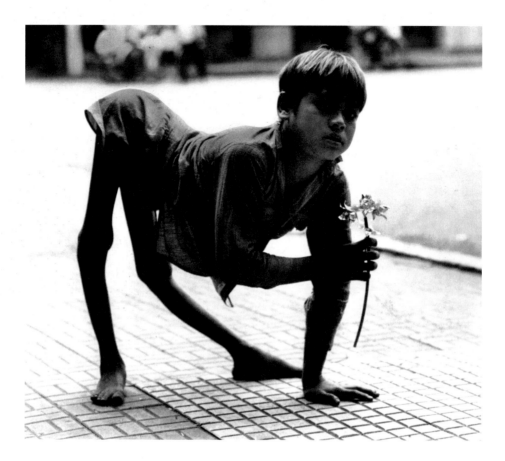

Plate 16. The abject conditions of Amerasians living in Vietnam were most dramatically represented in an October 1985 photograph taken by Newsday photojournalist Audrey Tiernan.

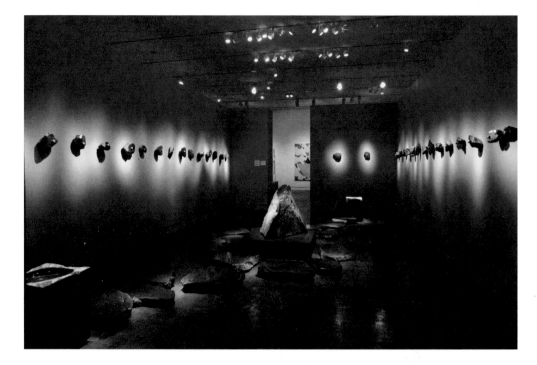

Plate 17. Kaili Chun (American, b. 1962)
Nāu Ka Wae: The Choice Belongs to You, 2006
Mixed media
Room-sized installation, Honolulu Academy
of Art, Honolulu, Hawai'i
Courtesy of the artist

Plate 18. Adrienne Pao (American, b. 1975)
Uncle Jeff and His Favorite Fighting Cock,
from the *Family Portraits* series, 2009
C-print
16 x 24 in.
Courtesy of the artist

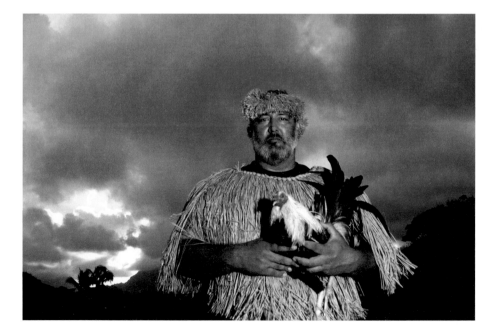

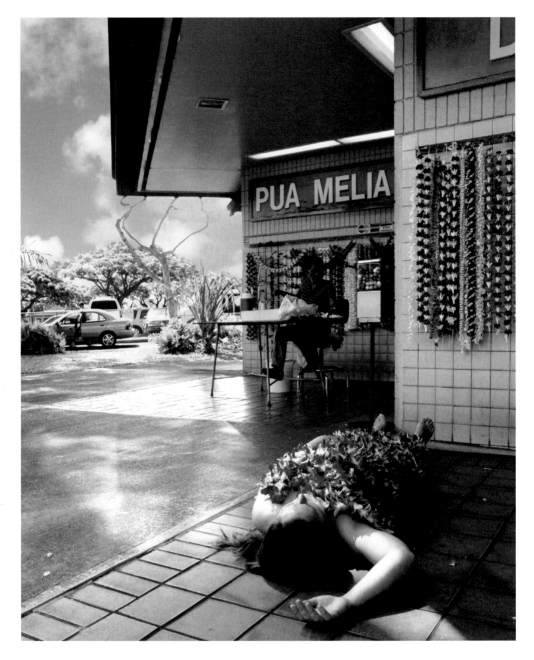

Plate 19. Adrienne Pao (American, b. 1975)
Lei Stand Protest / Lei Pua Kapa, from the *Hawaiian Cover-ups* series, 2004
C-print
36 x 30 in.
Courtesy of the artist

Plate 20. Adrienne Pao (American, b. 1975)
Searching for Roots at the International Marketplace / A'a Kapa, from the *Hawaiian Cover-ups* series, 2004
C-print
36 x 30 in.
Courtesy of the artist

Plate 21. Adrienne Pao (American, b. 1975)
Sunset at Sunset Beach / Napoʻo ʻana o ka Iʻ Kapa, from the *Hawaiian Cover-ups* series, 2005
C-print
36 x 30 in.
Courtesy of the artist

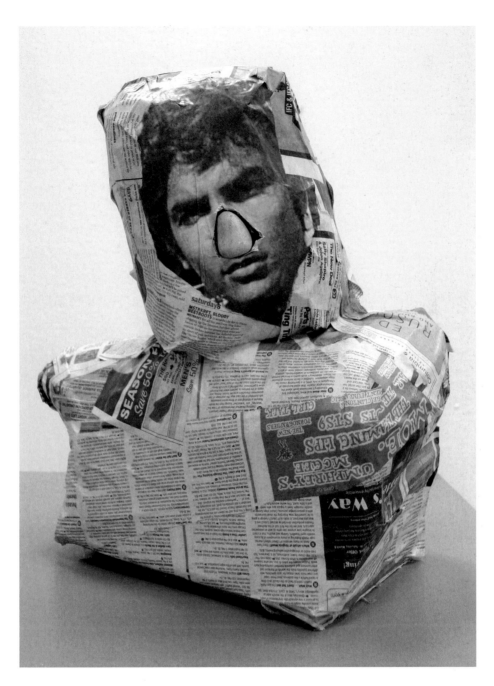

Plate 22. Samia Mirza (American, b. 1986)
I've Always Wanted Your Nose, Dad, 2008
Brown paper, newspaper, masking tape, Xerox of a photo of "Dad thirty years ago," rock
16.75 x 11.75 x 9.25 in.
Courtesy of the artist

Plate 23. Li-lan (American)
Two Views Bridged, 2000
Oil on linen
42 x 54 in.
Courtesy of Jason McCoy Inc.

Plate 24. Li-lan (American)
Bird of Passage, 2001
Oil on linen
30 x 24 in.
Courtesy of Jason McCoy Inc.

Plate 25a

Plate 25b

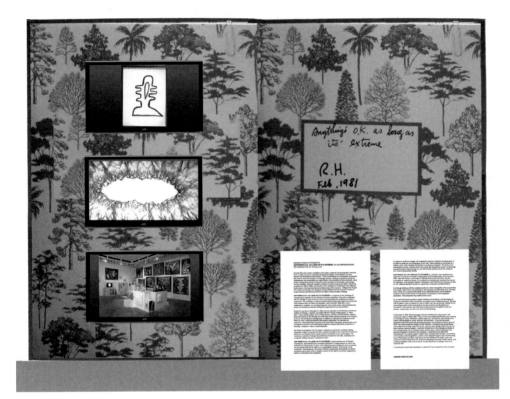

Plate 25c

Plate 25c. Amanda Ross-Ho (American, b. 1975)
ANYTHING'S O.K. AS LONG AS IT'S EXTREME (Reprise), 2013
A site-specific presentation developed for *War Baby / Love Child: Mixed Race Asian American Art*
Photographic banner print, flatscreen monitors, text on panels, dimensions variable
Courtesy of the artist

(facing page)
Plate 25a–b. Amanda Ross-Ho (American, b. 1975)
ANYTHING'S O.K. AS LONG AS IT'S EXTREME:
AN INCOMPREHENSIVE RETROSPECTIVE OF RUYELL HO, 2008
Installation view from *Chinaman's Chance: Views of the Chinese American Experience*,
Pacific Asia Museum, Pasadena, California, March 6–July 27, 2008
Courtesy of the artist

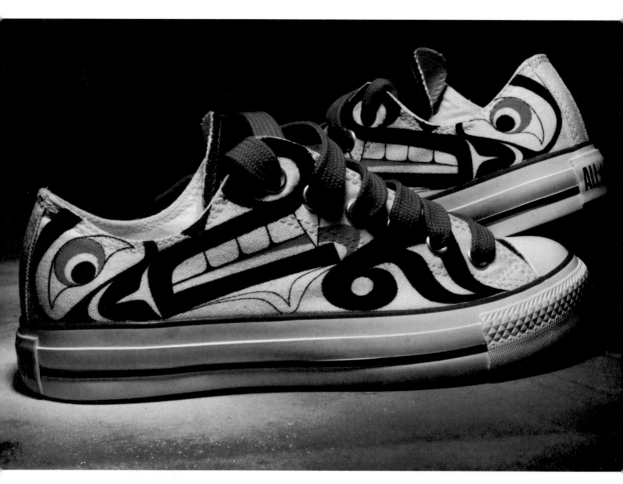

Plate 26. Louie Gong
(Canadian Nooksack, b. 1974)
Wolf Chuck, 2009
Custom-painted shoes
Courtesy of the artist
Photo: Victor Pascual

(*facing page*)
Plate 27. Louie Gong
(Canadian Nooksack, b. 1974)
Coast Salish Dragon, 2009
Acrylic on canvas
16 x 22 in.
Courtesy of the artist

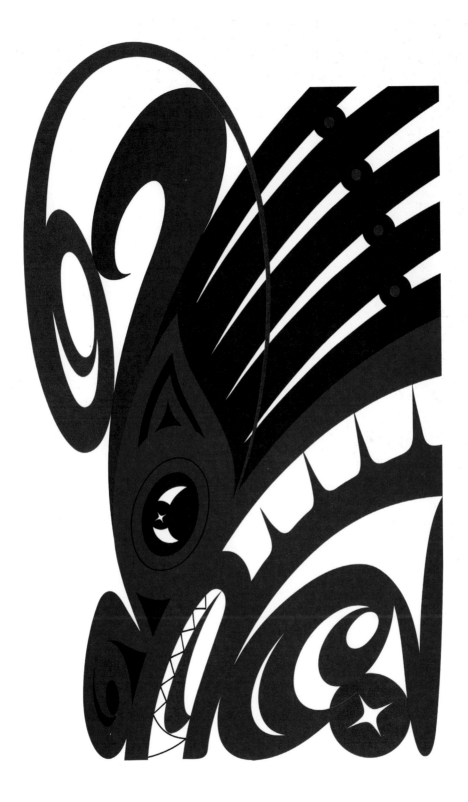

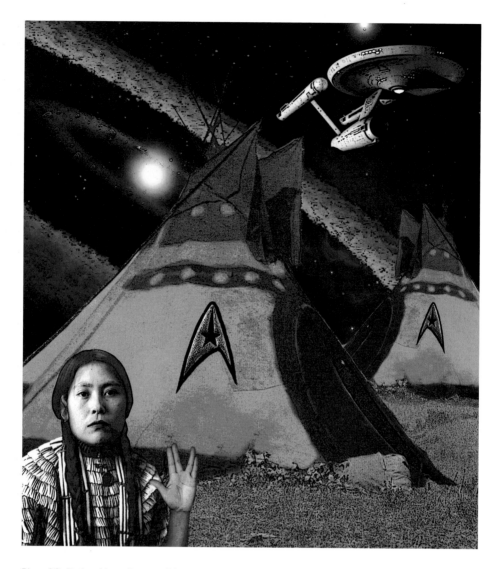

Plate 28. Debra Yepa-Pappan (Korean–Jemez Pueblo, b. 1971)
Live Long and Prosper (Spock Was a Half-Breed), 2008
Digital print
20 x 18 in.
Courtesy of the artist

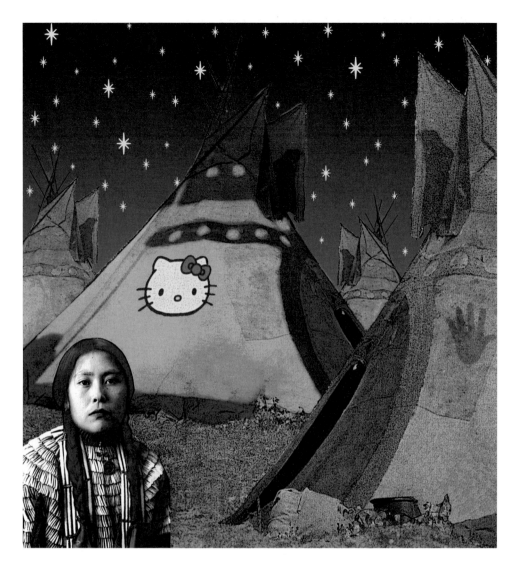

Plate 29. Debra Yepa-Pappan (Korean–Jemez Pueblo, b. 1971)
Hello Kitty Tipi (Starry Sky), 2007
Digital print
20 x 18.5 in.
Courtesy of the artist

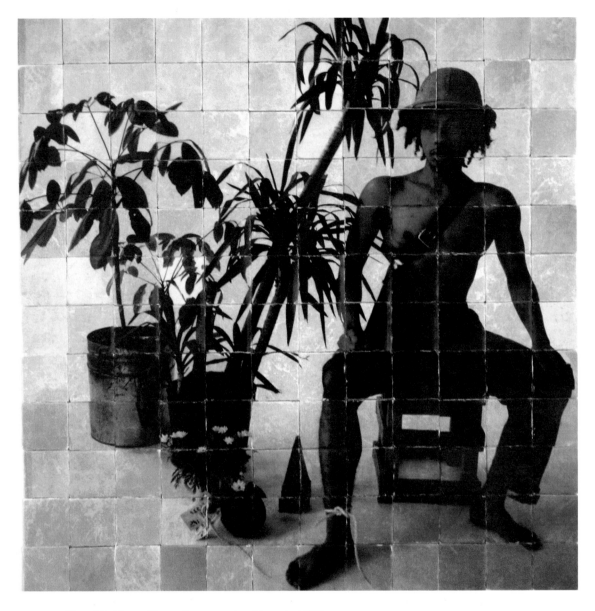

Plate 30. Albert Chong (Jamaican-American, b. 1958)
Portrait of the Artist as a Victim of Colonial Mentality, 1979/2010, 2010
Photo transfer on marble tiles
48 x 48 in.
Courtesy of the artist

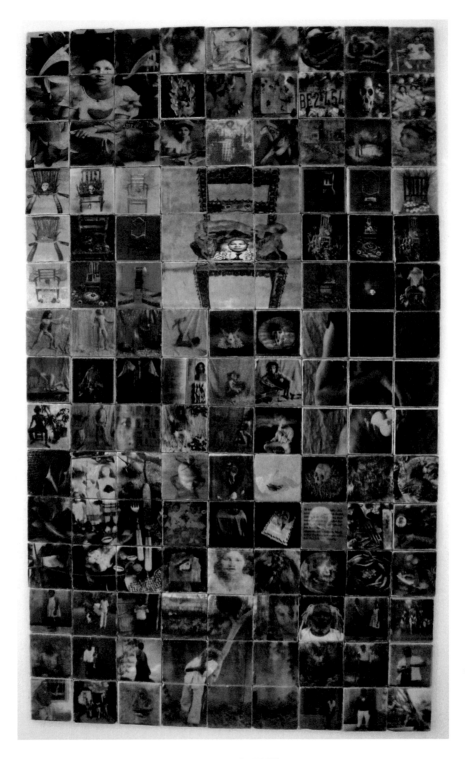

Plate 31. Albert Chong (Jamaican-American, b. 1958)
Imagining the Past, 2009
Photo transfer on marble tiles
60 x 36 in.
Courtesy of the artist

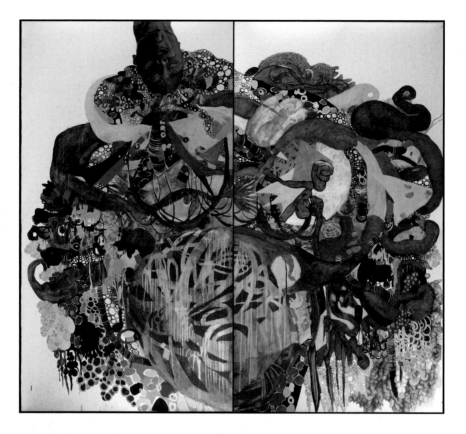

Plate 32. Mequitta Ahuja (American, b. 1976)
Dream Region, 2009
Oil, enamel, acrylic, waxy chalk on paper
78 x 104 in.
Collection of Alyssa and Gregory Shannon

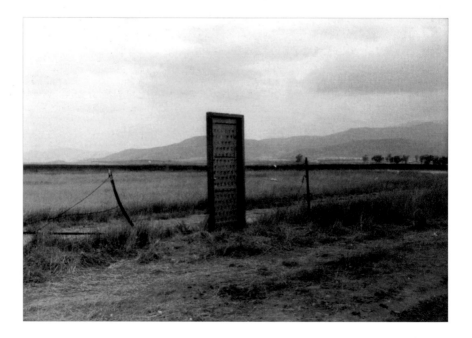

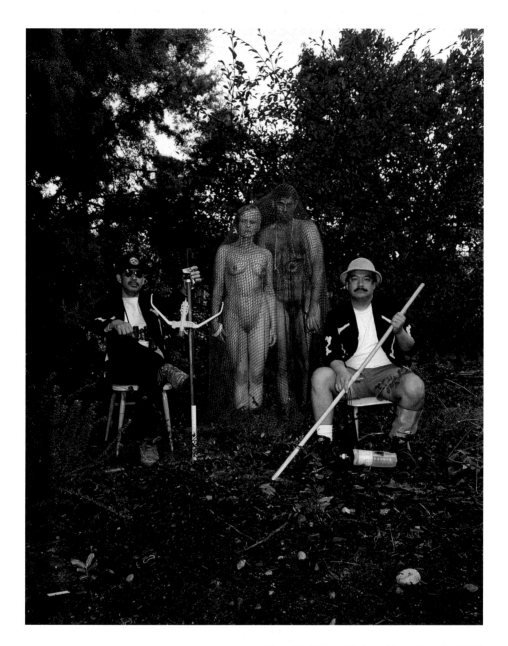

Plate 34. Richard A. Lou (American, b. 1959)
Captives of Fate, from Los Anthropolocos'
White-Fying Project performance by Richard
A. Lou and Robert J. Sanchez, 1995
Photo: Jim Elliott
Courtesy of the artist

(facing page)
Plate 33. Richard A. Lou
(American, b. 1959)
Border Door performance, 1988
U.S/Mexican border between San Diego and Tijuana
Photo: Jim Elliott
Courtesy of the artist

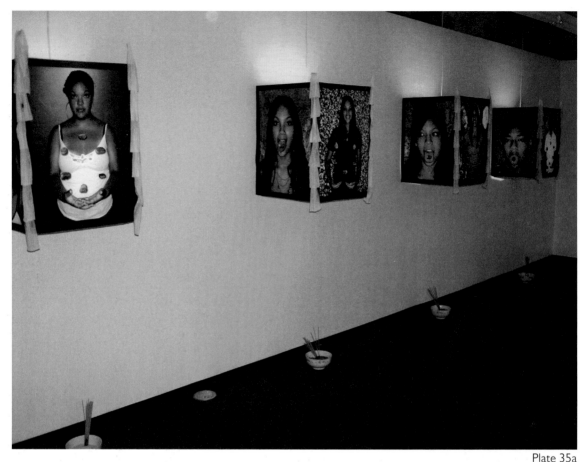

Plate 35a

Plates 35a,b. Richard A. Lou (American, b. 1959)
Stories on My Back, 2008
Installation view from *Richard Lou: Stories on My Back*, Power House Memphis, Memphis,
Tennessee, November 21–29, 2008
Audio, digital prints, corn husk, bowl with rice, beans, incense
Installation dimensions variable; each lantern is approx. 36 x 24 x 24 in.
Courtesy of the artist

The installation *Stories on My Back* is based on the stories the artist's father shared with his
family. Richard A. Lou's father was a paper son from Canton Province, China, but his father
believed that he had been born in Coahoma, Mississippi. One of the stories he would share
was about his attempt to lose his Chinese accent by placing pebbles in his mouth and reciting
vowels and consonants in English out loud while walking around Moon Lake in the Mississippi
Delta. As part of an oral tradition, the artist's children, photographed juggling pebbles,
holding pebbles in their mouths, and holding the Chinese character that reads the family
name of Lou, are charged with the obligation of carrying forward their grandfather's stories
of class, power, race, and assimilation.

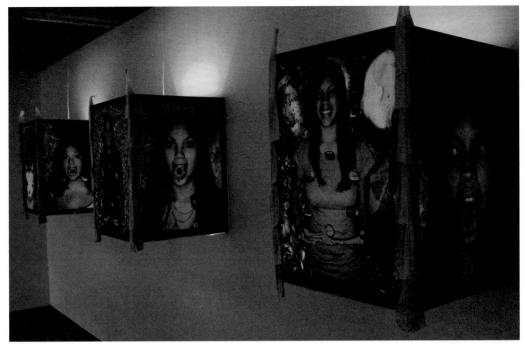

Plate 35b

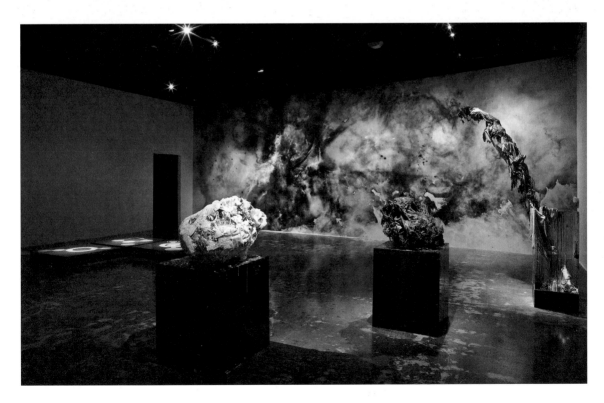

Plate 36. Cristina Lei Rodriguez (American, b. 1974)
Installation view of *The Possibility of an Island*, MOCA at Goldman Warehouse, North Miami,
Florida, December 4, 2008–March 21, 2009. Photo: Steven Brooke

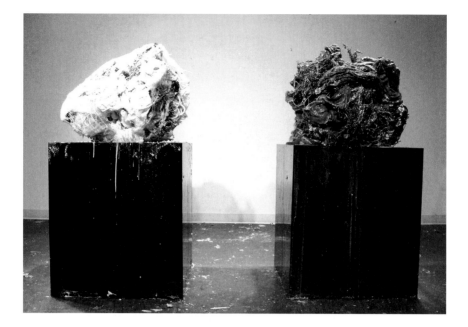

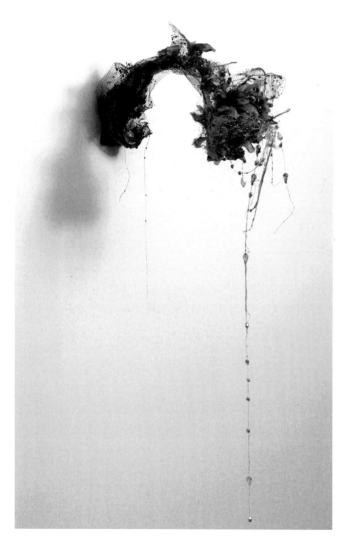

Plate 37. Cristina Lei Rodriguez
(American, b. 1974)
Decadence (Opal) and *Decadence
(Red Coral)*, 2008
Plastic, foam, epoxy, paint, metal
wire, chain mesh, selected objects
Each 54 x 26 x 28 in.
Courtesy of the Fredric Snitzer
Gallery and Team Gallery

Plate 38. Cristina Lei Rodriguez
(American, b. 1974)
Forever, 2008
Epoxy, plastic, artificial plant, paint,
assorted objects
12 x 2.5 x 6 in.
Courtesy of the Fredric Snitzer
Gallery and Team Gallery

a world structured around racial and ethnic hierarchies, divided by gender domination, and fractured by ever-widening divisions of class. Images have power like words have power. The power of the word "Hapa" is that it makes the mixed Asian American community visible—but it also has the power to divide mixed Asians from their identity in the very moment they claim it. It raises questions: Who has the power or right to use language? To use image?[51] As Margo Machida reminds us: "Rather than subsuming Native Hawaiians under an Asian American rubric, the premise [of this volume] is one of examining the phenomenon of mixing at different levels and among diverse groups, in which Hawai'i provides unique perspectives due to its large Asian populations, alongside other non-indigenous groups, whose combined presence has exerted a profound impact on the indigenous Hawaiian people, their land, and culture."[52] Set against this theoretically hopeful milieu, the phrase "Don't worry, be hapa" references the tensions around mixed Asian Americans in Asian American communities and in society at large: What are we? What should we *be*? If mixed Asians should try to just "be" ourselves, what does it mean to "be" mixed Asian?

Despite the popularity of both the terms "hapa" and "Hapa" in mixed circles and popular culture, in the course of interviewing artists for this volume, only one artist self-identified as "hapa." The mixed Asian African American, Asian Latinos, Asian indigenous artists, regardless of their phenotype, openly acknowledged their mix but tended to publicly identify as African American, Black, Chicano, Latino, Hispanic, or Native as a sign of political and racial solidarity. In contrast, Asian white artists seemed to have the greatest number of "options" because they could choose to not address issues of their mixed identity and still gain full acceptance in the art world; choose to subtly or indirectly deal with issues of identity in their work, without having their work essentialized as "ethnic art"; or identify explicitly as mixed Asian American. They may each engage a variety of these options in different circumstances. These observations match sociological findings, as noted by DaCosta in *Making Multiracials*, that when groups who consider each other social equals intermarry, such as is becoming the case for Asians and whites and, increasingly, Latinos and whites, "ethnicity becomes largely a symbolic identification, chosen rather than ascribed, and relatively inconsequential in one's daily life."[53]

Commonalities in the ways in which artists of mixed American Indian and Native Hawaiian ancestry understood race on a personal and familial level as an expansive category that extends, rather than threatens, the indigenous family also became apparent. Despite an individual's self-identification, however, in the context of legal tribal citizenship and access to tribal land rights and resources, issues of authenticity and blood lineage can turn quite abruptly. This is exemplified in the August 2011

Cherokee Nation's ousting of thousands of descendants of Civil War–era Black enslaved people who had long been official members of the tribe.[54]

Sculptor Samia Mirza is Yemeni, Chinese, Hawaiian, Malaysian, and English and grew up in Hawai'i before moving to Chicago for art school and eventually relocating to Los Angeles. She "feels like race is everything. . . . Lineage matters. If you're five different things, you stand up for each fifth of the pie. . . . Hawaiians hold on to the preservation of their culture and the overthrow of the Hawaiian government has a lot to do with that." Mirza argues that identifying as Hawaiian is an anticolonial action: "First we are Hawaiians and then we are Americans. Even people who are not of Hawaiian blood lineage oftentimes identify themselves as Hawaiians; people have pride in their land and in themselves . . . there's an inherent animosity between us and the mainland."[55] Mirza's experience shows how much Blackness dominates the discussion of race in certain geographic locations. For example, a teacher in Chicago commented, "I don't know why you're making deep fried sculptures. It's deep fried— the South—you think about, like, southern food," in reference to works such as *Deep Fry Your Soul* (2007) (plate 6), but in an Asian American–dominated context, the sculptures might have been read as related to tempura. In *Hawaiian Blood: Colonialism and the Politics of Sovereignty and Indigeneity*, J. K'haulani Kauanui argues that the predominant Black-white binary model is inadequate for understanding Native Hawaiian identity:

> It may be tempting to compare Hawaiians' practice of counting anyone with Hawaiian ancestry as Kanaka Maoli [Hawaiian for "True People"] with the hypo-descent rule used to define blackness. . . . This system was created during the Jim Crow period to avoid the ambiguity of intermediate identity among those of African descent. . . . Today, black identity still tends to be regarded as primarily for the sake of collectivity. Kanaka Maoli identification is also about collectivity; however, that inclusion is not premised on the exclusion of one's other racial identities or ancestral affiliations.[56]

The Waning Yet Persistent Tide of "Post-race" Rhetoric

Why reinscribe difference by looking at art and artists through a racialized lens? In direct contradiction to this notion, perhaps the most dominant discourse of difference over the past decade within the contemporary art world has been that of the notion of "post-race." "Post-racial" interrogatives echoed through the art world beginning in 2001 with curator Thelma Golden's *Freestyle* exhibition at the Studio Museum in Harlem, in which she raised the question "Can African American artists

be *post-Black*?" By 2008–9, the term "post-racial," while still controversial and confusing, seemed to be a household word as the press increasingly referred to the post-racial Obama era in which issues of racial identity are seen as merely optional.[57] Art historian Kymberly N. Pinder, author of *Race-ing Art History*, describes how exhausting it had become to answer the question "Can artists be *post-Black*?" According to Pinder, the question engages in "semantic acrobatics," although the inquiry necessarily uncovers generational divisions between and among African American artists.[58] Ytasha L. Womack, filmmaker, journalist, and author of *Post Black: How a New Generation Is Redefining African American Identity*, characterizes the notion of post-Black as speaking to diversities and complexities in African American identity and culture: "Whereas the social dynamics of decades before required a uniform black American identity to battle impending social injustice, the new opportunities afforded the generations of today as a result of victories won and fallen barriers have given rise to a growing diversity that some are enthused about and others are not."[59] In sharp contrast, when asked about the concept of post-racial, Lavie Raven, program director/project coordinator for the University of Hip-Hop in Chicago, just shook his head and said that all one needs to do is drive from Chicago's South Side to the North Side to see the persistence of economic and racial segregation. A far cry from post-racial idealism, Raven said, "Chicago is more segregated today then we were in 1963."[60] Questions about post-race function to facilitate dialogues about race, such as the following comment from artist and past president of MAVIN, Louie Gong: "Mixed race isn't post-race. It's not less race. It's more race. . . . In order to dialog about mixed race, we need more understanding. It's not a dialog to forget about issues of race."[61] Mixed race is about being more conscious and more attentive to race, rather than less, which challenges the racist, imperialist, blood quantum logic that demands we identify in fractions in order to limit our racial identities.

Such quantifiable slippages foreground *Automythography*, by the aforementioned figurative painter Mequitta Ahuja, which "blends cultural history and myth with personal narrative."[62] As Ahuja avers, such blending instantiates a "legitimacy to the idea of post-racial in the same way that people have talked about the end of art history or the death of painting or the death of the novel." Seeing it as a "rhetorical device," Ahuja argues that post-racial does not signal the end of racism but rather suggests that "The inherited paradigms of 'race' are no longer adequate for describing issues of color, class, privilege, culture, community, etc. and their interconnected relationships within our current society. I see the past paradigms of 'race' as having been based on binaries. We now need a more complex model of discourse."[63]

Similarly, artist Kip Fulbeck questions how we can "rightfully call ourselves a post-

racial society when Justices of the Peace are still denying interracial couples the right to marry."[64] Indeed, Fulbeck's query—which brings into focus the persistence of race in the making of difference—alludes to a recent "miscegenation" case. In October 2009, Keith Bardwell, a justice of the peace in Louisiana, drew widespread criticism for refusing to issue a marriage license to an interracial couple. The previous year, California's Proposition 8, the Marriage Protection Act, restricted the definition of marriage to opposite-sex couples. The film *Muni to the Marriage* (2004), by San Francisco–based filmmaker and marriage equity activist Stuart Gaffney, makes connections between antimiscegenation laws and those banning same-sex marriage. Gaffney asks, "What purpose does the term 'post-racial' serve? Does it mean we are beyond racism? If so, I know we're not there yet. Does it mean we don't 'see' people's race any longer? We're not there yet either. Does it mean we now see race as an artificial social construct to move beyond? Do you think we're there yet?"[65]

Analogously, Danish filmmaker Jane Jin Kaisen, a Korean adoptee who splits her time between Los Angeles and Europe, wonders if, for artists, post-racial identity, similar to a transnational identity, "is a way to escape from identity politics and the critique that there has been of that." She argues, "If we start saying that we're all transnational, we're all post-racial, what happens to all the real problems? What happens when the structural oppressions of race continue? . . . *Post-race* maintains a very particular structure."[66] Like Kaisen, mixed Filipina visual and performance artist Jenifer Wofford maintains transnational perspectives on U.S. race-based discussions, examining "intercultural exchange and discourse, often playing with notions of culture, difference, liminality or authenticity."[67] She says,

> It's like saying we're "post-feminism": it's so clear that discrimination and inequality still exist, and that a lot of nastiness still goes on. . . . I think that the limitations some artists feel about identifying racially is the same stigma that many female artists used to associate with identifying as "feminists": that perhaps the term feels constraining to them or their expected audiences. ("White Hetero Maleness" is also a limiting identity, but nobody seems to acknowledge *that* one, despite its pervasiveness in the art world.)[68]

Conclusion: Wading to Shore

War Baby / Love Child is in many ways a "post" text insofar as it maps the conditions and politics that circumscribe critical mixed race studies rather than positing mixed Asian American identity as a "new" and celebratory fixed identity. This volume follows the trajectory of its artists, who both create and articulate exactly what it means

to be mixed in a "post-racial" imaginary while recognizing the persistence of, as artist Jenifer Wofford notes, "the structural oppressions of race." Photographer Gina Osterloh speaks to the desires and dilemmas of wanting to make work in which identity is not overtly foregrounded but is an underlying fact. "It gets tricky because on one hand you do want to just make work that's conceptually strong and not have it be pigeon-holed and have it be within a set construct but at the same time you do need to recognize certain histories and social histories. Not so long ago [before 1967] it was illegal for our parents to even get married or have children together."[69]

Wofford's painting *MacArthur Nurses I* (2009) (plate 7) epitomizes how artists in this volume balance divergent positions of alterity. Such subjectivities embody the historical and political contexts, which are mapped onto the Asian and mixed race Asian American body. Concurrently, in resistive fashion, these artists militate against dogmatic representations of identity in their work. For Wofford, at stake is her own liminal positionality as a mixed race transnational Filipina, which fuses a colonial United States–Philippines to the mid-twentieth-century mass migration of Filipino nurses to the United States.[70] *MacArthur Nurses* is compositionally based on the 1944 "iconic/notorious WWII photograph of American General Douglas MacArthur arriving on the beach in Leyte, Philippines: at once an image of heroism and return, but also an image of conquest and falsehood (since the photos were staged, and re-staged, several times to get the right dramatic effect)" (fig. 5.1). Extending the history of the MacArthur beachhead scene's construction (and themes of conquest) to the present, she replaced the U.S. soldiers in the original image with an "army" of Filipina nurses. Painted in full color rather than in the black and white of the original photograph, ominous light gray clouds sweep behind the nurses, emphasizing both their bright white, 1950s-style nurse uniforms and their off-white skin color. The lead nurse wears spectacles and has a firm square jaw and determined gaze that further underscores the parody of the historic photograph and lends an air of gender ambiguity that defies the hypersexualized stereotype of nurses. In her interview (ch. 5, "Wading to Shore"), Wofford describes the nurses as "emerging through the surf, conquering some new land, or perhaps just returning to their homes after many years away."

Structure of the Book

We have attempted to balance the breadth and depth of this emergent topic, but this book is only a start. Significant mixed Asian American histories are not adequately covered in this volume (e.g., Punjabi Mexicans of California, Irish Chinese of New York, various discourses around Asian Transracial Adoptees).[71] But we hope that what we have been able to cover is original and will critically push the limits of

Asian American art and U.S. and mixed race history. For example, in the Philippine-American War and World War II section, we felt that it was crucial to foreground the post-1898 U.S.-Filipino mixing, as this has been historically absent in visual culture and underrepresented in mixed race studies, and to disrupt the dominant discourse in Asian American Studies, which focuses so heavily on early Chinese and Japanese immigration histories.

Following this introduction, Part Two: "War Babies" features contextual essays and artist interviews organized around four major wars between the United States and Asian countries that have resulted in significant mixed Asian populations in the United States: The Philippine-American War, World War II, the Korean War, and the Vietnam War. For the two contemporary Japanese American artists included in this volume, Chris Naka and Laurel Nakadate, the most obvious subject matter of their video works is September 11, but, as their interviews reveal, their work carries strong echoes of the Japanese American incarceration, which continues to be a haunting legacy of World War II.

Part Three: Hawai'i is a dedicated stand-alone section focused on Hawai'i and multiracial Native Hawaiian and mixed Asian–Native Hawaiian artists. The exotification and commodification of Hawai'i within the U.S. imagination has played a distinct role in twentieth-century nationalist melting pot rhetoric on racial progress and mixing, of which the "Happy Hapa" syndrome is the egregious epitome.[72] This has led to a fetishized valuation of mixed Asians and hapa people, which Lori Pierce critiques in chapter 14, "Six Queens," her analysis of mixed race identity politics and U.S. nationalism in Hawai'i. In chapter 15, "Remixing Metaphors," Margo Machida explores the way that U.S. government structures relating to Native Americans were extended to encompass Native Hawaiians and thus how issues of blood quantum, disenfranchisement, and kinship are explored in contemporary art by mixed heritage Native Hawaiians.

Part Four: "Love Children" explores the double meaning of the term "love child" as both "bastard" and "racial savior." The chapters in this section are structured around relationships shaped through exclusionary immigration laws, antimiscegenation statutes, and gendered racial hierarchies. Because the racial hierarchy has so deeply shaped social structures in the United States, we chose to organize these essays and artist interviews on mixed Asians around a modified pentapartite racial hierarchy; mixed white Asians, mixed Asian Native Americans, mixed Black Asians, and mixed Latino Asians, with mixed Pacific Islander identity addressed in the Hawai'i section.

Part Five: Conclusion closes out the book with a critical examination of our current moment and a call to action to look beyond issues of self and exceptionalism and

continue fighting for social justice generally and against racial inequalities specifically. In chapter 31, "The Biracial Baby Boom and the Multiracial Millennium," Camilla Fojas traces, through an analysis of film and popular-culture images, the "war baby" and "love child" tropes into the current "generation mix" as she cautions against construction of mixed race identity as a "sign of democracy" and a continuation of "American exceptionalism based on the erroneous notion that the United States is somehow more just and racially democratic than the rest of the monoracial world." Finally, in chapter 32, "Loving Days," Marriage Equality spokesperson and artist-filmmaker Stuart Gaffney and Loving Day founder Ken Tanabe traverse the historic *Loving v. Virginia* decision, their personal histories, and their use of film and visual media to effect social change. In this chapter, people of mixed heritage act as self-empowered inheritors of the Lovings, the couple who fought all the way to the Supreme Court for the right to love across racial boundaries and won. The struggle between legal constructions of identity, community definitions of belonging, and personal identities will continue, limited legal recognitions notwithstanding. U.S. neocolonialism and neo-imperialism demand the maintenance of the racial hierarchy, which will continue to dominate the construction of mixed heritage Asian American identities. Mixed heritage Asian American artists may confront and move beyond the "war baby," "love child," and "Happy Hapa" images, but queering and miscegenating these discourses will take deliberate, specific, resistance to the interrelated forces of racialization, heteronormativity, and patriarchal domination while maintaining openness to globalized identities in their intersections.

"WAR BABIES":
U.S. WARS IN ASIA AND MIXED ASIANS

Philippine-American War and World War II:
Postcolonial and Mestizo Identity

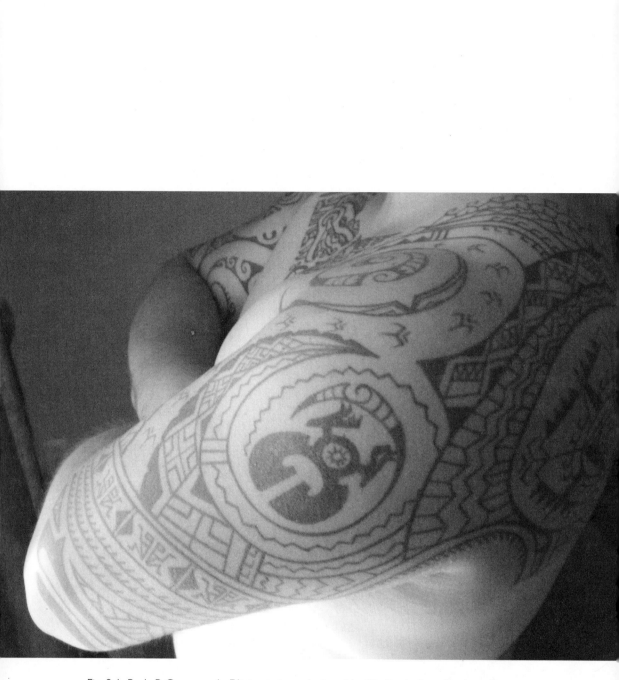

Fig. 2.1. Rudy P. Guevarra, Jr. Filipino tattoos designed by Elle Festin from Tatak ng Apat na Alon (Mark of the Four Waves). Photo courtesy of Rudy P. Guevarra, Jr.

Skin Stories, Wars, and Remembering:
The Philippine-American War

RUDY P. GUEVARRA, JR.

> It is my deliberate judgment that there never was a war conducted, whether against inferior races or not, in which there were more compassion and more restraint and more generosity.
> — Governor William Howard Taft

MY TATTOOS are more than ink on my body (fig. 2.1). They are my "skin stories."[1] They connect me to my history in all its manifestations—colonization, resistance, survival, and permanence. They invoke a history of wars and imperial desires, opposition and violence, the political act of forgetting, yet the ability to endure. Tattoos are the link to my indigenous pasts and a reminder of my multiethnic identity. As a Mexipino, I am fortunate to have two histories, two cultures—one Filipino, the other Mexican. Getting my body covered with ink, I wanted to tell a story about my family, my peoples, and myself. My tattoos represent contemporary understandings of these vestiges of my past, summoning my peoples' resistance to colonial rule and their will to endure and survive so that I could tell this story. They are my body's way of remembering.

As a Mexipino, I am a product of dual colonial legacies; my desire to connect with my indigenous pasts inspired me to consciously adorn my body with modern interpretations of indigenous Filipino and Mexican tattoos. These sacred symbols, motifs, and designs tell my family story: where we come from and how we represent that past in a modern world. The symmetry of the various designs comes together to form what I see as a multi-indigenous map: a link to my ancestors. These tattoos blend together on my body in an ink-inspired mestizaje—centuries of cultural and racial blending—reminders of wars once forgotten, buried beneath a landfill of historical denial and amnesia, in both the United States and the Philippines of my paternal lineage. My Filipino lineage is Ilokano and Tagalog, both indio and mestizo. What marks my body is a story. These stories jump out at me from my skin, for my existence is an intimate product of wars in the homeland and, in particular, the Philippine-American War (1899–1902). In this chapter, I discuss the Philippine-American War and how

tattoos on the body represent a cultural road map of this history. I also examine how Filipina/os in the twenty-first century connect to the past and recover their history through these visual manifestations.

Indigenous Pasts, Mestizaje, and Spanish Colonialism

The Philippine Islands are an archipelago of more than 7,100 islands in the northern region of Oceania, a "sea of islands" in the Pacific that includes Samoa, Tonga, Tahiti, Hawai'i, Fiji, Aotearoa (New Zealand), Papua New Guinea, the Marshall Islands, Guam, and the Northern Mariana Islands, to name a few.[2] Before European and American intrusion, interisland relationships existed within the archipelago and with other neighbors such as Indonesia, Southeast Asia, India, and China. These ancient exchanges of peoples, goods, and cultures were complex and endure in shared cultural traits evident in the Austronesian language throughout most of Oceania; the motifs and designs of ancient Filipino tatak (tattoo), similar to Samoan tatau; and religious influences in the Philippines such as Islam.[3] This blending of peoples and cultural influences was a form of mestizaje in Oceania predating Spanish arrival. Early cultural blending of Chinese with Filipino indios resulted in the Chinese mestizo population. Because of this historical blending, Chinese mestizos constituted a much larger population, were more integrated, and identified more with Filipino indios culturally and socially than did Spanish mestizos under Spanish colonialism.[4]

This was the Philippines encountered by the Spanish when they first failed to conquer the islands, when the navigator Ferdinand Magellan died at the hands of Visayan datu (chief) Lapu-Lapu, in April 1521. Spain succeeded in colonizing the Philippines in 1571, after its bloody conquest of Mexico (Nueva España), tying both countries together under Spanish colonialism.[5] This connection was sustained for the next 250 years through the Manila-Acapulco galleon trade (1565–1815).[6] Through this colonial relationship, people, precious metals, consumer goods, and agricultural produce traveled across Oceania, between Mexico, the Philippines, and Guam. This resulted in mestizaje: the cultural and racial blending of peoples in which indios and mestizos from the Philippines mixed with Mexican indios and mestizos, Africans, and Spanish in Mexico and the Philippines, forging generations of mestizos who shared in a rich history of mixing through colonialism.[7]

Life under Spanish tutelage was oppressive for the majority of the Filipino population. Revolts and other forms of resistance continued during the three hundred years that Spain ruled the Philippines.[8] However, it was not until the execution of Filipino writer and reformist José Rizal (a Chinese mestizo) on December 30, 1896, that the cry of revolution reverberated throughout the Philippines. From 1896 to 1898, Filipinos,

both men and women, waged a war of revolution against Spain.[9] Andres Bonifacio, Emilio Aguinaldo, and other officers in the Katipunan, the organization that led the charge, pressed the Spanish hard and were well on their way to achieving independence when the United States intervened, snatched away their newly won freedom, and forced its own imperial desires on the Philippines as a means of establishing their economic, military, and geopolitical domination across the Pacific. The Philippine Islands were sought after for their location, strategically close to markets in Asia.[10] Proponents of imperialism in the United States thus betrayed Filipino revolutionaries, who now had to fight another war to win their liberty and freedom from yet another foreign aggressor, which was expanding its own empire across the globe. This relationship of domination shaped the racial mixing that occurred in the Philippines and the legacies of that experience. Indeed, American colonialism forged generations of mestizos in the archipelago, much as Spanish colonialism had in the Philippines and Mexico. Imperial wars were responsible for continued race mixing, as soldiers and other agents of empire cohabitated, married, and/or had children with local indigenous and mixed race women. The Philippine-American War, for example, paved the way for new waves of mestizos, as white and African American soldiers and local Filipina women were involved in relationships and had children together. This historical episode was the foundation for future imperial relationships in which the United States secured its military bases and soldiers continued to have relationships with local Filipina women. Generations of mixed race mestizos would be the by-product of the Philippines' continuing colonial and neocolonial relationships with the United States. Seizing the Philippines, however, was the first step in this long, complicated process.

The Betrayal of American "Democracy"

The United States had earlier dispossessed resisting American Indians of their lands, during what was known as the Indian Wars. In an aggressive diplomatic move, the United States had issued the Monroe Doctrine in 1823, stating that European powers colonizing or intervening in the Western Hemisphere would be seen as a threat to U.S. national security.[11] In the U.S.-Mexican War of 1846–48, the United States took half the territory of newly formed independent Mexico, under the claim of Manifest Destiny.[12] In a move orchestrated by sugarcane planters and their cronies in 1893, the United States militarily supported the illegal overthrow of Queen Liliʻuokalani and the Hawaiian Kingdom, which was then annexed to the United States as a territory in 1898, marking the beginning of U.S. overseas conquests.[13]

The weakening of Spain's colonial empire was an opportunity for the United States

to extend its own empire both in the Caribbean and in the Pacific. In this context, a mysterious explosion occurred on the U.S.S. *Maine* in Havana Harbor, on February 15, 1898, and the stage was set for the Spanish-American War of 1898, which lasted for six months.[14] As the Philippines fought for independence, the United States prepared to colonize the islands, while Commodore George Dewey forged an informal alliance with the leader of the Filipino revolutionary forces, Emilio Aguinaldo, who was informed that the United States "would at least recognize the independence of the Philippines under the protection of the United States Navy."[15] Despite this verbal agreement, President William McKinley had no intention of recognizing the newly independent nation.

Completely ignoring the fact that Filipino forces already controlled most of the islands and had declared their independence from Spain, President McKinley annexed the Philippines as a U.S. territory by presidential proclamation.[16] In an act of betrayal, the United States signed the Treaty of Paris with Spain on December 10, 1898. In it, Spain transferred sovereignty of Puerto Rico, Guam, and the Philippines to the United States, relinquished its claim to Cuba, and sold the Philippines to the United States for twenty million dollars.[17] Filipinos were denied participation in the treaty negotiations; thus, they had no say in their future and became a colonial possession of the United States. President McKinley ordered the military in the Philippines, aiming "to extend American sovereignty over the entire country by force."[18] The U.S. military provocation of Filipino forces on February 4, 1899, set off hostilities.[19] The Philippine-American War had begun.

Filipino Resistance to the "Savage Wars of Peace"

Early in the war, the U.S. military used its superior firepower to annihilate thousands of Filipino troops, as the first major battle between U.S. and Filipino forces illustrates: one British witness recalled after the battle, "This was not a war; it is simply a massacre and murderous butchery."[20] Lacking weaponry, Filipinos turned to guerrilla warfare, a more successful campaign with the full support of the Filipino people, who saw this as a nationalist fight for independence and sovereignty. The United States responded by slaughtering both troops and civilians. As General Shafter remarked in April of 1899, "It may be necessary to kill half the Filipinos in order that the remaining half of the population may be advanced to a higher plane of life than their present semi-barbarous state affords."[21]

According to historian Paul A. Kramer, this demonstrates that the Philippine-American War was "a race war."[22] Shafter's statement and the political cartoons depicting the United States' empire overseas at the time illustrate American arrogance and the

quest to enforce white supremacy across the globe. This arsenal of racist imagery depicted Filipinos (along with co-colonials Native Hawaiians, Cubans, and Puerto Ricans) as savage, uncivilized, ignorant, and in need of American enlightenment through civilization, democracy, and education. Similar to portrayals of Native Hawaiians, drawings of Filipinos were phenotypically similar to the visual racializations of both African Americans and American Indians, with the same exaggerated features (fig. 2.2). Filipinos were also called both "nigger" and "Injun."[23] Moreover, Rudyard Kipling's 1899 poem "The White Man's Burden" suggests that the United States "assume the responsibilities of imperial overlordship."[24] Benevolent assimilation would benefit America's "Little Brown Brothers" in the Pacific.[25] Both President McKinley and his successor, Theodore Roosevelt, were imperialists with no intention of giving the Philippines independence. Filipinos sought to win over the general U.S. population to their cause by appealing to ideals of democracy and liberty, highlighting the irony that Filipinos were fighting the United States for the same principles of independence and sovereignty for which Americans had once fought in their own revolution.

The U.S. government and media depicted Filipino revolutionaries as "insurgents" in order to delegitimize their revolution. However, notable figures such as abolitionist Frederick Douglass, antilynching crusader and women's rights activist Ida B. Wells, satirist Mark Twain, and Republican senator George Frisbee Hoar criticized the United States for its blatant lies about wishing to spread democracy to the Philippines while slaughtering its people. Political cartoons in favor of an anti-imperialist perspective showed Filipinos fighting a just war for liberty and independence and depicted the atrocities of the U.S. military.[26] Linking Filipino rebellion to the global struggle against racism, Douglass condemned the United States for its race problem at home, particularly with African Americans.[27]

African Americans were sent to the Philippines to fight, but many objected to being used to oppress other people of color in an unjust war. Filipinos reached out to African American soldiers, offering them a chance to fight in solidarity against a common oppressor. This led a significant group of African American soldiers to defect to the Filipino military, including David Fagen, who became a captain and led several successful campaigns against the United States; for this, a $600 price was put on his head. More than a thousand African American soldiers decided to remain in the Philippines after the war and married local Filipinas. Their Afro-Filipino children would be another chapter in the legacy of mestizaje that resulted from the war.[28]

As Filipino resistance increased, U.S. forces began to wage war on the entire population. As one American noted, "Our soldiers took no prisoners, they kept no records; they simply swept the country and wherever and whenever they could get hold of

Judge

COPYRIGHT 1899 BY ARKELL PUBLISHING COMPANY OF NEW YORK.

"HE WOULDN'T TAKE IT ANY OTHER WAY."

Judge, Arkell Publishing Company, New York, March 4, 1899 [artist: Victor Gillam]

Fig. 2.2. "He Wouldn't Take It Any Other Way," artist Victor Gillam's racialized portrayal of U.S.-Philippine relations, in Judge (New York: Arkell Publishing Company, 1899), front cover. Used with permission, from Enrique de La Cruz, Abe Ignacio, Jorge Emmanuel, and Helen Toribio, The Forbidden Book: The Philippine-American War in Political Cartoons (San Francisco: T'Boli Publishing, 2004), 85.

a Filipino they killed him."[29] "Howling wildernesses" existed wherever U.S. soldiers passed. Prisoners of war were executed; women were molested and raped; property, livestock, and crops were destroyed; looting was rampant; and murder and torture with the "water cure" were common. Even children were not spared. General "Howlin' Jake" Smith ordered: "Kill everything over ten."[30] Civilians were rounded up and sent to concentration camps where thousands died of disease, sickness, and malnutrition. The resistance continued. For example, Filipinos ambushed and beheaded U.S. soldiers in the Balangiga massacre. In response, U.S. commanders and their troops were ordered to "make a desert of Balangiga."[31]

As the war intensified and reports of both U.S. and Filipino casualties poured in, public outcry mounted in the United States. Censorship of the press was implemented so that U.S. atrocities in the Philippines would not be reported, nor could anti-imperialists denounce the war. However, letters from soldiers to their loved ones made their way into both local and national newspapers, revealing the atrocities that continued to occur in the name of democracy. According to one soldier's letter, "As we approached the town the word passed along the line that there would be no prisoners taken. It meant we were to shoot every living thing in sight—man, woman or child."[32] Although U.S. military records count about 250,000 civilian and insurgent deaths, the actual toll was much greater. Destruction of entire villages, depopulation campaigns, and sickness and disease in the concentration camps caused an estimated one million deaths, or one-sixth of the population.[33]

President Roosevelt facilitated historical amnesia by proclaiming the war to be over on July 4, 1902. However, resistance continued in areas such as Mindanao in the southern Philippines until 1916, despite U.S. colonial education and pacification programs.[34] The United States also provided basic necessities to the population, such as food and medicine, which created dependency and an image of generosity instead of brutality.[35] An occupying army of teachers, the Thomasites, instructed Filipinos in English and taught the values of American exceptionalism and democracy that shaped Filipinos' views about themselves, their colonial relationship to the United States, and the new American mestizos, or Filipino Amerasians. As part of this colonial education, early American mestizos of this era would be privileged to a certain degree because of their white ancestry and phenotype and were treated according to the racial hierarchy that the United States implemented in the Philippines as part of its imperial legacy. The treatment of future generations of American mestizos and those of Afro-Filipino descent would be more complex, with varying levels of discrimination and marginalization. Given that the Spanish and Americans both colonized the Philippines, Filipinos were indoctrinated in the colorism and racism that both colonizers left behind. Those of Afro-Filipino descent would be marginalized based on

these two discriminating principles. Amerasian children of white-Filipino or African American–Filipino ancestry who were born out of wedlock and abandoned by their military fathers also experienced discrimination and marginalization by larger Filipino society. These were just some of the experiences the war produced. As Reynaldo C. Ileto notes, "The remembering of a gruesome war of occupation and resistance would only undermine the myths of the special Philippine-American relationship that prevailed throughout the twentieth century."[36] Philippine nationalist and historian Renato Constantino contends that this "miseducation of the Filipino" erased the war's realities because "the most effective means of subjugating a people is to capture their minds . . . education, therefore, serves as a weapon in wars of colonial conquest."[37] Education pacified Filipinos and instilled the historical amnesia that existed until the Philippine nationalist movement of the 1970s, which followed the fight by students of color, including Filipina/o Americans, for a relevant education: ethnic studies.[38]

Recovering Our History

Filipina/o Americans are involved in a historical, cultural, and identity revival that ties them intimately to the Philippines. One manifestation of remembering their history is contemporary Filipino tattoos, which connect Filipina/o Americans to the past with political messages embodying resistance to colonialism through modern interpretations of ancient designs and the use of baybayin, or alibata, an ancient Filipino script. These sacred and symbolic links allow Filipina/o Americans to wear their family trees; Filipino tattoos have become a rite of passage for many Filipina/o Americans, including those of mixed race or ethnic ancestry, like myself, who might not otherwise be visually identified as Filipina/o.[39] These tattoos are also a visual representation of resistance in rejecting centuries of colonialism. They are also a part of the decolonization process as they evoke the indigenous ties we share with our ancestors. Wearing these tattoos is reclaiming that part of our identity.

Legacies of war, the mestizaje, and intergenerational traumas and resistance to colonialism have thus been carved into my body and bled with ink—a reminder that people endure. We recover our histories and remember that which the colonizer sought to bury under centuries of miseducation and denial. Ethnic studies scholar Joanne Rondilla notes that we share this experience with Pacific Islanders and other colonized peoples in Mexico, Central and South America, and the Caribbean, among other locales, even in the twenty-first century as we continue to fight colonialism in all its manifestations: militarization of island homelands, economic strangulation, floods of tourists, loss of ancestral lands and natural resources (and the struggle to

hold on to what remains of them), and the diaspora of our peoples.[40] Thus, my "skin stories" remind others of who I am as a multiethnic Filipino—a Mexipino—connected to others in the world who share a history that has been wrought through war and resistance.

Eating Your Heart Out: An Interview with Lori Kay

Born May 1, 1962, in San Diego, California, LORI KAY *is the daughter of a Filipino father and a European American mother from Virginia. She is noted in the* Encyclopedia of Asian American Artists *(2007) for her sculpture and collage art. The exhibitions most significant to her personally are the 2004 show* Hearts in San Francisco, *which benefited San Francisco General Hospital, and her solo exhibition* Half Breed: In Search of a Whole Identity *at the Manor House Gallery, Arts Council of San Mateo County, in 1995. Kay's large bronze sculpture* The Broken Wishbone *was a fixture at San Francisco State University for more than a decade.*

Kay responded to a list of e-mailed questions from Wei Ming Dariotis on June 10, 2010, and provided a few clarifications by phone and in follow-up e-mails (summer and fall 2010) to Dariotis.

WEI MING DARIOTIS: How does the term "war baby" relate to your identity?

LORI KAY: I come from a long line of warriors. My father's family resisted the occupation of their home, the Philippines, from the occupation of the islands by Spain to the siege by Japan during World War II. While the family rice farm (plate 8) was taken over by the Japanese, members of my family secretly sent food to the resistance. Many of my uncles and cousins were killed during the battle of Bataan. My father was able to enlist in the navy because of an agreement made during World War II by the U.S. government that Filipinos could serve in the U.S. Navy in the lowest capacity that was available, but still not be granted U.S. citizenship. He further served as part of the blockade during the Cuban Missile Crisis and performed two tours of duty in Vietnam.

My white mother was a warrior in a different way. Raised in the South with little acceptance of people from races other than Caucasian, she met and fell in love with my Filipino father in Norfolk, Virginia. Her family was against the marriage from the beginning, and yet she stood up against the narrow mind-set of her family and the culture of the South in the 1960s and married him. They could not legally be married in Virginia at the time, so they traveled to Washington, D.C., to be wed.

WMD: This is strongly reminiscent of the story of Richard and Mildred Loving—they also were not allowed to marry in Virginia and had to go to Washington, D.C., to get married.

LK: When my parents returned to the white neighborhood that was my mother's home, they were not accepted. My father lived on his navy ship and my mother lived in her old neighborhood. They were finally able to move to San Diego, California, where I was born. My parents believed they would find more acceptance in California. Still, they encountered prejudice on the West Coast, too. One of my earliest memories is of—when I was still in my stroller—a woman pointing at me and saying, "You're a sin," and then telling my mother she was a sinner. People would often tell my mother what a good woman she was for adopting "refugee babies." There are eight children between my parents' marriages, two from my mother's first marriage, five from my mother and father together, and one from my father's current marriage. My mother raised seven of us, some blond-haired and blue-eyed, and some dark-haired and brown-eyed.

We moved to Guam from San Diego and lived there for four years on the U.S. military base. My sister and brothers and I would caravan behind the missile trucks as we rode the school bus. We played in the bunkers built there during World War II. Live grenades were sometimes found. Two Japanese soldiers were also found living in a remote part of Guam during the early 1970s, and they did not know the war was over.

WMD: Living on a military base, there must have been a few other mixed Asian kids. How did you relate to other mixed heritage kids? Did you feel like you had a community?

LK: We were told by my mother and her friends that we were not allowed to play with the mixed race children of a woman who was rumored to be an Asian prostitute living on the base.

We moved to the San Francisco Bay Area from Guam when I was twelve. By now, my parents had five children together. Unfortunately, my parents, unable to ever totally overcome the cultural divide, divorced when I was nineteen, and my twin brothers were split apart with separate court-appointed custody.

WMD: Let's talk about your work as a woman artist—a mixed heritage Asian American woman artist.

LK: As a young artist, I suffered an identity crisis in the 1990s. Having studied the Western canon of art history with all-white male professors, I could find no role model for myself. I had also studied in Switzerland and Italy. While I was working in a fine arts foundry where the only other woman was the secretary and women were not allowed to drive the forklift or weld, I challenged another sculptor during a technical casting disagreement. He literally hung me up on a hook by my coveralls so that I could not get down by myself.

I was looking for direction in what I could study for a master's degree and found none. I produced my own show as a solo artist, entitled *Half Breed: In Search of a*

Whole Identity, exhibited at the Manor House Gallery in Belmont, California, in 1995. Through this show, I was able to find my voice, a critical turning point in my career. I started working in other media, spent time sculpting in the Philippines, and found a mixed race community of artists. I became involved in the Hapa Issues Forum at UC Berkeley. I am still involved with the Filipino community through my family, playing the kulingtang [a traditional Filipino percussion instrument] and teaching my daughters traditional [Filipino] dance. I am currently working on sketches for a piece on the juxtaposition of my family's warrior tradition of cannibal heart eating and the tech-savvy family both in the Philippines and the San Francisco Bay Area. Inspired by this, I am including fiber optics, LED wire/lights, and woven floor mats in a mixed-media piece. I find it surreal that I am only a few generations from heart eating, and then I watch my cousins harvest our family's rice paddies with a caribou and sickles while texting.

Resources

Art at the Dump: The Artist in Residence Program and Environmental Learning Center at Recology, 44. San Francisco: Recology, 2010.

Hallmark, Kara Kelly. "Lori Kay." In *Encyclopedia of Asian American Artists*, 87–90.

"Lori Kay." In *Cheers to Muses: Contemporary Works by Asian American Women*, 24–25. San Francisco: Asian American Women Artists Association, 2007.

Manicini, Jennifer. "When the Eye of the Beholder Is Ours." *The SCS Environment* (July 2005): 8–9.

Somewhere Tropical:
An Interview with Gina Osterloh

GINA OSTERLOH *was born in 1973 in San Antonio, Texas, to a German American father from the Midwest and a mother from the Philippines. She majored in media studies at DePaul University in Chicago, where she fell in love with photography. In 2007, she received her MFA degree from the University of California, Irvine. She has had solo shows at Silverlens Gallery, Manila, Philippines; Yerba Buena Center for the Arts and 2nd Floor Projects, San Francisco; Chung King Project, in Chinatown, Los Angeles; and Green Papaya Art Projects, Quezon City, Philippines. Osterloh has also participated in numerous group shows in Australia, Hong Kong, the Philippines, and the United States. Her work has been featured in* Hyphen Magazine *and* Art in America. *In October 2008, Australian writer Gina Fairley declared in* Art Asia Pacific *that Osterloh's work "transforms the human subject of her surreal photographs into a prop, devoid of identity."*

On February 1, 2010, Laura Kina interviewed Gina Osterloh in the artist's industrial Los Angeles art studio. They focused on Osterloh's 2006 Somewhere Tropical *series, in which she grappled with her conflation of the constructed tropical landscape of Los Angeles with stories of the war-torn yet idyllic tropical landscape of her mother's native Philippines.*

GINA OSTERLOH: I grew up in Ohio, in the Midwest. My mother is from the Philippines and my father is German American, and unlike the stereotype, they met in a graduate school for education in Texas. Everyone says, "You must be an army baby." My mom actually emigrated from Cebu, Philippines, to Guatemala first. She joined a Belgian convent, and she hated it! A wealthier older woman sponsored her to live with her in Texas and go to graduate school. She had already gotten her graduate degree in the Philippines, but it didn't count in the States at that time. My father is fifth-generation German American. He grew up on a dairy farm in Ohio on Osterloh Road. They named it after his great-great-grandfather, basically one of the first Europeans to claim and farm the land.

LAURA KINA: How do you identify yourself?

GO: I identify as Filipino German American.

LK: Do you have identity ties to any particular communities?

GO: Yes and no. I moved to L.A. for graduate school, and through art events and maybe even through Galleon Trade [a series of international arts-exchange projects between the Philippines, Mexico, and California], which wasn't that long ago, with Jenifer Wofford, I also met Filipino diaspora and performance scholars Eric Reyes and Lucy Burns. My colleagues and community started to grow from these experiences. Around Galleon Trade, I also met Sarita See, someone whose insight and conversation I am very thankful for.

LK: It's funny that art exhibitions show these communities are actually creating communities that weren't there beforehand. Do you address your mixed heritage identity, themes, or histories in your artwork?

GO: Even though it's not literal, it's always an influence, a constant fact. Mixed race identity obliterates discrete race categories and complicates binary and oppositional relationships. When you're mixed race, there are acute differences between external and internal identity constructs. Growing up in the Midwest, there was the constant experience of simultaneously passing and not-passing according to majority/minority race groups, as well as how one identifies inside one's home and outside. It's not a dichotomy or even a question of two different entities mixing. In turn, metaphors such as camouflage, misperception, and the blank developed quickly in my photographs. As society views mixed raced individuals as unreadable, the unreadable has become a visual strategy in my work.

My first art critique class was at the California College of the Arts. I asked Tammy Rae Carland, the photography professor there, if I could sit in her class. One of our first assignments was for everyone to pick a text to make a class reader. I picked "Beauty and the Beast: On Racial Ambiguity" by Carla K. Bradshaw, from the book *Racially Mixed People in America*, edited by Maria P. P. Root. It was such a life-changing essay. Growing up in Ohio and even as an undergrad at DePaul, I had never been introduced to concepts of passing, external social constructs, and internal responses to these external categories of racial difference until reading *Racially Mixed People in America* [see follow-up exchange at the end of this interview]. I was aware of these dynamics and forces but had never read a text or even narrative story based on mixed race.

LK: What does the phrase "love child" evoke in you in relation to your personal history?

GO: It reminds me of the generation and people my parents didn't want to be a part of! They're both in their seventies now. My father would visit me in San Francisco when I lived near Haight Street [in the Haight-Ashbury neighborhood] and— even in 2000—he would say, "Those people are really independent-thinking, huh?" So he was definitely distrustful of long-haired people.

LK: What, if any, are your family's associations with war?

GO: My mother was in World War II; she was four years old. My grandfather, her dad, was kind of a local mayor of a barangay [a city district] in Cebu, so he was wanted by Japanese officials as part of the Filipino community there. The Japanese soldiers burned down their house, and they were on the run, hiding for four years, but they all made it somehow. So this was my first connotation of the Philippines mixed with other more idyllic stories. My grandmother owned a fish shop, so they were always fishing and spending time in the sea. My father is from a family in Ohio in which four generations spoke German, but during World War II, when he was in third grade, they all had to stop speaking German . . . it was kind of this internalized shame.

LK: Do you feel that your work references anything to do with war directly or indirectly?

GO: Both. In the earlier works, I used direct representations of camouflage in relation to war. Starting from those references to war within the generic tropical landscape, I realized those metaphors were already quite full, so I wanted to take the metaphorical strategy of camouflage outside the context of war, to a visible relationship between the body and space.

LK: Your later work develops the concept of camouflage. Can you tell me about your 2006 *Somewhere Tropical* series?

GO: *Burnt Out, Died, Got Some Rest #1* (2005) (plate 9) was the very first set construction I made. I was grappling with this infatuation I had with the tropical landscape my mother would tell me about. I was also conflating that with the semitropical landscape of L.A. I had just moved to L.A., and for the first time I had this expansive view; I had palm trees in my backyard. Both places have been represented as very cliché landscapes—but within the cliché are histories of tourism, war, and war films, layered with my mother's story of World War II. Her stories of living in the Philippines were mixed with idyllic fishing-on-the-ocean stories and the most horrific experiences from World War II. So it was always a mixture of the idyllic with complete horror.

I was very frustrated with portraiture at the time. Within each photograph, I was trying to insert myself but not be recognized or categorized automatically. With photography, I was frustrated with this pinpointing—this quantification or summing up—of the subject in portraiture. I was also still responding to questions from childhood of "Oh, what are you?" Through photography, my first response was to put on camouflage pants in a faux-tropical B-movie set.

Rapture (2006) (plate 10) and *Collapse* (2006) (plate 11) was my first step toward a flattened backdrop in the room, as well as a play between two- and three-dimensionality. I bought the sunset and palm trees set on eBay, and the rugs are from Mexico and Peru.

LK: How did you make the choice for those rugs?

GO: It was more of a color palette. I was also interested in the misidentification of where the rugs came from; a lot of people thought they were from the Middle East. I had never been to the Philippines, and I made *Rapture* and *Collapse* when I first got back from my first trip. With *Rapture*, I was interested in this gesture of giving praise and relinquishing any individuality to a greater color field or landscape. I was also interested in the line between giving praise and being apprehended by a larger power. With *Collapse*, I was still trying to reference these histories of my mother's stories in World War II—her experience was so horrifying, yet she still holds fond memories of her homeland. These works were an attempt to conflate histories of war and this love and my desire to return to this landscape. Although I realized in many ways this relationship of desire is constructed and not really my home, it's always filtered. It's just like the sunset here, in L.A.

LK: The neutral leisure suit woman, in *Collapse* and *Rapture*, did you envision that as a character or maybe embodying your mom or yourself?

GO:: I was trying to think of something neutral—a middle-gray, nondescript, anonymous woman figure. When I look back at those works, I see my use of metaphor is a bit clunky, too literal.

LK: Even then you chose not to show your face. So can you talk about that denial?

GO: Starting with the very first *Burnt Out* works, I was interested in this refusal to be identified. I wanted to insert a nonverbal strategy to refuse being categorized within photography.

LK: That's an important link for someone seeing these early works and your work now, trying to figure out the connection. Also, your use of set design and certain concepts are here in these early works.

GO: I think that in more recent works, the positioning of *the blank* as a shape of refusal, and my interest in the void or a cut in the wall, are a kind of a tear in that cohesiveness.

LK: I see so much of the language of painting in your work. Is that something you think about?

GO: When I look at painting, I'm very conscious of the body's position in relationship to viewing the work, especially with large color field painting.

LK: And the format of your pieces is larger.

GO: It's the act of inserting and establishing a visible relationship between the figure and these color field rooms. Structure is very important to me, the pared-down minimal structure of the room. I started to see the room as the stand-in for language and the language of seeing. In many ways, it's the visible structure of perception—or

misperception—and a space where the definition of the figure is not fixed, can be misinterpreted or misperceived.

In a follow-up e-mail interview on June 28, 2010, Osterloh expanded on the profound impact Bradshaw's essay and Tammy Rae Carland's class had on her work. The essay introduced questions and visual metaphors of camouflage and passing as a means "of concealing 'true' identity" within one's majority or minority group. She explained that attempts at passing are internal responses to external social constructs, to illogical race constructions in North America (see Bradshaw, "Beauty and the Beast," 99).

GO: I just reread the essay again. It's still very relevant and offers visual strategies as an artist. I was especially drawn to her positing [that] to bridge external categories of difference is not a deviant act; it is specifically inclusive. "To transcend artificial, irrational barriers is not an act of deviance; rather, it requires engaging in a process of adaptation" [Bradshaw, "Beauty and the Beast," 100].

A couple years later, after the class with Tammy Rae Carland, I was at UC Irvine in graduate school. I began to work with camouflage within portraiture as a means to resist portraiture's desire to locate truth, an essential nature, within its subject. I remember some of the first set constructions I created—I wanted to have a body present in the photograph that could not be easily identifiable. I still work with camouflage in located parts within a photograph, as well as actively applying camouflage to the room itself. In my work *Copy Flat,* a gray-dot spray-paint pattern creates an inherent focus problem in the structure of the room; in terms of perception, there is a fluttering relationship between surrounding space, an individual, and the group.

Transcribed by Marco Cortes, 2010

Resources

Bradshaw, Carl K. "Beauty and the Beast: On Racial Ambiguity" In Root, *Racially Mixed People in America.*

Buckley, Annie. "Gina Osterloh." *Art in America, the International Review* 1 (September 2009): 154.

Fairley, Gina. "Shooting Blanks." *Art Asia Pacific* 60 (September–October 2008): 205.

Stallings, Tyler. *Truthiness: Photography as Sculpture.* Riverside: University of California, Riverside and the California Museum of Photography, 2008.

Wading to Shore:
An Interview with Jenifer Wofford

According to her website, JENIFER WOFFORD *is an artist who uses varied media, including "sculpture, installation, painting, drawing, photo, video, performance, teaching, and curating." Incorporating what she describes as a "mish-mash visual poetics of travel, temporality, literature and slapstick," her work—whether solo, in collaboration with her sister Camille, or as one-third of the performance art crew Mail Order Brides/ M.O.B—confronts "political realities and global inequities," as she describes in her artist's statement. Wofford is Filipina and European American. She was born in San Francisco and raised in Hong Kong, the United Arab Emirates, and Malaysia. With an MFA degree from the University of California, Berkeley, and a BFA degree from the San Francisco Art Institute, she is an artist and educator currently based in the San Francisco Bay area. Her work has been exhibited in the San Francisco Bay Area at the Berkeley Art Museum, Yerba Buena Center for the Arts, Southern Exposure, Richmond Art Center, and Kearny Street Workshop; nationally at New Image Art in Los Angeles, Nora Eccles Harrison Museum in Salt Lake City, and thirtynine hotel in Honolulu; and internationally at Future Prospects in the Philippines, Galerie Blanche in France, and Osage Gallery Kwun Tong in Hong Kong.*

Wei Ming Dariotis interviewed Jenifer Wofford via e-mail on May 23, 2010, about her life and her painting MacArthur Nurses I *(2009), which draws a correlation between the history of World War II and subsequent Filipina nurse migration to the United States.*

WEI MING DARIOTIS: Can you tell me a little about your biography?

JENIFER WOFFORD: I'm half-Filipina half-Caucasian American. I was born in San Francisco and grew up in Hong Kong, Dubai, and Kuala Lumpur. We returned to California when I was fourteen.

WMD: Who are your parents, and how did they meet?

JW: My mother was born in Manila during World War II, then raised in Guam. She moved to the U.S. at age sixteen to attend university. My Filipino relatives are scattered throughout Metro Manila, Batangas, and California. My father was born in California to a family of compulsive itinerants, each generation moving somewhere

new: arriving from England around 1650, settling briefly in the South, then Oklahoma, then Montana, and down into California.

My parents met in Thailand in the mid-1960s. Dad was doing surveying work for an American company; Mom was visiting her brother, a contractor on the same project. They didn't really hit it off until they both happened to move back to the Bay Area around the same time. They married in 1968, a banner year for interracial weddings. Mom's two siblings also married European Americans, so many of my cousins are also mixed.

WMD: What words feel most comfortable to describe your identity?

JW: Given my childhood moving around overseas, I would say that I identify as a Third Culture kid as much as I do biracial. I usually describe myself as Filipina American.

WMD: With what cultures do you feel most strongly connected?

JW: Given the sort of weird childhood in neither the Philippines nor America, I didn't grow up with a strong sense of either culture. I got involved with the Filipino community through visual art much later, when I was an undergrad in art school, and this continues to be my strongest tie to the culture. I think that much of my consciousness as an artist was deeply shaped by my connections to other Filipino American artists like Carlos Villa, who mentored me. They taught me so much about the importance of community, collaboration, and good Filipino food being integral parts of a creative practice! I do have a strong connection to both Malaysian and Mexican cultures as well, though this is less of an active community involvement.

WMD: How do you feel that being mixed is addressed in your work as an artist? Is race an "optional" issue for you?

JW: Being mixed definitely plays into my artwork and life decisions. Probably the richest source of material in my work of the past decade has been both Filipino culture as well as a hybridized sense of A/P/A [Asian Pacific American] culture.

Perhaps more than my own specific ethnicity/culture, I think I've been far more influenced by the wide variety of experiences and cultures I've been participating in over the years. One's conception of one's "culture" is such a construct, an amalgamation of many, many other things than blood. While I grew up in relative comfort, I also grew up constantly aware that I didn't fit in, physically or culturally, in any one environment. This awareness has left me committed to blurring margins and boundaries as much as possible, rather than promoting the supremacy of one particular culture over others. And I tend to use a lot of humor and irony in my work: it allows me a different sense of exploration, play, and subversion, rather than an overt/rigid accusation or declaration. I definitely have strong opinions, but in art, ambiguity and playfulness can reach people more effectively.

Fig. 5.1. General Douglas MacArthur wades ashore during initial landings at Leyte, Philippine Islands, 1944. Still Pictures Records Section, National Archives and Records Administration, 531424.

WMD: What are your associations with the terms "war baby" and "love child"?

JW: My family doesn't have too many conscious associations with war. Certainly, World War II in the Pacific affected my mother more, but she was so young at the time, she doesn't recall much.

My parents have occasionally joked over the years about the ways in which people would ask the loaded "How *did* you meet?" early on in their relationship, the under-lying assumption being, of course, that she was a bar girl, masseuse, prostitute, or war bride. They had fun, messing around with people around this.

I've made a lot of work related to Filipina nurses in recent years. This labor history is deeply intertwined with U.S./Philippines colonial and war histories. Most recently, I made a painting of a group of nurses wading to shore à la Douglas MacArthur, which is absolutely World War II related.

MacArthur Nurses I (2009) (plate 7) is based on the iconic/notorious World War II photograph of American general Douglas MacArthur arriving on the beach in Leyte,

Philippines (fig. 5.1), at once an image of heroism and return, but also an image of conquest and falsehood (since the photos were staged and restaged several times to get the right dramatic effect). It just seemed to beg to be deconstructed, [so] I chose to reconstruct this "beachhead scene," replacing the American soldiers with Filipina nurses, emerging through the surf, conquering some new land, or perhaps just returning to their homes after many years away.

Beyond the MacArthur/Leyte reference, I've always been very compelled by images of people standing in, or pushing through, water. I've been thinking of images and their stories as ever more amphibious. Marshlands and swamplands, anywhere land and water negotiate a mushy balance, are interesting to me. Waters rise, things become unmoored, are displaced. Partly this is the iconography of a post-tsunami Asia and a post-Katrina America: for me, it's as much the imagery of flood disasters and global warming as it is of immigration and arrival, of conquest, of an overwhelming limbo. I've often fixated on images of people and places in this kind of in-between state.

Resources

Buuck, David. "Jenifer K. Wofford on Market Street Kiosks." *Artweek*, December–January 2008–9.

Choy, Catherine Ceniza. "The New Face of Immigration: Flor de Manila y San Francisco." In *Art on Market Street*. San Francisco: San Francisco Fine Arts Commission, 2009.

Light, Claire. "Drawing across Difference: Artist Jenifer Wofford Makes Connections." *Hyphen Magazine*, no. 14 (Spring 2008): 16–17.

Wofford, Jenifer. "Artist Statement." WoffleHouse, http://wofflehouse.com/wofford/statement/.

World War II:
Mixed Race Japanese Americans

Fig. 6.1. Stephen Murphy-Shigematsu as the Celtic Samurai, 1969. Darrow School high school yearbook photo, New Lebanon, N.Y. Courtesy of Stephen Murphy-Shigematsu.

The Celtic Samurai:
Storytelling a Transnational-Transracial Family Life

STEPHEN MURPHY-SHIGEMATSU

MY MOM AND DAD met in postwar Tokyo, Occupied Japan. They worked in the same building downtown where MacArthur's general headquarters were. Mom spoke a little English and Dad spoke a little Japanese, and like most couples, they really couldn't understand each other, so naturally they fell in love. Dad thought Mom was lovely, and Mom thought Dad was charming, and so they decided to marry. And that's when the trouble started.

I never understood my parents' story until I saw the film *Sayonara* (1957). Then I imagined my dad was kind of like Marlon Brando's character, Major Gruver—an American man full of defiant desire for an Oriental doll. Gruver eventually turned out okay, but at first he just followed the party line, believing it was wrong for Americans and Japanese to marry.

He didn't come around until his buddy Joe Kelly, played by Red Buttons, convinced him there was nothing wrong with marrying a Japanese woman. Japanese didn't like these marriages with Americans either, but when Mom told her family she wanted to marry Dad, they were surprisingly accepting, saying that as long as he respected her, it didn't matter that he was American. But like Gruver and Kelly, Dad had a hard time getting married.

Grandpa Shigematsu went to the city hall, but when the people there found out the groom was an American, they said they couldn't approve the marriage; he had to go to the American embassy. When my dad went there, the embassy personnel told him the same thing—Americans couldn't marry Japanese. "You can't take her to the States anyway, son, so why marry? And where do you want to live? California? You know they wouldn't let you marry a Mongolian there either. Better to just forget about her and go back to the States by yourself; there's plenty of good American girls there."

But Dad didn't take their advice and stayed, and while everyone waited for the marriage to be legalized, he just moved into my mom's family's house in Tokyo, and soon there were kids being born and we had one big happy family (fig. 6.2). Grandma, who had adopted mom, her younger sister, when mom was five and never given birth

Fig. 6.2. Murphy-Shigematsu family portrait, Tokyo, 1953. Left to right, front: father, Fred, sister Johanna, sister Margaret, Stephen, mother, Toshiko; rear, grandfather Mitsuo, grandmother Mitsu. Courtesy of Stephen Murphy-Shigematsu.

herself, finally had her babies. But one day, Dad came home and said he was taking us all to the United States. We were excited until we realized Grandma wasn't coming—she had to stay with Grandpa—and my sisters started crying. My mom just said, "Shikata ga nai," which is what she always said when there was something tough that we had to do—there's no other way, so stop whining! Grandma begged Mom to leave one child for her, but my parents couldn't decide which one, so they took us all. Grandma lost her only child and all her grandchildren. We left Grandma standing on the docks of Yokohama, got on a big ship to San Francisco, and watched her get smaller and smaller until she disappeared.

We were on our way to Pittsfield, Massachusetts, where my dad's parents had emigrated to from Ireland half a century earlier. Dad said we had to stop there on our way to Southern California. I'm not sure if he had a poor sense of geography or was tricking us, but that's how we ended up in New England. The Murphys were waiting for us. They even called out the Catholic priest to welcome us to America.

Life in the United States wasn't too bad; the steaks were big and the hot dogs were a foot long. There were hot fudge sundaes with a red cherry on top and pink clouds of

cotton candy. When McDonalds and Dunkin' Donuts came to town, we kids had all we needed. We missed Grandma, but she sent us packages with Japanese goodies like nori (seaweed), sembei (rice crackers), yohkan (red bean candy), and handmade clothes that never fit us because they were always too small. And we had a new Irish family who took us into their home and nourished us, and before we knew it, we were Americans. We even got religion. My mom was Buddhist and my dad was an atheist, so naturally they decided to raise us . . . Catholic. I don't know why; maybe they were just trying to make us Americans.

Not everyone was nice. Some people didn't like Japanese. When we first came in 1953, they said this negativity was because of the war, but when people told us to go back to China, it was confusing. Some people weren't mean but didn't know what to make of us. They had never seen a family like ours—American husband, Oriental wife, and their mongrel kids. While people didn't know what to make of us, they thought they knew who Mom was. They called her a "war bride," which was a nice way of saying she was a bar girl who had been lucky enough to catch a good American boy who took her to the U.S.A. They didn't know Mom at all. The Christians thought Mom was a heathen, so they came to our apartment to convert her. Dad let them inside, but when they started to call Mom "Theresa," he got mad and told them her name was Toshiko and she wasn't changing her name for them and that it was time for them to go. I was proud of my dad for that.

Mom was lonely, and I was just a little kid, but I think I already knew there were two things missing from her life. One was a bath and the other was rice. Now, Japanese must be the cleanest people in the world, totally obsessive-compulsive about baths; you can't sleep if you don't take a bath. When Mom started acting funny, we told Grandma Murphy that what Mom really needed was a nice bath. So she made one for her. And when she called Mom, we all went running up to the bathroom. And there it was—a long tub, and deep, but with only about six inches of water in it. And when we put our fingers in it, it was lukewarm! We all asked at once: "Where do you wash?"

We were used to washing outside the tub so that the water in the tub would stay clean. But there was no drain in the floor. None of us could figure it out, so Mom said, "Better go get Grandma."

When Grandma came, we asked, "Where do you wash, Grandma?"

"Why, right in the tub!"

We all looked at each other in amazement. "You mean you just sit right in the dirty water?"

Grandma looked at us in amazement as if it was the most normal thing in the world. Some of you probably think it's normal, too. Then she said something I'll never forget.

"Well, can water be dirty if it has soap in it?"

It was kind of like a Zen koan, and I've been trying to figure it out ever since. Well, we all got into the bathtub and splashed around, but Mom just watched us. I think she gave up on taking a bath in America.

She still had hopes for the rice, but Grandma cooked only baked potatoes, fried potatoes, mashed potatoes, scalloped potatoes . . . but it wasn't potatoes Mom wanted—it was rice. Life without rice for a Japanese is like life without sunshine, and Mom began to despair that food in America would not keep her alive.

So Grandma got a good idea of how to make Mom happy and took us down to Lucky Garden, the Chinese restaurant in town. It smelled funny, and they had this stuff on all the tables, La Choy Soy Sauce. Mom tasted it and made a face at first but then smiled as if to say, "Better than nothing." They had all these weird-sounding dishes like chop suey and chow mein and the house special, the pu pu platter. Now we didn't know a lot of English yet, but we were kids, and we knew pu pu, and we told Mom, "We don't want no pu pu platter."

Mom got mad and said, "Stop dirty talk, not that kind of pu pu. Just eat it!" A big bowl of rice came, and we got all excited, but when we tasted it, why it wasn't gohan at all, because it was Chinese rice, Texas long grain, not the sticky rice that we knew. Though she tried to hide it, disappointment was written all over Mom's face. Grandma didn't understand why Mom didn't like the rice, so Dad explained that we weren't Chinese, we were Japanese, and it was Chinese rice.

Mom decided to check out the rice situation in Massachusetts for herself, and so we headed down to the A&P supermarket and walked up and down the aisles. People stared at us like we were monkeys in a zoo, whispering to each other as we walked by. Mom's face grew fierce, but she kept walking; she was a woman on a mission. Suddenly she stopped, and there it was—rice! There was Minute Rice—"Just add Boiling Water" "Perfect Every Time!"—and there was Uncle Ben's Converted Rice. Now I don't know what it was converted from or converted to or if that kind of a conversion is anything like what the missionaries were trying to do to Mom, but all I cared about was the picture on the box. I was fascinated by Uncle Ben; I had never seen a man like him.

"Who's Uncle Ben?" I asked.

My sister, who had an answer for everything, pointed to the pancake section and said, "Look! Why, he must be Aunt Jemima's husband!"

Mom scolded her, "Don't be silly, they're not even related." She grabbed the Uncle Ben's off the shelf, and we rushed home.

Grandma offered to cook the rice and told Mom to relax. So we went into the living room to watch television. Luckily, Mom's favorite show was on. Now, I don't

know why she liked *I Love Lucy* so much. She hardly ever laughed, and only when no one else laughed, but mostly she just watched with a quizzical expression on her face. Maybe she was trying to figure out what it was Americans thought was funny, or maybe she thought Lucy was a good role model for how to be an American woman, because she started to dress and put on makeup like Lucy. Anyway, some time later, Grandma called us to the kitchen. "The rice is ready!" Mom's face brightened, and we all went to the kitchen, and there it was.

We all stared at it until my sister finally said, "What's the brown stuff?"

"Raisins."

"And the yellow stuff?"

"Eggs."

"What about the yucky stuff?"

"Cream and sugar."

I looked at Mom's face and wondered what she was feeling. Was she happy? She had her rice. Was she sad? It wasn't really her rice. Was she lonely? Maybe she was imagining a steaming bowl of white sticky rice with an umeboshi (pickled plum) on top. But Mom smiled and looked at Grandma and said, "Thank you for making rice" and had her first taste of rice pudding.

Reflection

In this written version of my live performance *The Celtic Samurai*, I tell the story of my transcultural journey between Japan and the United States and show how American men of diverse backgrounds and Japanese women came together despite the immense legal and social barriers that stood between them. However, the opposition drove many couples apart, with some Japanese women becoming single mothers and others giving up their children. The kids were heavily stigmatized as the children of the former enemy and occupiers and immoral women, with prejudice and discrimination directed at them.

A popular narrative of the postwar era is the inspiring story of Miki Sawada, the daughter of a noble family married to a man who was once the ambassador to the United Nations. Sawada claims that an apparently mixed race baby fell into her lap from the overhead luggage compartment while she was traveling on a train one day. The incident shocked her into action, and she dedicated her property and life to establishing and running an orphanage, the Elizabeth Saunders Home, where more than a thousand mixed-blood children were raised. Sawada believed that the kids needed to be separated from an unforgiving Japanese society and sheltered in her institution. She drew attention to the plight of these children, leading novelist Pearl

Buck to establish a foundation in 1964 to help what she called "Amerasians," who were born all over Asia, wherever the U.S. military went.

Most couples that were able to marry did not remain in Japan, and tens of thousands came to the United States and settled in California, around military bases, or wherever the American spouses called home. They were called "the loneliest brides in America" by *Ebony* magazine and encountered incredible adjustment difficulties, symbolized by the loss of the most basic comforts of familiar foods and customs.[1] They also endured hostility from many communities, including from Japanese Americans. Their resilience and perseverance in raising their children in an adopted homeland is a story that needs to be told. My mother's story was part of a larger so-called war bride phenomenon of post–World War II U.S.-occupied Japan.

When war brides and their families came to the United States in the years following World War II, they encountered the harsh remnants of the trauma inflicted on persons of Japanese ancestry. Following the December 7, 1941, bombing of Pearl Harbor by the Japanese Imperial Navy and the resulting wave of anti-Japanese hysteria, President Franklin D. Roosevelt signed Executive Order 9066 on February 19, 1942. A month later, the Department of War began forcibly removing all "Persons of Japanese Ancestry" from western coastal regions to inhospitable inland "relocation" camps. In General John L. DeWitt's "A Jap's a Jap" environment, the "evacuation" of some 120,000 Japanese Americans and Japanese nationals was clearly more racially motivated than a "military necessity," as even the elderly, the ill and infirm, children, infants, and orphans were interned.[2]

Little is known of the fates of those of mixed ancestry, but according to a 1949 edition of the Japanese American newspaper *The Pacific Citizen*, Colonel Karl Bendetsen, administrator of the Wartime Civil Control Administration, infamously stated, "I am determined that if they have one drop of Japanese blood in them, they must go to camp."[3] Of the 101 Japanese American orphans and foster children who were rounded up and sent to the Children's Village in the Manzanar internment camp, many were of mixed Japanese heritage and some were said to have had as little as one-sixteenth Japanese ancestry, with several reporting later that they did not even know they were part Japanese until they were interned.[4] The U.S. Army's schizophrenic policy toward mixed marriages and people of mixed heritage was irrationally driven by racial prejudices and the one-drop rule mentality.[5]

After they were released from the camps, Nisei (second-generation Japanese Americans) and Sansei (third-generation Japanese Americans) followed an "all American" economic and cultural survival model of assimilation into the dominant white culture, and rates of intermarriage with whites steadily increased, as did the number of mixed Japanese Americans. Today interracial and multiracial Japanese American families

and individuals are commonplace, with three out of four persons of Japanese ancestry being of mixed ancestry, the descendants of war brides and intermarried Japanese Americans.[6] They are now the "new face" of Japanese America, leading the trend that many other Asian American groups are following. It is instructive to look back at a generation when "hapa" or haafu (the Japanese term for "half") were regarded not as cosmopolitans but as "war babies" in Japan and white America, and even as inu (Japanese for "dogs," or, in this case, "mutts"), and were treated as outcasts by the Japanese American community.[7]

Yonsei Hapa Uchinanchu:
An Interview with Laura Kina

LAURA KINA *is an artist who explores issues of transnational and mixed heritage identities through her paintings, drawings, mixed media, and textiles. She is Yonsei (fourth generation), of Okinawan and European American descent, and grew up in Poulsbo, Washington, strongly influenced by her Okinawan American father's cultural heritage from Hawai'i. Her work has been shown internationally in India, and she has mounted solo shows in Chicago at Woman Made Gallery and the Gene Siskel Film Center, in Miami at Diana Lowenstein Fine Arts, and in New Haven, Connecticut, at Grand Projects. Kina currently lives in Chicago, where she teaches for the departments of Art, Media, & Design, American Studies, Women's and Gender Studies, and the Global Asian Studies minor at DePaul University and has been involved in a myriad of Asian American arts organizations, including DestinAsian, Asian American Artists Collective, Foundation of Asian American Independent Media, Diasporic Asian Arts Network, and the International Network for Diasporic Asian Art Research.*

Wei Ming Dariotis interviewed Laura Kina by e-mail on September 26, 2011, about her identification with the labels "war baby" and "love child," particularly as the latter term relates to her charcoal drawings, The Loving *series (2006), and the word "hapa," which she used as the title of a series of large-scale oil paintings collectively titled* Hapa Soap Opera *(2003–5).*

WEI MING DARIOTIS: Can you tell me how you grew up identifying, and if the "war baby," "love child," or "hapa" labels we have been exploring in this volume relate to your own biography?

LAURA KINA: I was born in 1973 in Riverside, California, and I grew up in the Pacific Northwest identifying as hapa and experienced a mixture of normalcy and exotic novelty surrounding my multiracial heritage. I'm not a "war baby," nor am I a "love child." I am a member of the "biracial baby boom." My parents' interracial love in the 1960s probably had more to do with a mutual affection for Jesus and cycling the steep hills of Seattle than it did with utopian ideals! My father, George Kina, is a Sansei Uchinanchu [member of the Okinawan diaspora] from the Big Island of Hawai'i. In 1919, my great-grandmother, Makato Maehira Gibu Hiyane, arrived through the pic-

ture bride system of arranged marriage in Piʻihonua, Hawaiʻi, to begin her life as a sugarcane plantation worker. Three generations worked the fields, sending money home to help support the family in Okinawa. By the 1960s, my father and his three sisters, seeing no viable future in the failing sugar industry, moved to the mainland for better financial futures, eventually becoming a doctor, nurse, teacher, and beautician.

WMD: How did your parents meet?

LK: They met at college mixer for new students in September of 1963 at Seattle Pacific University. My dad was a junior transfer pre-med student from University of Hawaiʻi at Hilo, and my mom, Diane Smiley, was an incoming freshman majoring in sociology and art. In 1965–66, a year before the Six-Day War, she did a study abroad at the Beirut College for Women, and it was during this time that they corresponded by letter writing that they fell in love.[1] They both went on to study at the University of Washington, and my dad became a family practitioner and OB-GYN. My mom's true passion was art, but when all four of us kids were young, she was a stay-at-home mom, and she used her creative talents in her volunteer work.

WMD: Can you describe your mom's side of the family?

LK: My grandmother, Mary Moreno, was a petite Basque-Spanish seamstress from a Spanish-speaking agricultural family in Northern California. My grandfather, Bob Smiley, was a brash Texan and a descendant of James Knox Polk, eleventh president of the United States, as well as of Major General George Pickett, whose infamous charge was the last battle at Gettysburg. With only an eighth-grade education but having been raised by a Black nanny with a PhD in chemistry, he toured the South Pacific, seeing "the Orient" through a naval torpedo submarine porthole. On a visit home to Kingston, Washington, he met my grandma through his mother, Ethel Gray Dismukes Smiley. Mary had gone to work for Ethel as a seamstress. Shortly after my grandparents were married in 1939, the navy sent them to Honolulu. In 1941, he was stationed in Pearl Harbor, where he developed an allergy to the air in his sub and was honorably discharged in October 1941, just missing the December 7th Japanese attack on Pearl Harbor. They returned to Kingston so he could work a civil service job at Keyport Torpedo Station.

My grandparents went on to be successful small-business owners, running a string of local businesses. They started by gathering scrap metal, and then they owned a gas station, a sewing notions store, a hardware store, a burger joint, a mini-warehouse storage, a Christmas tree farm, and a cable company, but the main business that my mom grew up in and that I remember was Smiley's Colonial Motel, a roadside motel near the Kingston Ferry dock. A few years ago, we sold it to a South Asian family who has renamed it the Blue Water Inn.

WMD: You mentioned your mom and dad had four kids. Did you and your siblings end up identifying in the same way?

LK: I was raised Evangelical Christian in a Norwegian town in the Pacific Northwest. I'm the oldest. When I was fifteen, my little sister, Alison, had Down's syndrome and died at age twelve. My Grandma Kina also lived with us, and she was an eccentric character whom I loved dearly. We all visibly or socially stuck out in some way or another . . . too dark, too short, too hairy, no nose, flat face, weird food. She used to make us Spam musubi (sushi). I eventually learned to be proud of difference, stick up for the underdog, and laugh at myself rather than being ashamed for not being like everyone else. My two younger brothers and I all identify differently and have all moved far from home, both geographically and in terms of our political views, religion, and the cultures we live in. I think out of the three of us, I focus on race and ethnicity, whereas my brothers seem to define themselves more by their careers. I guess that's probably true of myself as well . . . I'm an artist first. I'm sure we have all changed our identities many times over the years.

When I was growing up outside of Seattle in the early '90s grunge scene, I was a disgruntled post-punk hipster. I ran off to art school in Chicago, became an Asian American activist-artist at the School of the Art Institute of Chicago, and married a Jewish bongo drummer in recovery fourteen years my senior. Now I'm an art professor, we're still married and have two girls (the eldest is my step-daughter, and she is Mexican American–Jewish), I eventually got tired of being the "goy" [non-Jew] in the family and converted to Judaism. It's complicated but fun. There's always something to make art about!

WMD: In your artist statement, you talk about addressing "the fluidity of cultural difference and the slipperiness of identity." Curator Larry Lee further describes your work as "Hello Kitty goes to Bollywood in Pearl Harbor by a Coca Cola sign. Or surely Pop gone haywire as the resultant byproduct the artist creates deftly fuses these loaded icons into a NeoPop Orientalism or less ironical Post Japonisme of East morphing West and vice versa not just Americanized but transnationalized."[2] Can you clarify what this means and describe what you are currently working on?

LK: Most of my work begins with an identity-based autobiographical impulse from which I start to collect images, stories, and histories, and I see what's missing, what's not being told, what's not obvious, and I go hunting for it. I'm interested in the overlap, fusion, disjuncture, or vibration that happens when I bring back the missing pieces (oral history interviews, photographs, objects, stories) and put them together. The strategies and methodologies I employ as an artist and scholar come from the artists I studied under. At the School of the Art Institute of Chicago, the late painter Ray Yoshida taught me to love, as curator Lanny Silverman put it, "pop culture minus the

irony."[3] Ray used to take his students to Maxwell Street on Sunday mornings to collect collage and reference materials from the resale vendors. He taught us how to see beauty and abstraction in the everyday. Painter Michiko Itatani gave me the freedom to imagine creating collaborative artistic systems and structures to sustain my work for the long haul as she introduced me to Chicago's rich DIY culture and legacy of alternative spaces. In graduate school at the University of Illinois at Chicago, painter Phyllis Bramson reinforced my penchant for pattern and decoration, and Kerry James Marshall, who paints what critics have often described as "emphatically Black" politicized figures, taught me how to think strategically, push my craft as a painter, and set an example for how I might envision creating an "emphatically" *mixed* world.

From 2002 to 2006, my work focused on the mixed race body in my *Hapa Soap Opera* (plate 12) and *Loving* series, but in my *Aloha Dreams* (2007) and *Devon Avenue Sampler* (2009–11) series, I shifted away from presenting isolated mixed race individuals to exploring specific time periods and places and how history impacts issues of identity. In my current *Sugar* series (2010–present), I'm focusing on my dad's family and community history as sugarcane plantation workers on the Big Island of Hawai'i. I think in cinematic terms; this series is set during the 1920s–40s and recalls ghost stories and features indigo kasuri–clad Issei Okinawan picture brides working as sugarcane plantation field laborers (plate 13).[4]

I remembered my grandmother telling me about hinotoma [fireballs] that would shoot up into the night sky from an old plantation graveyard. While they were a natural phenomenon caused by volcanic gases, everyone thought these were obake, or ghosts. This image is parallel to the traces of collective memory I have of the lives of my family before World War II. Only a few family photographs exist, and many of the stories, artifacts, and details of early plantation life were thought to be unimportant or unintentionally vanished with my family's language shifts from the Uchinaaguchi dialect to Pidgin to mainland English, along with the general Nikkei [people of Japanese heritage] move toward assimilation, following the bombing of Pearl Harbor and Japanese American internment, and a similar move for Okinawans, stemming from the colonization of Okinawa and its culture by the United States and Japan.

WMD: How did you go about finding the missing pieces to begin telling your family story?

LK: In summer 2010, I went with my father back to his hometown of Pi'ihonua, to talk story with community elders from Peepekeo, Pi'ihonua, and Hakalau plantations about the lives of the Issei and Nisei women. I used a snowball technique of gathering stories and having one person introduce me to the next, recording and transcribing the interviews, and going back to check facts. Many of them gave me copies of family photographs, or they drew diagrams to explain things like what a cane knife looked

like, what hajichi [geometric Okinawan hand tattoos] they remember their mothers or aunties in the community having, how the permanent wooden and portable aluminum cane flumes were constructed.[5] I also did traditional research from books and library and community archives. At the end of the day, though, I have to shut my eyes and use my imagination, take a good lesson from the Buddhist Obon tradition, and invite my ancestors to present themselves to me.[6] I have to learn how to listen to ghosts. The process of working on the *Sugar* series has taken me through the ether of myth and memory into the beautiful yet grueling world of manual labor, cane field fires, and flumes to explore themes of distance, belonging, and cultural reclamation.

Resources

Boris, Staci, and Sarah Giller Nelson. *The New Authentics: Artists of the Post-Jewish Generation*), 40–41, 91–95. Chicago: Spertus Press, 2007.

DeRango-Adem, Adebe, and Andrea Thompson. *Other Tongues: Mixed Race Women Speak Out*, 48, 74. Toronto: Inanna Publication, 2010.

Kina. "Half Yella."

9/11 Manzanar Mashup:
An Interview with Chris Naka

Born in 1983, CHRIS NAKA *is a native of Chicago. His father is Sansei and was born in the Manzanar Relocation Center, a Japanese American internment camp, and his mother is a secular European American Jew. Naka earned his BFA degree in 2006 from the School of the Art Institute of Chicago and his MFA degree from Northwestern University in 2011. He is best known for short video works that, as he described in a July 23, 2011, e-mail, "combine elements from user-generated content, popular culture, and everything else he has saved on a hard drive (or buried in his heart)."*

In 2011, Naka's work was featured in a two-person exhibition at Julius Caesar in Chicago, and his videos have been screened at Roodkapje, in Rotterdam, Netherlands; Kavi Gupta Gallery, Slow, and the Zhou B Art Center in Chicago; Spark Contemporary Art Space, in Syracuse, New York; and Palazzo Papesse, in Siena, Italy.

Laura Kina interviewed Chris Naka about his postapocalyptic short animation The Tale of Selling the Tale *in his Northwestern University MFA studio in Evanston, Illinois, on January 19, 2010.*

CHRIS NAKA: My dad claims to be one of the last, if not *the* last, born in the Japanese American internment camps. His family lived in California before relocating to Manzanar. I think the only direct effect this bit of family history had on me is a kind of weird, residual anger. Well, maybe not anger, but I harbor a kind of exaggerated frustration or mistrust of the government that I never saw my family display. Even if you ask my grandma today, "How did you feel about the internment camp?" she would say, "If it was U.S. citizens living in Japan, we probably would've interned them, too." A couple years ago, I heard an anecdote about my grandfather—he passed away before I was born, but after hearing this story, I felt a certain close connection to him. There were two lines at the camps for processing; at the end of the first line, the U.S. military was demanding Japanese Americans sign a pledge of allegiance to the United States. My grandpa said, "Why the hell would I sign allegiance to the United States? You're going to throw me in jail. I'm not going to sign anything, forget it." And the soldier replied, "Okay, that's fine. You can go stand in that line." Grandpa said, "What's that line?" And the soldier said, "You go back to Japan." Finally, my grandpa

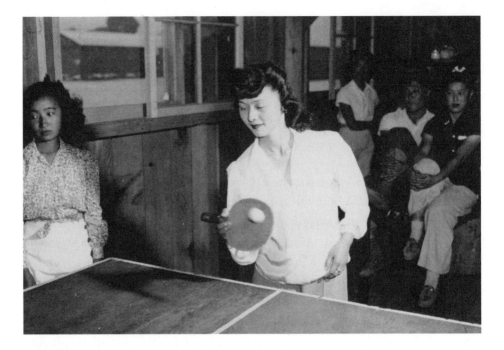

Fig. 8.1. Chris Naka's grandmother, Chiyeko Nakashima, as a high school student playing table tennis in a girls' recreation hall at the Manzanar War Relocation Camp, Manzanar, California, 1942. Photo: Francis Stewart. The Bancroft Library, University of California, Berkeley, 1967.014 v.23 CD-515—PIC

said, "Alright, I'll sign the paper." I just love how he had this big moment of standing up to the government; they told him, "We'll send you back to a war zone in Japan," and he said, "Alright, I'll sign the paper; we'll go to the camps."

LAURA KINA: I can't believe I've known you all these years and didn't know your family was in camp!

CN: In some ways I assume it's a part of every Japanese American's story that's been in the country for a certain amount of time. There's actually a great picture of my grandma playing Ping-Pong in Manzanar that's in the permanent collection of some university's library (fig. 8.1). The photo is of my grandma with this immaculate hairdo—it's like the weird 1950s curler hairstyle, and it's just very strange. It's funny because my family didn't know the picture existed until several years ago when one of my little cousins was writing a history report in high school on the internment camps and she googled "Chiyeko Nakashima," and all these pictures came up and links to internment camp web pages. We had to ask other family members, "Is this Grandma?" And they said, "Yeah, that's an old picture of Grandma," which no one knew existed.

LK: How did your parents meet? What's your mom's background?

CN: My mom is Russian, Romanian, and German . . . I think? They met during graduate school. My dad is eight years older than my mom and had already received his master's degree in history from DePaul University, and my mom was a master's student at DePaul, studying education. My mom had to take a history class outside of her major, and her professor kept handing out my dad's papers and saying, "These are the best papers that I've ever received. Use these as an example for your final." My mom loved my dad's writing and hung on to a number of his old papers. Several months later, they met at party, and she was like, "Oh! You're the Dennis Naka that wrote these history papers." And he was like, "Yeah, that's me. Let's go make some half-Japanese babies." Just kidding about that last part. I hope.

LK: So she can honestly say that she fell in love with his mind first! How do you identify yourself?

CN: Always a hard question. I don't know. I was just about to say "global citizen," but I realized how stupid that is. If someone said, "Global citizen," I would say, "Man, lame." When I was younger I wanted to be white really badly because there weren't a lot of Asian kids where I was growing up. That choice has always been really interesting to me because I automatically gravitated toward the majority voice before I had more information about my surroundings and could contextualize my identity. I thought, "My best chance to—sort of—not be noticed and not be picked on at recess is to just say I'm white and never really address anything about my dad or my Japanese heritage." However, as I became older, I felt more of a pull from the Japanese side of my family, but I still wouldn't necessarily claim that I'm Japanese without a qualifier. I would feel bad saying I'm Japanese, but then that's usually what people want when they ask you "What's your identity?" or "Where are you from?" They don't want me to say, "My mom is German," because that's always met with a follow-up question, "Well, what's the other thing?" like it's the prize at the bottom of a cereal box. Most of the time "German" doesn't really work as an answer without leading to a question like "The way you look doesn't really match, so what's the other thing?"

LK: What terms do you use to describe your mix?

CN: If I indexed everything I've ever said about my identity and averaged it out to a single term, it would probably be "half-Asian," because I think it's become an easily recognizable form of identity in the American cultural consciousness. Most people in the U.S. have a reference to work from if you say you're half-Asian. They'll say, "Oh, like Keanu Reeves, Tiger Woods, etc." and name all these celebrities, so "half-Asian" is a kind of shorthand template for my identity that alleviates the need to go into numerous specifics.

LK: Do you have identity ties to any particular communities?

CN: When I was younger, I was fortunate to receive scholarships from the Japanese Service Committee and the Japanese American Citizens League for my education in the arts. At the time, I had mixed feelings about it. However, I ultimately ended up engaging with several projects in the Chicago Asian arts community that I wouldn't have known about outside of those organizations. My roommate Ken is from Japan and had dual citizenship for a while, so he's plugged into this whole other, more authentic Japanese community, or, not authentic, but that's the one that's closer to keeping customs and things as they are in Japan and not really assimilating. But I don't have access, necessarily, to that community; I think it's a language barrier.

LK: Do you address your mixed heritage in your artwork?

CN: I used to make more work that confronted my identity head-on, but I don't as much anymore. It was something, definitely, in my artistic development that was very important for me to understand and address—it was extremely useful to do it. I took classes on mixed race identity, like Romi Crawford's Mixed Feelings: Images of Mixed Race America, at the School of the Art Institute of Chicago, and we read all these texts theorizing biracial identity and the formation of race in America. Mixed heritage, identity, etc., are all things I studied and remain interested in today.

LK: In the title of this volume, we reference the "war baby" / "love child" stereotypes—

CN: I like the title of the book, because I didn't have any concept of the "war baby" idea until after I took Romi's class. When I meet older people, they often say, "Oh, I bet your mom is Japanese," and assume my parents met in dramatic, wartime fashion and my dad is Marlon Brando in *Sayonara*—but I'd say, "No, my dad is Japanese," and they'd be like, "Oh, that's shocking to me," and I never understood why that was when I was growing up. When I was in college, I figured out why.

LK: Can you talk about your latest video, *The Tale of Selling the Tale* (2009) (fig. 8.2a,b)?

CN: It's an animated left-to-right pan of a composite landscape created in Photoshop by blending together imagery culled from posters for big-budget Hollywood apocalyptic/postapocalyptic films. I composed the landscape first and then added decaying stone statues into the scene sourced from figures in nonapocalyptic movie posters . . . movies like *Bruno* or *I Now Pronounce You Chuck and Larry*, some of the kids from *Twilight*, and Lindsay Lohan in *Mean Girls*.

I was trying to pinpoint what the Godzilla-like cultural response was in the U.S. following the September 11th terrorist attacks. I don't think there has been a big franchise launched in response to 9/11 the same way Godzilla was birthed from Japan's relationship to nuclear war. I was thinking about how images depicting a certain kind of fear, destruction, and desolation were already present and being prophesied by imagery in popular culture prior to 9/11. I wanted to combine all those images together

Fig. 8.2a. Chris Naka (American, b. 1983), *The Tale of Selling the Tale*, 2009; single-channel HD digital video, 5 minutes. Courtesy of the artist.

The Tale of Selling the Tale is a digitally animated slow pan (left to right) over a smoke-filled, collaged landscape stitched together from a collection of apocalyptic movie posters. Monumental, crumbling stone statues sourced from manipulated photographs of actors in nonapocalyptic movie posters are scattered throughout the animation.

Fig. 8.2b *The Tale of Selling the Tale*

and see what that fictional space looked like when imagery from all these different films exist in a shared reality.

A lot of my videos are very short in duration and created to be infinitely looped. There's often a static portion that doesn't change and moving, animated elements that fly through or interact with the static.

I'm trying to speak to a desire to have my videos occupy "painting time." A majority of gallery and museum patrons devote the same amount of time to viewing a painting as they do a twenty-minute video. I wanted to make videos that would be encountered like paintings. I have always been inspired by screen savers, old animated loops, and animated .gif files coming from Internet culture, which, at the time when I started making video work, were a lot more primitive.

Ten years ago, I wanted to be a painter. When I started school, I quickly realized painting wasn't for me, but also that painting was loaded with history and things that I didn't want to be responsible for. I tabled painting in favor of practices that seemed more amorphous, more open, and ripe for the kind of uneducated exploration that irresponsible, teenage Chris Naka craved.

LK: I was noticing that the look of this piece is like an ink painting on silk . . . like a scroll.

CN: I thought about it before I finalized how I wanted the camera movement to work—at first, I had the camera moving all over the place before settling on a horizontal, left-to-right pan. I started thinking of the video as a scroll after I finished all the Photoshop work on the background image but before anything was animated. It was made by creating one big image that was dragged in front of a camera to reveal small segments of the larger image. There's something very attractive about revealing only small portions of a single, larger image to viewers and never revealing the whole thing at once . . . Instead, everything is revealed over time, and each smaller image section could be its own composition or element that individual meaning could be derived from.

Transcribed by Marco Cortes, 2010

Resource

Fusi, Lorenzo, and Naeem Mohaiemen. *System Error: War Is a Force That Gives Us Meaning*. Cinisello Balsamo, Italy: Silvana, 2007.

Gravity Always Wins:
An Interview with Laurel Nakadate

LAUREL NAKADATE *is a photographer, video artist, and filmmaker and jokingly describes herself as "halfway in between a picture bride and a cowgirl!"*[1] *Nakadate is Japanese, Irish, Welsh, Scottish, and Cherokee. She was born in 1975 in Austin, Texas, and raised in Ames, Iowa.*[2] *She received an MFA degree in photography from Yale University and a BFA degree from Tufts University and the School of the Museum of Fine Arts, Boston. She lives in New York City. Her work has been exhibited at MoMA PS1, Long Island City, New York; the Yerba Buena Center for the Arts, San Francisco; the Getty Museum, Los Angeles; and the Museo Nacional Centro del Arte Reina Sofia, Madrid. In 2009, her first feature film,* Stay the Same Never Change, *premiered at the Sundance Film Festival and was subsequently featured in New Directors/New Films at the Museum of Modern Art and the Lincoln Center. Her second feature film,* The Wolf Knife, *premiered at the Los Angeles Film Festival in 2010 and was nominated for a 2010 Gotham Award and a 2011 Independent Spirit Award. A ten-year retrospective of her work opened at MoMA PS1 in January 2011. Nakadate is represented by Leslie Tonkonow Artworks + Projects in New York City.*

This edited interview with Laurel Nakadate weaves together content from her Parlor Room visiting artist lecture at the School of the Art Institute of Chicago in November 11, 2009, with follow-up conversations between Laura Kina and Nakadate at a dinner party in Chicago's West Loop on November 11, 2009 and a phone interview on July 21, 2010.

LAUREL NAKADATE: My dad was a young professor in American lit., and my mom was his student. They were exactly the same age, though [both born in 1943 and only three months apart]. She was a single mom of three when she was in my dad's class. Then they got married and had my brother, Nick, and me.

LAURA KINA: Did your mom's and dad's parents accept their marriage? Was there resistance?

LN: No, it's just the state of Texas that wasn't fine with it, you know, a few years earlier! [Texas antimiscegenation laws were not overturned until 1967.] My birth certificate says "father 'yellow'/mother 'white.'" It's amazing. It says I'm half "yellow" . . . I was born in 1975—it's not like it's even that long ago!

LK: Do you address mixed heritage identity, themes, or histories in your artwork?

LN: Not really, not so specifically or directly. Any amount of feeling like the Other or an outsider comes from growing up as a half-Japanese girl in the Midwest. I don't think it's necessarily about a greater historical reference. I think it's just such a personal experience.

LK: In 2006, curators Melissa Chiu, Karin Higa, and Susette S. Min curated your work in *One Way or Another: Asian American Art Now* at the Asia Society in New York. You've talked about pushing back on the show's premise by, instead of making work about being Asian American, shooting videos in which you "discover America" through documenting chance encounters with strangers in public spaces or in their homes—usually older, white men—whom you refer to as your "collaborators." You ask them to follow you or have a fictional relationship. In doing so, you co-opt and turn the tables on the expected gendered and racialized power relationship. I'm curious if being Japanese American plays a role in your work.

LN: I'm Japanese American and I'm proud of this, but I have a problem with shows that are just about one group. Shows need to be about the work, regardless of racial issues . . . it's a complicated relationship.

LK: Do you have ties to any particular communities?

LN: I really feel like a Midwesterner. I grew up in a really small town, and so I had the luxury and freedom to think about the larger world and wonder a lot about what it was like. One thing about being a Midwesterner is that you trust people and you're really open and caring and really inquisitive. But you're also terrified of everything.

LK: What, if any, are your family's associations with war?

LN: My grandpa [Katsumi Nakadate] grew up in Portland. He was the first Japanese American Eagle Scout [1930]. He became an anesthesiologist. He was working in the hospital when [World War II] broke out. Some official men took him into a room and started interrogating him, and it was clear they were trying to suss out whether or not he was a spy. At a certain point during the interrogation, they brought in another guy who had happened to be in his Boy Scout troop growing up. So he said, "Oh my God, that's just Kats Nakadate. Whatever. Leave him alone. He's an Eagle Scout." So he ended up getting treated fine, but it was one of these situations where, had he not been so embedded in Americana and the idea of taking part in groups to be an American, he probably wouldn't have gotten off so easy during that interrogation. He fought for the United States as a medic in the 442nd Regimental Combat Team, but his family was interned in Camp Minidoka in Hunt, Idaho. They stayed a little bit longer than they had to because my dad's aunt, my grandmother's sister, was in the camp still with her children. She developed tuberculosis in the camp and got really,

really sick and almost died, so my grandmother and my father stayed a little longer than they needed to in order to be with her.

LK: You were doing what you have described as "inconsequential videos of myself dressed up in a Girl Scout uniform exploring the world" when you caught the crumbling of the World Trade Center on video. At what point did you start shooting? Did you just happen to be up on your rooftop shooting, or did you run up there once you heard it had happened?

LN: I went up there because there was obviously something happening and I wanted to see what was going on. My first impulse, when anything is happening, is to take out my camera. It was not premeditated. I woke up and that's what was happening in the world. I think any photographer's first impulse was to take pictures that day because nobody knew what was going on.

LK: When you were talking about your grandpa being an Eagle Scout earlier, that gave me another read on how you were dressing up to be a Girl Scout. Was that connection something you were thinking about?

LN: No, definitely not. For me, the concept of Girl Scout is so different from my grandfather being an Eagle Scout. I grew up scouting, and for me, the concept of Girl Scouting was this notion of discovery and playing the role of a girl uncovering stories. Like, what does it mean to wear a uniform and to try to fit into some sort of mold in the world? What does it mean to take that character out into the world and try to discover something? For me, I was using that character as a narrator or a storyteller.

LK: How was *Greater New York* (plate 14) originally received? [*Greater New York* (2005) is a music video mashup of Nakadate's 2002 *We Are All Made of Stars*, incorporating five years of video footage.] Specifically, can you talk about when you showed it the first time in 2002, at Daniel Silverstein Gallery in New York, versus when you showed it in 2005, at PS1 in Queens, in the exhibition *Greater New York*?

LN: The first time that it screened, I think a lot of people were offended by it, saying, "How can you make work out of this thing?" And I thought, "How can we as artists not make work out of what's happening in the world?" How can we as artists pretend that the world doesn't exist? To me, it made perfect sense to show that work. But four years later, people were more willing to take time with it and try to understand my experience of that event . . . the initial blow had worn off. I think that people were more receptive, and it felt more like a melancholy looking back rather than a frontal assault. I feel like those reactions are fair and fine. I'm not going to try to mediate the audiences' internal reaction to that footage, but it is interesting that the footage got very different responses in the beginning and end of that four-year period.

LK: You changed the name from the first time you showed it?

LN: The first time it was called *We Are All Made of Stars*, and it was a six-channel installation of an hour of footage. The second time it was shown as a single-channel, very short, edited piece, at PS1. I called it *Greater New York* then because . . . I felt that the short edit was really a little love story for New York. I saw all the footage as information and stories, and in just the same way you could take a short story out of a collection and read it alone, you could take my video footage and shuffle it and reedit it, and that would be interesting, too. In some ways, I think it allowed the footage to evolve and find its own voice, and that was really interesting to me.

LK: You seem to be interested in "causing trouble" in terms of the documentary form by insisting on putting yourself in front of the camera.

LN: In straight documentary, you are always there anyway. My art is about free fall, toying with danger and desire and its relationship to failure, and beauty being the bedfellow to disaster. Gravity is hilarious, and it always wins; dancing is slightly embarrassing. It's a good place to be.

Transcribed by Marco Cortes, 2010

Resources

Biesenbach, Klaus, Cornelia H. Butler, and Neville Wakefield. *Greater New York 2010*. New York: MoMA PS1, 2005.

Indrisek, Scott. "Laurel Nakadate." *The Believer Magazine*, October 2006. http://www.believermag.com/issues/200610/?read=interview_nakadate.

Nathan, Jesse. "Bravery, Panties, and Devil's Tower: The Rumpus Interview with Laurel Nakadate." *The Rumpus*. Last modified April 8, 2009. http://therumpus.net/2009/04bravery-panties-and-devils-tower-the-rumpus-interview-with-laurel-nakadate.

Korean War:
Korean Transracial Adoptees

Producing Missing Persons: Korean Adoptee Artists Imagining (Im)Possible Lives

ELEANA J. KIM

TRANSNATIONAL ADOPTION from South Korea began in the aftermath of the Korean War (1950–53), when thousands of mixed race children began appearing on the streets of Seoul and around the 38th parallel. A consequence of military intervention and, later, occupation, these children were a visible reminder of South Korea's economic and political subordination to the West, especially the United States. Due to the stigma of impurity, "mixed-blood" children were ushered onto planes, hastily legislated acts and petitions smoothing their way into white and Black American homes. By the end of the 1950s, mixed race children in Korea no longer constituted a crisis; as their numbers declined, international adoptions, which expanded to Scandinavia and Western European nations in the 1960s, were sustained through the transfer of full-Korean children into white families. These adoptions increased exponentially to a peak of more than 8,000 children per year in the mid-1980s. Largely because of negative international attention during the 1988 Summer Olympics in Seoul, the South Korean government instituted a plan to curtail and eventually discontinue adoptions by 1996. Overseas adoptions consequently declined considerably during the 1990s but never ceased entirely. During the 2000s, an annual average of roughly 1,500 children were sent to Western European and North American families.

Along with poverty and class subordination, gender has also been a significant factor in Korean international adoption. Due to culturally embedded preferences for male children, from the 1950s to the 1980s, girls were more often sent for adoption than boys. Rather than being victims of war, these adoptees suffered from patriarchy and structural violence related to South Korean industrialization and a gross lack of welfare services. Some were fourth or fifth daughters born to couples striving for a son; others were from poor families and were sent abroad in lieu of their brothers. For the poorest and most desperate families, however, gender was an irrelevant consideration. Once unwed motherhood overtook poverty and divorce as the main circumstance associated with relinquishment, gender ratios for children adopted overseas

began to normalize. Moreover, the past several decades have witnessed radical changes in adopters' gender preferences as cultural and economic transformations related to South Korean modernization have dislodged some patriarchal conventions. Son preference has largely waned in urban areas, and domestic adopters, who receive priority, now overwhelmingly prefer to adopt female children, believing they are easier to raise. Consequently, the majority of Korean children adopted overseas in the past decade have been boys. These converging processes of reproductive politics, international adoption, and gender preferences have resulted in a demographic curiosity: the next generation of transnational Asian adoptees will be composed primarily of male adoptees from Korea and female adoptees from China.

In total, more than 160,000 Korean children have been adopted into white Western homes since 1953. As the first waves of Korean adoptees came of age, they began to meet one another and develop organizations and networks, creating spaces in which to explore their individual experiences, produce a collective sense of personhood, and share a common sense of "disidentification."[1] For adoptees of the first generation (1950–80), who were predominantly socialized as "white" and "just the same" within the home yet racialized as "Asian" and "other" within broader social contexts, social belonging was inherently problematic, especially as they grew older, leading to a disidentification with categories of (monoracial) family, homogeneous nation, and essentialized ethnicity or race.

The Art of Korean Adoptees

With the advent of the Internet in the late 1990s, these nascent groups quickly consolidated into a transnational Korean adoptee subculture. Over the past decade, annual and biannual conferences, regional associations, and electronically mediated social networks have facilitated the production of a collective identification for adoptees dispersed across the Western world and South Korea, the "birth country," to which adult adoptees began to travel in the 1990s, some for short visits, others for more extended periods. Their social practices and cultural productions constitute significant contributions to public discourses about adoption within South Korea and transnationally in Western receiving countries.[2]

In tandem with the emergence of the adult adoptee subculture, creative work by adoptees began to circulate through electronic media and at alternative sites of Asian diasporic art production and exhibition. Mihee-Nathalie Lemoine, who was adopted and relocated to Belgium in 1968, became a crucial hub in a growing network of Korean adoptee artists around the world.[3] Based in Seoul for more than a decade, Lemoine organized exhibitions of diasporic and adoptee art and helped make the

exhibition of adoptee artwork integral to adoptee social organizing and community building. Throughout the late 1990s, she and other adoptee curators, along with non-adoptee Korean diasporic collaborators, exhibited work by adoptees in the United States and South Korea through shows such as *Spaces for Shadows* (Seoul, 1997) and *Snapshot: A Portrait of Korean Adoptees* (Los Angeles, 1999) and formed artists' collectives and projects such as Han Diaspora, Kim Lee Park Productions, and *O.K.A.Y.: Overseas Korean Artists' Yearbook*. Adoptee artists until that time had largely been isolated from other adoptees. The first shows featured artwork explicitly concerned with the experience of adoption, but as the number of adoptees who pursue advanced degrees and training in art academies and universities has increased, the technical and thematic range of the work has expanded. In the past decade, many artists from Europe and the United States, including Lemoine, Jette Hye Jin Mortensen, Anna Borstam, Trine Mee Sook Gleerup, kate hers, Maya Weimer, and Jane Jin Kaisen, have worked in a variety of media, such as film and video, painting, illustration, performance, textiles, and mixed media, exploring adoptee subjectivity and interrogating the political economy of adoption. They have created vibrant networks of collaboration and exhibition, making their work more visible and accessible to the broader adult adopted Korean community and the global art world.

Situating Adult Adoptee Visual Culture

One striking aspect of the adoptee subculture is its lack of collective cultural forms, symbols, or images. The visual culture of adoptee social spaces and adoptee subcultural identities are often composed of abstract logos or designs, traditional Korean cultural artifacts, or playful appropriations of Korean symbols. Also in abundance are photographs—of adoptive families, birth families, Korean adoptee communities, and trips to Korea, for example—which evidence the preoccupation of many adoptees with family, kinship, and collective identity. The lack of distinctive "cultural" icons or symbols among adoptees can be understood as a function of cultural displacement at a young age and their liminal status of being in between social, national, and familial spaces. This liminality is often depicted in adoption agency manuals through hopeful images of Asian adopted children dressed up in folk attire of their adoptive country or adult adoptees dressed in traditional Korean clothes.

Several scholars have examined autoethnographic and/or autobiographical films, memoirs, and poetry by adult adoptees as windows into the adoptee experience and subjectivity.[4] Less attention, however, has been paid to the proliferating work of adult adoptee visual artists. Given the radically textual, logocentric cultural production of adoptees and the lack of collective symbolic imagery, I am especially interested in

how adult adoptees produce images and meanings that attempt to articulate individual subjectivity and collective histories and personhood.

The work examined here could be called "experimental" or "conceptual." It is primarily filmic and photographic and shares certain characteristics with what Hamid Naficy calls "accented cinema" in that it is profoundly connected to histories of forced migration and contemporary cosmopolitan mobilities.[5] In contrasting this work to dominant narratives of transnational adoptee experience, I frame them as representing and/or performing "missing persons" rather than depicting the autobiographical lost-and-found or search-and-reunion narrative organized around a quest for the ultimate truth of adoption or one's "real" identity. The missing persons in this work are, not long-lost natal kin or the already forfeited authentic self, but, rather, products of the radical contingency effectuated by adoption as a form of displacement and exile. This comparison leads to the construction of a convenient dichotomy between "conventional" adoptee search-and-reunion narratives, as exemplified in films such as Deann Borshay Liem's *First Person Plural* (2000), Nathan Adolfson's *Passing Through: A Personal Diary Documentary* (1999), and Gail Dolgin and Vicente Franco's *Daughter from Danang* (2002), and the more conceptual work of experimental video artists, with the caveat that all these films necessarily produce meanings in excess of what can be contained within any given narrative.

Within the structure demanded of generic narrative conventions of exposition, conflict, and resolution, these documentaries build tension around a central conflict for the adoptee between longing for the birth family and assimilation into the adoptive family, mapped across boundaries of cultural and national difference. The narrative resolution for adoptee directors such as Borshay Liem and Adolfson resides in knowing that their "true" families are the ones that raised them and that, even though reunions open up new questions, the search helps reconcile their internal conflicts and brings them to greater self-understanding.

In addition to examining the alternative aesthetics and epistemologies of conceptual art by adopted Korean artists, it is necessary to contextualize this art within a network of circulation and exhibition that constitutes an emergent adoptee global artscape, which exists in relation to a broader Korean adoptee transnational counterpublic. The work thereby cannot only be viewed as individual acts of self-expression but must also be seen as forms of cultural activism through which political negotiations of individual and collective agency and the moral value of international adoption are played out. More than mere windows onto adoptee subjectivity, therefore, I interpret adoptee artistic production as mediations of individual and collective identity produced with self-consciousness about the politics of representation, potential markets, and dominant images and discourses of adoptees in public culture.

Fig. 10.1. Poster used as a social intervention prop in kate hers's video *Missing* 놓침 (2004–6), a single-channel digital video based on social intervention work (missing persons project), 7 min., 24 sec. Courtesy of the artist.

Synopsis: An American artist returns to Seoul, where she was born and given up for adoption almost thirty years before. The video interlaces various technologies of birth-family search to investigate the adoption process and its underlying Christian ideals. This performative autobiographical piece addresses issues of belonging, transnational identity, language, and the rupture between yearning and reality.

These artworks at once reflect and constitute adoptee identity and contribute to the formation of new public forums of opinion making, social imaginaries, and political solidarities.

Missing Persons and Transnational Adoptee Accents

The title of this essay is inspired by artist kate hers's installation *Noh-Chim (Missing)* from the *Visions from the Periphery: Adoptees and Aliens* exhibition in Seoul in 2007 (fig. 10.1). The title reads "Looking for someone," suggesting ambiguity of address and identity—who is seeking, and who is being sought? Around the time that hers appeared on Korea's most popular family-reunion television program, posters bearing

the scant information from her adoption file alongside pictures of herself as an infant and a young woman were wheat-pasted in downtown Seoul. She produced an experimental video incorporating footage from her television appearance, but rather than screening the program and replicating the essentialized spectacle of adoptee dislocation and commodification of art objects, she created an installation of a pile of one hundred DVDs of the work and invited gallery visitors to take one, thereby effecting the dissemination of the artwork and the dissolution of the installation.

After seeing hers's installation and video, I began to recognize other instances in which adoptee artistic production could be read as attempts to re-present and perform missing persons in ways that foreground the radical contingency of relatedness and indeterminacy of identity. For instance, Danish adoptee Jette Hye Jin Mortensen's *My Grand Grandfather* is a fake documentary on two-channel video: on one screen is an intimate interview with the artist about her great-grandfather, Carl Nielsen, an icon of Danish nationalism and composer of the Danish national anthem. As she speaks about her relationship to him and what she has "inherited" from him, images of her "ancestors" appear on the second screen, provoking the viewer to consider the relationships of similarity and difference between the metonymic symbol of Denmark and the adopted Korean descendant of this iconic national figure.

Artist KimSu Theiler's video installation *Hair Watch* (2008) presents a different window onto adoptee identity that has to do with recovery of lost time and memory (fig. 10.2). The video is silent except for a brief conversation at the beginning, in which Theiler and an interlocutor discuss two photographs: her intake photo at the orphanage and her passport photo, taken shortly before she left for the United States. She tries to figure out how long she spent in the orphanage by comparing the length of her hair in the two photographs, noting that her hair seems to have grown about two inches. The first half of the video shows in rapid succession a series of headshots of the artist, taken daily over the course of 136 days, the time required for her hair to grow two inches. The artist wears different clothes each day, but her expression remains plain and stoic, and each shot is framed identically. What changes is the shape and length of her hair. The second half of the video superimposes those 136 images over the orphanage photo using a transparent filter, with a graduated reversal between the two, and the succession and repetition of video images over the static black-and-white photo produces an animated, flickering effect in the eyes. The affective power of the work resides in the haunted animation of Theiler's eyes, an effect produced between the two images.

The video employs a processual method of daily self-documentation for recovering what, in dominant adoption discourses, might be considered the inconsequential non-time of the orphanage, the non-place from which the child must be rescued, in

Fig. 10.2. KimSu Theiler (American, b. 1970), *Hair Watch*, 2008; video (loop with sound). Courtesy of the artist.

order to be brought into the normative space of the nuclear family, where, it is often presumed, the child's real life begins. *Hair Watch* can be interpreted as an attempt to bring the orphan past and adoptee present into the same spatial plane and temporality and to return an agentive power to the passive gaze of the excluded orphan, the silent and silenced object of Western charity.

These examples suggest forms of expression and representation alternative to the dominant ones that frame adoptee identity as a playful mix of "Western self" and "Asian heritage," most often demonstrated through the juxtaposition of adoptees' ethnically marked bodies and their adoptive countries' cultural markers. Adult adoptees have moved well past these representations, which rely on culturalist pastiche, instead capturing existential and ontological experiences of hybridity beyond the surface effects of race and culture. Moreover, in contrast to the search-and-reunion narrative's injunction for self-completion by solving the puzzle of kinship, adoptee artists produce missing persons through their work by highlighting the contingency of relatedness and the open-endedness of identification and disidentification.

Maya Weimer's project *Seven Families* (2004) takes this radical contingency, rather than lost "roots" or "heritage," as a starting point (figs. 10.3, 10.4). She performs an insertion of self into a discordant racialized context, recalling Nikki S. Lee's *Projects*, by posing with tourist families of different backgrounds on the streets of New York.

Fig. 10.3. Maya Weimer (American), *The Douglas Family*, from the *Seven Families Project*, 2004; C-print, 16 x 20 in. Courtesy of the artist.

My name is Beth Douglas, and I was adopted at age three and raised in a small town in Texas. This is a photo of me with my dad, Nick, taken by my parents' biological daughter, Theresa. My mom, June, passed away from cancer a few years ago. My dad and I recently went to Philadelphia to attend Theresa's graduation from medical school, and afterwards, the three of us decided to make a quick visit to New York City, since I had never been there before. I had an amazing time but would never want to live there. I am much happier living in Miami with my two dogs, running a small café.

Weimer defamiliarizes the family snapshot by performing a (dissonant) "self." There is nothing wrong with this picture—or is there? The mini-biographies that accompany the photos add another layer of "reality," irony, and humor. The make-believe life is part of the adoptee's subject-world, possible lives that are at once fantastical and mundane. She thus (re)inscribes a subject who is randomly born out of historical contingencies and, for the viewer, produces an experience unsettling in its normalcy.

In her experimental short video *Rendez-vous*, Weimer combines still photos with evocative audio montage in order to convey surreptitious and quasi-romantic longings for a figure from her past; this figure is as haunting and elusive in her present reality as it may have been in the author's memory and fantasies. Instead of finding

fig. 10.4 Maya Weimer (American), *The Nilsen Family*, from the *Seven Families Project*, 2004; C-print, 16 x 20 in. Courtesy of the artist.

My name is Greta Nilsen, and I was raised in a Seoul orphanage until age seven, when I was adopted and raised in a small town near Trondheim, Norway. I have been living in New York since 1994, when I came to study painting at Pratt College. I now live in Brooklyn and work as an illustrator, specializing in children's books. I am very close to my mother, Eva, a high school art teacher, who was always very supportive of my creative interests. When I was ten, my mother divorced from my adoptive father. She eventually remarried Lars, a farmer, and had a biological child of her own, my stepbrother, Erik. This photo of my mother, Erik, and Lars was taken during their stopover in New York en route to their vacation in the Caribbean.

completion and certainty, this piece documents the artist's reunion with her birth mother as a dreamlike disorientation composed of fleeting moments of irresolution. Weimer says of *Rendez-vous*: "Out of necessity, my own photos were combined with found photos, an evocation of the way in which so much of the adoptee's biographical history is a composite of truths and fictions, an open-ended narrative that can be endlessly rewritten, as establishing a 'definitive' version is almost always impossible."[6]

(Im)possible Lives

There is now a well-established circuit of adoptee conferences and events that provide arenas for the exhibition of adoptee artwork. Together with the artistic work and network of adopted Korean artists, this artscape offers a compelling case for understanding the role of art in mediating transnational subjectivities and constructing new transnational social imaginaries and forms of cultural activism. The emergence of this network of adoptee artists is connected to the Korean adoptee subculture at large, which is organized around conferences and regional and international adoptee associations. Adoptee artists regularly perform and exhibit together and have been doing so more dramatically with large exhibitions in 2004 and 2007 in Seoul in conjunction with major adoptee conferences. In these exhibitions, which are organized as showcases for adoptee work by Korean and adoptee curators, questions of aesthetic quality and identity politics loom large. Who is included and on what grounds become matters for intense discussion and debate. For the artists themselves, being able to identify as "adoptee artists" who make "adoptee art" provides opportunities for exhibition and community building yet can also impose categorical demands and limitations on their practice as artists with diverse interests and influences. As kate hers states, "I have problems with the idea that all the work does one thing, or that's all that we do."[7]

Comments such as this suggest adoptee artists' heightened awareness of the structures of the art world and market and their marginalized place within it, as adoptee artists and as artists of color who may not fit into conventional diasporic designations. Whether or not this artist network will continue to thrive is an open question. But the collective exhibition of the work undeniably serves as an intervention in the dominant image of the adoptee in Korea and the West—a person whose life is often assumed to be organized around a search for wholeness through a return to biological origins or cultural roots. In contrast, adoptee experimental work, largely nonnarrative or abstract and not always even explicitly about adoption, provides important alternative representations that foreground the ontological state of displacement, contingency, and disidentification with dominant ideologies of kinship, nation, and race.

Although I would like to argue for the counterhegemonic function of adoptee art, understanding the dynamic relationship of the work to activism or collective empowerment among members of the adoptee community requires more research. I can, however, assert without hesitation that the experimental, nonrealist work of adoptee artists productively disrupts an increasingly fixed and essentialized image of the adoptee in Korea and the West. These works return instability and liminality to adoptee identity and to Korean adoption, which, through mass-mediated representations and the

consolidation of the adoptee community, risk reducing adoptees' complex histories to that of a knowable Other with a typical life history.

At this moment in particular, when there is a growing consensus about who the Korean adoptee is—emanating from the adoptee community itself and within Asian American studies—it is important to locate potential interventions in the objectification and reification of adoptee subjectivity and experience. In this, I should note my role as a critic and curator of adoptee cultural production and the ways in which academics often participate in the production of the knowable Other even as they engage in self-critical, reflexive deconstructions of their own discursive and disciplinary projects. Adoptee conceptual artists produce missing persons in contrast to the expected telos of the adoptee search-and-reunion narrative, in which the true self requires completion through the attainment of familial and biographical knowledge. Adoptee art interrogates the production of knowledge itself, opening up alternative epistemologies and temporalities of kinship and identity. These artists produce images of individual and collective experience out of the losses and ambivalences of adoption, but rather than attempting to reconstruct identity, they take missing persons and their impossible lives and open up new possibilities for individual (dis)identifications and collective politics.

Crossfading the Gendered History of Militarism in Korea: An Interview with Jane Jin Kaisen

JANE JIN KAISEN *was born in 1980 in Korea and adopted by her Danish parents, Bodil and Jorn, when she was three months old. She was educated at the Royal Danish Academy of Fine Arts and participated in the Whitney Museum of American Art Independent Study Program in New York as a Fulbright Scholar. She recently finished the MFA program at the Interdisciplinary Studio Area in Art at the University of California, Los Angeles. Through her films, videos, performance, text, and photography, Kaisen creates her own genealogy, connecting her singular story of transracial international adoption with others who share a similar form of "struggle or misrecognition": Korean war orphans and adoptees, former "comfort" women, U.S. war brides, and Filipino migrant laborers in South Korea and their mixed race children. In 2004, Kaisen cocurated the* International Adoptee Gathering Exhibition *in Seoul and cofounded UFOlab (Unidentified Foreign Object Laboratory), a Scandinavian-based artist/activist group working with postcolonial and feminist theory for international adoptees' rights. She is also part of artist collectives that address diaspora and transracial adoptee experiences, such as Orientity.*[1]

Laura Kina interviewed Jane Jin Kaisen about her film The Woman, the Orphan, and the Tiger *on February 1, 2010, in her UCLA MFA studio in Culver City, when she was 70 percent finished with her film and her degree program (she completed both in spring 2010).*

JANE JIN KAISEN: I'm Korean-born, Danish-adopted, residing in the U.S. I went back to Korea for the first time as an adult when I was twenty-one and found my biological family. Being in L.A., Denmark becomes different than it was when I grew up. My adoptive parents in Denmark are working class. My dad mostly worked for a newspaper as a truck driver. My mom has worked with children in day care and kindergarten for many years.

LAURA KINA: How did you become an artist?

JJK: I don't think I knew that when I started doing art and was admitted to the Royal Danish Academy of Fine Arts. But in retrospect, it really fulfills a lot of things that I'm interested in, such as communication and understanding culture, history,

and psychology. There's freedom to question things by using other channels of communication besides spoken or written language.

LK: When you went back to Korea, did you find out what town you were originally from?

JJK: My family was from an island south of the main peninsula of South Korea called Jeju-do, which is now a tourist island but has a really tragic history. During the Korean War, there was the Jeju-do massacre. My mom went to Seoul to give birth to me, but most of the family still lives in Jeju-do.

LK: I've heard it's the Hawai'i of Korea.

JJK: Yes. It has a different atmosphere than the mainland. It has an island culture like Hawai'i.

LK: How do you identify yourself?

JJK: It's been an interesting question for me, particularly while being in California. Questions of race are interpreted differently here than in Europe. I'm living in Koreatown in L.A. Being here made me realize how ingrained my European background is in terms of ideas of race and gender. A Danish Korean adopted friend in Seoul has started to identify herself as "Danish Korean," which I thought was really interesting because that term doesn't exist in Europe, whereas here you could say "Korean American." In Europe, it's been very much the assimilation model. If you possess the language or the culture, then you can be considered a Dane. But only to a certain extent. You still have this racial displacement. In general, Europeans don't want to talk about race, whereas here it's a completely different discourse. With adoption, it becomes complicated. As soon as you say "Korean Danish," there really isn't any kind of heritage. The longer I spend here [in L.A.], I see how Danish I am in many ways, but also how I want to disassociate in some ways from my Danishness because it automatically cancels out the part of me that is non-Danish. It is about coming to terms with a form of racial identity. It's also a process of dis-assimilation in a way.

If you take into account class and gender, too, then you get this really crazy dynamic: a lot of economically better-off Korean students. The funny thing in my case is that whereas Europe is perceived as wealthy, my parents in Denmark are working class.

LK: Your biography disrupts the stereotypes of adoptees?

JJK: Yes, while at the same time, being in a top university situation, I am often read into a whole other migration of primarily upper-class Asian students, whereas in Koreatown in L.A., I sense the legacy of war and gendered migration.

LK: Do you have ties to any particular communities?

JJK: I think what I have is the Korean adoptee community. It's a young commu-

nity, in many ways. It is really only in the past ten years or so that it has formed inter-nationally. Over the past nine years, I've been going to Korea every year either for community-related things or for personal reasons or for art. The Korean adoptee community provides a space where adoptees from various countries with different backgrounds and perceptions of themselves meet. There's a shared heritage of a gap, of a lack of a history, which *The Woman, the Orphan, and the Tiger* (plates 15a–c) also portrays.

As the adoptee community has become more solidified, because more and more Korean adoptees have moved back to Korea and are organizing in different countries, it starts to embrace a broader concern: for instance, the relatedness of Korean War orphans and war brides. It is interesting to observe how the adoptee community has grown from being an isolated community to reaching out to single mothers in Korea and to other diasporas. It is a transgressive community, which contrasts against dias-poras more commonly constructed from cultural, linguistic, or familial ties.

LK: Do you ever address mixed heritage in your artwork?

JJK: In recent years, I've come to recognize more how intimately tied these ques-tions are and how the experiences are very similar. Adoption from Korea started after the Korean War with mixed race children fathered by U.S. GIs and Korean mothers. They were then ostracized by Korean society. Later "Korean-Korean" children were adopted. I have a lot of mixed race friends, especially here in L.A., and I can see a lot of similarities between their experience and my adoptee experience.

This film also deals with the women who work around the U.S. military camp towns in South Korea today, 90 percent of whom are Filipino. Korea's new economy creates gendered migration to Korea, and now those children are fathered by U.S. sol-diers with Filipino women. Are those children going to be adopted? What kind of status are they going to have? History repeats itself.

One of the things I found most interesting about working with this film is the question of stereotyping. The former "comfort" women and women who were employed as sex workers for the U.S. military have issues that are closely related, but there has been dissociation between the two groups because the "comfort" women were enslaved by the Japanese military, whereas many people perceive U.S. military prostitution as voluntary. But the structure and oppression around the U.S. military sex industry is related to the "comfort" women. It is a trauma that resonates within a broader Korean American and Korean adoptee culture and has transformed into racial and gendered stereotypes in the broader culture.

It is my belief that speaking these traumas can reconcile some of these histories. There is a section in the film where one woman talks about her Korean mother and her American father, and not knowing what that relationship entailed, but just having

all this baggage of traumas and stereotypes. She talks about releasing this "ghost" into the world, the trauma of these silenced histories. It is about sharing that pain collectively and thereby possibly being able to repair it. I hope, in Korean culture, where patriarchy is so heavily enforced, that bringing these issues to light can create awareness and transgenerational solidarity.

LK: So rather than people just looking at their own individual trauma, you're throwing these issues up in the air at the same time, seeing where they intersect, and saying, "Let's have a cross-generational dialogue about our similarities"?

JJK: There's a shared legacy that came out of the aftermath of war, and in this way, ties around identity can be formed outside of race and nationality.

LK: What does the phrase "love child" evoke for you?

JJK: Adoption has been conceptualized in the West as a means of "saving children from the third world." During the Korean War, average Americans could show sympathy through adoption. Children became a symbolic way of channeling the broader geopolitical aims of the nation into the personal concerns of the family. I think there has been very much, and still is, a discourse of "humanitarianism" around international adoption. This discourse is very contradictory in the case of Korea because it's not a poor nation, but it has been very important to maintain this narrative in the West.

LK: What was the inspiration for making *The Woman, the Orphan, and the Tiger*?

JJK: I wanted to focus on the effects of war and sexual violence on women and children and how this history is perceived in the present. It is really important to understand the present moment and to document endeavors of women from my generation—all the women protagonists in the film are between twenty-six and thirty-eight—who have returned to Korea and are starting to form a collective and question official narratives around adoption and the Korean War.

LK: You're in the heart of the adoptee wave. This population is coming of age at the same time and asking similar questions, and making art. So many artists!

JJK: Yes. I experienced a lot that the people who are really active are artists or writers—and a lot of them are women. Why is it that women ask these questions? Maybe it's because they are confronted with history in a different way.

What's so amazing about working on this project is that all the people I worked with are also friends, colleagues, and women I respect, and I admire their work in art, writing, and activism. Some of them are adoptees; others belong to the broader Korean diaspora. They include Grace Cho, the Korean American author of *Haunting the Korean Diaspora*, about the specter of gendered migration and the war brides; Korean-adoptee writer Jane Jeong Trenka; Korean-adoptee scholar-poet Jennifer Kwon Dobbs; Danish Korean adoptee poet Maja Lee Langvad; Tammy Chu, a Korean-

adoptee filmmaker; and Soni Kum, who was raised in Japan as North Korean. Additionally, My Sister's Place, an NGO [nongovernmental organization] that has existed for a very long time around one of the older U.S. military bases in Korea, has been assisting women around the camp towns with legal and social matters. Through My Sister's Place, we contacted women who have worked as sex workers and club owners around U.S. military bases in Korea. Two of the women we interviewed are Korean women in their fifties who have been working in the camp towns since the '70s. In addition, two younger Filipino women's voices resonate within the film.

I've been collaborating with my partner, Guston Sondin-Kung, on the film. It was a long process of figuring out *how* to tell these stories and properly represent each issue. It was important for us not to show sex work [military prostitution] in an explicit or exploitative way. The former "comfort" women are often portrayed in painful testimony situations, but we chose to use only archived footage from the war crimes tribunal and speeches held during demonstrations, to show their strength and determination for recognition.

LK: Can you talk about the structure of the film?

JJK: In the very beginning, you hear a chorus of multiple voices. The chorus is composed of the totality of voices that later on carry the narration. At first, you can distinguish the different voices, but they become layered until their speech becomes incomprehensible, signifying an urgency of really wanting to speak about something that is unclear. It is as if the voices struggle to tell stories that are untellable. As the film proceeds, the voices talk about being haunted by things from the past, things that are retained within the body. Then the film abruptly cuts to images from present-day Incheon International Airport in South Korea, representing "the return" of the diaspora.

LK: In the clip you showed me, it looked like we were seeing a pan of an airport as seen while on a moving escalator. It was abstract, but you get a sense of being in a transitional space, and then you hear narration, right?

JJK: Yes. You experience the airport simultaneously as an alienating transnational space and as a very intimate space. Then the film cuts to an unraveling of a genealogy between the former "comfort" women, military-camp-town women, and international adoptees. I've been thinking about biopolitics and how women's bodies have been produced in relation to military and patriarchy. That's really what the three generations share in common, a biopolitical and geopolitical mobilization of their bodies enabled by both colonial and occupying forces, as well as by the ROK [Republic of Korea] government.

The film is not only about U.S.-Korean relations; it also portrays Japan's colonial influence on Asia. A sequence is shot around former comfort stations in Shanghai

where "comfort" women were enslaved. In addition to physical and mental subjuga-tion, the three generations also share transnational migration. The film cuts from the former "comfort" women and talks about the yanggong-ju, a derogatory term literally meaning "Western princess," used both for women who married GIs and for women who just fell in love with Westerners. In talking about the yanggong-ju, the film also portrays the second wave of migration of Koreans to the U.S. after the Korean War.[2] It's a heavy history, in the sense that it's a part of almost every Korean American family history, but it is at the same time silenced because it's very ambivalent and traumatic. The narrative functions as memory, not chronologically, but very organi-cally, in which past and present, main narrative and side stories, are intertwined.

The end of the film deals with the present effects of constant U.S. military presence in Korea since the end of World War II. It shows how residues of the war resonate within various contemporary spaces, for instance, at the Korean War Memorial, in the upper-class neighborhood of Apgujeong, and in the camp towns.

In the film, several protagonists talk about "body as a text" and how the body is marked by the way it was produced. When members of the diaspora return, a con-frontation happens. Although they may not remember histories of biopolitical vio-lence because these have been silenced and repressed, the body carries a memory and serves as a reminder. For instance, with the adoptee generation, although there might not be a memory, the body carries a kind of memory in itself. As one protagonist in the film describes it, return is about insisting that certain histories did happen, about insisting that her biracial body, which embodies the legacy of the Korean War, has a right to be in that space.

Transcribed by Marco Cortes, 2010

Resources

"Incheon Women Artists' Biennale Main Exhibition." In *Incheon Art Platform.* Incheon Metropolitan City: Incheon Women Artists' Biennale Organizing Com-mittee, 2009.

Rethinking Nordic Colonialism—A Postcolonial Exhibition Project in Five Acts. Hel-sinki, Finland: The Nordic Institute for Contemporary Art (NIFCA), 2006.

Stoker, Kim. *Adoptee & Alien—Visions from the Periphery.* Seoul: Kyung Hee Univer-sity, 2007.

Vietnam War:
Vietnamese Amerasians

Lost in Their "Fathers' Land":
War, Migration, and Vietnamese Amerasians

CATHY J. SCHLUND-VIALS

In Vietnam, when they shouted behind my back or when they taunted me—half-breed, half-breed—I began to think that maybe I am not Vietnamese. Maybe I am more American . . . I thought that some parts of me must be American, though I don't know what that means. —Nguyen The My, "Vietnamese Find No Home Here in Their Fathers' Land"

MY ADOPTIVE PARENTS spent the first thirteen years of their marriage in search of a child. By February 1975, they found two. Five months earlier, on September 2, 1974, my brother and I were born in the Thai province of Udon Thani, just outside Udorn Royal Air Force Base, the headquarters for Air America, a CIA-owned passenger and cargo airline. Heavily active during the Vietnam War (1959–75), Air America's pilots transported civilians, politicians, doctors, war casualties, refugees, and sabotage teams to fronts in Vietnam, Laos, Cambodia, and Burma.

Both air force base and airline figure keenly in Vietnam War history. Air America and Udorn Royal Thai Air Force Base were partners in covert Cold War operations, which involved (among other campaigns) the "dirty war" in Laos (1953–75).[1] Air America supplied the food and weapons that fed and armed Major General Vang Pao's anti-Communist Royal Lao Army. The base was also a CIA training ground for Cambodian and Laotian pilots. Hence, the air force base was a central front in the war, a fact largely buried since its closure in June 3, 1974.

In the shadow of clandestine campaigns, Air America's most "hopeful" legacy is evident in its "rescue" initiatives. Such missions are evident in the Operation Frequent Wind campaign, which evacuated 50,493 South Vietnamese and American civilians (including 2,678 Vietnamese and Vietnamese Amerasian orphans).[2] These evacuations took place during the war's final days, and many involved Air America's black helicopter fleet. Illustratively, in an iconic photo taken by Dutch journalist Hubert Van Es, an Air America helicopter sits precariously atop the CIA-occupied

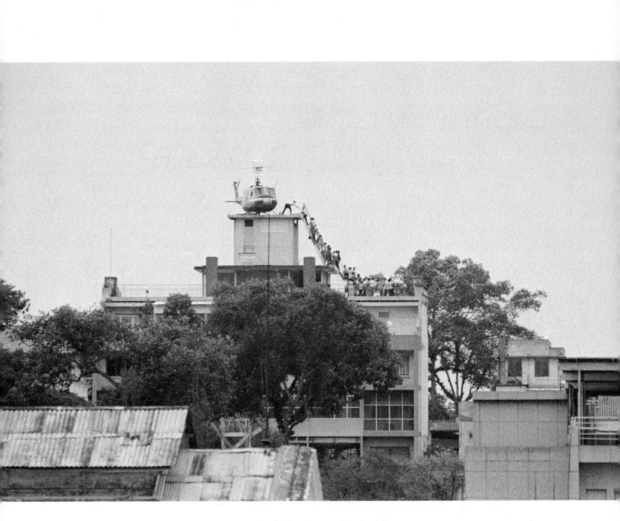

Fig. 12.1. A CIA employee (probably O. B. Harnage) helps Vietnamese evacuees onto an Air America helicopter from the top of 22 Gia Long Street, a half mile from the U.S. Embassy, April 29, 1975, Saigon, South Vietnam. Photographer: Hugh Van Es. Bettmann Premium/ CORBIS, U1835718.

Pittman apartment complex (fig. 12.1).[3] To the right of the image is a set of stairs, overwhelmed by a line of people desperately trying to board.

The chaos contained in Van Es's photograph proves an apt metaphor for the unresolved nature of the Vietnam War and foreshadows the humanitarian crisis that was to follow. Despite the "success" of military rescues such as Operation Frequent Wind and the optimistically named Operation New Life (which transported 111,789 Southeast Asian refugees to Guam), a sizable number were left behind.[4] In the war's aftermath, nearly three million Vietnamese, Cambodians, and Laotians sought asylum in Europe, neighboring Thailand, Australia, and the United States. In response to an

impending abandonment disaster, the U.S. Congress passed the Indochina Migration and Refugee Assistance Act on May 23, 1975, facilitating the legal entrance of evacuees. In 1980, Congress passed another refugee act, paving the way for the largest influx of individuals from the region to the United States. Such acts (de facto domestic apologies for U.S. foreign policy) further a reading of the war vis-à-vis folly and failure.[5]

Nevertheless, one group, Vietnamese Amerasians, was not able to immediately gain access to the United States. This population—which Kien Nguyen, author of *The Unwanted*, estimates at 50,000—are principal actors in the most striking legacy of Vietnam War "left-behindness."[6] According to journalist David Lamb,

> As adults, some Amerasians would say that they felt cursed from the start. When, in early April 1975, Saigon was falling to Communist troops from the north and rumors spread that southerners associated with the United States might be massacred, President Gerald Ford announced plans to evacuate 2,000 orphans, many of them Amerasians. Operation Babylift's first official flight crashed in the rice paddies outside Saigon, killing 144 people, most of them children. South Vietnamese soldiers and civilians gathered at the site, some to help, others to loot the dead. Despite the crash, the evacuation program continued another three weeks.[7]

Despite the tragedy, Operation Babylift would still be responsible for the successful evacuation of 3,300 children, including the Vietnamese Amerasian protagonist of the 2002 award-winning documentary *Daughter from Danang*.[8]

As a cinematic narrative, *Daughter from Danang* tells the tale of a Vietnamese Amerasian circumscribed by war and haunted by parentage. The titular character, Heidi (originally named Mai Thi Hiep), returns to Vietnam and is reunited with her mother. The product of a relationship between her Vietnamese mother and an American serviceman, Heidi was adopted by a white family in Tennessee and raised in the United States. In a tense moment, Heidi's mother reveals, "When I gave birth to her, she had no father, so I gave her my last name. And I gave her the name Hiep because it means 'united,' united with her mother."[9] In so doing, Heidi's mother underscores the complicated matrix of Vietnamese American identity, which brings together war and absent fatherhood.

It is this reproductive connection to the Vietnam War (as love child–turned–war baby) that fixes my personal history as a mixed race product to the Cold War. Like the character in *Daughter from Danang*, I was adopted (with my brother) and relocated to the United States. For me, adoptive parents took the form of a Scots-Irish American serviceman and his Japanese wife. My biological mother was Cambodian, and my "original" father was a presumably white American GI. I take after him, a fact ver-

ified by phenotype and my adoptive mother's stories. I grew up knowing he returned to his wife and children in Massachusetts after our due date.

These paternal "truths" are confirmed in Thai adoption court papers. Indeed, my biological mother maintained: "the natural father of the child had left Thailand a month after the child was born. I wrote him if he wanted the child. His answer was that he never had any children in Thailand . . . I am unable to care for and support the child because of poverty and besides, I have other five children to care for and support."[10]

My fathers (biological and adoptive) were 2 out of the 2.15 million American servicemen deployed during the Vietnam War. Of that number, 1.6 million were in active combat. A total of 58, 260 Americans were killed in action, and another 1,724 Americans were reported missing in action.[11] The numbers of Southeast Asian casualties are far less precise, though the Vietnamese government reported in 1995 that 1.1 million died during the Vietnam War and almost 3 million perished in Laos and Cambodia.[12]

Such a paternal disavowal underscores a forgetting that is personal *and* political. From illicit bombings of the Cambodian countryside to the underground war in Laos, from untold stories of U.S. human rights abuses and unacknowledged war crimes, my biological father's refutation of paternity eerily echoes denials levied by U.S. heads of state during and after the Vietnam War. It is within this amnesic, paternalistic milieu that my familial history partially converges with the life stories of an estimated thirty thousand Vietnamese Amerasians (like Mai Thi Hiep in *Daughter from Danang*) who have eventually made their way to the United States in search of home. In many instances, such quests occur alongside a largely unfulfilled pursuit of fathers who abandoned them before or soon after their births.

The abandonment of Vietnamese Amerasian children is discursively mirrored in characterizations of the Vietnam War. Redolent of "surrendering" and "withdrawal," the very act of *abandoning* intersects with the decision to pull troops out of Vietnam and other parts of Southeast Asia. For present-day hawks and doves, the Vietnam War as U.S. imperial event generates a host of interpretations that hinge on "support." For American neoconservatives, it was an alleged lack of support afforded troops (militarily and domestically) that is to blame for a U.S. loss. In the case of liberals, the question is one of policy support, which asks whether U.S. troops should have been sent in the first place.

Predictably, American debates about the war rarely encompass a non-U.S.-centric perspective, inclusive of Vietnamese Amerasians who occupy a neither/nor space. Because of politics in Vietnam (the country of origin) and the United States (a possible

site of asylum), Vietnamese Amerasians embody a transnational, racialized script marked by a double-sided abandonment. In 1980, the Vietnamese director of social welfare in Ho Chi Minh City (previously Saigon) asserted in response to Vietnamese Amerasians, "Our society does not need these bad elements."[13] Ten years earlier, faced with the growing number of children fathered by U.S. servicemen, the U.S. Defense Department averred, "The care and welfare of these unfortunate children . . . has never been and is not now considered an area of government responsibility."[14]

If, as journalist and author Christopher Hedges asserts, war is "a force that gives us meaning," for Vietnamese Amerasians it is a transnational reality that "brought them into being."[15] As Caroline Kieu Linh Valverde maintains, Amerasians in Vietnam were labeled bui doi (dust of life). Victims of racial discrimination fueled by their affiliations with the American antagonist, Vietnamese Amerasians had "very little opportunity for economic mobility."[16] This assertion of racialized limitation is confirmed in the May 19, 1988, *New York Times* article "Children of 2 Lands in Search of Home." According to reporter Lisa Belkin, Vietnamese Amerasians were "branded" by their "black and Caucasian skin . . . as the enemy. There are accounts of Amerasian children being abandoned on the streets of Saigon, forming gangs to help care for each other and turning to prostitution and theft."[17]

The abject conditions of Amerasian life in Vietnam were most dramatically represented in an October 1985 photograph taken by *Newsday* photojournalist Audrey Tiernan (plate 16). On assignment in Ho Chi Minh City, Tiernan saw Le Van Minh, a fourteen-year-old Amerasian boy. Abandoned by his mother at age ten, the victim of untreated polio, Minh worked on the streets of Ho Chi Minh City and lived in an alleyway. In Tiernan's photo, Minh, with back hunched "like a crab," holds a flower "fashioned from the aluminum wrapper in a pack of cigarettes."[18] The image was reprinted in multiple outlets, catching the interest of four students from Huntington High School in Long Island, New York, who, the following year, in 1986, collected twenty-seven thousand signatures on a petition to sponsor Minh's medical treatment in the United States.[19] Seeking a political endorsement, the students turned to Robert Mrazek, a Democratic representative for the Third District of New York (Long Island). Moved by Minh's story, Representative Mrazek traveled in 1987 to Ho Chi Minh City, where he encountered many more Amerasians who repeatedly stated that they "want[ed] to go to the land of [their] father[s]."[20]

Soon after, Mrazek wrote and sponsored a three-page immigration bill that foregrounded the Amerasian Homecoming Act. In so doing, the New York representative made possible the mass migration of Vietnamese Amerasians, who had previously been excluded from U.S. immigration legislation. According to Sucheng Chan:

Even though Congress passed an Amerasian Immigration Act in 1982 to enable children known to have been fathered by Americans to immigrate, that law benefited only individuals from Korea, Thailand, the Philippines, and elsewhere, but not those in Vietnam, because there [were no] diplomatic relations between Vietnam and the United States. . . . The 1987 Homecoming Act . . . allows American-Vietnamese born between 1 January 1962 and 1 January 1976 and certain members of their families to be admitted into the United States as immigrants, so long as they apply for their visas before March 1990.[21]

Though written in 1987 and passed in 1988, the Homecoming Act was not implemented until 1989. Since then, almost twenty-three thousand Vietnamese Amerasians and sixty-seven thousand of their Vietnamese family members have come to the United States.[22]

Even with such "homecomings," Vietnamese Amerasians continue to occupy a liminal citizenship position in the States. To date, Vietnamese Amerasians are not automatically granted U.S. citizenship, despite U.S. parentage. Since 2003, Democratic representatives Jim Moran (Virginia) and Zoe Lofgren (California) have introduced two Amerasian Naturalization bills intended to amend (via citizenship) the Homecoming Act.[23] In 2007, H.R. 4007 (the Amerasian Paternity Recognition Act) was brought to congressional committee. According to Moran, "This legislation makes it explicitly clear that these Amerasians are not simply 'permanent residents,' but are citizens of the United States and are entitled to all of the rights and privileges and responsibilities that come with it. . . . This country has a moral duty to grant them citizenship and welcome them with open arms."[24] Even with Moran's impassioned "moral duty" plea, the bill has not yet been brought to the House floor.

The unresolved question of Vietnamese Amerasian citizenship thirty-five years after the Vietnam War highlights a particular failure in U.S. politics. Situated within contested contours of race, nation, foreign policy, and immigration law, Vietnamese Amerasians have been cast as human war remnants and Cold War casualties. As Maria P. P. Root provocatively maintains, "Reflecting the interplay between societal structure, politics, and economic agendas, the emergence of the Amerasian in the U.S. conscience has been tied to either war or labor needs, thus making it easier to objectify these products of interracial unions."[25] With little to no familial and communal support, Vietnamese Amerasians continue to be "lost"—politically, socially, and economically—in "their fathers' land."

In Love in a Faraway Place:
An Interview with Serene Ford

SERENE FORD *describes in her artist's statement how her relationship with photography began. As a child, she writes, "I looked at my parents' wedding album. To the child I was, the pictures were moments I could never touch, encased were people I would never know. In the photos, they were not my parents, rather two people in love in a faraway place. I had a sense of yearning attached to those photographs. Photographs were always something I could catapult myself into." She was born in 1975 in Sacramento, California, to a Vietnamese mother and a white U.S. GI father and raised in the Pacific Northwest. She graduated from the Department of Photography and Imaging at the Tisch School of the Arts at New York University in 1998. Ford currently lives in Los Angeles.*

Serene Ford met with Laura Kina in Culver City, California, on February 1, 2010, to talk about Ford's series I'm The Girl Who Survived the War: Photographs from Viet Nam *(1998–2003) (plates 2–4).*

SERENE FORD: My parents got married in 1971 in Viet Nam (fig. 13.1) and then came to California. They met in Viet Nam; it's a sweet little story. My dad was a soldier, and my mom, I think she worked in a candy shop or something, and he would go visit her and bring her flowers. After eight months of wooing her, they went to coffee, and they fell in love after that. He knew he was going to marry her the first time he saw her. It was cute.

They moved to California, which is where my dad's from. Then they went to college at UC Davis. I've got an older sister, me, and then my younger brother. I was preschool age when we moved to Washington. That's where I grew up. I went to high school outside of Seattle, and then I moved to New York shortly after graduating. I started out at Evergreen [College, in Olympia, Washington], doing science and chemistry and that kind of thing. Then I moved to New York for a year to work for a photographer. I learned how to print and then went to art school at NYU [New York University].

I always felt a strong connection to my parents' story, and I was obsessed with their photographs when I was a kid.

Fig. 13.1. Serene Ford's parents, First Lieutenant David Elwood Ford and Hoang-Phi thi Nguyen, wedding portrait, 1971, Hoi An, Vietnam.

LAURA KINA: Did people ask you about their story a lot? Was that how the obsession started?

SF: Well, I loved looking at their pictures because they were so young and so innocent. I always get weepy. They were just so sweet. It always just touched me. As a kid, you don't understand things, but I knew that they took a big risk to be together.

LK: And I'm sure the language barrier and everything, too . . .

SF: Well, no, my mom spoke English and French. She was well educated.

LK: What's her family like in Viet Nam?

SF: I think she had a big family. It's funny, both of my parents' families are a little mysterious. I think there were nine kids in my mom's family. A few of them died in

the war. She was arranged to be married twice, and the guys died. But she always knew that she wasn't going to marry a Vietnamese man.

LK: Was her family accepting?

SF: I don't think they liked it, but she was very headstrong. She made her decision and I think her family decided to go along with it. By the time they were in love, it was too late.

LK: Your dad's side of the family, did they accept it?

SF: Not so much. I think it was hard for them. The older I got, the more I realized how gutsy it was to do that, not just racially but politically. They got married in Viet Nam, so my dad's family couldn't do anything about it. It was a done deal.

LK: How do you identify yourself?

SF: I never really like answering the question when somebody asks me, "Well, what are you?" because I feel like I'm neither but both. If I have to be nailed down to something, I up and say "I'm Vietnamese and American." But I like the ambiguity.

LK: Is the term "Amerasian" loaded in a way that you don't like?

SF: Yeah, I would never use that word for me, but that's just me. I find it very limiting . . . I understand why one would use it and how it fits me—although I would never adopt it for myself. It's a stamp that says nothing of one's personhood, and when I think of it applied to me, it feels very cold. I have an Asian mother and an American father, end of story with the term. To me that is just the beginning. My world is painted by the heart, and the term "Amerasian" does not speak to that aspect of human identity. Worlds collided for my parents to meet, and I only know this from my own story. When I hear someone say they are "Amerasian," I want to know why and how . . . I want to understand the elements that came together to create that person.[1]

LK: Do you have identity ties to any particular community?

SF: No. There are times when I do . . . sounds weird, but sometimes I feel Asian or feel an affinity toward that. It's weird because I feel Asians don't really think I'm Asian.

LK: What about an artists' community?

SF: That counts, it's true. But I don't always like to get too involved with the politics behind racial identity, if that makes sense. The work in Viet Nam was definitely me trying to understand the history of who I am.

LK: What are your family's associations with war?

SF: It's a good question because there's so much to it with my family. It was always part of my family, but we never talked about it. Sometimes I forget about my dad's connection to the war because I think—Viet Nam equals my mom, but my dad was a soldier. I know that had there not been a war, they would not have met, so it's a tricky

one. And my mom never spoke Vietnamese in the house because my dad spoke English. So every once in a while, we would get a phone call from one of our relatives and it would be funny to hear her speak her language. People always ask, "Why don't your kids speak it?" but I don't think she wanted us to know it. I think it was painful because she was leaving it behind, but again, that's my interpretation.

I remember when I first did the exhibition at NYU [*I'm the Girl Who Survived the War: Photographs from Viet Nam* (1998)] after I received the Rosenberg Fellowship, I had asked my mom to write for the show, and she had this sentence that always stuck with me. It's something like, "War created us, its own exclusive race." And I always thought, "How interesting," because war is part of my awareness. She writes poetry, she writes stories, and she's working on her own novel. My dad is a CEO. He's the sweetest man. He writes poetry for his executives, and he meditates. He's an incredible man.

LK: What made you go into photography?

SF: I took it in high school; I had a great photography teacher. I spent a couple of summers in Europe and I was a TA for a really well-known photographer, Bruce Davidson. I remember being nineteen and in Paris and being like, "Oh my god, I have to do this." And so I asked him, "Do you need help in New York?" and he was working on a book and he said, "You'd be perfect."

LK: So that's how you landed in New York?

SF: Yeah. I think he really just wanted someone to wash prints, but it was so cute. I flew home and asked my parents if I could move to New York, and they were totally supportive.

LK: Do you feel your work references anything to do with war, directly or indirectly?

SF: It's hard for me to separate me from war or the work from war.

LK: What does the phrase "love child" evoke for you in relation to your personal history?

SF: Well, I think it's a very sweet term. I never think of the illicit part of it, even though I know that that's part of the context. I would like to think I'm a love child, but I guess maybe my sister counts more than me [*laughter*].

LK: Do most people read you as white?

SF: A lot of people think I'm Latina . . . when I was in Viet Nam, people would say to me, "Same same, but different," and I knew what they were saying, which I thought was very sweet.

LK: They would say it in Vietnamese, right?

SF: No, they would say, "Same same, but different" in English.

LK: So they knew you were—

SF: They could tell.

LK: What was your intent with the series *I'm the Girl Who Survived the War*? What did you want to accomplish, what does it mean, or is there anything about the process of the work that you want to tell me about?

SF: I remember applying for the travel grant from the photography department [at NYU]. I remember thinking, "I want to go to Mexico," and then I thought, "Why would anybody give me money to go to Mexico?" I went a little deeper, and I thought, "Where could I go that would be meaningful?" In my heart I knew I had to go to Viet Nam. I also felt old enough and close to my mom, so I asked her to go with me. She had never been back. So it was my first time and her going back after, I think, twenty-seven years. It was funny, before I applied, I called her up and I was, like, "Hey, mom, if I apply for this, will you come with me?" She was so cute, she said, "Yes!" I could tell she was going as my mom to protect me, but I also felt that she needed to go for herself, too.

My plan was that we were going to start in the south and go north. My mom is from central Viet Nam. I didn't know a lot about the history. I mean, I knew there was a war there, but I never read up on it because I felt, like, I come from it and I don't want to know all the gory details. I got there and I had these expectations that I would understand it, or if I could see what happened that something within me would make sense. I just wanted to understand the history and see where my parents met and where my mom grew up. I knew that she left a lot behind that she never really talked about, and every once in a while, she'd cry if someone spoke of Viet Nam.

I just remember looking around, and for days I was wondering, "Where is it?" Because, unless you know there was a war there, there's no trace, there's no remnants of it. I kept thinking, "Okay, so what do I do here?" I'm supposed to be figuring something out, and it didn't make sense to me until I got back to the U.S. My mom had a sister in Viet Nam, and I thought, "Okay, when we meet the sister, we're going to see it." So we went to the town where she knew her sister lived. And, mind you, we hadn't called her or anything; my mom didn't have a phone number. We got to the town of Nha Trang, which is a beach town, and I'd ask, "Okay, mom, how are we going to find her?" And she wasn't ready, and I could tell that she needed a day just to prepare. We were sitting on the beach, and there was this man who was walking along the beach photographing. This man was a professional photographer, and my mom asked him, "Do you know so-and-so?" And he goes, "Oh yeah, she delivered my baby." Somehow he knew how to find her. I think she just knew it was going to work that way, or maybe she was okay not finding her sister. We got back to the hotel and the gentleman dials the number and gets her on the phone. I remember seeing my mom cry.

The next day, we get out of the car, and I see her sister, and there's no hug. My

cousins come out, and I felt a little bit of this intensity, but very nonemotional. I could see what was going on in my mom just because I knew her, but there was nothing outward. I was like, "Okay, what is going on with this disconnect? Is it me? Am I just looking for a postcard or something?" And then I thought, "Wait a second. I didn't literally survive this war—I don't know what it's like." The whole trip I was waiting and just trying to piece it all together. I felt sad for my mom because I knew how painful it was for her. It was very disorienting. They survived a lot. They had their house taken away and all sorts of things, but there was no sign of emotion. And then I asked, "Mom, how come you guys haven't hugged?" And she just cried; she didn't have a real answer for it.

So we didn't stay that long. We stayed about a week. There wasn't that family connection, even though I was really glad to be there and I'm glad we saw each other. But I had this mental idea of family, and they weren't unkind to me or anything, they were sweet people. The longer I was there, I just kept photographing, but it was weird because I felt very lost.

LK: You know, I saw the whole series, and I noticed you're photographing chickens or certain things that might look like tourist photos. Was that part of it, like just sort of looking for something in the landscape that would tell you about anything?

SF: Yeah, I was looking for remnants. There is the chicken photograph, the dead chickens, and I just remember seeing one with the head showing and an eye open, and I felt like that was me. Like I was kind of dead but I had an eye open. I feel differently about it now. That ghost picture, *Ghost of a Girl* (plate 2)—

LK: Where did you shoot that?

SF: We were staying in someone's house—I forgot who it was. It was someone who picked us up at the airport, maybe a cousin of a cousin. We had stayed there, and I was in the living room. I just had my tripod set up, because I felt like I had to photograph. Most of the time I didn't know what to photograph, because I felt so out of place. I remember being in the living room with my tripod, and I took a few pictures. And then a girl came through the doorway and it was dark, so it was a slow shutter speed. It just kind of was ghostly. And I didn't see any of this stuff until I got back because it was film; it wasn't digital.

LK: You don't know until you're home what you have.

SF: Right, and I think that's why I kept feeling so lost. . . . But I'm really glad that I was in that space where I couldn't see what I was doing, because it took me a little distance to see that the pictures really did reflect where I was during that time.

LK: The colors are so intense. And the photo of your mother, *Mom* (plate 3), looks like she's sitting in a restaurant, and she's looking off to the left and there's some writing in the background?

SF: Yeah, that was a restaurant, and right across the street was her old house. This was in the little town she grew up in called Hoi An [a coastal town in southern central Viet Nam]. That's where we stayed the longest. For some reason, we both felt at ease there. So we were sitting at this restaurant and we were talking to the gentleman who owned the restaurant, and he recognized my mom through the resemblance to her dad. He told her, "That's where your sister used to live." And so that was the picture. The wall behind her was green and the writing on the back is the local specialty, the noodle dish that they like to eat there.

LK: What were you talking about at the restaurant, because she just looks really— you captured a moment of her looking back?

SF: You know, it was really incredible, because she let herself be vulnerable to me and she was really giving with me in that she knew that I was there to work and explore myself, too. More than she could say, she was going through so much.

LK: And the piece that you took of her sleeping, *Mom Sleeping* (plate 4), is under a mosquito net, right? . . . There are just beautiful pinks there. They're gorgeous photos, and they do seem about dreaminess and memory.

SF: And that's why when I came back, I saw that the pictures reflected memories that I didn't actually have. I was feeling these weird tactile but hard-to-depict emotions—like a really fluid space—and I'm so glad that the work actually shows that. Before I went to Viet Nam, I was mostly in love with black and white, but I thought, "I'll bring color just in case." So I ended up really liking the color work.

LK: They felt like the most emotionally loaded to me. And the colors—how they weave together and tell a story.

SF: I remember that picture of her sleeping. We were in this little hotel, and she was sick. I think it was right after we had left her sister's house. So I was out and about shooting; I really had to force myself to go out. And I came back to the room, and she was sleeping under a net. I just thought she was so tender and I loved her so much for being there with me but didn't want to invade her space.

Resources

Ford, Serene. Artist's statement for the New York University Asian/Pacific American Studies Gallery exhibition *War Retold: Photographs from Viet Nam*, 2003.

————. "Vietnamese Americans: Diaspora & Dimensions." *Amerasia Journal, UCLA Asian American Studies Center* 29, no. 1 (2003): 182.

HAWAI'I:
MIXED RACE AND THE
"DISCOURSE OF ALOHA"

Fig. 14.1. *Paradise of the Pacific* cover, December 1948, featuring the six Miss Ka Palapala beauty queens of the University of Hawai'i (Honolulu: Hawaiian Islands Press Pub. Co., 1888–1966). Used with permission from *Honolulu* magazine. Cover scan provided by Hawaiian Collection, Hamilton Library, University of Hawai'i at Manoa.

Six Queens: Miss Ka Palapala and Interracial Beauty in Territorial Hawai'i

LORI PIERCE

IN DECEMBER 1948, six Ka Palapala beauty queens of the University of Hawai'i graced the cover of Hawaii's monthly magazine, *Paradise of the Pacific* (fig. 14.1). The girls were arranged to suggest a lei, and the image was reproduced in color, deepening the association between the women and the flowers adorning them. The Miss Ka Palapala beauty pageant had been a tradition at the University of Hawai'i since 1937. It was sponsored annually by the university's year book, *Ka Palapala*, and was so popular in the local community that prominent businessmen, politicians, and visiting celebrities frequently acted as judges. The contest had been suspended during the war but was revived in 1946 by demand of the student body, especially returning veterans.

The Miss Ka Palapala contest was distinctive in that several young women were awarded the title. Each queen represented one of the major racial groups among the student body at the University of Hawai'i. The racial categories used in the Miss Ka Palapala contest were fluid and diverse, reflecting the multiethnic character of Hawai'i's local culture. (The students were responsible for deciding the categories in which to compete. Once, twin sisters competed in two separate categories.) Generally, there were representatives from the Chinese, Japanese, Korean, and, by 1948, Filipino communities. There was sometimes a Miss Hawaiian but never a Miss Portuguese in spite of the prominence of both ethnic groups. However, there was always a "cosmopolitan," or mixed race, queen, a "hapa" girl. Miss Cosmopolitan was not just any mixed race woman, but a woman who was part Hawaiian. Her heritage could reflect any number of *other* ethnic groups as well (e.g., Hawaiian, Chinese, and Portuguese), but she was most likely to have been hapa haole, part Hawaiian and part white.

In the two-page spread in *Paradise of the Pacific*, five of the queens were shown in small four-by-six photographs framing the left-hand page, but the editor featured Miss Cosmopolitan in a large, full-page shot. Although all of the queens shared the title, the photo layout suggested that Miss Cosmopolitan was *the* Ka Palapala Queen, that she was the overall winner, judged to be the most beautiful of the six. The editor wrote the following explanatory note:

Dear Reader: If it were at all possible we would have depicted an ethnic rainbow on our cover design. This would have been a much more appropriate symbol for the University of Hawaii [sic]. . . . This is not meant to say that we conceive of this university as a melting pot in the typical travel brochure sense of the term. . . . We are not quite that naïve. . . . We acknowledge the fact that "racial" fraternities exist in practice. We are aware that the registrar's office still requires students to list down their "racial ancestries." Ka Palapala still sponsors yearly "racial" beauty contests. . . . It may be that what the sociologists term the process of assimilation is as yet incomplete. Or, it may be that we cling to traditions, customs, conventions simply because they are traditional, customary and conventional. We wanted an ethnic rainbow to illustrate the point that in spite of all these traditional artifices emphasizing ethnological differences, peoples of different heritages can form as beautiful a harmony as that of the spectrum of the rainbow. The time has come for us not merely to recognize these differences, but also to understand them. Cultural diversity need not be cause for conflict.[1]

The problem of Hawai'i's demographic distinctiveness was a nagging concern. Hawai'i was not only racially diverse, but that diversity was the result of a large Asian American population. The editor of *Paradise of the Pacific* voiced prevailing concerns of those audience members who might still be troubled by the depiction of Asian beauties. Did these girls "cling to tradition," or were they really loyal Americans? In the event of another war, would Miss Korean, Miss Chinese, and Miss Japanese act as members of the larger American community? If Hawai'i's citizens identified as members of distinctive ethnic communities rather than as fully assimilated Americans, was Hawai'i ready for statehood? How, then, to depict the beautiful "harmony" of race in Hawai'i? In the end, Miss Cosmopolitan represented the resolution to the problem. In spite of customs like this beauty contest, she suggests that in the ideal future, there would be no such "ethnological distinctions." In the future, Miss Cosmopolitan—the racially mixed beauty queen—would prove that "cultural diversity need not be cause for conflict."

The editor's statement, the Miss Ka Palapala contest itself, and the implicit privileging of Miss Cosmopolitan represent a complicated truth about racial norms in Hawai'i. Hawai'i enjoyed a reputation as a place where "race relations worked" and the existence of a large mixed race hapa haole community often served as evidence supporting that claim. Sociologists descended on Hawai'i in the early decades of the twentieth century to study what seemed to them to be a social anomaly: an ethnically diverse community that seemed to have experienced none of the racial conflict that epitomized Jim Crow America.[2]

But World War II brought hundreds of thousands of American GIs and war workers to Hawai'i, most from small, all-white or rigidly segregated areas of the country. It was "the first strange place," the staging ground that would prepare them for war in the Pacific.[3] The Hawai'i of travel brochures, stage shows, and *National Geographic* was no match for the actual experience of living in a place where the outward signs of white supremacy were virtually nonexistent. The war helped to introduce Hawai'i to America through the stories and experiences of these GIs; a few returned to live there, but many felt uncomfortable in a place where whites were a minority, the locals looked like the enemy they had been fighting, and there was wide acceptance of race mixing.[4] The plot of James Michener's *Tales from the South Seas*, adapted as the 1949 stage play and 1958 movie *South Pacific*, demonstrated a deep-seated American discomfort with racial mixing. Films like *Pinky* (1949) and *Imitation of Life* (1934, 1959) compounded racial anxiety by illustrating the sad fate of the "tragic mulatto." The American encounter with Hawai'i during and after World War II intensified the sense of ambivalence and discomfort raised by the existence of mixed race people.

Interracial relationships and a mixed race population had long been a fact of life in Hawai'i beginning with the arrival of white foreigners. The first generations of mixed race children in Hawai'i were nearly all the results of unions—marriages, common-law relationships, or rape—between white men and Hawaiian women.[5] Initially, these children were not counted separately from the Hawaiian population. Early census tabulations divided the population between "foreign" and native and often did not account for the ethnic or national origins of the foreign population. By the middle of the nineteenth century, children with Hawaiian mothers and foreign fathers were sometimes counted as foreign "half-castes."[6] They might also be counted as "native" if the paternity of their fathers was not revealed or not known.

The decimation of the Hawaiian population by disease meant that interracial relationships were a means of survival for the Hawaiian community.[7] The Hawaiian population collapse was dramatic; the lowest contemporary estimate is that there were 500,000 Hawaiians in 1778 (the highest is more than a million); the first official census taken in 1831 lists only 130,313 Hawaiians in the entire archipelago. By 1850, that number had dropped to 82,000; forty years later, it was under 34,000. But, during that same period, the numbers of part-Hawaiians steadily rose from 983 to nearly 8,500.[8]

Not only were part-Hawaiians becoming more numerous, but they began to enjoy greater status in the community. Many members of Hawai'i's elite classes were hapa haole, but the vast majority of mixed race children were being produced almost exclusively by Hawaiian women through their marriages and relationships to white (and later Chinese and other foreign immigrant) men.[9] It was widely held that part-Hawaiians were more economically and socially successful because they enjoyed the

best of both worlds, or, perhaps, the best of both bloods. Their fathers—whether white or Chinese—instilled in them love of education and the initiative and drive to succeed in the modern world, something that was ostensibly lacking in their mothers. Any "bad influences" from their mothers (speaking Hawaiian, for example) were mitigated by the fathers' forward-thinking attitudes and actions.[10]

Part-Hawaiians came to symbolize an important element of what I call the "Discourse of Aloha," the discursive and figural representation of race in Hawai'i that celebrated ethnic diversity in a way that did not threaten white political, economic, or social control. The Discourse of Aloha alleviated racial tensions, which had existed in Hawai'i since the arrival of foreigners. The domination of the Hawaiian Kingdom by white Christian missionaries, the overthrow of the monarchy by their descendants, the emergence of a single-crop agricultural industry that relied on the importation and exploitation of Asian labor, all contributed to uneasy and sometimes volatile relationships between the white minority and the Asian and Hawaiian majority. The Discourse of Aloha drew attention away from institutional oppression in the educational system, employment, and law by appropriating this Hawaiian concept that symbolized love, generosity, and open-heartedness, promoting it as the central value of local culture in Hawai'i. Because aloha was so essential to local culture, public expressions of racial tension, when they arose, were considered to be a violation of the aloha spirit. Through the Discourse of Aloha, it was possible to cultivate an image of Hawai'i as a racial paradise, an image that was especially important because of the potential for interethnic relationships to become unruly.

At the University of Hawai'i, the various ethnic groups strove to maintain racial harmony, and the Miss Ka Palapala contest was an attempt to highlight the most prosaic and unproblematic nature of local culture rather than draw attention to the sources of social conflict. The editor of *Ka Leo 'O Hawaii*, the campus newspaper, expressed the precarious nature of race relations on campus: "Everyone recognizes that one of our most serious problems is harmonizing different racial groups. . . . We believe that the best principle . . . is to remember the racial question just well enough to appear as though we do not remember it. . . . We should remember well enough to endeavor to have all the races participate in student activities without appearing to make a conscious effort in this direction."[11]

The very existence of Miss Cosmopolitan in the Miss Ka Palapala beauty contest was a testament to the vision of Hawai'i as a racially tolerant community, a successful social experiment. The assimilation of Asian immigrants worked, as evidenced by the Ka Palapala beauty queens, one from every group, equally beautiful, equally represented. In spite of the editor's queasiness about calling attention to race, she clearly believed in the vision of Hawai'i's progressive racial ideology. Her privileging of Miss

Cosmopolitan illustrated her understanding that the racial future of Hawai'i was in the erasure of race altogether, no longer bound to traditions of native ancestry. Miss Cosmopolitan's mixed racial heritage proved that eventually, in Hawai'i and perhaps in the world, race would cease to matter. This was a seductive vision of the future—one that bore very little resemblance to the reality of Hawai'i for working-class laborers who, in 1948, were still fighting against paternalistic racial policies on the plantations and in schools, the judicial system, the military, and other institutions.

Racial mixing in Hawai'i was an ambivalent social norm. It reflected a long-standing tradition of cultural hybridity but also demonstrated the degree to which white supremacy circumscribed social status. The existence of six queens was a natural by-product of an ethnically diverse community, but the valorization of Miss Cosmopolitan in this case suggests a desire to disguise the power of race in Hawai'i. Race mixing was uncommon and unacceptable to most midcentury Americans, but in order to garner acceptance, Hawai'i's social and political leaders made every effort to feature mixed race and hapa haole people in public displays and social celebrations like the Miss Ka Palapala beauty contest. Their existence demonstrated the possibility of racial harmony in the context of a racial hierarchy, a visual affirmation of the Discourse of Aloha.

Remixing Metaphors: Negotiating Multiracial Positions in Contemporary Native Hawaiian Art

MARGO MACHIDA

THE WORK of many contemporary visual artists from Hawai'i and the Hawaiian diaspora—of both indigenous and immigrant origin alike—is indelibly marked by complex polycentric concerns and sensibilities. The distinctive character of the islands as a site of contact, conflict, and mixing among peoples from multiple geographic origins finds palpable expression in projects that engage cultural production as a primary ground for assertions of presence / co-presence, place, and belonging. The artists Kaili Chun and Adrienne Pao are multiracial descendants of unions between Native Hawaiians and other groups, mainly of Western European and/or East Asian ancestry.[1] Although Chun's and Pao's interests, approaches, and visual idioms differ, and neither addresses issues of mixed heritage as an overt subject, that vantage point nevertheless distinctively inflects these artists' efforts to articulate their abiding relationships to the contentious sociocultural, political, and physical space of Hawai'i. For Chun, who lives on O'ahu, indigenous identification takes precedence over other aspects of her multiracial heritage. In contrast, Pao has long been a resident of California, and her mixed background provides a fulcrum with which to negotiate a self-described insider/outsider relationship with Hawai'i. Such inclinations underscore the contingent nature of personal identification and affiliation and thus influence which aspects of their multiple heritages are selectively foregrounded or downplayed in their lives and art. Yet despite significant differences in ancestries, standpoints, and motivating contexts, both of these artists have found that affective bonds to the islands sustained through connections to family, Native Hawaiian culture, and place remain pivotal as sources of meaning.

With historic patterns of settlement and formations of local culture in today's Hawai'i embodying the combined interventions of Oceanic, Asian, and Western peoples, the island chain's position as a Pacific crossroads—first settled by seafaring Polynesians sometime between 300–800—has long been shaped by forces of globalization. Since being annexed by the United States in the late nineteenth century, the Hawaiian Islands have served this nation as a stepping-stone to the Asian Pacific, as a

major military stronghold, and as a source of wealth, including their role as a prime destination in the global tourism industry. One consequence of this centuries-long trajectory of intercultural byplay, overlay, and cohabitation among successive waves of newcomers and indigenous Hawaiians is the large number of mixed race Hawaiians who currently compose the majority of the islands' indigenous population.[2]

Even though Native Hawaiians commonly have accepted those of multiracial descent into their communities, and some in the U.S. media laud Hawai'i as the "melting pot" state and as a model of racial harmony with the highest rate of interracial marriage in the nation, their mixed race status also presents highly charged political issues related to indigenous lands and other entitlements.[3] Due to the United States' tangled history surrounding juridical definitions of race, the concept of blood quantum long employed in its dealings with Native Americans would be extended to enfold Native Hawaiians. Passed in 1921, the Hawaiian Homes Commission Act stipulated that one parent must be of at least 50 percent Hawaiian blood for an individual to have access to land set aside for Native Hawaiians, thereby ultimately disenfranchising those with more extensive mixed heritages through the contravention of local kinship-based definitions of indigeneity.[4] According to a Native Hawaiian filmmaker, "In the Hawaiian world, my mom marrying an Irish man did not make me less Hawaiian. . . . All it does is extend the family to include the Irish."[5] Given the potential political, cultural, and positional tensions presently associated with issues of mixed Native Hawaiian heritage, it should not be surprising that the approaches of artists like Chun and Pao, when engaged with such matters, would necessarily entail a high degree of self-awareness and mindful deliberation.

Kaili Chun

Sculptor and installation artist Kaili Chun was born in Honolulu in 1962. She describes herself as a Native Hawaiian of indigenous, Chinese, and European ancestry, but considerations of mixed heritage have never been central to her sense of self, although they are allowed to subconsciously play into her art.[6] Faced with a contemporary social and physical environment that is pervasively shaped by U.S. business and military interests, and the unavoidable presence of settler populations that significantly outnumber Native Hawaiians, Chun views her people and culture as beset from all sides.[7] Feeling responsible for promulgating an explicitly place-based Hawaiian worldview through her work, Chun's primary catalyst for art making is an ongoing "challenge" to establish a means "to continue to exist as a Hawaiian" despite long-standing policies that have deprived her people of agency, stripped them of their traditional culture, and separated them from their land.[8]

Chun, in seeking to express such a standpoint, finds inspiration in the 1970s renaissance of Hawaiian culture that encompassed broad-based efforts to revive and reassert the native language, cultural practices in their multiple forms (arts, crafts, music, dance, etc.), and traditional agricultural, navigational, and healing skills. In her efforts to understand what it means to be a modern Hawaiian, the artist apprenticed herself to a master Hawaiian wood-carver and canoe builder and also pursued training in architecture and studio art. By combining these variant practices, she sought to develop a syncretic approach intended to collapse distinctions between "high art" and culturally embedded life-based practices associated with the indigenous community.

In order to stress the telling effect that place has had on her, the artist, who was born and raised in Hawai'i, uses her work to embody a thoroughly "Hawaiian epistemology" formed around the sacralization of place and its primal spiritual connection to the āina, the land itself.[9] Since the land, in the Native Hawaiians' creation myth, is the progenitor of the Hawaiian people, it is through land that they all trace their genealogy. This shared ancestral bond with the Hawaiian Islands is therefore foundational to the structure and lineage of all traditional social relationships. Indeed, as one activist-scholar remarks, "In Polynesian cultures . . . our blood-lines and birthplace tell our identity."[10] Given the centrality of this belief system to their ethos, the removal of the land from Hawaiian control and traditional use does not become simply a matter of the loss of territorial rights and resources but carries far more alarming implications: the severing of a people from the wellspring of their sense of collective being.

At the same time, Chun's work reflects on how her people's lives and sensibilities are complexly envisioned through, against, and beside the Western presence. Rather than setting up what one Hawaiian scholar describes as "false dichotomies between Western and Hawaiian, colonizer and colonized,"[11] or atavistically invoking some idealized, pre-contact state of affairs, the artist often allows for multiple, even contradictory elements to exist side by side. In responding to social conditions and dominant institutions that Hawaiians did not create, are unable to adequately control, and yet cannot avoid,[12] the artist suggests the productive—and necessary—tensions that arise from a deliberately critical yet open-ended recognition of the entirety of the history and circumstances of the group with which one identifies. Chun's work, therefore, consciously exists in a state of active and at times painful apprehension as the artist probes the multiple points of contact by which such positions have, for good or ill, been mutually constituted. In this, Chun emphasizes that the survival of Hawaiians as a people is, by necessity, integrally dependent on non-Hawaiians coming to perceive the value of their culture and thereby supporting them in their struggles. Through her

art, Chun urges every group in Hawai'i to make ethical choices by acting in ways that will better sustain the survival of each. Seeking such points of connection, the artist's more recent projects incorporate an interactive and dialogic dimension in order to serve as a public ground on which to bring diverse audiences closer to an awareness of her worldview. At the same time, the artist's phrasing of these ideas remains primarily metaphorical, poetic, and elusive, challenging non-Native viewers to actively engage with and decipher the multilayered implications of her work.

An eloquent expression of this interrelational approach is found in Chun's mixed-media conceptual installation *Nāu Ka Wae: The Choice Belongs to You* (plate 17). Presented in 2006 at the Honolulu Academy of Arts, it functions as a public site of contemplation, where viewers are invited to enter a Native space that embodies the close spiritual relationship indigenous Hawaiians have to their land. The installation, intermingling references to Christianity and to the European and American presence in the islands, gestures to the historic shaping of Hawaiian culture via hybridization and external imposition. Flanked by ceremonial rock basins filled with water and sea salt, elements essential to sustaining life, two pathways composed of volcanic rock function as stepping-stones that encircle a lele stone, a central upright boulder. Forty smaller hollowed-out rocks arrayed along the surrounding gallery walls concealed ghostly photographic images of important figures from Hawaiian history beneath dowel-like wooden plugs imprinted with related texts. Conceived as a culturally specific crucible for intercultural contact, the sizable boulder at the heart of the *Nāu Ka Wae* installation provides a symbolic spiritual and political jumping-off place that facilitates viewers' reconsideration of their attitudes and, in due course, inspires them to make fresh choices about their beliefs and affiliations. Significantly, among the role models Chun chose to commemorate were non-Native Hawaiian individuals who have contributed to the survival of the Hawaiians as a people and a culture. She furthered this dialogue by regularly visiting the gallery and making herself available to converse with engaged viewers in the hope of fomenting exchanges and insights between groups.

Chun's current untitled project, ultimately intended to comprise a temporary open-air exhibition of more than forty elongated free-standing steel cages (each eight feet by eight inches by eight inches), is designed to be set upright in sand and partially immersed in the surf at the seashore near the artist's home. For Chun, these grouped pylon-like structures, their total number corresponding to the artist's age at time of installation, act as a stark motif signifying the imposed foreign infrastructures and belief systems that confine Native Hawaiians and their natural environment alike. Taken together with its future site on a beachfront—a "transitional zone" where land and ocean dynamically interact—the project's placement provides the artist with a

means of also alluding to the open-ended processes of circulation, contact, and mixing that continue to reconfigure the peoples, cultures, and terrain of Hawai'i. Chun, who regards the human and natural worlds as parts of a living coextensive system, likens the anticipated passage of water, air, and sand through those structures to the communication and ideas that have flowed between different island groups despite sociocultural barriers and thus gestures to the necessity for active Native Hawaiian participation in conceiving respectful, equitable ways of fomenting local change. As a symbol of ongoing cultural realignment and psychic flux, and as a form of self-sign, the concept underpinning the piece further resonates with Chun's perception of the fluid and potentially variable nature of mixed racial identifications, bringing to mind her own youthful efforts to find personally meaningful ways of mediating among her various heritages.

Adrienne Pao

With a father of Hawaiian, Portuguese, and German descent and a mother of French and English descent, multiracial identity provides the primary frame though which Adrienne Pao, a California-based photographer and conceptual artist conceives of herself and her relationship to Hawai'i. Born in 1975 and raised in California, the artist has long maintained ongoing connections via regular visits with her many relatives on O'ahu, all of whom are part-Hawaiian. Family stories, passed down by her paternal Hawaiian grandmother when Pao was a child, initially provided a valuable conduit to the artist's indigenous heritage. According to the artist, it is only through this lens that she approaches her work in Hawai'i. Pao, when discussing her art in public settings, will first scrupulously establish her Hawaiian connections by reciting personal genealogy—drawing upon this living oral tradition common to Polynesian cultures.[13] Yet, in foregrounding the centrality of mixed ancestry, and having spent most of her life in the Hawaiian diaspora, Pao is well aware—especially when in Hawai'i—of the oscillating balance she maintains in concurrently being an "outsider and insider, tourist and indigenous person, and colonizer and colonized."[14]

Throughout self-performative photographic tableaux that form the long-running *Hawaiian Cover-ups* series (2004–present) (plates 19–21), the artist employs bodily self-imagery, in a glossy color-saturated palette that echoes tourist posters and *National Geographic*–like images, as the vehicle for scrutinizing the intricate and sometimes contradictory dual awareness that characterizes her ongoing relationship with the islands. Photographing herself embedded in a multiplicity of island locales, she establishes strong physical and imaginative linkages with the local landscape, including its abundant plant, animal, and aquatic life. Since a mixed heritage, as Pao affirms, also

provides ready "access to the places and people and different realities of Hawai'i . . . that I would normally not have if I were only a tourist," throughout the *Cover-ups* series the artist subtly plays off disparities between registers of representation associated with very different desires and experiences of Hawai'i.[15] In this, her motifs juxtapose the perspectives of its actual inhabitants with the seductive notions of an unspoiled natural paradise so favored by tourist transients, for whom the realities of local life and history are characteristically hidden or willfully occluded.

Access to the ocean and to oceanic life figures prominently in Pao's experience of the islands. Moreover, one of her uncles, a cabinetmaker by trade, is an enthusiastic fisherman and crafter of traditional fishing nets. The first piece in the series, *Fishskin Blanket Amidst the Mokulua's / I'a Kapa* (2004), depicts the recumbent figure of the artist, her head angled back toward the sea. The image is set on a stretch of shoreline near the town of Kailua, where her father and other family members had built a house in the 1960s. Here, Pao, in an image equally seductive and repulsive, commandeers a picturesque setting of tropical splendor frequently reproduced in travel brochures. The artist, however, disrupts this seemingly tranquil scene by blanketing herself under a dense skein of raw fish skins, a reference to the location's also being a major breeding ground for sharks. The haptic qualities of such foodstuffs, as well as the physicality of the surrounding vegetation and earthy substances, provide Pao with tangible means of grounding herself in local residents' practices and their literal and symbolic experience of such places.

In *Coconuts for Sale / Iwi Puniu Kapa* (2005), Pao, inspired by World War II–era tourist postcards, wryly sports a skimpy bra fabricated from coconut shells in order to address the dense convergence in Hawai'i of art, the romance of distant travel, commerce, and advertising, its omnipresent apparatus of visual persuasion. Against the backdrop of an open-air fruit stand located in a popular tourist area on O'ahu's North Shore, Pao, seated amid a waist-high mound of coconuts, places her eroticized image in the sunlit foreground while a young female vendor, of darker complexion and enveloped in shadow, can be dimly glimpsed behind the sales table. However the artist, who observes, "I 'look' more Caucasian than Hawaiian, my skin is olive but light," hardly fits the clichéd iconic prototype of the dusky tropical maiden.[16] In plainly contrasting her fair skin with that of the darker woman, Pao underscores the privileging of lighter skin conferred by a racialized Western social hierarchy. Yet she also acknowledges, in her capacity to share in the Native Hawaiian perspective, its local counterpart: the indigenous preference for dark skin that is the Native population's means of distinguishing itself from haoles, or whites. Indeed, given the intrinsic ambiguity of how people of mixed race like herself can be perceived, Pao is often taken for a mainland tourist when traveling on her own around Hawai'i, whereas she

is accepted as "local" when appearing in Native communities with family members, whose appearance collectively embraces a broad range of Polynesian and European features and skin tones. At the same time, the artist knowingly plays with and against the seductive trope of the native woman to manifest the long-standing commodification and consumption of Native Hawaiian culture. Such a scenario underscores how the escapist ideal of an alluring Pacific paradise as well as Pao's own body are implicitly perceived as being for sale in such representations.

As the majority of Native Hawaiians are today of mixed lineage, Pao, in her most recent body of photographs, *Family Portraits* (2008–), takes a personal approach to the range of "types" that compose the modern Hawaiian family by individually portraying her many local relations who are of mixed Hawaiian and European descent. What began as a modest project of gradually depicting her living relatives on Oʻahu would organically evolve, through dialogic, open-ended collaboration and group "brainstorming sessions," into a larger familial photographic project in which each sitter determines how she or he will be presented.[17] Seen as a counterpart to the *Cover-ups* series, this continuing effort underscores both the complex demographic reality of modern Hawaiʻi and the significance of how formulations of race and ethnicity are not merely externally imposed but are also being interactively constituted through the collective agency of local groups, in which the family plays a foundational role.

Informed by her exposure to critical theory, visual culture studies, and feminist studies, Pao is acutely aware of how post-contact Native Hawaiian culture has been extensively codified in ethnographic and popular media along limited lines, personified by figures like scantily clad maidens (usually hula dancers), fierce tattooed chieftains and warriors, and canoe-paddling spear fishermen. The artist is certainly sensitive to the possibility that her relatives, when invoking this type of imagery, may be internalizing aspects of Hawaiiana and thus perpetuating what she terms the "Hawaiian fantasy." Nevertheless, Pao finds it striking that most of her family members have, so far, opted to foreground such tropes in their visualizations of self.[18] In *Uncle Jeff and His Favorite Fighting Cock* (2009) (plate 18), for example, one uncle dons the traditional male hula garb of a deceased relative, a lifelong practitioner of the form and renowned chanter, solemnly incarnating the time-honored likeness of the Hawaiian warrior. In *Auntie Winnie Wearing Hina Hina (Pele's Hair)* (2009), a fair-skinned relative, inspired by popular depictions of the indigenous volcano goddess Pele, stands amid the encircling twisted trunk of a lofty banyan tree while draped head to foot in elongated strands of moss known locally as "Pele's hair." *The Three Cousins—Malia, Pohai, and Leilani* (2009), by contrast, in a scene reminiscent of the ancient European motif of the Three Graces, presents a trio of tropical-flower- and lei-adorned young women who decided to be photographed together. In the photo,

taken at sunrise on a rocky promontory overlooking the Pacific Ocean, one of the bikini-clad women displays a bare breast while another grasps a cell phone in her outstretched hand. In a social context in which the indigenous community commonly acknowledges those of mixed backgrounds as Native, such enactments underscore the abiding sense of connection to place conferred via common kinship. All the more so, as the artist asserts, because such identification can also provide a considerable "source of power," as one's lineage is joined to those of the local family gods, the 'aumākua.[19]

Coda

These richly envisioned bodies of work by Kaili Chun and Adrienne Pao call attention to the continuum of evolving positions within which mixed race Hawaiian heritages are nowadays conceived—ranging from the foregrounding of a single aspect of a multiethnic heritage as primary to the active embrace of mixed ancestry as the grounding for life and art. Further, each artist, even while fully recognizing the deep-rooted and often intractable tensions that may impede her efforts, has sought to incorporate an active dialogic component in her work by providing needed sites of engagement for Hawaiians and non-Hawaiians alike. Such expressive projects emerge in response to the vortex of pressures buffeting this dynamic island environment, including an increasingly assertive indigenism; competing claims to position, power, and resources; growing social and physical hybridization; the pervasive impact of U.S. culture and commerce; and the lingering effects of colonial imposition. The subjective optic offered by contemporary multiracial Hawaiians artists highlights the spectrum of choices individuals make about how and with whom they will associate and ally themselves and what they may find meaningful in differing contexts and situations. Their approaches to art making can make available textured insights into how the positions of different island groups are being reconceived and recast through symbolic and direct interchange with one another. Indeed, by attending closely to such artistic "conversations," a more multivalent picture emerges of the vital concerns, interests, desires, and antagonisms of its various stakeholders. The work of such artists, therefore, presents a double challenge both to idealized and undifferentiated invocations of Hawai'i as a multiethnic "paradise" and to overdetermined, conflict-driven rhetorics that would exclusively stress binaries and stark divisions between indigenous and settler groups.

Hawaiian Cover-ups:
An Interview with Adrienne Pao

Born in 1975 in Oakland, California, ADRIENNE PAO *is a mixed Native Hawaiian photographer based in San Francisco. She received her MFA degree in photography from San José State University in 2005 and is full-time faculty and curriculum coordinator in the online photography program at the Academy of Art University. Her work has been has been widely published and exhibited, including recent shows at Wave Hill Glyndor Gallery in the Bronx, New York; the Balcony Gallery in Kailua, Hawai'i; the Museum of the African Diaspora in San Francisco; Recoleta Cultural Center in Buenos Aires, Argentina; and Caixa Cultural in Rio de Janeiro, Brazil.*

Adrienne Pao met with Laura Kina in Chicago, Illinois, on February 13, 2010, to "talk story" about her Hawaiian Cover-ups *photographic series.*[1]

ADRIENNE PAO: I grew up in El Cerrito, near Oakland, California. We moved to Richmond shortly after that, and then to El Sobrante, a little unincorporated town in the middle of Richmond. My mom and dad divorced when I was four.

I went to Hawai'i at least once a year with my dad. When I got older, I started spending summers. Everybody in the extended family lived together outside of Honolulu in Kailua, which is not touristy. It's a smaller town—beautiful and pretty relaxed, not the fast pace of Honolulu.

My dad is an architect, that's his trade, but he is an artist. He gave me one of his old cameras when I was fifteen or sixteen. I was a really good student in high school, but I was bored, so I started using the camera . . . it became something that I was passionate about, it became something that I could ask the questions with, and there was never an answer. I started going to Albany Adult School. They had a darkroom class— you could pay fifty dollars and use their facilities. There was a teacher, in his eighties, who had been my dad's teacher a long time ago. It wasn't really a class, but he would be there to tell you how to do things, if you needed it.

LAURA KINA: Is your mom an artist?

AP: She is a psychotherapist. My grandmother was a concert pianist, and she performed in vaudeville and at Radio City Music Hall, which was so unusual for women during that time. My dad is the native Hawaiian side, and my mom is French and

English. My mother's father was also really artistic, and he did these funny and beautifully drawn comics. Just recently, she started showing me amazing drawings she does while watching TV.

My mom was sent to BYU [Brigham Young University] in Utah for college, but she wasn't Mormon. She did not like it. She left by transferring to BYU in Hawai'i; then she transferred to University of Hawai'i. My mom and dad met in a class at University of Hawai'i. She was very lonely. Things had happened to her, and she really needed a centering person. She met my dad and became part of the family, moved into one of their apartments and was taken care of, so she feels very close to everybody there. She was visiting Tutu up until she died.

LK: How do you identify yourself?

AP: I identify as "multiracial." People will ask me the question "What are you?" and I always wonder where that question comes from, but I don't mind it because I get curious, too, about where people are from and what their ethnic background is. I'm part Native Hawaiian, English, French, and Portuguese—a little bit of German, too.

LK: Do you have ties to any particular community?

AP: I identify with the Hawaiian community, but mostly in relationship to my family. When I'm in California, I don't really go to Hawaiian festivals. I definitely have that culture as a prominent force in my self and my own life.

LK: Do you ever address mixed heritage in your artwork?

AP: Absolutely, all the time. As an artist, I need to place myself, because that's how I locate myself within the work. I always consider that I am a part Native Hawaiian person, born and raised in California. When [I'm in Hawai'i,] I'm definitely part of Hawai'i and Hawaiian tradition and Hawaiian family and all of the things that go along with that. However, I'm also an outsider. I can see through that lens. I can see the beauty, I can see the paradise, I can see the rapture in that place. Everything for me is always the experience of insider and outsider at the same time.

I set up a framework for *Hawaiian Cover-ups*, both conceptually and technically. It was usually the top two-thirds or half of the frame that was very seductive and beautiful and something occurring in the bottom half of the frame where I'm being covered up by fish skin or palm fronds or something identifiable as a Hawaiian iconic object. I represent something that's buried or being covered up or not being looked at. Not always negatively. Sometimes there's just history or stories or things that are underneath that aren't necessarily known, and that's not a negative thing, either—that's just multilayers.

LK: In your photographs, your phenotype is startling: you're very light-skinned. I'm wondering what role that plays in your work, and in real life, in terms of being accepted as an insider or outsider?

AP: In Hawai'i, it's considered more attractive and desirable to be dark-skinned, so everybody wants you to get tan. My mom is blue-eyed, blonde-haired, very light, and my dad is dark, dark hair, darker skin, and I came out completely light-skinned. There's a total mix in our family, the whole range—*Family Portrait* is what a contemporary Hawaiian family looks like. There's a whole range of skin colors, skin tones. The ethnic makeup of people there is very specific to that place. I notice when I'm with my family members, I'm treated like a local; out by myself, I'm treated like a tourist.

LK: When you're in California presenting work about Hawai'i, do people think, "Oh, this is some white lady making work about this" or . . . ?

AP: I don't know because nobody's ever said that to me. Whenever I'm talking about the work, I state my place at the very beginning so people understand, although people ask me, "What are you?" But I think also because my last name is Pao, they're like, "Wait, are you Chinese?"

LK: What are your associations with war?

AP: My tutu was born in 1916—there was still a queen in Hawai'i at that time [Queen Lili'uokalani, the deposed last queen of the Hawaiian Kingdom, died in 1917]. My tutu lived through World War II in Hawai'i. She was a hula dancer and danced for the president, and I think she would dance for troops sometimes, too.

LK: Why was she chosen or chose to dance in front of the troops?

AP: She was a very beautiful woman—like a glamorized Hawaiian. Tutu's mother died shortly after childbirth, so she was raised partially by Auntie Keahi [Julia Keahi Luahine Sylvester], one of the last Hawaiian hula dancers who practiced traditional methods, and trained as a young girl by Auntie Keahi—who I'm named after—along with her cousin Iolani Luahine, who became one of the greatest dancers in the islands. Tutu was married and had started a family by World War II and the attack on Pearl Harbor. She remembered hearing the planes flying over, as the family was living close to Nu uanu Valley. My grandfather was employed at Pearl Harbor at the time and was summoned to work.

LK: Do you feel that your work references war?

AP: I'm working so heavily with colonization, a by-product of war. I use World War II iconography. Soldiers would buy postcards of the hula girls who were usually not Native Hawaiian; they were either lighter, so that they had a non-Native look, or they were Hawaiian-looking but not necessarily Hawaiian.

I'm addressing family portraits, and I'm amazed how infused visual iconography from World War II is with contemporary part-Hawaiian people. I'm fascinated that people will embrace the colonizer's history even though they're not happy about the turn of events, but there's so much infused in Hawaiian culture that people take own-

ership of it. When you take ownership of a colonized space, it re-empowers it, in a way. But it supports it, too. There's a fine line, and I'm interested in that space.

LK: Can you talk about your *Hawaiian Cover-ups* series, specifically *Lei Stand Protest / Lei Pua Kapa* (2004) (plate 19)?

AP: I've actually gone back and forth on the title of *Lei Stand Protest*. I'm not "anti–lei stand." Leis are incorporated into our family—we use them, we love them. I feel like that's a protest about the commodification of culture.

LK: That is the lei stand coming out of the Honolulu International Airport?

AP: Yes. I kept thinking about all these objects that had immediate identification with Hawai'i, and leis were one of the first things. There're all those lei stands at the airport.

LK: You pull your car off to the side road, you buy one, and greet your visitors.

AP: Yes, it's tradition. Usually, that's where the locals buy leis to go greet family members or whoever is coming. We buy leis there even for larger family events.

LK: My question is about the position of insider or outsider.

AP: That space is both of those. I talked a lot with lei stand owners and asked if it would be okay if I photographed myself there, and they were really into it. They thought it was funny and really fun to arrange the leis on me, and they let me borrow leis to do it. I also was with my family members. We came over a period of a couple of days and got to know them. They were definitely the insiders working on the process, the laboring, of making a lei, selling a lei.

LK: Your protest is not gathering any attention, so that to me reads as very humorous. Was that intentional?

AP: Absolutely. There's always humor—the performance, the element of playfulness is essential. That's number one for me.

LK: And *Searching for Roots at the International Marketplace / A'a Kapa* (2004) (plate 20)?

AP: I'm covered up with banyan tree roots. There's a huge banyan tree in the International Marketplace where people buy all these goods. They're not even goods from Hawai'i; they buy all these tourist things. It's in Waikiki, it's just bustling, it's crazy, things are lit up, there's a banyan tree in the middle, which is what I'm leaning against.

LK: You and I just watched Anne Keala Kelly's film *Noha Hewa: The Wrongful Occupation of Hawai'i* (2010). The idea of your ancestors' bones physically in the land and reclaiming the land, lying down on the land—those are really serious issues in terms of race. Are you playing with those in your pieces?

AP: I was thinking about being a person sleeping through this massive infrastructure and tourist thing that's happening all around me and within all of these crazy

levels of occupation and commodification taking place. I titled it *Searching for Roots* with a couple of different interpretations: how I think about tourism, how you're searching for your own sense of self in a place. And then I think about where I look for roots.

LK: Tell me about *Sunset at Sunset Beach / Napoʻo ʻana o ka lʻ Kapa* (2005) (plate 21).

AP: I needed to photograph it at Sunset Beach at sunset, because it's all about replication. There are about three hundred postcards of Hawaiian sunsets making up the blanket covering me. I stopped in every drugstore that I found. I thought it would take me days to find that many postcards to make a huge blanket, and it just took three hours because there are so many interpretations of sunset.

LK: How has your work been received?

AP: There're so many different levels. There's the first level: for me, the most important thing was dealing with my family on this project and how they received it. They came and helped me. Now we have memories of these experiences; they were so crazy, so funny and kind of grotesque sometimes, but you know, we all did it together. That was my first priority, so we have memories of it. The second is dealing with the public in that space and making sure everybody felt comfortable. And then there's putting it into the public. It's been shown in Hawaiʻi and in San Francisco at the Museum of the African Diaspora and at SFMOMA Artists Gallery, and there are some writings about it. That's been really positive for me because it's been placed in a context either with Hawaiʻi associations or with diasporic associations, and I think that's a perfect context for it.

Transcribed by Marco Cortes, 2010

Resources

Cooks, Bridge. "Beneath the Paradise." *Exposure* 39, no. 1 (Spring 2006): 27–32.

Morgan, Eleanor. "Camp Attack: Californian Artists Present Tent Dresses with a Political Twist." *Dazed and Confused* 2, no. 66 (October 2008).

Pao, Adrienne. "New America Now." National Public Radio, San Francisco, February 2009.

I've Always Wanted Your Nose, Dad:
An Interview with Samia Mirza

SAMIA MIRZA *is a sculptor whose work combines a punk-rock sensibility—using debased materials and references to pop culture—with wistful to angry autobiographical references. Born in 1986 in Corvallis, Oregon, Mirza was raised in Honolulu, Hawai'i. Her mother is Native Hawaiian, Chinese, Malaysian, English from Hawai'i, and her father is from Yemen. She earned her BFA degree from the School of the Art Institute of Chicago (SAIC) in 2008 and moved to Los Angeles in 2009. In 2010, she opened up Actual Size Los Angeles, a storefront gallery in Chinatown collaboratively run by artists Lee Foley, Justin Greene, and Corrie Siegel. Her work has been featured at Roberts & Tilton, in Culver City, California; Louis Pohl Gallery, in Honolulu; Alfedena, Kunsthalle Chicago, Koscielak Gallery, and the Thirteenth Annual Asian American Showcase in Chicago.*

Laura Kina interviewed Samia Mirza in her home-studio in Los Angeles on February 26, 2009.

LAURA KINA: Growing up in Hawai'i, was it strange to have an interracial family?

SAMIA MIRZA: Not really—everyone is mixed there. Though I'm a bit of an odd one, I guess: Middle Eastern and Native Hawaiian–Chinese. But race is race, and people come from all over the place. Religion is where the issues come into play. Muslim or Catholic, hmmm? It's confusing as a child. On Friday, my brother and I would go to the mosque, and on Sunday, we'd go to church. One god, three gods, Jesus, Muhammad, Holy Communion, Ramadan, oh, my head would spin! It's always been the thing that separates my dad from the rest of them. The Muslim community in Hawai'i is small; people don't know much about their practices or beliefs. Religion has always been the point of contention. Race is no big deal; God is.

LK: I would say by far, in my own family, religion is a far bigger deal than race. I converted from Christianity to being Jewish, and nobody really blinks an eye about race in my family, but religion . . . that's a big deal.

SM: When my mom and dad married, she converted from Catholicism to Islam. There was no way his family would let him marry a non-Muslim, and in many ways, there was no way her family would let her do the same. She did it though. Her mother never went to the wedding. It wasn't in a church.

LK: When they separated, did she convert back?

SM: No, she's never formally converted back. It's really crazy though, because there's an expectation from both sides to follow in their religious footsteps. But I'm on my own now, and there are bigger fish to fry than this centuries-old topic!

LK: Where did you go to school?

SM: I attended Kamehameha School, from the fourth grade all the way up to my senior year when I graduated in '04. The mission of the Kamehameha Schools is to fulfill Bernice Pauahi Bishop's "desire to create educational opportunities in perpetuity to improve the capability and well-being of people of Hawaiian ancestry."[1] As such, they give preference to applicants of Native Hawaiian descent who can submit evidence verifying that at least one of their pre-1959 ancestors is Hawaiian.[2] My mom is Native Hawaiian—my grandfather is 72 percent Native Hawaiian, so she qualifies for [a] Hawaiian [Home Lands] homestead.[3]

I am currently interested in the monument and the statue and interpretations of such. I want to bring the underbelly of things upward . . . things that are hidden in the dark, things that go bump in the night. These recent pieces deal with iconoclasm . . . in regards to a beautiful marble statue with a missing nose or missing arms or different parts of the body being gone as evidences of disagreement and a destruction of value. My work stems from mythology that I've grown up with; there are many personal back stories associated with these works. I tend to think that people from islands carry an element of mysticism, superstition, and history in the ways that they see the world. I went to an all-Hawaiian high school, and when I moved to Chicago, it didn't take long for me to realize that I was brought up in a very different environment than many of my peers and that my education was very Hawaiian-centric. I didn't know about Western philosophy—European philosophers and thinkers are always discussed at art school and are in many ways a foundation—and that really bugged me. I knew philosophers of Hawaiian culture and the history of Hawai'i, and maybe that's all I can remember because I was so intrigued by it. Initially, I was upset and embarrassed by my education, and I would often think to myself, "Ah, I hate this. At Kamehameha, they sent me out into the world not knowing practical stuff." But by my third year at the School of the Art Institute of Chicago, it kind of clicked. I realized I could use everything I was taught from my education and upbringing, especially all that mythology, to my own advantage. I had a lot to say.

LK: Can you tell me about your sculpture *I've Always Wanted Your Nose, Dad* (2008) (plate 22)?

SM: That's a bust of my father. As a child, it was a bit odd growing up with a Middle Eastern father and a mixed race mother from O'ahu. My dad used to tease me that I didn't have a bridge on my nose like those on his side of the family. He would

say, "Oh, you don't have a bridge yet. You'll have a bridge as you grow older; your bridge will form." This started to become a big deal to me as a child, and I had hoped for my bridge to form the way wisdom teeth sort of come in at, like, seventeen, you know? In a silly way, the piece comes from wanting a nose like my father's, an inclined slope that bridged my nose to my forehead. Having lived in Hawai'i, I was always around my mother's side of the family, but there always remained another side of my background that was such a mystery. I'm on an island; they're on a desert.

In my final year at SAIC, I found myself interested in the classical monuments, how they existed then and what we see now. Statues, busts, full figures, they follow a specific recipe. Chin up and out, contrapposto, elegance, bravado, wet drapery—there is a checklist. I was experimenting with papier-mâché and the various states it could be worked to. I knew I wanted to create something that had its nose chipped off, in reference to iconoclasm. I was sitting in the sculpture courtyard at SAIC, and I had just printed a number of portraits of men that I had been wanting to use with my sculptures, everyone from people I knew, to Michelangelo's David, to a random old man I found on Google.

And among those photos was a picture that I've always liked of my dad in Cairo during the '70s. I think it's because I've often associated that photograph with his final years in the Middle East; it may have been his last time in Egypt. English occupancy in Yemen caused him to move around often in his early life, and by the early '80s, he left his homeland to study in California. The photo has always communicated a "fare-well" quality. His expression is that of opportunity, beginnings, and youth, with such bright eyes, almost an old starlet. I had found my image. In the quick pace that I work, I chopped the photo off the rectangle of the page, took one look at it, and cut his nose out. I didn't even have a material choice in mind yet. With the nose cut out, I found a rock and thought, "This is exactly what is going in the gap that was his nose!" and there it went, kerplunk! This is a sculpture of someone who has a nose made of rock. It's ancient and old; it's been around for awhile. The nose has such a big role; it's the part that juts out of your face and leads you. What happens when you have your nose in the air? What happens when the navigator falls asleep? What does it mean for someone to have their values turned upside down? How do you function with a rock as a nose? It looks correct but it's incorrect.

LK: Do you ever address having a hybrid identity in your work, or is it something that's subtly there? . . . You use rocks a lot, and I can't help but think, "What is more Hawaiian than . . . "

SM: . . . Rocks. Ahh, rocks get you into trouble in Hawai'i. You do not take a rock from where you've found it because of the mythology and spirit that it holds, especially one from a volcano. If you do remove it from where it rests, something or

someone will come back for it and bad luck will consume you. My interest in rocks came from a fascination I had in poi pounders, which are implements for cooking that are made of solid stone. Making food with a rock rather than a pan is such a crazy concept to me. I am interested in petroglyphs and the idea of people making use of what they have to tell stories, to feed themselves, even to defend themselves in vulnerable states. The rock is a blank slate with so much to be applied.

An island can often feel like a rock—still, never changing, and isolated. The first time I used a rock as an impetus to form my sculptures was in a project called *Karate and Dolphins.* I took two disparate things and threw them together on an amorphous rock shape. My newest project, *Kings and Trapezoids,* addresses the idea of mixed identity and abstraction. I've collected hundreds of images and put together a book where the two subjects are scattered throughout. Upon glancing at the first few pages, one may notice a system telling apart the two subjects and their differences. The contradiction is that after flipping through the book, the images of kings lose their significance and become just as abstract as their counterpart, the trapezoid. The trapezoid is also a reference to an empty throne.

<div align="right">

Transcribed by Marco Cortes, 2009

</div>

Resource

Ferrando, Alexander. "In the Artists' Hands: Actual Size Los Angeles." *Flash Art*, July 22, 2010, http://www.flashartonline.com/interno.php?pagina=onweb_det&id_art =563&det=ok&titolo=IN-THE-ARTISTS—HANDS:ACTUAL-SIZE-LOS-ANGELES.

"LOVE CHILDREN":
DOMESTIC RACIAL HIERARCHIES,
ANTIMISCEGENATION LAWS,
AND REVOLUTIONS

Eurasians and "Hapas":
Mixed White Asians

Both Buffer and Cosmopolitan:
Eurasians, Colonialism,
and the New "Benevolent" Globalization

WEI MING DARIOTIS

The Eurasian middleman obviously finds it crucial to speak in a tone that would not jeopardize his positions as both the native-informer and the compradore. — Meiqi Lee

WHETHER through deliberate encouragement or through inevitable forces of domestic absorption of cultural capital, European colonialism created in its wake communities of Eurasians who, as buffer "middlemen," functioned to keep racial categories safely apart during the colonial period, in contrast to the more contemporary image of Eurasians as cosmopolitans who provide the illusion of unity.[1] Describing the narrative written in 1916 by Sir Robert Ho Tung, a Eurasian magnate known as the "Grand Old Man of Hong Kong," Meiqi Lee notes the "multi-dimensional worldviews that the Eurasian middleman negotiates as he skillfully positions himself in relation to different ideological spheres."[2] Eurasian men were allotted some roles in business and government service, while "Eurasian women . . . often worked as teachers, nurses, secretaries, clerks and telephone operators."[3] These middle-class occupations would appear to place Eurasians comfortably as buffers; however, Eurasian identity under colonialism was anything but comfortable.

The definition of the "colonial" period varies from place to place but in general terms runs from the early sixteenth century to the mid-twentieth century, with colonialism in Asian countries largely ending after World War II, though it has certainly lingered, for example, in Hong Kong until 1997. By discussing the postcolonial, it can be easy, as Gayatri Spivak warns, to slip into serving "the production of current neocolonial knowledge by placing colonialism/imperialism securely in the past"; thus an examination of Eurasian identity that traces the relationship of colonial buffer-middleman to global cosmopolitan must resist this slippage.[4] These identities differ but do so along a continuum linked to that of colonialism and neocolonialism. The relationship between Eurasian buffer and cosmopolitan identities illuminates Euro-

pean and American colonialism in Asia, and the current state of globalization, as what Howard Winant calls a "racialized social structure."[5] That Eurasian identities have the potential to confound colonial and neocolonial projects that depend on maintaining the segregation of the racial hierarchy is emphasized by the fact that "the Eurasian image continues to be one of the rarest representations in U.S. motion pictures of television programs."[6] Eurasian American artists such as Isamu Noguchi, Li-lan, and Kip Fulbeck create images of Eurasian identities against this current absence of Eurasian images while relating to or distancing from complex histories of colonial Eurasian identities.

Eurasians such as Anglo-Chinese, Anglo-Indians, Dutch-Indonesians, and French-Vietnamese were generally the children of unions between European men engaged in the colonial project as military or political governors and indigenous Asian women. Colonial Eurasians were often educated in British-, Dutch-, or French-style schools, with the objective being their eventual service in the government of the colonized country.[7] This position of Eurasians as somewhere between white European colonizer and native Asian colonized subject uncomfortably blurred racialized boundaries. In other words, while Eurasians in some places and at some times functioned to partially resolve the colonizer's "race problem" by increasing the whiteness or familiarity of the colonized, the Eurasian could never achieve the limited characteristic of whiteness itself being defined by an ideal of purity. This contradiction gives birth to the "tragic Eurasian" dilemma of being forever caught between two worlds, always suspended before achieving the ultimately desirable whiteness. This tragic Eurasian image, a painful variation on the idea of the Eurasian as buffer, figures the Eurasian as the sign of what is lacking—whiteness—and thus serves as a warning to maintain racial boundaries, the racial hierarchy, and the colonial project.

The British in India, Malaya, and Hong Kong had a different attitude toward interracial relationships compared to the Portuguese in Macau, the Dutch in Indonesia, the French in Indochina, and the Americans in the Philippines, Guam, Samoa, and Hawai'i. Although there were no antimiscegenation laws in Hong Kong, Europeans who failed to observe social segregation from Chinese faced ostracization from the European community.[8] British attitudes toward Eurasians shifted over the colonial period; while there had been some limited early acceptance of Eurasians and of mixed marriages in British colonial India, by the late eighteenth century, official policies began to shift toward greater segregation.[9] In contrast, Bosma and Oonk argue, "The Portuguese and their successors, the Dutch, encouraged marriages between European men and Asian women, and tried to assimilate their progeny, by means of Christian education, into European civilization."[10] And yet, as Harald Fischer-Tiné and Susanne Gehrmann suggest, "The particular history of the *Indisch* [Dutch-Indonesian] has

long been erased from the national collective memory in postcolonial Indonesia as well as in the Netherlands, where they migrated in large numbers after Indonesian independence."[11] Similarly, and just as invisibly, in the postwar period, Eurasians from Hong Kong migrated to England, Australia, and the United States.[12]

The shift in image from the Eurasian as buffer to the Eurasian as cosmopolitan is related to this geographic shift; no longer in the Asian country of origin, providing a buffer between colonial and indigenous populations, the postcolonial Eurasian has moved into the center of empire, into the modern metropolis of the West. In the postcolonial late twentieth century, the Eurasian as buffer becomes the Eurasian as cosmopolitan, emphasizing a new kind of colonialism—a cultural and economic colonialism known as "globalization." According to Rebecca Todd Peters, "Postcolonial critics argue that the dependency of the global South on the economic models and policies of the global elite has created a new situation in which they describe globalization as neocolonialism."[13] In the new colonialism, Eurasians are no longer tamed natives but become instead a symbol of *falsely benevolent globalization,* or a sign that we are all just getting along. Like fusion cuisine, the postcolonial cosmopolitan Eurasian makes the taste of the foreign Other palatable by muting spices and blending the familiar with the foreign into a commercially viable, completely marketable, lightly tanned, safe or tamed feminine. It is critical to the project of benevolent globalization that the Eurasian cosmopolitan be a woman, because as a woman, she can be seen as sympathetic or sexually available, much like the image of the "tragic mulatta," while Eurasian men, like the Eurasian pimp in *Miss Saigon* or George Chakiris's hapa haole doctor character in *Diamond Head* (1963), in contrast, are seen, like mulatto men, as being too intelligent and ambitious for their racial status.[14] This intelligence, due of course to their white heritage, makes them dangerously unsuitable as colonial or racialized subjects, though, as Misa Oyama notes, because of their mixed heritage, they are "entitled to be self-contradictory."[15] The threat represented by the Eurasian man versus the Eurasian woman is illustrated by the fact that in British India, "Young educated Eurasian men were not welcome at the public dances where many of their sisters met British husbands."[16] This threat is seen from both sides, as the image of the Eurasian as buffer-middleman, with implications of near-white privilege, is clearly related to the untrustworthiness that Asians and Asian Americans often associate with Eurasian identity. For example, Paul Spickard describes the class differences among Eurasians and characterizes those perceived as higher class, among whom he counts Isamu Noguchi, as "aware of the Asian aspect of their identities—even trading on it in their careers—but essentially white in outlook and connections."[17] Essentializing Eurasians as "white in outlook and connections" both constructs Eurasians as traitors to Asian identities and idealizes Eurasians as embodying a solution to racism.

While the Eurasian man has been constructed as the ideal buffer-middleman, it is the Eurasian woman who is more likely to be seen as a present-day "true" cosmopolitan. Early images of the Eurasian as the cosmopolitan in the colonials' seat of power emerge through the writings of two Chinese and white British sisters raised in Canada: Edith Eaton, who wrote under the Chinese pen name Sui Sin Far, and Winnifred Eaton, whose Japanese pen name was Onoto Watanna.[18] Edith Eaton lived in San Francisco, Seattle, and Boston and died in 1914; her sister, who spent many years in Chicago and New York, lived forty years longer and therefore was able to communicate in a medium that was only just beginning during Edith Eaton's lifetime: film. Watanna's novel *A Japanese Nightingale* (1901) was made into Broadway play and a movie directed by George Fitzmaurice in 1918. Later, she wrote for numerous Hollywood studios. The images Watanna produced differ from those of her sister, however, because she created a false identity for herself as a Japanese noblewoman (despite being Chinese). Though these issues have caused some Asian American critics to dismiss her work, she was also a highly successful Asian American author in the first half of the twentieth century. Her success is instructive. It tells us that there is a desire for the beautiful fiction in which Eurasians as cosmopolitans comfortably bridge white and Asian, West and East, but mostly so that West can cross to East, leverage Western capitalist buying power, consume, engage in sexual domination of the feminized Asian, and safely return, while the East is supposed to stay where it is—a nice place to visit.

Drawn from her work as a journalist in both San Francisco and New York, Edith Eaton's stories, such as "'Its Wavering Image'" and "Leaves from the Mental Portfolio of an Eurasian," have been lauded for telling the truth about the reality of Eurasian communities, as reflected in the photos of Chinese-Irish American families in New York City in *Tea That Burns: A Family Memoir of Chinatown* by Bruce Hall or those on display at the Museum of Chinese in America in New York.[19] It is worth noting that the Eurasian characters Eaton created belie the benevolent colonial cosmopolitan image as they make transparent the tensions of the racial hierarchy.[20] In the midst of lambasting some Chinese American writers for presenting what he calls a "fake" image of Chinese in order to cater to the presumed Orientalism of white audiences, critic and writer Frank Chin counts Edith Eaton as among those writing "knowledgeably and authentically" about Chinese Americans in his seminal essay "Come All Ye Asian American Writers of the Real and the Fake." And for their construction of "authentic" images of Chinese people in diaspora, as well as of Eurasians specifically, Chin also praises two other Eurasian authors, Han Suyin, author of the memoir *A Many-Splendored Thing*, which was made into the movie *Love Is a Many-Splendored Thing* (1955), and Diana Chang, author of *The Frontiers of Love*.[21]

Set in the hypercosmopolitan city of Shanghai during the 1932 Japanese occupation, *Frontiers* depicts three variations on the cosmopolitan Eurasian trope: Feng Huang, Mimi Lambert, and Sylvia Chen. Feng Huang hypernationalizes himself as "Chinese" against both European and Japanese colonizers, thus demonstrating the danger the male Eurasian presents to the colonizer and situating Feng outside the ideal Eurasian cosmopolitan elite. Mimi Lambert, as a woman seeking the love of a white man whose family will never accept her because of her Chinese heritage, embodies the perfect example of the tragic Eurasian stereotype. The third Eurasian, Sylvia Chen, resolves the conflicts inherent in her cousin Feng and her friend Mimi as she is able to move easily between Chinese and European American cultures, establishing herself firmly as the perfect cosmopolitan type: beholden to neither parent culture, she seems to exist in and as a symbol of a universal global city. What remains invisible is the way that global city is dominated by white and Asian racial and ethnic hierarchies.

The invisibility of Eurasians is enforced in the art world as everywhere else. As Lucy Lippard writes, "Many of the 'Asian' artists in the United States are, like Noguchi, Asian American in 'race' (Eurasian) as well as in citizenship. Yet even if they are half-Anglo, they will be categorized 'Asian.'"[22] Noguchi and Li-lan struggled with this categorization throughout their careers. Noguchi's sculpture of a lynched African American man was dismissed as "just a little Japanese mistake," a characterization that frustrated Noguchi in his attempt to "belong to America."[23] Yet Noguchi sought identification with Japanese Americans, voluntarily entering the Poston internment camp (Colorado River Relocation Center), where, in October 1942, he drafted an essay titled "I Become a Nisei."[24] In chapter 19 in this volume, Li-lan describes her struggles with her identity while growing up in New York City, belying the idealized image of the cosmopolitan Eurasian woman effortlessly negotiating multiple identities. Like Noguchi, Li-lan draws heavily from Asian and specifically Japanese references in her work, not to trade on her Asian heritage but because Asia is a place where she feels at home. Neither is Kip Fulbeck "essentially white in outlook and connections"; his work, particularly the photos in *Part Asian, 100% Hapa*, in recalling anthropological photos of racialized "types," confronts the racial hierarchy upon which colonialism is built. His 1991 experimental autobiographical video *Banana Split*, combines fragmented images from still photographs with a complicated soundscape that prominently features a Chinese American family playing mah-jongg while Fulbeck narrates short stories about his Chinese American Eurasian identity. There continues to be little recognition of Asian American art qua Asian American art in the art world, yet these Eurasian artists have insisted on making it and on being recognized and categorized as part of the Asian American community. Globalization brings wealth to

the metropolis of the colonizer and appears to grant elite status to the Eurasian as the symbol of completed or finalized colonization of Asia; however, Eurasian artists negotiate the critical continuum of buffer-middlemen to cosmopolitan symbol of racial unity and, in doing so, make visible not only their own invisible image but also the racial hierarchies on which colonial and neocolonial racial structures depend.

Cosmopolitan Views: An Interview with Li-lan

Born and raised in New York, the artist LI-LAN *has lived in Japan and currently lives in New York and East Hampton. The daughter of a German American mother and the famous Chinese émigré painter Yun Gee, Li-lan incorporates architectural imagery from East and West in her paintings. Birds and planes in flight, insects and animals, and perhaps an occasional figure, invoke perspectives, passages, and boundaries, creating ambiguous transitions. Ambiguity is a common theme in her work, which has been widely collected and displayed in many solo exhibitions at such galleries as the Tina Keng Gallery / TKG+ in Taipei, the Jason McCoy Gallery in New York, and the Nantenshi Gallery in Tokyo.*

Following a brief in-person meeting in San Francisco facilitated by Mark Dean Johnson, cocurator of Asian | American | Modern Art: Shifting Currents, 1900–1970, *at the de Young Museum in San Francisco in 2008–9, this interview was conducted by phone on April 17, 2009.*

LI-LAN: Mine is not a "war baby" story at all. My parents met in New York. My father came to San Francisco, from China, in 1921. He moved to Paris in 1927 and then to New York in 1930. He met my mother in 1935. He returned to France in 1936 and lived in Paris until 1939. He came back to New York after the outbreak of the war. He divorced Paule de Reuss before he left Paris and married my mother in '42. They separated three years later and divorced in 1947. I visited my father all my life and saw him on most weekends until he died when I was nineteen. Now I see so many biracial families all around me, but I hardly knew any Asian people as I was growing up. There were none in my schools and none that I knew outside of my schools—until I was really hanging around with poets and artists of the Beat Generation—other than a few friends of my father's.

I was using my father's address and going to PS 1 in Greenwich Village. It was ethnically mixed, but the school found out that I really lived uptown with my mother, so I was expelled in the first grade. My neighborhood was Irish Catholic. It was lonely, because they were very racist. I think I was the only ethnic child in my whole class. I was called names every day, and I was extremely unhappy. My mother looked for a private school, but we couldn't afford any. I got an interracial scholarship to Downtown Community School. It was very left wing; Pete Seeger, the folk singer, taught there. The principal, Norman Studer, was called up in front of the House Un-

American Activities Committee. It was a difficult time in the United States! In my class, there were only three ethnic children—and we were all on scholarship. We were the only three who were poor and the only three who were racially different. It was better than the public school, but it was another difficult situation.

The first biracial person I met was Isamu Noguchi. I met him when I was eighteen or nineteen. Well, it's a famous story, written everywhere now. When I met him, he just looked at me and said, "What are you?" And I said, "Well, I'm half Chinese and half German American." And he said, "Oh, just like I am—I'm half Japanese and half Irish American."[1] We became lifelong friends, and I saw him several times a year. He'd come by and visit me in the country or in New York City. Our being biracial was always a topic of conversation, because, of course, he was born before me and he'd had difficulties all his life.

WEI MING DARIOTIS: Did you meet him through your father?

LL: No, I met him through an artist named Len Lye, a kinetic sculpture artist from England. Around this time I was hanging out in the Village and in the artists' bars, even though I was underage, and I would go to poetry readings. I met lots of different people and especially Japanese artists because there were a lot in New York at that time. And then I married a Japanese artist and went to live in Japan. We were very involved in the art world there, and I love the Japanese aesthetic. All of it—the architecture, the way food is presented—everything. Actually, I met my former husband because I knew so many Japanese artists. I knew Arakawa, On Kawara, Takeshi Kawashima. Isamu would be at a lot of the parties because they would always invite him. They were much younger, but he liked coming over and having friendships with all of us.

WMD: Did he think of himself as a Japanese artist?

LL: No, I think he thought of himself as both: Japanese and American. Everybody else thinks of him as only a Japanese artist, though. He told me about all the difficulties he had in Japan and here. He liked—and disliked—certain aspects of each culture. I actually think he thought of himself as not only both but having a very difficult life because of his cultural background.

WMD: Earlier, you mentioned the term "biracial." How do you identify yourself?

LL: I never know what to say. Every time I go out to an opening or a party, it seems someone always says, "What are you?" Sometimes I feel annoyed because I think we should be past this, so I just say, "I'm an artist." But they say, "No, no, no, where are you from?" or "Where are your parents from?" I say different things at different times. Sometimes I say I'm Chinese American, sometimes I say I'm American, biracial—it depends who I'm talking to and what my mood is.

I loved Mexico, and I had two long braids and earrings; a lot of people thought I

was Mexican then. Or if I was on the Upper East Side, people would come over and start talking to me in Spanish, but I can't speak it at all, and then I would have to say what I really am. I think I liked being thought of as Mexican for a while.

WMD: Why is that?

LL: I was really madly in love with Mexico. Mexico was just beautiful, and, personally, what attracted me were the people, the art, and the nature. Many artists were drawn to Mexico and South American countries. It was the first foreign country I had been to. I felt really comfortable. I also felt comfortable in Japan. I went to Mexico two or three times before I went to Japan. I also visited Italy and France before Japan. I loved Italy very much.

WMD: But have you ever gone to China?

LL: Yes, I went in 1980; we were one of the first groups to go. I think we were the second artists group. Then I went in 1995 because I was invited to talk at the Central Art Academy in Beijing. I went again in 2007 because I was in a show; my gallery in Taiwan opened a gallery in Beijing.[2] I was there again in 2008 for my exhibition.[3] When I went with the group in 1980, I got permission to leave the group and go by myself to my father's village down in Taishan with a translator of the language of that area, because they didn't speak Cantonese or Mandarin.

WMD: Do you speak Mandarin?

LL: No, I only speak a little Japanese. I wish I did. My father tried to teach me Cantonese when I was a child, but I didn't want to have anything to do with it. I don't think I wanted to be Chinese when I was a child.

WMD: In China, did you feel accepted?

LL: Half and half. It was strange in my father's village. It is a small, agricultural, poor village. They did want to know something about my father's life. They seemed to accept me completely. I told them he had died, which they didn't know, and they said, "Oh, well, he didn't come back; you came, same thing." They showed me the house he grew up in and asked me if I wanted anything, so I took a photograph of my grandmother. The second time I went back, they had me do an ancestral ceremony. They killed a chicken, and they put me in front of the ancestors' portraits and did a little prayer. This was completely foreign to me, but I was trying to respect their traditions. I couldn't understand anything I was doing. I had people from Hong Kong translating, but they didn't really understand the language completely either.

WMD: Do you think your father's status as an artist mediated your relationship to China?

LL: Well, now it does. In 1980, it didn't because they had never heard of him. In 1995, they'd heard of him, but not as much as now. But it depends. If we're doing a business transaction, and they don't like something I want to do, then they tell me

[*laughs*], "Oh, you're too American." But sometimes they say, "Oh no, we like you because you have Chinese blood, so you're fine."

WMD: In Jess Frost's article on your website, she describes your landscapes as "often depicting a deep and complex space involving an entry or exit of some kind, combining interior and exterior spaces, as well as varied architectural references," which she says is due to your "culturally eclectic background and lifestyle."[4] You are often referred to—like Noguchi—as "cosmopolitan." How do you feel about that characterization?

LL: When I work, I never think about these things. I'm sure it's in there, because whatever I am is in my work, but I'm not consciously thinking about this. I think about it when I talk—to you or somebody else.

I like Jess Frost's characterization because it wasn't pigeonholing. I don't want to be stuck somewhere. In New York, they have Asian week every year, and I was beginning to get stuck. It's the way African American artists always get stuck in shows in February. Maybe I picked up some of Noguchi's attitudes from knowing him for so long, but he would get very grouchy about certain things. Sometimes I just want to be a person without all this baggage all the time.

WMD: Did Noguchi also not like being pigeonholed?

LL: Yeah, I think so. Definitely. Other people might say different things about him, but I did feel this. I don't know if he minded being known as a Japanese artist. I had a home in East Hampton, and he would come out every summer to go swimming. We would get together with Saul Steinberg, the *New Yorker* artist. They would have very interesting conversations, some about this topic. He did say a few times that he felt his work was not respected or known enough in this country and that this was partially because they were always making him "just" a Japanese artist. I think he thought that if he didn't have that, he would be known as a more important artist. He was a great sculptor . . .

WMD: I have questions about being labeled "Asian American" versus "mixed race" or "cosmopolitan" and how each label might both inform how people might read your work and limit how people see it.

LL: Right! I have questions about that, too! [*Laughs*] I guess in a way I like "cosmopolitan," because it's the broadest. But I'm all of those things and I'm none of those things, in a way. It is awkward if people say, "Oh, you're Chinese" or "Chinese American," because I'm not totally . . . actually I'm half German or half American.

WMD: In some of the eye paintings—one of them is from a postcard of a geisha, and then some of them seem to be your eyes (plates 23, 24). Have you ever found people misreading them *all* as your eyes?

LL: Yes, that has happened a few times. They're not all my eyes. Only two are my

eyes, and the others are from other places. Only one was of geisha eyes. Some were Korean. Actually, one was from a German postcard, which is the mate to the first painting of my eyes. One was for a self-portrait exhibition I was invited to be in, and I just wound up doing my eyes. I did the other one of the German eyes, and I thought actually if you put the two together, they would really be my eyes [laughs]—Chinese eyes and German eyes. Not that anybody else looking at the paintings would ever think that, but I thought it.

WMD: In your 2007 artist's statement, you said that the image of your eyes "references how others perceive me,"[5] but I note that because the eyes look directly at the viewer, they also suggest how you see the world.

LL: I would agree with that. In a way, you grow up being who other people think you are in the world. I look very Asian, but some biracial people don't look very Asian. I think if I didn't look very Asian, my life would've been very different because people wouldn't have thought of me as Chinese. I spoke to author Lisa See about this. Did you read the book *Half and Half*? She's three-fourths Caucasian, one-fourth Chinese. She said people say racist things about the Chinese, not knowing she is Chinese. People see her as being white, but people see me as being Asian. So you grow up with a different kind of attitude about the world and maybe even about yourself. I'm sort of glad people think of me as Asian [laughs]. I wasn't, when I was a child; it was hard because of the period of time. I wasn't happy then. But that changed as my life went on. I was so comfortable living in Japan because for the first time in my life I looked like everybody else. All my life I think I had been the only one—in school, classes, you know, all that. Suddenly there I was—nobody knew I was American unless I spoke!

I think of how difficult my life was, and then I think about Isamu Noguchi. When he was young, the stigma really existed very strongly. For my father, too—I mean, I can only imagine what he went through. It was harder for him than for me, and it was harder for me than for young people now. I hope it is easier for them. I hope that with each generation it gets easier, but my father often had a terrible time. My parents couldn't walk down the street together. My father would be assaulted, all kinds of miserable things happened because of being a mixed race couple—in New York City! I know when I was in high school, if any of my non-Black friends would go out with a Black man that would be big trouble.

WMD: Did you and Noguchi ever talk about how being mixed Asians affected your artwork?

LL: He talked about how they related to his work in Japan, and how they related to his work here. I had issues: like whenever I'm in Asia, people would talk about how American my work is or I am—less in Japan. And when I'm here, then they say how Asian I am or how Asian my work is. So, I'm always the Other. I think he talked about

always being the Other, but I don't know if he addressed it exactly in his artwork. I haven't addressed it in my artwork, but I'm sure it's there because the same thing happens with my artwork, except in Japan, because of the Japanese inspiration in my work. But in China they do think it's very American, and in Taiwan they think it's very American, and here they think it's very Asian. I myself think it's whatever I am, which I guess is all of that. I don't know how to break it down.

WMD: On your website, there's a quote by Noguchi: "Li-lan has found that blank page of our school notebook, which we may all claim as our own. Upon it we can write our thoughts freely, beyond race and without prejudice."

LL: Isn't that wonderful? I love that.

WMD: He wrote this in 1980, projecting forward to a post-racial time "beyond race," but there is also a lot of pain in the quote.

LL: I think he had a lot of pain in his life. So did my father, and so did I—especially when I was young. Not really now, but when I was a child, it was very hard to be Asian at that time. Now I like it, because it gives me many more doors to go through. To go back to Jess Frost's quote, it gives me much more access to the world. I wouldn't have the same access to China or Taiwan, I'm sure, if I weren't Chinese. And I really like that. That's expanded my own interior world so much.

But it was so painful when I was a child—that's why I wouldn't learn Chinese, and I wouldn't wear the little Chinese costumes my mother put me in, and I wouldn't do any of these things, because I hated it. And now I regret so much that I didn't learn Chinese—how stupid I was! But when you're a child, you react to what's going on around you.

Resources

Brodsky, Joyce. *Experiences of Passage: The Paintings of Yun Gee & Li-lan.* Seattle: University of Washington Press, 2008.

Ebony, David. "Transmissions: Recent Work by Li-lan." In *Li-lan: Recent Paintings and Pastels.* Taipei: Lin & Keng Gallery, 1997. http://www.li-lan.com/texts/Ebony_transmissions_1997.

Ratcliff, Carter. "Li-lan." In *Li-lan: Silent Journey.* New York: Jason McCoy, 2006. http://www.li-lan.com/texts/ratcliff_li_lan_2006.

100% Hapa: An Interview with Kip Fulbeck

Raised in Covina, California, by his Chinese American mother and European American father, KIP FULBECK *is an artist, spoken word performer, filmmaker, and professor of art at the University of California, Santa Barbara. He is the author of* Mixed: Portraits of Multiracial Kids *(2010),* Permanence: Tattoo Portraits *(2008),* Part Asian, 100% Hapa *(2006), and* Paper Bullets: A Fictional Autobiography *(2001). He has also directed a dozen short experimental and documentary films including* Lilo & Me *(2003) and* Banana Split *(1991). Mixing autobiography, humor, and accessible representations of everyday people, Fulbeck's work is widely regarded as seminal in raising awareness of the mixed race and, specifically, mixed Asian American experience.*

Wei Ming Dariotis conducted this interview via e-mail on November 4, 2009, and Laura Kina followed up with a phone interview on December 1, 2010.

WEI MING DARIOTIS: How do you identify yourself?

KIP FULBECK: Father, husband, artist, teacher, swimmer, lifeguard, surfer, musician, etc. In terms of ethnicity, I usually say "Hapa, multiracial, Asian American, American, Cantonese" . . .

LAURA KINA: How did your parents meet?

KF: My dad was my mom's TA. She was widowed in China, and she came to California and enrolled at USC [University of Southern California] as an English major, and she was put in an ESL [English as a second language] class—even though her English was really good—and he was the TA for it. He kicked her out after the first day because her English was too good, but then she saw him on campus and asked him out to go to a Methodist luncheon. That was her opening line, and she's Buddhist and he's an atheist.

WMD: Do you identify as multiracial? If so, what terms do you use to describe this?

KF: I usually say "Hapa." When I was about six, my cousins told me I was Hapa, and that seemed a lot more natural than "Eurasian" or "Amerasian," which always felt a bit clinical. I grew up in an almost entirely Chinese household (my siblings were full-blooded Chinese from China and Taiwan). I was the white kid who didn't speak the language, didn't like the food, didn't understand the culture, etc. Right when I started to accept my identity as a white American, it came time to attend school,

where I was one of only two Asians on the entire campus. Getting picked on for being a Chink when I identified as a white American really threw me for a loop. It's like I didn't really have a place to fit in anywhere . . . I didn't know a single other Hapa. I think that's why even now identity figures so prominently in my work.

WMD: Do you have community or identity ties to any particular communities?

KF: Certainly I have ties to various multiracial and multiethnic communities. Then again, I have connections to tattoo communities, surfing communities, guitar communities, swimming communities, Santa Barbara communities, Solana Beach communities, local Hawai'i communities. In terms of ethnicity, the Japanese American community has been particularly supportive of me and my work. The community's familiarity with and acceptance of multiracial and multiethnic identity is more palpable for me than with other Asian Pacific Islander groups on the mainland. In Hawai'i, it's a whole different story. You're local first.

WMD: Do you ever address your mixed heritage identity, themes, or histories in your artwork?

KF: Sure, all the time. I started with *Banana Split* in 1991, then off and on again throughout my films, books, and performances. Whether I choose to directly address the topic or not, my work will always be Hapa work, always be Asian American, always be Chinese American, always be male work, heterosexual, etc. Your work reflects where it comes from. My work for the past several years has been creating systems for others to interact with, for others to express their identities. We all have a need to tell our own stories and, in our culture, we don't get many opportunities.

The Hapa Project (2006) (plate 5) was my first work emphasizing this strategy . . . giving people the opportunity to define themselves with their own words and image. These handwritten statements with individual photo portraits eventually went on to become a book, web community, and traveling solo show. A collection was also included in the groundbreaking *RACE: Are We So Different?* exhibition put on by the American Anthropological Association.

WMD: Do you feel that your work references anything to do with war or being a "love child" directly or indirectly?

KF: My mother was married to the second-in-command to Chiang Kai-shek and lived in southern China during the Japanese invasion. After he died, Madame Chiang Kai-shek helped her emigrate to the U.S. To this day, she still bears ill will toward Japan and won't purchase a Toyota or a Sony television. Yet at the same time, she's quite open to Japanese American culture. Go figure.

My father was a navy fighter pilot in World War II, stationed on Majuro in the Marshall Islands. It's funny that when I meet other Hapas with military dads, their moms are often also from overseas. But my parents met here. Oh, and she's the first

Asian woman he ever dated. War comes into play sporadically in my work. I've written about my father's service both in film and in book form, as well as about my own decision not to enlist.

In terms of the "love child" concept—not consciously. People may mistake me for such when they view old photographs of my parents, especially if my dad is in uniform. I wrote a poem about it way back, about how all the Hapas I knew had American dads and foreign-born moms, and how so many of their dads were in the military.

LK: Can you tell me what inspired you to make *The Hapa Project*?

KF: I thought of the project when I was seven or eight years old, just when I was going to a school where I couldn't really figure out where I was fitting in . . . I was the white kid at home and the Asian kid at school. I didn't know any other Hapas. There was no one in my area, no one on TV . . . nothing. I remember thinking, "I wonder if there is anyone else like me?" and how cool it would be to have a book like this. I thought of it when I was a kid but never did anything until I was in my mid-thirties and I had a girlfriend who said, "If you don't do this, someone else is going to do it and you won't like it, so just do it."

WMD: What was the process of creating *The Hapa Project*?

KF: I began photographing volunteers at a Hapa Issues Forum conference in San Francisco in 2002. I photographed everyone as identically as I could, attempting to be as neutral as possible in terms of exterior identifiers (no accessories, glasses, heavy makeup, clothing, expression, etc.). I shot all over California, as well as in Honolulu, Waimanalo, Chicago, Madison, Syracuse, and New York City, eventually shooting 1,200 participants of all ages. Interestingly, probably three-fourths of the volunteers were female, which parallels what happens in my identity classes as well.

Individuals designated their ethnicities in their own words, so they were free to use terms like "Jewish" or "Scottish," which don't appear on the census. I corrected spelling errors (apparently, most part-Norwegians don't know how to spell "Norwegian") and for the sake of symmetry and clarity changed terms such as "Black" to "African American," "white" to "Caucasian," etc. Participants were asked to respond to the question "What are you?" in their own handwriting. They had a seven-by-seven-inch box to do it in and as much paper as they needed to get it the way they wanted.

Importantly, every participant got to okay their own image. A camera is a tremendously powerful tool, and the power dynamic between photographer and subject is significant. For this reason, I wanted to give some of the power back to the subjects. It was never going to be completely democratic—it is, after all, my concept, my project, and my design—but there are some strategies you can employ to make it less

unilateral. I photographed one woman seventeen times before she was satisfied with her image. I couldn't tell them apart, but she could.

I wanted as blank a slate as possible. Every way we present ourselves visually, from our style to our glasses to our jewelry to our expression, is a way of outwardly identifying ourselves culturally and socially. And I wanted people to just be who they were at their base, to be as much as possible at their essence. This can be very empowering to some, and very threatening to others. It all depends on how we react to our created selves, how cognizant we are about our individual identities, and how much we put into our external projections.

LK: Can you talk specifically about the subject matter in the portrait of Eric Akira Tate that reads "100% Black 100% Japanese"? How did you meet Eric?

KF: When I started doing the Hapa work in the late '80s, Cindy Nakashima wrote me a card that said "We have to meet! We've got this group called HIF [Hapa Issues Forum],[1] and we really want to see your work." Through them, I met Paul Spickard and Teresa Williams-León, G. Reginald Daniel, all these different people . . . this whole community.[2] When I first met Eric, it was at HIF, and he had just founded it along with Greg Mayeda and Steve Masami Ropp. Back then, HIF was so small and we were really just looking to each other for support, and I remember that was Eric's staple line. When I eventually photographed him, he was kind of reluctant because he was already an attorney, but I said, "Eric, you gotta be in this book. I need you. You're kind of OG on this." So he came in and wrote it down, and that was it.

WMD: Talk about your determination to use the word "Hapa" in the title, *The Hapa Project*, given the controversy over its use.

KF: I've actually never heard of any controversy about the word in real life, having lived and worked in Hawai'i. It's just not an issue there. People refer to me as "Hapa" or "hapa haole," and that's that. Any arguments that do come up occur only in Internet forums or academia, and those aren't environments I'm particularly interested in since they're so removed from the real world.

LK: Now that *The Hapa Project* and *Mixed: Portraits of Multiracial Kids* have been out for a while and are still touring around the country, what are your reflections on these projects? You also became a father during the middle of these projects as well.

KF: Yeah, I'm always kind of surprised because I've dealt with the identity thing for so long in my own life. I forget the impact that even bringing up the subject has for a lot of people. I'm still really struck and touched when I get these e-mails and personal letters about how this project brought someone to tears because they never felt part of a community. They always felt they were the only ones. That's really important to me. Especially with *Mixed*. . . . A lot of these parents were saying to me, "We were crying. Our kids were fine in the exhibit, but *we* were the ones crying." It's a different

world now. My son goes to daycare, and there's eight kids in his class: two Black kids, two Hapa kids—he's one of them—one Asian kid, and two white kids. That's their everyday life. It looks very different from my nursery school.

Resources

Barron, Stephanie, Sheri Bernstein, and Ilene Susan Fort. *Made in California: Art, Image, and Identity, 1900-2000.* Berkeley: University of California Press, 2000.

Marchetti, Gina. "Pursuits of Hapa-ness: Kip Fulbeck's Boyhood among Ghosts." In *Where the Boys Are: Cinemas of Masculinity and Youth*, edited by Murray Pomerance and Frances K. Gateward. Detroit: Wayne State University, 2005.

Sussman, Elizabeth, Thelma Golden, John Hanhardt, and Lisa Phillips. *1993 Biennial Exhibition (Whitney Biennial).* New York: Whitney Museum of Art, 1993.

Archiving Ephemera:
An Interview with Amanda Ross-Ho

Born in Chicago in 1975 to a Chinese father and an Italian mother, AMANDA ROSS-HO *currently lives and works in Los Angeles. Her installations incorporate reprocessed objects and images from everyday life, mass culture, and the studio process itself. Since graduating with her MFA degree in 2006 from the University of Southern California, Ross-Ho has had ten solo shows in London; Belgium; Chicago; Los Angeles; Minneapolis; Pomona, California; Austin, Texas; and New York. She has exhibited nationally and internationally and has had shows at the Museum of Modern Art in New York and the Museum of Contemporary Art in Chicago. Her work was included in the 2008 Whitney Biennial and the 2008 California Biennial. Ross-Ho is represented by Cherry and Martin in Los Angeles, Mitchell-Innes & Nash in New York, and The approach in London. Her work has been featured in publications such as* Art in America, Artforum, Modern Painters, *and* Frieze.

On behalf of the Department of Art, Media, & Design, Laura Kina invited Amanda Ross-Ho to be a visiting speaker at the DePaul University Art Museum on November 13, 2008. She continued their conversation on February 25, 2009, in Ross-Ho's industrial warehouse studio in downtown Los Angeles.

LAURA KINA: How do you identify ethnically or racially?

AMANDA ROSS-HO: It's complicated because my mom's Italian and our household was neutral. There was not a ton of Italian heritage being infused, nor was there a ton of Chinese. It was very much about what that odd combination was, and so it's very hard for me to describe what that is. When I interact with my father's siblings, I recognize all these tendencies that they bring to things, which I have inherited—certain little things I definitely recognize but with which I don't identify very closely.

LK: You used the word "neutral" to describe growing up in Chicago?

AR: Yeah, that might not be the right word, but I'm trying to think what is the best word for a household that is the averaging of two distinct approaches. I have this joke with my boyfriend, saying that I was raised by wolves, because a lot of times my parents' approach was about reinventing; it was definitely an alternative situation. I feel like having hippie parents who were setting about to eschew things that their parents

had indoctrinated them with sort of ended up creating this other kind of environment where you're inventing your ethnicity. The cultural identity of our small family became more about that idea of championing things that you have allegiance to—whether it be making art or whatever. It was sort of like the weird averaging of two people trying to redefine their inherited cultural imprints. I related more to my mom's family, for the most part, growing up, than I did my dad's family. My dad's family is from Shanghai, but he has a sibling in Chicago. My mom's family is located in the Midwest, so I spent more time with them, growing up and hanging out with crazy Italians, but they also weren't completely embracing the ideal of the American family.

LK: Back in 2003 when you had your *Dogmatic* show in Chicago, you showed a work called *Summer Fun Club* in which you and your friends are adults reenacting a childhood slumber party. Can you tell me more about your childhood?

AR: *Summer Fun Club* is a photograph that was at that time a reenactment of a twenty-year-old photograph of myself with my two best friends. When we were kids, we had a club called the Summer Fun Club. Our moms had a women's group, and they would have all the daughters of the women's group go from one mom to another over the summer. Instead of going to camp, they had a DIY camp.

LK: Brilliant idea!

AR: This is what I'm trying to tell you—DIY family! Basically we became close friends, we're still close friends, and we still talk on the phone regularly.

LK: One week at each house?

AR: Yeah, loosely—the basic structure of the club was that each mom would take the group of kids and have an activity for the day; each mom sort of had her own special thing. My mom was an ecologist at that point, so she took us to natural areas and we did fun stuff like going to the forest preserve. Another mom owned a store, so we'd get to play in the store and hang out. It was very well rounding. . . . That was a very important moment for me because it was a hypercreative training camp.

LK: How do you identify yourself in terms of your mixed heritage? For example, some people will call themselves "multiracial," some say "mixed race," "Hapa," "Eurasian," etc.

AR: I usually say I'm half Chinese, half Italian. The next question usually has to do with the math or the chemistry—

LK: Like "What are you?" "How did your parents meet?"

AR: Yeah, like "How did that happen?" It's an unlikely kind of match in many ways for people. They met in August 1969, and I was born in 1975. My parents met on Woodstock weekend in 1969. Legend has it my mom was actually dating another person at the time, and she was waiting tables at this restaurant next to Second City, in Chicago . . . she has all these great stories about John Belushi. My dad had opened

this photo studio in town somewhere around there, and he was much older than her, like eleven years, but apparently my dad was being set up on a double date with a friend of a friend. They happened to go out to dinner at the restaurant where my mom waited tables. One of the guys that was at the table knew my mom, and so there was a mutual friend somewhere in there, but she was waiting tables—she wasn't at dinner with them. My dad was supposedly being hooked up with this other woman, and what ended up happening instead was [that] they claim that they saw each other, snuck out of the restaurant together, did acid all night, and then my mom moved into his apartment the next day. That's the story.

LK: That's so funny—you are totally a "love child."

AR: They got married in 1972, and they were married for seventeen years. They are no longer together, but it was a very long marriage, and I guess in a way you couldn't describe a love child better than that. That's the quintessential story. It wasn't immediate, though. I wasn't born like nine months later or anything like that, but I'm also an only child, the sole product of an unlikely union.

LK: Both of your parents are artists and commercial photographers. How did this influence your work?

AR: It's something I go back to as a primal scene or primal experience. My father is a painter, but he is also a professional photographer. He did two things: he photographed artists' artwork, which he still does now, but for a long time, when I was very small, he also worked in a commercial studio that shot mostly catalog photography, specifically for large clients like Sears. It was commercial photography, like product shots and basic wardrobe, things like that. This wasn't fashion photography. It was about shooting backpacks for Sears. Working-class photography.

From a very early age, I was able to see what went into making a picture. Just being able to see the construction of images was really useful and interesting. The photographers would use a lot of trick photography, retouching, and props. For example, when they shot food, they would use a lot of fake materials. For a kid, the veneer of photography is a perfect place—to see that all broken down was huge for me. Experiences like watching my dad stringing things from a fishing line to create effects were equivalent to a kind of magic. The idea of breaking down that divide between being a consumer and being someone who produces the stuff that you consume, and having access to the "behind the scenes," was important.

My mom was a photographer, too. She shot as an artist and she also shot for newspapers. She had a more objective practice. Her artwork was almost the opposite of my father's—she shot a lot of architectural compositions, people, street scenes. She shot a lot of domestic kind of vignettes in our house. I've used some of her photographs in my work. We had a darkroom in our house and it was across from my bedroom.

Every day my parents were in there making photographs, and I observed them produce photography.

LK: I thought that was so cool that you opened your DePaul talk with an image of Obama. It was just nine days after the November 4th elections, and we were all so excited that Obama was the president-elect. Can you tell me again about seeing your mom at the election rally in Grant Park on CNN?

AR: I was at home in L.A. My boyfriend and I were watching the election. We'd been following it all day, we'd been volunteering, we were so into it like everyone else was. My mom had called me earlier in the day and said that she was going to go to Grant Park because her best friend housed one of the staffers during the election and got a VIP pass. I was regretful that I didn't plan to be home [in Chicago] on that important day. I made her promise me to send me text messages from the site to give us updates. It turns out she was right at the stage. She was sending me these messages saying, "You wouldn't believe how crazy this is." I'm watching the TV live, thinking, "Wow, this is insane." We're experiencing it remotely, and then her face popped up. It was right before Obama came out, and her face popped up on the screen, and we started screaming because we didn't know what else to do. For me, it brought things full circle, unifying that historical collective experience with a big and personal moment.

What was incredible about it was that the experience affirmed gestures that I was already cultivating in my practice. I had just finished doing all this work where I was finding generic images and locating things that were personal within, and then I did an exhibition where I was doing the reverse, finding images that kind of felt generic but were actually really personal. This experience was like a real-time actualization of that kind of collapse.

LK: How did you come to be selected for the show at Pacific Asia Museum, *Chinaman's Chance: Views of the Chinese American Experience*, in Pasadena, California? And how did you respond to the curatorial premise?

AR: When curator Chip Tom started thinking about doing that show, he contacted me and told me about the basic premise, about the Chinese American experience. It took me a while to figure out how to solve the problem of inserting myself into that concept. Not because it wasn't pertinent—it certainly made sense that he would come to me on some level, I'm making work, I'm Chinese American, it added up—but in order for me to address the topic, I felt my position had to be completely transparent. I don't really navigate through heritage in my work directly. It's something that emerges occasionally as a by-product, but it's not something that I seek to really unpack as a specific kind of content. One of the things that happens when I'm asked to make something site specific or situation specific is [that] I think about

what's going on in my life. For a year plus, I had been sorting and archiving all of my father's old artwork as part of cleaning out his house, which he needed to move out of due to a long-term illness he had been fighting. He is since better, so that's good, but it was a really powerful experience. I'm an only child, so I was the only person to deal with the situation. It was a very personal experience where I was alone in his home sorting all of his things—not only his artwork but his personal effects—in the most intimate way possible going over all of my father's history. I didn't connect it to art in any way at that time. It was purely a family project. I knew that it was something that would influence the work somehow because of the intensity of it and because the method that I was [using to go] through all of this stuff was very similar to the way I work in my art anyway.

LK: Physically?

AR: Yeah, but also just in terms of an approach, like sorting through images. I have this vast library, and one of the things I do regularly is sort pictures; it's basically this attempt to make sense of all of this totality of stuff. I was engaging in my father's archive in that way because that's the way I engage in things but also because there was an excess of material. That is something that I've inherited from him, this sort of overwhelmed feeling resulting from trying to deal with all of excess of the ephemera that exists in the world. By going through all of his things, two things were happening. Number one, this practical thing of finding and archiving all of his artwork that I had no idea even existed or had not seen in so many years because it was buried in his house. And the other thing was realizing that a great deal of my own artistic approach had come from my dad and through his approach, not only as an artist but as a person—and also specifically as a Chinese person. So all of these things triangulated.

I learned so much about him, but I also learned a lot about myself in terms of my own work. The experience triggered all these important ideas and, I realized, okay, this doesn't have to be about squeezing myself into this cookie cutter and trying to identify as Chinese American. The piece is called *ANYTHING'S O.K. AS LONG AS IT'S EXTREME: AN INCOMPREHENSIVE RETROSPECTIVE OF RUYELL HO* (2008) (plates 25a–b), which is a piece of text that my dad had written in one of his sketchbooks. It says a lot about his approach and underscores his personal philosophy. I think a lot of what has been his project of coming here and building himself as an artist and an American has been about trying to navigate what his personal relationship with an American ethic is. My dad grew up in China and moved here in 1955. I lifted that text from a huge selection of other text written in his sketchbooks. This project included about fifty, but there are hundreds more sketchbooks that include writing and drawings, combinations of imagery and language. (See Ross-Ho's proposed remake of *ANYTHING'S O.K. AS LONG AS IT'S EXTREME (Reprise)* [plate

25c] for the 2013–14 traveling exhibition *War Baby / Love Child: Mixed Race Asian American Art*, DePaul University Art Museum and the Wing Luke Museum for the Asian Pacific American Experience.)

LK: You also had a video play.

AR: I did. It was impossible to show all of the pages of the books, so what I did was I scanned all the pages and made a slideshow. It was meant to feel like it was way too much. I brought as much stuff as I could from the archive to include in the installation, but it didn't really even scratch the surface; much of it had to remain in Chicago. Everything in the installation is either his work or a piece of presentation furniture from the museum. I didn't make anything, I didn't bring anything of mine in there, yet it still felt like it was completely my work. This was a completely transformative thing for me, where I realized that what I was achieving with this process was isolating the structure of what I do. I was replacing the found objects and made things that usually occupy my works with this stuff that was very charged with a personal kind of energy. For me, it's about the orchestration of things in combination with one another to create a conversation. The things themselves are mutable. They can change, because they're placeholders for this bigger idea, which is about the way a system of language works together and the way objects in an environment combine to create a system of understanding. It's like hieroglyphics—they basically stand for something individually but together they create this logic system. So that project became ultra-pertinent and way more important than I realized.

Transcribed by Marco Cortes, 2009

Resources

Huldisch, Henriett, and Shamim M. Momin. *Whitney Biennial 2008.* New York: Whitney Museum of Art, 2008.

Stillman, Steel. "In the Studio: Amanda Ross-Ho." *Art in America* 4 (April 2010): 82–89.

Taft, Catherine. "Studio Check: Amanda Ross-Ho." *Modern Painters*, November 2010: 27, 29.

Mixed Bloods:
Mixed Asian Native Americans

Reappearing Home:
Mixed Asian Native North Americans

WEI MING DARIOTIS

"Indian" has a racial connotation in law, as in everyday speech. Nonetheless race—that is, aboriginal ancestry—does not by itself identify someone as Indian for most legal purposes. The standard supplemental mark of Indian Identity, which makes Indianness unique, is membership in a self-governing tribe. — Alexandra Harmon

WHILE AMERICAN INDIANS are constructed as the indigenous forever in danger of extinction, Asian Americans are constructed in binary opposition as forever foreign. Late nineteenth-century fears of a "Yellow Peril" invasion of Asians contrast with images of the disappearing Native, but the realities of Asian American and American Indian interactions move outside the white-Other dynamic to reveal tensions and negotiations around location, relocation, constructions of "home," and notions of difference and kinship. Mixed race identity emerges very differently from an American Indian–centric perspective than from an Asian American one because of both internal community constructions of racial identity and external processes of racialization. Dominant discourses of Asian American mixed race identity have been historically structured around colonialism and war and lately have signaled upward mobility and assimilation. In Native terms, mixed race identity specifically centers around being legally enrolled in a tribe and issues of blood quantum, which has in recent years been used in some cases to exclude people of mixed Native and African heritage, effectively disappearing them from the tribal home.[1] Race has deeply shaped how each group has been colonized or used within U.S. capitalist imperialism. While blood quantum has been structured to limit access to federal support and land rights, rules of hypodescent functioned to generate a larger pool of enslavable people by racializing them as Black.[2]

Historically, there have been politically and artistically significant mixed Black American Indians, like the well-known figurative sculptor of the late nineteenth century Edmonia Lewis (Ojibwe, African American, Haitian), and strong scholarship has developed on mixed Black and American Indian communities and identities.[3] Robert

Keith Collins, exploring the "inconsistencies between self-understanding and racial recognition" for people of mixed African American and American Indian heritages, suggests that the dynamics of the racial hierarchy interact with family histories and personal communal connections so as to generate complex identities for people of multiple minority heritages.[4] Collins argues, "[r]acial expectations have affected how black and Indian mixed-bloods have been understood and why some are motivated to forcefully assert their culturally specific or generic Native American heritage despite their 'black' appearance."[5] Exhibitions including the 2009 traveling exhibition *IndiVisible: African-Native American Lives in the Americas*, produced by the National Museum of the American Indian, the National Museum of African American History and Culture, and the Smithsonian Institution's Traveling Exhibition Services, and the 2011 exhibition *Red/Black: Related through History*, at the Eiteljorg Museum of American Indians and Western Art; documentary films such as Alicia Wood's *American in Red and Black: Stories of Afro-Native Identity* (2008); and the work of artists like California photographer Valena Dismukes create a visual record and expression of Black and American Indian identities.[6]

Within the larger category of mixed American Indian identity, Asian and Native identity has been even less visible than that of Black-Indians. Having a visible home and being seen as belonging in it can make all the difference for the construction of a viable identity.[7] Male-dominated early Asian immigration ensured that early Asian-Native interracial relationships were predominantly between Asian men and Native women. Did home for people of mixed Asian and Native heritage in the late nineteenth and early twentieth centuries reside in paternal, borderline-legal, migrant labor camps or in maternal, self-governing, sovereign, yet marginalized reservations? How did the post–World War II urbanization of Native people shift mixed Asian and Native identities?

Recognizing that art can illuminate hidden stories, a Native community advisory and artist selection committee curated *Cultural Confluence: Urban People of Asian and Native American Heritages* for the Wing Luke Museum of the Asian Pacific American Experience in 2011, in which "The historic legacies and contemporary lives of people who are both Asian and Native American come together for the first time. . . . Through a mix of contemporary art, new media and storytelling, *Cultural Confluence* explores what it means to be Native in the city at a time when nearly two thirds of Native Americans live away from their tribal reservations and ancestral homes."[8]

At this exhibition, Tlingit-Filipino glass artist Preston Singletary created *Curio Shop*, an installation of glass representations of traditional Tlingit basket forms set up as a late Victorian domestic scene: a chair draped in Tlingit fabric stood in a wallpapered corner of a room, with a glass basket and a scattering of similar basket forms

and a cedar box form rendered in glass arranged on an "Oriental" rug; two shelves floating above this collection held additional glass pieces, photos, other objects, and a mask; and what appeared to be sepia-tinted historical photos of Tlingit people adorned the ornately wallpapered walls. A fascination with colonial subjects as objects led both American Indian and Oriental objects to be displayed in Victorian curio cabinets and sold in curio shops. While Asians in America were the imported colonial subject, American Indians were the foreign indigenous, a contradiction complicating the construction of American Indian racial identity within the U.S. racial hierarchy.

In his artist's statement, Singletary describes his discovery of the "primitivist" underpinnings of modern art: "My work began to take on a more figurative and narrative style with a new intent. I found a source of strength and power that brought me back to my family, society, and cultural roots." He goes on to acknowledge the complications of affirming his commitment to telling the story of his contemporary Native identity while decrying the limitations this identification places on his work: "I sometimes hope that people will view my work on other levels not associated with 'ethnic art.' At the same time, it is this inspiration that gives my work its power. I see my work as an extension of tradition and a declaration that Native cultures are alive and developing new technologies and new ways of communicating the ancient codes and symbols of this land."[9] Though Walter Porter, in "A Spokesman of Culture," describes Singletary as attributing "many qualities of his work to ancestral or genetic memory," Singletary's art does not seem to overtly explore his Filipino heritage, and indeed this part of his identity is often omitted from descriptions of the artist and his work.[10]

Perhaps at least in part because of the way the Native art market focuses on the racial identities of the artists, mixed Native and Asian artists are often identified primarily by their Native heritages, though without always denying their Asian and or other heritages. For example, Debra Yepa-Pappan and her mother, a Korean immigrant, integrated into her father's Jemez Pueblo culture, while Louie Gong is a multigenerationally mixed Chinese and White member of the Nooksack and Squamish communities. Both artists clearly proclaim their Asian heritage, yet both are situated primarily as American Indian artists. It is important to note here that although there is a thriving Asian American community art scene, and Asian American artists sometimes get passed as "Asian" or subsumed into white dominant art, there is no institutionalized Asian American art market as such, so for mixed Native and Asian artists, as Paul Chaat Smith says, American Indian identity vis-à-vis the fine art world is a form of "strategic essentialism."[11] Given these pressures to adopt an essentially American Indian identity, contemporary mixed Native and Asian artists challenge the double invisibility of the mixed heritage identity through work that merges these heritages

into powerful images that overtly confront the bifurcation and limitation of mixed race identities.

Louie Gong's *Coast Salish Dragon* (2009) (plate 27) is a Chinese dragon rendered in a Coast Salish idiom; the design is a powerfully realized merging of a quintessential symbol of Chinese identity with a stylized, contemporary interpretation of Coast Salish imagery. Sharing other mixed heritage peoples' interest in Spock as a symbol of mixed race identity, Debra Yepa-Pappan's *Live Long and Prosper (Spock Was a Half-Breed)* (2008) (plate 28) uses a historical Edward S. Curtis photo as its base and super-imposes the Star Trek emblem on the side of the tipis, hangs the starship *Enterprise* in the starry sky, and manipulates the hand of the Native woman (Yepa-Pappan inserting her own Korean-Jemez image in the space of the archetypal Indian from the problematic Curtis photograph) in the foreground into the work's eponymous Vulcan hand gesture.[12] In *Hello Kitty Tipi* (2007) (plate 29), the artist adorns the symbol of American Indian romantic nomadism with the pan-ethnically adored sign of Asian cuteness-cum-capitalism. Yepa-Pappan's reinterpretation of Curtis's falsified history, created in the belief that traditional American Indians were on the verge of disappearing, reclaims the spaces of American Indian identity as present, contemporary, and inextricably intermingled with global popular cultures, or, as contemporary performance artist James Luna (Luiseño and Mexican American) describes it: "Indians . . . are not here to confirm some contemporary notion of updated Edward Curtis imagery come to life. To be sure, many of us still adhere to revered traditions; we can still—some of us—make beautiful baskets and beadwork masterpieces, but we are also full of contemporary complexity, sophisticated sensibility, in-your-face irony and humor."[13] Gong and Yepa-Pappan use this "in-your-face irony and humor" to convey the "contemporary complexity" of mixed Native identities against the weight of centuries of misrepresentation.

The histories of specific mixed Native and Asian Americans are somewhat difficult to trace, though some have controversially suggested that pieces of jade and shipping ballast stones demonstrate that ancient Chinese sailors interacted with Native peoples along the west coast of North America. The first recorded contact between Chinese and Native populations is in 1788, when an English captain brought fifty Chinese carpenters and blacksmiths to Vancouver Island.[14] During the influx of Chinese immigrants escaping the chaos caused by the Opium Wars in southern China and drawn by the Gold Rush, antimiscegenation laws encouraged Chinese men to seek out American Indian women as partners from California to Washington and British Columbia. This history is illustrated in the mixed Native character, Kelora Chen, in Sky Lee's Chinese Canadian novel *Disappearing Moon Café*, whose unknown father was either white or Chinese and the unnamed American Indian man participating in

the 1969–71 occupation of Alcatraz who claims a Chinese grandfather in Shawn Wong's autobiographical novel *Homebase*.[15] Conflict and competition for scarce resources, spurred by mutual distrust and fueled by cultural miscommunication and white-constructed divide-and-conquer stereotypes, marked many early Chinese and Native interactions. There is even some evidence that Chinese men used Native women as a means of gaining a foothold in the United States when anti-Chinese immigration laws would have evicted them.[16]

In the late nineteenth and early twentieth centuries, European Americans viewed both Asian immigrants and American Indians as outcasts, which inevitably shaped the way the two groups saw each other, even as their phenotypical resemblances resulted in misidentifications and sometimes translated into a kind of recognition of the other as kin.[17] For example, the Chinese Eurasian protagonist, Lucy, in Mei Mei Evans's short story "Gussuk" works as a nurse in Kigiak, Alaska, and, because of her phenotype, is repeatedly seen as a member of the local Inuit population rather than as white or gussuk (missionary) and certainly not as Asian.[18] Correspondences between the appearances of these two differently racialized groups may be related to histories of migration and to the role of environment in shaping phenotypes, as well as how people of mixed Asian and American Indian heritages construct their identities. These identity constructions are also deeply imbued with the specific histories of particular Native and Asian ethnic groups in relation to one another as well as to European Americans and the racial hierarchy.

Shared labor and near habitation have contributed to intermarriage between many Asian and Native American groups. For example, Northern California Point Reyes Coast Miwok have often intermarried with Filipinos and Latinos with whom they shared agricultural labor.[19] While Sino-centric concepts of Chinese identity may have made it more difficult for mixed Native Chinese people to fit into the Chinese American community, the mestizaje of Filipinos has allowed for some mixed Native Filipinos to find a home in Filipino American communities.[20]

When Japanese American strawberry farmers recruited Filipino American workers to assist in their increasingly successful strawberry farms on Washington State's Bainbridge Island right before the United States entered World War II, they did not know that Executive Order 9066 would soon send them away from their farms before the critical harvest time. The farms' Filipino caretakers, desperate for more help for the harvest, recruited Canadian First Nations families, and many of the women who came soon married the Filipinos. There were twelve marriages the first year and many more afterward. The narrator of Lucy Ostrander and Don Sellers' *Island Roots* (2006), which documents this history for the first time, says, "The children of these marriages called themselves Indopinos and became an integral part of the Bainbridge Island

community."[21] In the accompanying study guide, self-identified Indopino Gina Corpuz (Squamish and Filipino) describes the film as honoring mothers and fathers who made "a life for themselves in a sometimes very unfriendly, racist America. It acknowledges the life-altering effect of World War II on the daily lives of Japanese American farmers and their workers, Filipino American men and Coast Salish women."[22] Corpuz makes her perspective on her forebears' experience explicit, saying they "were traumatized by alienation, displacement, and war and passed this fear onto us, the second generation, forcing us to grow up in an environment of both cultural and psychological confusion." Resolving this confusion means examining the traumas caused by both external forces and internal community reactions to those pressures. As Corpuz describes it, "our cultural authenticity was questioned because English is our first language and we sang our first drum song as late as age 30. We no longer worry about passing the 'Asian' or 'Indigenous' litmus test. Our Indipino footprints reveal us to be authentically one hundred percent Asian and one hundred percent Indigenous." Ultimately, she concludes that the Indopinos of Bainbridge Island are "a strong, committed people made up of two cultures proud to hold up the structural remains of times past." This resilience of mixed heritage identity through trauma is a hallmark of mixed American Indian identities, or, as Bonita Lawrence argues, "urban mixed-blood Native people . . . represent the other half of a history of colonization."[23]

The reality of Asian and American Indian merging deconstructs paradigms that posit American Indians as nearly extinct indigenes in contrast to Asians as perpetually foreign (male) sojourners in the nation-states of North America. Mixed Native and Asian artists can use art to open spaces for looking at mixed heritage identity that do not often exist in American Indian or Asian American communities. By recognizing their own relationships with histories of colonization, violence, forced relocation, and family lineages that connect what racial binaries would sever, mixed Native and Asian artists establish the primacy of kinship over race in determining identity and help mixed Native and Asian communities reappear in the homes from which they have been dislocated.

Walking in "Chindian" Shoes:
An Interview with Louie Gong

LOUIE GONG *is a Seattle artist who describes himself as "a Native of mixed heritage (Nooksack, Squamish, Chinese, French, Scottish) who was raised by his grandparents, father, step-mom, and extended family both in Ruskin, B.C., and in the Nooksack tribal community."[1] Gong is an advocate for pushing the discourse about mixed race identity to include the low-income experience. A senior board member and past president of MAVIN and codeveloper of the Mixed Heritage Center, he launched "What Are YouTube?," a viral YouTube video that inspired* MSNBC.com's *"Multiracial Americans Surge in Number, Voice," by Mike Stuckey, part of* MSNBC.com's *Gut Check America series. Since then, Gong has shared commentary or been featured in more than sixty major news outlets, including the* New York Times, NBC Nightly News, Indian Country Today, *and many others. He views his art as an extension of his activism and founded Eighth Generation, where he custom "tricks out" shoes with Coast Salish–style art on Vans shoes that "represent his complex identity" (plate 26). He is the subject of a 2010 short documentary film,* Unreserved: The Work of Louie Gong, *which chronicles his "unique style of merging art and activism."[2]*

Laura Kina interviewed Louie Gong in Seattle on August 25, 2009.

LOUIE GONG: I was born in Mission, British Columbia, Canada, which is a very small town about forty-five minutes east of Vancouver, very near the American border. I grew up there in the area until I was ten years old, when my family moved about twenty miles south across the U.S. border to the Nooksack tribal community. I lived there from age ten to twenty-three, my second year of graduate school.

LAURA KINA: Since you had to cross the Canada-U.S. border, how did that work in terms of immigration?

LG: The Jay Treaty addresses whether or not the international border exists for tribes whose traditional area of resource exploitation existed on both sides of that border. Nooksack and Squamish, the two tribes that my family is connected with, both move back and forth across the border freely. I have my tribal ID, which could theoretically get me across the border right now. I'm nervous about trying to test it,

as U.S. Customs is not known for being up to date on treaty law and the rights of tribal people. It's a great illustration of how complicated Indian identity is.

I went to school at Nooksack Valley High School, and ironically we were the Nooksack Pioneers. The irony that exists in that name didn't really hit me until last year, when someone interviewed me and asked me the same question. It was a largely all-white school, and the surrounding community was all farmers. When I started there in fifth grade, there were about twenty people just in my grade from the Nooksack tribal community, and by the time I was in tenth grade, there was one other Native person in my grade and just a handful in the whole high school.

LK: Did they drop out of school or go somewhere else?

LG: All those things and also pushed out . . . the rate of attrition for Native people of my generation and Nooksack community is very, very high.

I'm second-generation multiracial. My dad is half Native—Nooksack and Squamish—and half Chinese. My mom was French and Scottish.

LK: And how does this all work in terms of tribal rights for you?

LG: Although they have the right to determine their own criteria for group membership, the majority of tribes still use blood quantum as their primary tool for determining who can be enrolled. This is because there's infrastructure already in place for doing tracking enrollment by blood quantum. It's also cultural as well, after having been forced to use it for so many years. Squamish has a blood quantum criterion of half and Nooksack [of] quarter. I'm quarter Native, and thus I'm enrolled "Nooksack."

The other dynamic we have happen in my family is this sort of split. All the aunts and uncles that are "half-Native" are enrolled Squamish because the Squamish Nation has really strong economic enterprises and Nooksack has fewer resources. So it's adaptive for them to be enrolled Squamish, although they still maintain cultural and family ties to Nooksack.

LK: Do you identify as multiracial? If so, what terms do you use to describe this?

LG: I often use "multiracial," small "m," as an adjective to help describe my identity and racial background. I don't identify as Multiracial, big "M." I also say "I'm quarter Native, 100% Nooksack" as a way of illustrating the difference between tribal membership, which is essentially citizenship, and the idea that tribal identity is somehow biological, which has been imposed on us through colonization.

My family and I sometimes refer to each other as "Chindian." I think that has been an endearment that we have for each other and also other people who are of the same mix. I remember coming up with that term after my first exposure to *MAVIN Magazine*, and it has caught on in my family. Now, for the younger folks, it's like they've

always had this tool for describing their identity, whereas all I had when I was little was "mutt" and "Heinz 57" and so forth.

LK: Do your ties to any particular communities change depending on where you live? Now you're living in the Muckleshoot area, right?

LG: I grew up in my tribal community, and that's one thing that sets me apart from a lot of people who have been really successful doing academic work around Native issues or the multiracial experience. I think a lot of folks have had the privilege of not being fully connected to their community.

LK: Had the privilege of it?

LG: Yeah, in terms of advancing through school and work. My perspective on my work is rooted in my community-based experience. What I want to do and what I think leaders should be doing is rooted in what the community's needs are, not in my own interests. That value is a heavy thing to carry in professional life. I want my work to be accessible to people who are growing up the way I did. I have a strong sense of community that is rooted in my growing up in Nooksack, but the absolute strongest connection I have to a community is among the urban Native community here in Seattle.

LK: Do you see this in other cities, or is this unique to places like Seattle or Chicago?

LG: There is a group of cities that were targeted for Indian Relocation Programs during the 1950s. Chicago was one of those cities, Seattle was, Tacoma, Oakland— those cities all have very large urban populations. What is special about what is happening here in Seattle right now is the way we support each other. In everything that I've accomplished over the last couple of years, whether it's with MAVIN or the shoes or my regular job, it is because there is a whole team of people that are ready to support whatever it is that I decide is important.

LK: That's beautiful.

LG: It's a beautiful, spiritual thing to experience. I feel like, the past year, I've been changed forever because of other people's generosity.

LK: Do you ever address mixed heritage identity in your artwork?

LG: Yes, my artwork has always just been a reflection of what's happening with me internally. My experience has been so powerfully shaped by moving back and forth between communities that you see that consistently reflected in my artwork. In the very first painting that I did, which looked like a Coast Salish rock poster with a little bit borrowed from graffiti art, there were many, many cultural influences present. Putting it all together in a bold way says that it's okay to be complex.

The urban and contemporary nature of my Coast Salish artwork is also very impor-

tant because tribal communities are often rigid about the way we measure cultural authenticity. It's a powerful statement to connect pop culture with Coast Salish art because the only legitimate place that we see Coast Salish art is on the wall of the museum on a piece of cedar—looking traditional and stoic. Although to someone outside the community, [this] might not look like that powerful a statement, I felt like it was, and I was sort of nervous about putting it out there.

I graduated high school with, I think, a 1.7 GPA, and I went to a community college. It took a lot of effort to get right on that cusp of what you need in order to pass. I did well until my Grandpa Gong passed away. He used to help my cousin and me do math homework with an abacus.

I went to Whatcom Community College (Bellingham, Washington), where my friends were going. Many of them ended up not finishing, but I just thrived as soon as I got into college. I went from Whatcom to Western Washington University, where I got my bachelor's degree in psychology. I took a year off, and then I went to graduate school at Western, to the School Counseling Program, which just accepts four people a year. There was no squeaking by in that program!

I feel like I came into my own as a graduate student. I never talked to anyone or made any friends my whole time through my undergraduate degree. What really helped me was finding Western's Ethnic Student Center, where I was able to connect with people of a broad range of backgrounds, including mixed race folks. I was involved with MISO [Multicultural International Student Organization] from the beginning, and those spaces really gave me license to be myself.

LK: When did you graduate?

LG: 1999 and all during that time from the time I was eighteen to twenty-three, I was working with Nooksack kids in the Nooksack school district and the Baker school district. When I finished my degree, that's when I went Kingston to work as a school counselor. Now I am the educational resources coordinator at Muckleshoot Tribal College.

LK: What are your family's associations with war?

LG: My grandpa was a paratrooper in World War II and taught hand-to-hand combat for the Canadian military, but I feel the legacy of colonization of that social political war against Native people has really impacted my family. My family is very impacted by the trauma of colonization, and that has impacted me in some of the same ways war impacts other families. I'm doing really well for myself, but I can see my family, who don't have the connection to the sort of standard Native experience, they don't view themselves as being legit. Although they're still impacted by the legacy of the boarding-school experience, they haven't learned any of it, so they don't have

names for it. So I see them struggling without names for the things that are influencing their lives, and it's hard to watch.

LK: What does the name of your new company, Eighth Generation, mean?

LG: It has two meanings. First, eight's a lucky number in Chinese culture. It's also a play on the idea of seven generations, an intertribal value that we should consider the consequences of our actions seven generations out. By labeling the business "Eighth Generation," I was giving a shout-out to those previous seven generations who, by virtue of their good decisions and bad decisions, created the platform I'm privileged to stand on now—to create the shoes and know how to put the website together and move forward.

LK: So what was your intent with this work?

LG: It happened completely organically. I just decided to buy a pair of Vans after wanting a pair for twenty-five years. When the shoes on the shelf didn't match my tastes—or reflect my unique experiences, history, or culture—I bought a gray pair. One night, just by the light of the TV, I grabbed them and just started personalizing them with a Sharpie marker. When I wore them to work the next day, people started bugging me to make them a pair.

LK: Can you tell me about your hybrid *Coast Salish Dragon* design (2009) (plate 27)?

LG: My dad was a champion kickboxer and Thai boxer throughout the 1980s who traveled the world fighting and winning championships. And he also ran a kung-fu kickboxing school. Every day I went to the gym. At a young age, I opened up the gym, vacuumed, sometimes taught classes—it was a big part of who I was, that sort of martial arts culture, and I was really connected to the idea of the dragon because of that. Once I started really exploring my art, the first thing I wanted to be able to do was a Chinese dragon. But trying to put together a Coast Salish design that reflects a creature that is not indigenous is really hard. So it wasn't until after many tries that I was able to actually put it all together.

I love that piece and I want my family to have it. It's traditional on my Native side to give away the first thing that you create. I feel an intimate relationship with the piece because I'm very physical with all of my art. I use my legs and all parts of my hands and prop it up everywhere at different angles.

I feel like merging art and activism is what I was meant to do because it's been received so well—and it's all coming together with my role as president of **MAVIN**. For instance, another dream of mine was to say "It's okay to be mixed" on *Indian Country Today* [*ICT*], which is the largest platform for reaching Native people across the country. In my work with **MAVIN**, I busted my ass for years using my words and nobody at *ICT* wanted to cover the topic. It wasn't until I started making the same

statements with my art that *ICT* finally covered my work and brought some responsible discussion about racial identity to a group of people who are often left out of mainstream discussions.

LK: Is it dangerous to identify as mixed within Native communities?

LG: I think so. I mean, we're the only community that has resources directly, legally connected to the way we identify. Additionally, group solidarity has been really important to Native people. Identifying as mixed can be perceived as threatening that solidarity.

LK: If you're part white, does that make it seem like you're part colonizer or viewed as part enemy?

LG: In tribal communities, the concern is not so much about identifying people as the Other as it is about strengthening the community. So when it's time to introduce yourself, you say your tribe and who your family is. It's to identify connections. That being said, I grew up with "white" mostly used with a negative connotation.

I've noticed that more and more people are saying that "I'm Native and this," but to identify as Mixed, capital "M," as a primary identity is not really happening too much in tribal communities. For generations, you've needed to demonstrate and reinforce your connection to the community because you depend on the community for food, protection, whatever. It's still important.

LK: I know in Hawai'i, if you were to say you're "part white," you could be viewed as "settler-colonizer," and there's a political incentive just want to claim being Native Hawaiian. That's a really heavy decision.

LG: There's a lot of that depending on the tribal community. Take, for example, the differences between the Nooksack tribe and a pueblo in New Mexico. The Nooksack tribe wasn't federally recognized in the 1970s because we missed the Treaty Council in 1855. So during the time between 1855 and the 1970s, Nooksack had no legal land base, and there was this Nooksack diaspora. When we come back together, half of us are mixed white or mixed Filipino. Identifying as mixed in our community is going to mean something very different from some of the more isolated communities like the pueblos.

My art is just another way for me to articulate my values. I think the real artistry in what I do is the way my art provokes conversations about identity. It's an extension of the work that I've done in the past as an activist and community organizer. So that label of "artist," I don't like it when people apply it to me in the conventional sense of the term. . . . I don't fit into those boxes.

Transcribed by Marco Cortes, 2009

Resources

Arviso, Dana. "Eighth Generation Shoes: Made for Walking in Two Worlds with Style." *Indian Country Today*, August 20, 2009, http://www.indiancountrytoday. com/national/northwest/53845647.html.

Rector, Tracy. *Unreserved: The Work of Louie Gong*. Directed by Tracy Rector. Video. Seattle: Longhouse Media Productions, 2010.

Stuckey, Mike. "Multiracial Americans Surge in Number, Voice." MSNBC.com, May 5, 2008. http://www.msnbc.msn.com/id/24542138/.

Hello, Half-breed!:
An Interview with Debra Yepa-Pappan

Born in 1971 to a Jemez Pueblo father stationed in Korea and a Korean mother, DEBRA YEPA-PAPPAN, *aka "urbanindengrrl," is a digital pop artist based in Chicago whose work portrays contemporary Native people and interrogates American Indian stereotypes. A 1992 graduate of the Institute of American Indian Arts in Santa Fe, New Mexico, Yepa-Pappan curated* Intrigue & Novelty, *an exhibition of artwork by Native American women, which traveled in 2009–10 to Beacon Street Gallery in Chicago, the Schingoethe Center for Native American Cultures at Aurora University in Aurora, Illinois, and the Mitchell Museum of the American Indian in Evanston, Illinois. Her Native pop art work has been shown in Chicago and Santa Fe, New Mexico, and was featured in the summer 2011 issue of the Smithsonian's* American Indian *magazine.*

Wei Ming Dariotis interviewed Debra Yepa-Pappan in Chicago on October 25, 2009.

DEBRA YEPA-PAPPAN: My dad joined the army in 1969, and he was stationed in Korea. My mother lived in a town that was nearby the army base. She worked, maybe in a bar or something, so that's how they met. He left Korea, still in the army, and she was pregnant as he was leaving. After I was born in Korea in 1971, my mom started working on coming to America because she wanted me to grow up with my father and because it would have been much harder for me to grow up as a half-breed in Korea. I would not have been accepted, and I would have been treated like garbage because I wasn't full Korean. So we immigrated to the U.S. when I was five months old, and we lived in Jemez Pueblo, near Albuquerque, New Mexico, with my father's family for several months before we moved onto the army base with my dad in Mississippi. We moved to Chicago when I was about a year and a half old.

Wei Ming Dariotis: You're born at that time period when the "love child" phenomenon was certainly coming about, but at the same time, your parents literally met because of war. How do you feel being put under the "war baby / love child" label?

DY: It fits—because in those times, there were a lot of babies born who were conceived from the armies that were stationed in these Asian countries. A lot of those mixed children in those Asian countries were not treated well. The ones who stayed, who grew up in those countries, they weren't treated well at all, and that's something

my mother wanted to avoid altogether. She knew that would happen to me—I would be one of those war babies, one of those love children. She loved me with all her heart, and her family accepted me. They were accepting, but nobody else would have been; it would have been hard for me to grow up there, and she didn't want me to face that. I never asked my father, because my dad loved me with all of his heart and he was the best dad in the world. He was always accepting, just so proud of everything I did, no matter what.

I grew up in Chicago. I didn't grow up with other Native kids; I grew up with Hispanic kids in the neighborhood. My first Asian friends were when I went to high school. I went to Lane Tech. It's so diverse, ethnically. My only Native connection was my father and my relatives back home or my cousins when they would come to visit. When I went to college, I chose to go to the Institute of American Indian Arts in Santa Fe, an hour and a half from Jemez, and the school was all Natives, so that was where I started getting into "being Native" and that's where I started to learn more.

WMD: Were you accepted as a Native, or were you just seen as Asian?

DY: Everyone mistook me for Inuit or Eskimo. Everyone would ask, "Oh, are you Eskimo?" I would say, "No, I'm Jemez and Korean." Then I'd meet other Jemez people and they accepted me.

WMD: Was that because they knew your family? Or how did they connect with you as a Jemez person?

DY: Yepa is very common in Jemez, but since they're of a younger generation, they didn't know who my dad was because he left the reservation a long time ago. Their parents or their grandparents remember my father. Jemez isn't very big. We have a tribal enrollment of over three thousand people.

WMD: How do you identify yourself?

DY: When people ask me "What are you?" I say, "I'm Jemez Pueblo and Korean."

WMD: Do you ever identify as multiracial?

DY: I had never referred to myself as "mixed race." I have always said, "I'm Korean and Jemez Pueblo." Or simply, "I'm Native American." When I was younger, I would say I'm 50 percent—I'm half and half. I don't use that term anymore because the blood quantum issue is such a huge issue. Who is to say how much of a person you are? You are who you are.

WMD: Do you ever address your mixed heritage identity and themes in your artwork?

DY: Most of my work deals with my identity. In the beginning, it was more about my Native side. I did a series about it: *I Is for Indians*. I was closer to my Native side because of my friends and other Native artists. My husband also—he's part Native. He's Kaw, Osage, Cheyenne River Sioux, and Scottish. My work was dealing with

Indian stereotypes and trying to convey that Indians don't live in tipis, Indians don't say "how," and so on. It's more recently that I started to integrate my Asian side into it. I needed to deal with the Native side first, because being Native, being here on our homeland, I needed to face that issue first before I could bring the Asian aspect into it. I feel I'm doing that more now, and it's starting to feel right.

WMD: What are some ways you have been incorporating your Korean heritage or identity with your Native heritage and identity?

DY: I'm trying to integrate words and language, Korean language, Korean writings, old Korean writings, script, just because they're very beautiful. I'm using a lot of origami patterns now, and I think I'm trying to hit it from a design aspect first and what works aesthetically.

As a Native artist, there are a lot of expectations, that you incorporate all these eagle feathers, coyotes, and turtles and all the expected imagery. I think my work is always going to be identity based because identity is always going to be an issue. We can't escape the fact that we are who we are, and there is still a lot of racism out there.

WMD: In *Live Long and Prosper (Spock Was a Half-Breed)* (2008) (plate 28) and *Hello Kitty Tipi (Starry Sky)* (2007) (plate 29), what were you thinking about? What was your impetus?

DY: The *Hello Kitty Tipi* image in particular grew out of "Indians live in tipis" from the *I Is for Indians* series. I used Edward S. Curtis photos and manipulated those digitally in Photoshop, and my face is superimposed on a Plains Indian woman. I've recycled that image and incorporated something [Hello Kitty] that's familiar right now, something so mass-produced, and not to mention the fact that Ji Hae [Yepa-Pappan's daughter] and I are both big Hello Kitty fans, too. It's also a statement on what's happening with Native culture and just how Native culture is so—

WMD: Commodified?

DY: Exactly. Native American culture is such a product now, like Hello Kitty, and it's mass-produced in China or Taiwan in the form of gaudy beaded headdress things you can hang from your rearview mirror or dream catchers and things like that. *Spock Was a Half-Breed* was driven by the show *Blazing Saddles*, in Santa Fe. It was a Native sci-fi art show. Again, this piece is recycled from the *I Is for Indians* series; instead of an Indian gesturing "How!" it's a Vulcan-like Indian gesturing "Live long and prosper." And Spock was a half-breed, just like me! As this "Native being," I related to him.

WMD: What do you mean by "Native being"?

DY: His philosophy felt very similar to who I am as a Native person and as an Asian person—how we're very spiritual and very philosophical—and his view on the

universe is similar to my view on the world and how we deal with it. The whole story: the beginning, the origin. Origin is so important.

WMD: The moment that was really telling for me in the new *Star Trek* movie is when Spock is before the Vulcan High Council, he's being accepted into the Vulcan Academy, and he's being praised for having achieved so much despite his "handicap."

DY: Right, and his handicap being that he's half human.

WMD: Exactly! That's the decisive moment when he chooses not necessarily to be human or to be Vulcan—he chooses not to let somebody else's idea about what it means to "be" authentically one thing or the other define him.

DY: You just helped remind me about Spock's father. One of the reasons why I'm so proud to be both Korean and Jemez is that both my parents embraced each other's cultures. My dad was always so proud of things that were Korean. My mom was always pushing, "You know you should be proud to be Native American." I remember that part specifically when Spock asks his father, "Well, why did you marry a human then?" and his father admits, "Because I love your mother. Even though she's human, I love her."

WMD: Because he was an ambassador, so he was saying, "It would make sense for me as an ambassador to be able to know this culture better." And then later he says, "But, really, I loved her."

DY: Right! Exactly. And that drove it home for me because that was exactly how my parents were. You know, they really did love each other and they loved each other's cultures. My dad loved Korean music; my mom loved Native music, still loves it. My father passed away, but she still listens to his music. As diverse as both cultures are, there are so many similarities, especially in spirituality.

WMD: Was your mother raised Christian?

DY: No, she and my father were instrumental in helping open the first Buddhist temple here in Chicago. According to my mother, she knew some Korean Buddhist monks who wanted to open a temple.

WMD: So this was specifically a Korean Buddhist temple? And your dad also helped? That's interesting.

DY: I don't think the monks were American citizens, so my dad signed the documents for them. We used to go to the temple every weekend and to the annual picnics. I have a picture somewhere: there's a huge group of Koreans, the monks, and some people from Jemez [who] were living in Chicago at the time, maybe about five or six of them, and my dad—and we're all having this picnic together. That to me was normal, but now when I look at that picture, I think, "Wow"—that was really some-

thing you wouldn't see during that time in the '70s. It's a good example of my dad embracing my mom's culture.

WMD: It sounds like the way your parents drew attention to the similarities and appreciated them really helped you find a way to be both without having to feel like you had to choose one side or the other.

DY: There was no way my mom could get around being Korean or my dad could get around being Jemez, and that's just how we lived. During celebrations like Christmas and Thanksgiving, we always had the traditional American turkey and stuffing, but then we also had rice and kimchi, and we had Jemez enchiladas and chili stew all in one sitting. My dad was never ashamed and my mom was never ashamed— that's just who they were.

Transcribed by Marco Cortes, 2009

Resources

"Debra Yepa-Pappan." *Red Ink Magazine*, Spring 2009.
Montiel, Anya. "Debra Yepa-Pappan: All Native, All Asian and All Chicago." *National Museum of the American Indian Magazine* (Summer 2011): 12–15, 18–19.
Weber, Candice. "Art Review: Transfusion." *Time Out Chicago*, no. 184 (September 2008): 55.

Blasians:
Mixed Black Asians

What Used to Be a Footnote: Claiming Black Roots in Asian American–Asian Caribbean Historical Memory

WENDY THOMPSON TAIWO

BEING CHINESE AMERICAN for me has always meant taking into account my own mixed race, post-1965 immigrant family background. I was born in Oakland, California to an ethnic Chinese mother who immigrated to the United States in 1974. She had never before gone to a drive-in movie theater or kissed a Black man and my African American father would introduce her to both. However, when my mother's family found out about her relationship, they forced her to end it due to their own racial prejudice, and when she didn't, they rejected her. This left my mother's marriage to a Black man in 1979 an ongoing subject of anxiety and embarrassment among my maternal relatives.

Over time, the marriage would fail, leaving her with three mixed race daughters who would remind her of where her path cut away from the rest of Chinese America and permanently bound her to Blackness. I remember how she would go to such great lengths in order to resist this: grooming us into nice little Chinese girls— obedient, respectful, polite—with no dark corners. However, there was no way that race, or more specifically Blackness, and its many meanings would not find its way into our lives, no way our mother could prevent it from chewing through the careful identities she had constructed for us. And so we stood divided in our own skins.

So long had I lived with the notion that it was normal to both privilege and reject parts of myself that I didn't even recognize my own desire to be whole until I was well into adulthood. By then I was nearly starved, having hungered most of my life for a language that could bring together a common cultural history and human geography encompassing Chinese and Black America. I thought that if I was able to find the pieces, I would be able to create that language. Thus began the journey to locate sites of interaction between Chinese immigrants and people of African descent and to address the seeming denial of the passage of Black bodies into Chinese American and Chinese Caribbean families and communities.

Historical reality places Chinese immigrant men on plantations across the American South after they had been recruited by southern white planters as replacements for emancipated Black labor (fig. 25.1). Among those who arrived and settled in the area, a significant number eventually took Black and mixed race women as wives and fathered the next generation as Chinese African American children. Yet, over time, it became clear that some privileges could be courted from whites as long as one stood as far away from Blacks as possible. And so certain members were pushed out of families and certain families were pushed out of communities until nearly all the darker parts of southern Chinese American community histories got swept under rugs laid out politely for white neighbors.

It was as bitter a sacrifice as one can imagine: intentionally letting go of beloved relatives and favorite family stories in exchange for what many would mistakenly assume was a sure way of attaining the American Dream. This racial and intimate betrayal that occurred in numerous Chinese communities across the Americas would leave a traumatic scar in the historical narrative that most would rather not touch. Because in order to tell the history the way it actually occurred, one would have to talk about the interracial sex, the close proximity of Blacks as neighbors and as good friends, and the ugly collective decision to adopt white supremacist ideals in what was an intensely racist climate and geography.

This collective decision was one of the motivations that led the Chinese community in the Mississippi Delta to use forms of racial policing in order to force out certain individuals who had known amounts of African ancestry. Through communal shunning and public outing, racially mixed men and women and their families were barred from participating in most public events and using common facilities. In some instances, these men and women chose to preserve their dignity by cutting ties and leaving both the community and the state behind. The following cases illustrate the attitudes and lengths to which members of the Mississippi Delta Chinese community went so as not to jeopardize what they felt were beneficial and positive relationships with whites.

In 1947, a young boy whose father was Chinese and whose mother was both African American and Chinese was expelled from a white Catholic school for misconduct. His parents went to enroll him in a nearby white public school, confident that he would be accepted. But after a meeting with the school administration, the boy was promptly refused. It was later revealed that local Mississippi Delta Chinese leaders had approached school officials and told them that the boy was not "pure Chinese," and this disclosure led to the decision to reject the boy. Angered by the ordeal, the family decided to pack up and leave the state.[1]

Fig. 25.1. A branch of the Joe Gow Nue and Co. Grocery and Meat Market, Leland, Mississippi, 1939. The Joe Gow Nue & Co. Grocery and Meat Market was one of the larger Chinese-owned enterprises in the Mississippi Delta and had multiple branches. The largest was the No. 1 store in Greenville, Mississippi. These stores catered to a largely African American clientele who utilized the stores not only as places to shop but as sites of leisure and informal exchange. Library of Congress, Prints and Photographs Division, FSA-OWI Collection, LC-USF34-052450-D (b&w film neg.).

In another incident, a woman who looked passably Chinese and had come to worship at a local Chinese mission was quietly turned away by some members of the congregation. When asked years later why this had occurred, one Delta Chinese resident would recall: "They didn't want the whites to know she had Hok-Guey [African American] blood in her . . . it was bad for them to be associated with her."[2] Left with few options, some mixed race individuals and their families chose to downplay or outright deny African ancestry in an attempt to remain a part of the community. Others lived somewhere on the margins.

Other communities across the country viewed interracial unions between Chinese and African Americans with a bit more ease and thus exhibited varying degrees of acceptance. Students who attended a Los Angeles Chinese-language school in the 1930s remembered peers who were of mixed Chinese and Black parentage with whom they interacted freely.[3] But generations later, where have these oral histories and artifacts belonging to Chinese individuals and families with African ancestry gone?

The continued erasure of lineage, community, and identity, whether intentional or unintentional, leaves an unfortunate absence in the rich history of people descended from Asian immigrants in the United States and the Caribbean. Those who came into contact with Black men and women would see their worlds through a different racial lens, an experience from which they would develop entire systems of knowledge and ways of being. Things were especially different for those who were most intimately connected: the girl who grew up in or near a Black neighborhood, the boy who had been "schooled" by his Black peers, and the man who fathered and raised five mixed race children.

Arriving partially under contract in the United States and the Caribbean as a predominantly male labor force, Asians in the New World often found themselves working and living alongside people of African descent. The majority were put to work on plantations or recruited to carry out various transportation and agricultural projects. And in response to a mix of dislocation, desire, and, in the case of the United States, legal restrictions meant to curb both further immigration and miscegenation, many of these men entered into romantic and sexual relationships with nonwhite women.

H. J. Clark noted in 1893 that in Trinidad, Chinese men "have intermarried freely with the native women, and their descendants are thus being gradually merged in the general population."[4] And in British Guyana, Henry Kirke, a magistrate who penned the memoir *Twenty-five Years in British Guiana, 1872–1897*, observed that "As Chinese women are scarce, the Chinaman has always a coloured woman as a concubine, and they generally manage to get the best looking girls in the place."[5]

Over time, Asians in the United States and the Caribbean would become active

members of the communities in which they lived, investing themselves in the local economy. They would transition from a laboring class to a small-business owning and professional middle class. In Jamaica, the Chinese opened up "grocery stores, bakeries, aerated water factories, ice cream parlours, restaurants, laundries, Chinese groceries stores, hardware stores, dry goods stores, bars and taverns, haberdasheries, wholesale groceries, agencies."[6] In Guyana, a small but steady number of Indians filled professional occupations as doctors, teachers, lawyers, "mechanics, clerks, postmasters, male nurses or dispensers, government civil servants, . . . interpreters, and police."[7]

Occasionally, these men and women would find themselves placed in contention with Blacks, whose perception of them as foreigners able to make certain gains and achieve certain professional opportunities where Blacks were denied led to hostility and violence.[8] However, they would continue to thrive in their new homelands, and their children would participate in such cultural markers of national identity as carnivals, sporting events, beauty pageants, politics, and various forms of artistic, literary, and musical production.

During the 1930s and 1940s, American-born children of Chinese immigrants who settled in or near predominantly African American neighborhoods frequented Black clubs and entertainment venues, "even stomping the lindy hop at the Savoy Ballroom."[9] Some of them had no hesitation about dating across the color line. According to an oral history interview of his sister conducted decades later, Chinese Angeleno Harry Lem had dated a series of African American women during the 1930s.[10] And despite the fact that their mother "quietly abhorred" his dating preference, Harry would bring the women over for dinner. As his sister put it, "Harry loved black women."[11]

These Asian Americans and African Americans were friends and lovers, colleagues and neighbors. And on occasion, they were people whose lives were torn by particular racial and political crises that could have separated them. During World War II, Executive Order 9066 mandated that persons of Japanese ancestry living in much of the West Coast be evacuated and interned, and some non-Japanese friends and spouses chose to stay with their loved ones.

Japanese American writer Jeanne Wakatsuki Houston was a child when she and her family were sent to Manzanar, where she recalled seeing a woman taller than almost all the other internees who wore "an Aunt Jemima scarf around her head." This woman and her husband had an adopted Japanese daughter with whom Houston occasionally played. It was only a matter of time before Houston "realized [that this woman] was half-black, with light mulatto skin, passing as a Japanese in order to remain with her husband."[12]

Before entering the camps, others had adopted certain styles of dress and behavior from urban Black and Chicano expressive culture and would continue to display and perform disruptive forms of fashion and speech in front of the other internees. This included a small population of young Nisei men and women who had grown up in cities like Los Angeles, Stockton, and San Francisco and instead of choosing to finish their formal education, "hung out in bars and on street corners." The young men dressed as zoot-suiters, wearing "broad brimmed hats, padded shoulders, pleated pants that dropped to narrow cuffs, and floor-length chains hanging from their pockets."[13] Some at Amache, which was also known as the Granada War Relocation Center, carried knives and would travel in packs to settle fights.[14]

Their street sensibilities and general disinterest in participating in the maintenance of peace and order in the camps were at odds with the political agenda of more conservative Japanese Americans who championed obeying orders, avoiding conflict, and keeping a low profile. But instead of a form of deviance, these youths' refusal to conform should perhaps be read as their expression of "a cultural politics that rejected [both] their inferiority and . . . [the] desire to be like the rest of U.S. society."[15] They used their bodies as a medium for expressing rebellious power and public resistance during a time when many Japanese Americans were disempowered and expected to submit.

Having a full history, which paints a complex picture of dynamic contact and exchange between Black and Asian people in the Americas, is a powerful tool. And although we lack a large archive of visual references that might illuminate the lives and stories found in these historical accounts, the few images that we do have serve as powerful testimony that challenges this precise omission in the canonical telling of Asian history in the Americas (fig. 25.2). These images attest to the fact that Black bodies—Black people—were present in the everyday lives of Asian immigrants and their descendants, shaping the various dimensions of their humanity and world.

Equally powerful are the contemporary works of individuals of African and Asian parentage. Artists Mequitta Ahuja and Albert Chong both offer the possibility of a hybrid vision of the self. In photographs and paintings, both use their bodies as lenses or canvases for mapping a story—about family and ancestry—while positioning bones and hair to speak to larger issues about roots and race. Their work, which places family and individual histories into frames, pushes viewers not only to rethink who is telling the story and what stories are being told but also to see the lineage of shared experiences between people of Asian and African descent in the United States and the Caribbean.

Fig. 25.2. Patricia Koo being held by a mixed race woman, Washington, D.C., 1918–20. Koo was the daughter of V. K. Wellington Koo, a prominent Chinese diplomat to the United States. One of her stepsisters, Genevieve, would later marry African American photographer, musician, writer, activist, and filmmaker Gordon Parks. Library of Congress, Prints and Photographs Division, FSA-OWI Collection, LC-DIG-npcc-00461.

Jamaican Hybridity
within the "Bowels of Babylon":
An Interview with Albert Chong

ALBERT CHONG *is best known for his photographs, which, in his words, "reanimate" remnants of old family photographs. Working with photography, installation, and sculpture, he addresses "personal mysticism, spirituality, race, and identity." Born in 1958, Chong grew up in Kingston, Jamaica, and moved to Brooklyn, New York, when he was nineteen. He attended the School of Visual Arts, in New York City, where he received his BFA degree in 1981. In 1991, already a nationally established artist, he earned his MFA degree from the University of California, San Diego. His work has been shown at museums and galleries around the world, and he has received numerous prestigious awards including a 1992 Individual Artist Fellowship from the National Endowment for the Arts and, in 1998, a Guggenheim Fellowship in the field of photography and the Pollock Krasner Grant. He has represented Jamaica in four international biennials, including the 2001 Venice Biennale, the 1998 São Paulo Biennale, and the seventh Havana Biennial in Cuba in 2000. He is a professor of art at the University of Colorado, Boulder.*

Laura Kina talked with Albert Chong on the phone in April 16, 2010, right after he finished installing his new work at Project Row Houses in Houston.

ALBERT CHONG: My ancestry is between Chinese and African-descent Jamaican. My grandfathers were from China, and my grandmothers were of African descent, what is commonly referred to as "Black Jamaican." A lot of it had to do with the Hakka people from China, from Canton. Some of them came through indentured servitude, but there was a lot of immigration around the 1900s. Places like Guyana, Jamaica, and Trinidad got influxes of Chinese and Indian immigrants. Initially, they worked the sugarcane fields, especially the Chinese in places like Jamaica. Most of the Chinese immigrants who gave up field labor opened their own businesses as shopkeepers and merchants. My parents were merchants and shopkeepers . . . we sold everything. My father was a sort of a jack-of-all-trades but primarily a merchant, also a petty court judge, and he dabbled in construction as well. Then, later on, we were confectioners. We made sweets and a lot of popcorn, every kind of popcorn

imaginable—caramelized popcorn, salted popcorn. We also made other confections such as tamarind balls, guava cheese [guava paste], coconut cake . . . all kinds of confections. We sold the family shop because things got really rough in downtown Kingston; we got robbed a couple of times. The previous family business was a grocery shop. So we sold everything from flour to sugar to salted provisions: every kind of thing a general store would sell. We were wholesalers and sold mostly to local vendors.

LAURA KINA: Do you identify as multiracial?

AC: My mother and father have almost the exact same hybridity and similar family histories in that both parents never knew their parents. My mother never knew her mother or father. And my father never knew his mother until much later in life when he managed to find her.

I guess I would identify as "multiracial." Generally it would be "Afro-Asian–Jamaican," but I also have a U.S. passport. My main ties, initially, were to Jamaica, but later ties, in Brooklyn, New York, were to the Afro-American community, especially the community of artists. And then, later on [ca. 1984], I became involved with the Asian American Arts Centre, Bob Lee, so through him, I've got a little bit of connection to the Asian art community in New York.[1]

LK: When I heard you talk at DePaul, this complicated family history seemed like a really important part of your artwork.[2]

AC: Yes. I've been trying to put the pieces together growing up over the years because the family has these different branches, from those of full African descent to us who are hybrids to then the other side who are all Chinese. Because I was the last child in the family of eight, I used to take a great interest in the photo albums and trying to identify with the individuals.

The real catalyst had to do with the one existing photograph my mother had of herself as a child, which she asked me to fix because it had gotten worn and torn. That was the image called *The Sisters*. That was in those pre-Photoshop days, and fixing it meant maybe trying to rephotograph it and doing what you could with it. In the process of rephotographing it, I ended up making a still life out of it, because I got a little bored by the process. That original image somehow got lost, so my still life became the only surviving photograph of her as a child.

I realized the importance of these images. I saw how they're very quiet testimonials to a life lived, evidence of one's existence, especially if you grew up sort of poor and disenfranchised. There wasn't much evidence of one's existence in those times because photography was not readily available to a lot of poor people. People like my mother or father got photographed at very specific occasions in their lives, usually in infancy or as children.

In my family, my paternal grandfathers would send the full-Chinese offspring to China, and those from unions with Black Jamaican women were generally left to their own destinies. My father, being one of those unions, never got to go to China. He spoke Cantonese, but that was always a sore point with him, the sort of racism within the family such that my grandfather respected only the full-Chinese offspring, even though in those days they took great liberties with the Jamaican women of direct African descent.

LK: When you made the original version of *Portrait of the Artist as a Victim of Colonial Mentality 1979/2010* (2010) (plate 30), you were still in Jamaica then, right? [Chong remade the work in 2010 by transferring the original image onto a grid of ceramic tiles.]

AC: No, that was done in New York. I had just moved to New York permanently in 1977, and the photograph was made in 1979. I had just started at SVA [School of Visual Arts] in 1978, so the photograph was made in 1979. Really [*laughs*], it was not something that I took seriously; it was done just as a joke. I was house-sitting a photo studio in Manhattan on Twenty-Sixth Street; I had these sets and would occasionally do self-portraits and portraits of friends. I was just playing around, working with some props that were there that included a pith helmet. I'd always been aware of these photographs that were made by colonial powers, by the British in India or Africa or wherever they colonized. Our knowledge of these places was through colonial portraits of officials. I was doing a spoof on the idea of the colonial type with the pith helmet and a ball and chain around my ankle, so there's a rope or a little cord tied to my ankle with a steel ball or iron ball, and there's some flowers and a stone obelisk. I was just trying to play with the idea of the colonial type, the colonial photograph of a colonial subject. And of course at that time in my life, having left Jamaica, I was this young militant Rastafarian—all that stuff was running around in my head: the idea of being from a colonized culture and being a transplanted Jamaican and being a militant Rastafarian, of fighting the system. So the photograph was made, but the first time it was exhibited recently was in Houston [in 2010].

It's never been shown because it's not a photograph I took seriously. But in looking back, that photograph led to the series of self-portraits called *I-Traits*, which is a series that went on for five years.[3] I was exploring the idea of a Pan-African cosmology to do with a transplanted hybrid individual with connections to Africa, the Caribbean, and now the United States and how to reassemble or to reassess one's self within the bowels of Babylon, as we would call it back then. Living from one Babylon to the next, which is how a lot of Jamaicans and Rastafarians, in particular, regarded Jamaica and any place to do with Europe and the West, as part of the Babylonian oppressive system. A lot of the self-portraits were about trying to create a visual iconography or

visual cosmology of sorts by referencing a lot of stuff that I would try to put into the picture.

LK: You've just finished remaking this piece at your Project Row Houses artist residency in Houston. What inspired you to cut it up and put it on tiles? It reads differently now because it has a physicality to it that it probably didn't have before.

AC: Exactly. That's what these pieces are about, trying to make photographs more substantial and almost sculptural and having a physical presence, a weight, a density, a mass. It's kind of odd because I don't look like that anymore—I wish I did.

LK: [*Laughs*] You are very good-looking there! One of the reasons I picked the piece out is that it looks like a contemporary fashion ad. It doesn't look like it's from 1979. It looks very contemporary, but it's the real deal.

AC: You know, I bought one of these buck knives in Long Island, just to open coconuts and to cook with, and so it became a personal object that I used a lot. That's what I'm wearing around my chest; the knife is in this sheath. I'll be truthful, I'm not working cerebrally or mentally a lot of times when I'm making photographs—otherwise I would shut down. I have to work by tapping the "universal subconscious," this idea of a long lineage of humanity that I tap into in terms of making these images.

These photos were done with a camera on a tripod, long exposure, me walking into the frame, doing my thing, and then walking out and turning off the camera. Generally, you walk in and it's a kind of spontaneous reaction to the camera, on one hand, and then, on the other, you have some sense that that's what you're trying to do. Some of the archetypes that occupied these images are the sage, the natural mystic, the farmer, the keeper of fire, the healer, all these kinds of entities that I was trying to call upon. None of it is really grounded. It was dealing with cultural stereotypes that had elements of proof to them and meaning, in terms of our path, in terms of a romanticized notion of Africa as well as being a kind of transplanted individual who's just another member of the diaspora.

LK: And what about *Imagining the Past* (plate 31), which you created for *Out of the Archive: Process & Progress* at the Asian American Arts Centre in New York, 2009?

AC: That one was a retrospective using select images from five bodies of work within one piece. There are photos from the *Throne* series, photos of the self-portraits, some from the color still lifes, some from the regular black-and-white still lifes, and some from the Jamaican portraits.

The show was about the Asian American Arts Centre's archives. Due to the small scale of the exhibition space, I didn't think that I could show a grouping of photographs that would make any sense. That was the first time I actually did the tile scheme. One of the inspirations of that piece, my girlfriend reminded me, was that she has been working with doing transfers onto different kinds of surfaces. So I

decided that I liked the idea, and I went to a tile shop, looking at what I could use, and then, my own dissatisfaction with the one-dimensionality of photographs. I've always been fascinated by objects and became sort of an object maker as well as an image maker over the years.

LK: Your work frequently addresses colonialism and postcolonialism. What does the phrase "love child" evoke for you in relation to your personal history or work?

AC: It would have to be connected to the males of the family, especially on my father's side, of having a lot of children outside of marriage and having mistresses and that kind of thing. Let's just say that, growing up, I discovered sisters out of the blue. I had a sister who came to live with us at one point when I was fourteen, who I never knew about. I think I still have two siblings who are not officially recognized. We've always been warned that whoever we hook up with, we should really find out who they are so that we're not related. On the Chinese side of the family, on both sides actually, there was a lot of "fraternizing." It's something that I myself didn't want to continue.

I remember a story the day my father died, when he was being buried in New York. A brother-in-law of mine was taking a friend to the airport, this woman I knew who was involved with a well-known Jamaican singer. He told me that the day of the funeral, he was taking her to JFK. She gave him a crumpled-up old photograph. And she said that her mother gave her this photograph and that the Chinese man in the photo is her father. She would always remember this Chinese man who would come and bring money for her mother. I still have the photo; I was in the photo actually. It was a photo of my father.

Jamaica was notorious because Black Jamaican women were less empowered and were not in the same positions of power as these Chinese males. In Jamaica, Chinese males had more status and were more affluent because of being merchants. There were a lot of unions of Chinese men and Black Jamaican women at that time, and my family wasn't any different. The hybrids of these families would seek each other out because they were the only people they felt comfortable with, because you weren't really accepted by the Chinese if you were mixed. Among the Black Jamaicans, you were accepted because you were disenfranchised the same way or disempowered. I think my parents sought each other out to some degree, and there were a lot of unions between hybrids in Jamaica.

There's so much mixing in Jamaica now, so I don't know that their quest for similar hybridity continues today. I never asked them if they actually sought each other out. I wanted to, but now it is too late to ask [*laughs*]. It was just that they had these very similar life stories, both being orphans, both having the same hybridity and all of that.

LK: Do you think that turning the photographs back into objects, as you've done in *Imagining the Past* and *Portrait of the Artist*, is part of the process of rehabilitating photography? You are a photographer, if anybody's a photographer. You've made huge contributions to photography. Does that sum up what's going on in the studio right now, of just getting the object back?

AC: Well, it's not even the object, it's the vision. It's the having something to say and having an interesting way of saying it. So many photographers have nothing to say or any interesting ways of saying it. There are a lot of white photographers with the same kind of cultural malaise, the whole business of having nothing to say because you're so privileged and the world is so good. If you can point a camera, does that make it a vision, or meaningful? I see massive retrospectives of photographers at the Whitney Museum, and it is the most boring awful stuff. I've been trying to figure out what's interesting about this stuff, and over time, it just grows more and more critically acclaimed, but there's nothing there.

That's what my life in photography has been about—it has been about trying to express the deeper aspects of my psyche, if that's at all possible. I don't think you can say anything meaningful with abstraction, period. There's no way of doing the narrative; it needs representation in order to communicate. I have a lot of friends, painters, who are Jamaican; we talk about the struggles for Jamaica and Jamaicans' insensitivities and near ignorance with art. And yet these same artists, they're doing nice abstract art, and I say, "Well, how do you bring the people into the struggle? How do you inform the people? How do you start out movements where art is an essential part of that process if you're doing these nice pretty mark-makings on canvas?"

You have entire generations of Black painters who embraced abstraction to the core. They weren't interested in the community. They just wanted the freedom to be artists, and they weren't interested in communicating the struggle. In certain works, they might have done that in the past, but really what they were after was the same privilege of subject matter not defined by race or ethnic identity that whites artists enjoyed.

But still, what can be said about them? How do you say that it contributed to the enlightenment of humanity or to the struggle of your culture or people? That's why the social realists were so important in regards to Mexico. It could never be done through abstraction. All the abstract painters I know, who happened to be Black, were really just, what I might call, "jonesing for privilege." We all wish we could have that privilege and freedom to make whatever we want whenever we want and be represented by some fancy gallery with loads of money. But that's not always our reality. In fact, it very rarely is.

Resources

Blink: 100 Photographers, 010 Curators, 010 Writers. London: Phaidon Press, 2002.

Chong, Albert. *Ancestral Dialogues, The Photographs of Albert Chong.* Carmel, CA: Friends of Photography, 1993.

———. "The Photograph as a Receptacle of Memory." *Small Axe, A Caribbean Journal of Criticism* 29 (2009): 128–34.

Hall, Stuart, and Mark Sealy. *Different: A Historical Context; Contemporary Photographers and Black Identity.* London: Phaidon, 2001.

Automythography:
An Interview with Mequitta Ahuja

Born in Grand Rapids, Michigan, in 1976, MEQUITTA AHUJA *is the daughter of a father from India and an African American mother; she and her sister grew up in Connecticut. Ahuja earned her BA degree at Hampshire College in Amherst, Massachusetts, and her MFA degree from the University of Illinois at Chicago. Holland Cotter, art critic for the New York Times, cited Ahuja's New York debut exhibition* Automythography I, *stating, "the pictures turn marginality into a regal condition" (June 1, 2007). In February 2010, she was profiled in the "Artist to Watch" feature of* ArtNews.

Ahuja's work has been exhibited across the United States and in France, Belgium, Germany, India, and Dubai and was featured in the 2007 Global Feminisms exhibition at the Brooklyn Museum. She has had solo exhibitions at the Minneapolis Institute of Art, the Museum of Contemporary Art Chicago, Lawndale Art Center in Houston, BravinLee Programs in New York, and Galerie Nathalie Obadia in Paris. She was awarded the 2008 Houston Artadia Prize as well as the 2008 and 2009 Joan Mitchell Award. Ahuja was a 2006–8 artist in residence at the Core program at the Museum of Fine Arts, Houston, and a 2009–10 artist in residence at the Studio Museum in Harlem in New York. She currently resides in Harlem.

Laura Kina interviewed Mequitta Ahuja via e-mail on April 19, 2010.

LAURA KINA: How did your parents meet?

MEQUITTA AHUJA: My father came to the U.S. from India for graduate school. He met my mother at the University of Cincinnati in 1969. I think both of my grandmothers were uncomfortable at first with their choice to be together. It was truly a foreign idea for my father to be with a Black American woman. This would not have been in the realm of my grandmother's experience; likewise it was very unusual for my mother to be with an Indian man.

LK: How do you identify yourself in terms of race, ethnicity, and religion?

MA: I identify as ethnically mixed, as Indian, South Asian, as Black, African American. I use all of these terms to refer to myself. In my lifetime, I have met only three people besides my sister who share an Indian and Black parentage. I don't use the term "race." I also identify strongly as an artist and feel part of the arts community.

Through my work, I feel I can have relationships with each group on my own terms. I live in Harlem. Harlem is predominantly Black but extremely diverse. There are African Americans, Dominicans, people from the Caribbean, Africans, native French, Spanish, and Arabic speakers, Muslims, Jews, Christians, the wealthy, the poor, Black people with PhDs, artists, teachers, and political activists. I have many Indian friends as well. My family has strong connections to the Indian community in Connecticut. My family is not particularly religious. My mother was raised Catholic, my father Hindu.

LK: How do these identity issues relate to your work?

MA: In order to make the complexity of my ethnically mixed subject position visible, I focus on self-portraiture and landscape. As self-portraits, my works inherently address my identity. I want the figures to be both generalized and specific. They are simultaneously female archetypes and self-portraits. The landscapes, which border on total abstraction, are the domain of the figure. I refer to my ongoing project as *Automythography*. A variation on the term coined by my artistic parent, author Audre Lorde, *Automythography* blends cultural history and myth with personal narrative.

LK: How do you relate to the ideas expressed in the title *War Baby / Love Child*?

MA: My father was born in the year of India's independence [1947]. Certainly, war is a factor in every person's family history; however, war doesn't enter my understanding of my parents' relationship. While I don't identify with the connotations of the term "love child," some of my relatives' marriages were arranged, whereas my parents' marriage was a "love-marriage."

LK: Can you tell me about your drawing *Spark* (2009) (plate 1) and your painting *Dream Region* (2009) (plate 32)?

MA: *Spark* and *Dream Region* are both pieces of a larger body of work in which I used two central devices, inversion of the head and exaggeration of the hair. The inversion of the head was to disorient the viewer's relationship to portraiture and to signal a shift from the real to the imagined, from the biographical to the automythic. The exaggeration of the hair is a response to the history of Black hair as a barometer of social and personal consciousness. I made the image of hair both physical and conceptual, giving it the psychic proportions hair has in the lives of Black people. The flow from the head became a flow from the mind: a vehicle of infinite possibility.

LK: When I look at *Spark*, I instantly think about your biraciality, but I also simultaneously associate it with DC Comics' Wonder Twins, Zan and Jayna, from my childhood in the '70s. . . . "Wonder Twin Powers ACTIVATE!" Were you referencing pop culture or your biraciality in any way? For example, you are wearing a kurta and a pajama. I also noticed in *Dream Region* that there is a decorative sensibility that

could be associated with a South Asian aesthetic and Orientalism more broadly. Can you talk about these choices?

MA: I use my own clothes, including salwar kameez, saris, etc., in the work. I think of the photographic process I use as a kind of private performance as I attempt to find an effective gesture for a given piece. My dress is part of the gesture. Each article of clothing contributes its shape to the shape of the figure. The shape of the figure, in turn, affects the composition of the piece. I choose clothes for their shape, drape, pattern, and character. As a whole, my presentation of myself embodies who I am, including my mixed ethnic heritage.[1] For *Spark*, very different than *Dream Region*, I wanted to limit my materials to pencil and paper and see what range of values, intensity, and material textures I could achieve within those limits while still maintaining visual drama and complexity.

LK: How do you approach your work formally?

MA: Formally, I usually pursue definitive shapes. Working large, I often build my shapes with smaller elements. Although embodied by a finite shape, I do aim for the work to suggest an endless, internal world extending beyond the limits of the page.

Resources

Franklin, John Hop, and Alivia Wardlaw. *Collecting African American Art.* Houston: Museum of Fine Arts, Houston, 2009.

Moyer, Carrie. "VIVA." *Modern Painters*, March 2007.

Reilly, Maura. *Global Feminisms.* New York: Brooklyn Museum, 2007.

Mestizaje:
Mixed Latino Asians

Revisiting *Border Door* and UnEarthing Los Anthropolocos' *White-Fying Project*

RICHARD A. LOU

The Two Impulses

When I begin to pull away at veils of transpired memories and experiences without the comforting intellectual framing of ideology, history, humor, and my training as a visual artist, I find some of those places where my raw and roiling anger resides, slightly hidden and alone. I have often joked about the love affair that I have with my anger, my intellectual muse imbued with an insidious relentlessness. And the work that I create is in response to the love I have for my family and community. Ultimately, my work is motivated by two impulses—love and anger.

An Unrecognizable Spot

As "mixed race" people, a notion that is already problematic, we complicate an entrenched binary dynamic of black and white in the United States of America by challenging the dominant culture's notion of purity—by creating space in a highly contested language in order to exist. As members of marginalized groups, we are discreetly understood to have another "other" to our Otherness. Our mixed race ancestry heightens our marginality, as we do not fit into any recognizable racial/ethnic category. We become a curiosity within a curiosity. In addition, our respective transitive affiliations within our own shifting communities become suspect. All of these dynamics serve to reinforce the neutrality/centrality of whiteness—a highly un-interrogated position. Whiteness becomes an invisible barometer of normality. Thus we are always asked to define ourselves, and we start where we always start—with our families, as a way of asserting and affirming ourselves culturally.

To be transported from one world into another, from Canton, China, to Coahoma, Mississippi, to San Diego, or Panuco, Sinaloa, to Tijuana, BCN (Baja California Norte), necessitates an incredible leap of faith and a great bundle of courage. To push against and to create a somewhat permeable bubble against the voluminous and

cacophonous culture of the United States in order to create an acceptable hybrid space that reflected my parents' own upbringing, to raise four children in a creative and nurturing environment must not have been an easy task. My mother became part of a twin bridge, my father being the other: one foot in China, the other in the United States. Her feet were in México, where their children could learn about their origins, their respective cultures, and their collective history within the curious and dynamic frame of an ever-changing present. Our family was both a product and emblematic of the fluid hybridity of the México-U.S. border region.

"A Border Phenomenon"

My father, Lou Yet Ming, was a "paper son" from Canton Province, China, and he rightfully claimed that he was from the Mississippi Delta in Coahoma, Mississippi. He was educated both in the United States and in China, traveling on trains and steamships as a young boy. A month after Pearl Harbor, he enlisted in the U.S. Marine Corps and served for the duration of World War II. He was honorably discharged from the marines as a technical sergeant in San Diego, California. At thirteen, my mother, Guillermina Arredondo Lizarraga, immigrated alone to Tijuana with only a second-grade education and the gritty wisdom of a survivor. She was from Panuco, a small silver-mining town in the mountains of southeastern Sinaloa, México, some 1,200 miles away. They met in Tijuana at a coffee shop where my mother worked as a waitress. The circumstances of their meeting highlight their courage as an interracial couple in the 1950s brought together by a world war, the racist aftermath of the Chinese Exclusion Act, sexism, and poverty. I remember explaining all of this when I met artist David Avalos, who in 1987 was a curator at the Centro Cultural de la Raza in San Diego. David had called me for a meeting to talk about my photographic work, *Inner City Portraits / Self Portraits*. Astonished by my family's story, David called my hybridity "a border phenomenon."

"Chino Chino Japones Come Caca y No Me Des"
(Chinese Chinese Japanese Eat Shit and Don't Give Me Any)

My father worked as a butcher for Mayfair Market in San Diego and would ferry my oldest sister, Linda, and me across the border daily to Harborside Elementary School in Chula Vista. The Migra (Immigration and Naturalization Services) would question our legitimacy and identity on a daily basis as we crossed the border into a destabilized sense of self. The daily crossings, and their idiosyncratic meanderings, were informative and formative in the construction of my worldview. In Tijuana, we were

part of the middle class, supported by my father's working-class union wages in the United States. As biracial children in La Colonia Roma, we were for the most part considered Mexican and accepted into a largely homogeneous community. We were a novelty and a quiet curiosity, and we were also subjected to lilting rhyming slurs, petitions circulated by our neighbors to have us removed from the neighborhood, and/or our friends telling us, "No puedo jugar contigo porque se me va a pegar lo Chino" (I cannot play with you because your Chineseness might stick to me). I remember playing baseball with my friends, and I will always remember the secret fights about our race. What my parents endured will remain mostly a mystery.

Growing Up on the Border

As a self-identified Chicano artist who is the product of an anticolonialist Chinese father and a culturally affirming Mexicana mother, so began my life as a Chicanese. Guillermo Gómez-Peña, performance artist–writer and MacArthur Foundation "genius" awardee, used "Chicanese" as a term of political endearment describing my hybridity. My work has been informed by my family and growing up in the San Diego–Tijuana border region where notions of fusion are a fluent part of a vibrant ethos of place. The border encouraged our understanding of hybridity and multiple possibilities. My perceived exoticness was normality, eating chorizo with white rice and soy sauce, or hearing old Peking Opera clanging away in the warehouse as my father would stuff pillows for the swap meet business and my mother would listen to Tambora on the stereo in her room while sewing. Our Thanksgivings were large and constantly shifting with faces, music, languages, and smells, with our extended loved ones coming in waves to eat hefty portions of turkey with dressing, tamales and tempura, cranberry sauce and Chinese barbecued pork, white rice and eggnog, all topped off with the exotic mashed potatoes that we, my brother and sisters, insisted upon.

"Go Back to México!"

Our elementary school principal in California tried to have us removed for living in México, outside the school district. My father showed up to a meeting with the school principal in his marine dress blues, displaying his Purple Heart, and that ended that. When I was about nine, we moved from our beautiful two-story home that my father built in Tijuana to a trailer park in Chula Vista. "Go back to México" became a haunting and common refrain. Cultural conflicts and misunderstandings were a fluent part of our family life as we navigated through our new surroundings. At Harborside Elementary School, I was taught that my mother's hero, Pancho Villa, was a

bandit. In the Chula Vista Junior High metal shop, we learned how to weld log holders for fireplaces that none of us had in our homes. At California State University, Fullerton, the only people on campus who looked like me were the janitors and two other Mexican American students, both named Art. During my history of photography class, a white male student turned around and leered at me. "Mexicans make the best car thieves," he said. Every filthy word and phrase in Spanish, English, and Spanglish would clatter against my clenched and grinding teeth to be smothered against my fucking useless catatonic tongue. But it was too late. As class began, the lights were switched off, the white boy smiled and turned around in his seat, and Professor Johnson started the lecture with images of Minor White.[1]

Balancing Border Door

From time to time, I am asked when I am going to make work about my Asian ancestry. I suppose that people feel a need for some form of equilibrium and that they find an imbalance in my work; therefore it is very un-Chinese of me. And yet my Chineseness has always been in my work as a Chicano artist. But how do I measure the amount of Chineseness it took to execute my last performance or installation or video or series of photographs or this essay? What is the correct percentage? And can I make it up on the next piece, or can I pay it forward on the installment plan? Maybe I can speak to my nephew Michael, the certified public accountant, and he could work out some amortization formula by which I should be able to cash in on my Chinese equity in thirty years. The irony is, and there are many, that *Border Door* (1988), a prominent piece in the history of Chicano art, is also Chinese.

Border Door has been my most notable achievement as an artist–cultural worker, and it has been largely underinterpreted as framed and understood solely within a Chicano visual vernacular, and that, to a large degree, is my fault. When Jim Elliott, a dear friend and fellow photographer (both of us trained as artists at Cal State Fullerton), and I discussed how he should photograph my performance piece *Border Door*, we were thinking about the austere nature of the border landscape in Southern California between San Diego and Tijuana in 1988. In seeking to accentuate the starkness of the landscape and the hopeful glint of dignity that the door offered, we decided that the use of black-and-white film would present the most striking image. *Border Door* exists, at this point, solely as a black-and-white photograph. But *Border Door* itself was not a black-and-white object: the door frame was slate blue, analogous with the blue sky, and the door itself was painted a bright gold to represent Gam Saan (Cantonese for "Gold Mountain") (plate 33). *Border Door* reflected both my father's

and mother's stories and circumstances. However, the black-and-white photograph documenting the *Border Door* performance/installation could not correctly translate the color of the golden door, another inadvertent cultural miscommunication.

Nonetheless, *Border Door* was a public act of transgression informed by the borderland it briefly occupied, a space "outside of the law," as David Avalos used to say to us. *Border Door* also was informed by my psychic borderlands, which exist within me as a racial and cultural hybrid occupying a position of resistance within a system of coercion. Its defiant stance was not lost to me, and I also saw it as self-healing, transformative, and an opportunity to consider other models for hope. *Border Door* embraces our existence in highly contested terrain. As marginalized people, we occupy a conflicted and conflated territory where it is seen as a contravention when we assert our desire for respect, our hope is a transgression, and seeking dignity is an act of disobedience.

Carnalismo

My undergraduate and graduate training at the university did not adequately prepare me for my affiliation with the Centro Cultural de la Raza or the Border Art Workshop/Taller de Arte Fronterizo (BAW/TAF). I was a member of BAW/TAF from 1988 to 1990. Both experiences were literally life changing. The Centro Cultural de la Raza became the birth site of my ideological self, and the collective membership of the BAW/TAF and the Centro Cultural de la Raza became my "tu eres mi otro yo" (you are my other self). Collaboration, community, collectivity, and carnalismo became the mainstay of our process and kinship in all of our work.[2] And throughout my activities at the various centros in California, I was polvito (dust) orbiting giants: Verónica Enríquez, Guillermo Gómez-Peña, David Avalos, Josie Talamantez, Marco Anguiano, James Luna, Amalia Mesa-Bains, Patricio Chávez, and Coco Fusco, to name a few.

While we were members of BAW/TAF, Robert J. Sánchez, a brilliant painter, and I began to collaborate on projects together. Our gravitation toward each other was based on our commonalities: our friendship, sense of humor, patience, work ethic, and families. Our differences were understood as complements that sustained our collaborative work from 1989 to 2005. The first two years, we worked almost exclusively in installation work that in some form questioned and documented our community's marginal status. While we had some "success" with the work, exhibiting in New York, Tecate, Istanbul, and Manchester, our work was to undergo a dramatic shift in 1991.

The White-Fying Project: *Los Anthropolocos*

In addition to many of the artists and activists working in and around Southern California, with whom we were closely associated, performance artist Coco Fusco helped shift our view of our own artistic practice and method of production. Her 1991 *High Performance* magazine interview "Shooting the Klan: An Interview with Andres Serrano," with the controversial photographer and "unwilling soldier in the Culture Wars of the early '90s," and her 1998 essay "Fantasies of Oppositionality" were particularly poignant. In her essay, she writes: "What is not always addressed in the policy discourse of multiculturalism is the segregated division of labor in which white intellectuals theorize about racism while ethnic film and video producers supply 'experiential' materials in the form of testimony and documentary, or in which the white intelligentsia solicits token third-world intellectuals to theorize about the question—that is, the problem—of the Other for the white intelligentsia."[3]

Understanding white supremacy as defined by Andres Serrano's 1990 *Klansman* series, which portrays seven members of the Atlanta chapter of the Ku Klux Klan, was an igniting revelation that compelled us to create work that inverted the power structure, positioning Chicana/os as the dominant culture. More than nineteen years ago, Los Anthropolocos, or the Crazy Anthropologists, embarked upon the work of repositioning Whiteness as a marginalized and exoticized Other. This strategy positioned Whiteness both in the center and on the margins of our proposed position as the dominant culture in a not-so-far-off fictionalized future. In our understanding, any attempt to reverse the colonial gaze required the reassignment of power. In order to create this dynamic, we needed to create a fanciful science fiction narrative, in which Chicana/os are the dominant culture in a future transformed United States of America, called United Aztlán. In this new nation-state of United Aztlán, Caucasians, or the Colorless, were believed to be a distantly extinct race. Using science, anthropology, and archaeology, Los Anthropolocos were able to place distance between themselves and the objectified "remains" of the Colorless and the "artifacts" they left behind. Los Anthropolocos, validated by their academic training and their affiliation with the fictionalized University of Aztlán, would create theories of how each Colorless artifact operated within the cultural practice of the Colorless. Our goal was to satire the systems of inquiry Western cultures use to define other cultures, thus critiquing these systems of knowledge.

The work produced by Los Anthropolocos assumed many forms: photographs, text, artist books, installations, performances, videos, and interactive web art. Our most prevalent strategy was the installation as museum. Within the structure of the museum/installation, we would display various "artifacts" with didactic material sup-

porting our theories about the Colorless culture, field photographs, "documentary" video of our findings, and tools we constructed for use at our dig sites. Our use of satire as an illuminating device allowed us to deconstruct museum practices and issues of representation and the misuse of science to reinforce established notions of racial hierarchy. Most of the work was purposefully crude and awkwardly elegant, as we were working within a repurposed rasquache aesthetics as a way of liberating subjugated knowledge within our fictional narrative.[4]

Decolonizing the Body as Performance

In summer 2010, I interviewed my old friend and collaborator Robert J. Sánchez, who recalled, "The narrative of the [two] characters is the central theme of Los Anthropolocos. Everything stemmed through the performative act." In the construction of the Anthropolocos narrative, we felt that in order to decolonize ourselves, we needed to colonize and fetishize the body of the Other, the post-dominant Other, the Colorless. So within this body of work, Los Anthropolocos subverted the colonial language for the purpose of creating an oppositional metanarrative in our satirical attempt to discover the essence of "whiteness." Our bodies acted as political territory and as sites of reclamation; their bodies became multiple screens for our flickering and transitory fears. As Robert would often say to me, "It is in the air." I do not think we were fully cognizant of the connections we were making with the demographic projections of 2050—somehow, in our Anthropolocos work, we had accelerated beyond a post-racial possibility. Or, as Guisela Latorre writes,

> The reversal that was inherent to the Anthropolocos project became even more provocative when Lou and Sánchez posed the hypothetical question of what would happen if the white body suddenly became the colonized body. In the photograph from the project entitled Captives of Fate, the characters of Drs. Lou and Sánchez show off what could perhaps be the crowning achievement of their reputable careers: the capture of two "fine specimens" from the "Colorless" tribe which was previously believed to be extinct in United Aztlán.[5]

The photograph Captives of Fate (1995) (plate 34), taken by James Elliott, to which Latorre makes reference, depicts Sánchez and me sitting in a heavily wooded area with our bone dinner jackets on while holding the tools of our trade: a net, a Rasquache Ninja Tranquilizing Crossbow, and a Tranquilizing Palo, or stick. Standing between us are two nude Caucasians, female and male, blanketed by a net and looking dejected. Between them, the only adornment is a glazed-doughnut necklace worn by the male.

Sánchez and I look triumphantly at the camera, beaming at our two newly discovered specimens in understanding of the historical nature of the moment. This gaze creates a photographic marker of achievement between the civilized and the primitive, the victorious and the vanquished, those of destiny and the irrelevant, while we are fantasizing about our soon-to-arrive fame, fortune, and celebrity status. Didactic text accompanies the photograph, describing Los Anthropolocos' post-capture moment of great achievement and despair: "After capturing and tranquilizing these two magnificent specimens, Los Anthropolocos were overcome by a combination of euphoria and grief. . . . Had they reached the end of their life work, searching for and analyzing the Colorless? And what will become of these godless brutes?" As we began to create and reflect upon the establishment of the Anthropolocos metafiction, the narrative in and of itself became an existential question: "And what will become?"

The Question of Chicano Exceptionalism

In our attempt to create an ideal nation, Los Anthropolocos left out everybody else, allies included. Los Anthropolocos' fictional establishment of a Chicano nation, United Aztlán, was just as xenophobic, jingoistic, and myopic as the one that forged us. We created our own version of Chicano exceptionalism, and, in seeing through our creation, our good friend and mentor Marco Anguiano remarked on more than one occasion, "The work of Los Anthropolocos is also critiquing the ability of the Chicano people to be able to govern justly; it implies that we will follow in the footsteps of our colonizers." Marco saw through the metafiction, the subversion of language, the inversion of power, the props and pratfalls, and the release of anger through our satiric narrative to see a promise for which he had fought for decades distorted, the hopeful realization of El Plan Espiritual de Aztlán, the forming of a Chicano Nation being lampooned by his closest friends and allies. This was the unspoken intended consequence of our work as Los Anthropolocos. Yes, we Chicanos could fail, too, and this was as provocative as saying "WHITE" too much and out loud. We felt as though we were approaching and broaching the dangerous. Marco, in his infinite wisdom, would go on to say, "Anything is possible, and the Chicano Movement is not above criticism."

Journey of a "Chicanese":
An Interview with Richard A. Lou

RICHARD A. LOU *is of Chinese and Mexican heritage and is a conceptual interdisci-plinary artist and community activist who makes politically charged work addressing issues of Chicano and multiracial identity and U.S.-Mexico border politics. He earned his AA degree in fine art from Southwestern College in Chula Vista, California, a BA degree in fine arts from California State University, Fullerton, in 1983, and his MFA degree from Clemson University in South Carolina in 1986. Perhaps best known for his involvement in the late 1980s with the Border Art Workshop/Taller de Arte Fronterizo (BAW/TAF) and his collaborative performance work with Robert Sánchez (Los Anthropolocos), Lou has exhibited his work in the United States as well as in Turkey, England, Italy, and South Korea. He is currently professor and chair of the Department of Art at the University of Memphis.*

Laura Kina interviewed Richard Lou via phone on May 7, 2010, about his installation Stories on My Back (2008). She asked about the Chinese American influences in his work and how the next generation of his art and family has evolved.

RICHARD A. LOU: Our father was Chinese, from Canton, and Mom is from Sinaloa, México. My older sister looks more Asian, then me next, then my sister less, then my younger brother less. Seemingly the more children my parents would have, the more Mexican they would look. In the Latino culture, there are lots of people who look Asian because of the indigenous population. There were all these people, when I was growing up in Tijuana, they would call, "Hey, chino," even though they were from the interior part of México. They would call me that because I was half Chinese, too. Mexican people call people "chino" if they have curly hair, and Chinese people don't have curly hair, so there's always that funny weirdness there.

I get a lot of my worldview from my parents. My mom was the "culturally affirming" kind of woman and super proud of who she was and where she came from. My father was a very proud Chinese man—and he was big, he was over six feet tall. My mom was, like, four feet ten inches. He was very anticolonialist because he grew up in China and in northern Mississippi, and so he was able to see the colonizing effects of Euro-pean world powers in China and the United States.

LAURA KINA: How did your parents meet?

RAL: My father was in World War II and was discharged after the war in San Diego because there is a huge military base.

I didn't know my father was a "paper son" until after he died.[1] I have an older brother from a different marriage, because my father was married three times. My father married this woman from the village in Canton and had my brother, Robert. My father was also in Japan, studying. When the Japanese invaded China, he had to leave because he was this ethnic Chinese in Japan. Because he was a U.S. citizen, he came back to the United States. But he's a paper son because my "grandfather," who moved to Mississippi back in the 1890s, had a son named Ming who died in transit from—I don't remember if it's from China to the United States or from the United States back to China. I think it's from the United States back to China. They used that son's birth certificate to bring my father over. There were, like, thirteen Lou villages in Canton, and so they brought my father over. That's what we call a "paper son."

My father was a meat cutter, and on Saturdays and Sundays, we'd go to the swap meet; during the week, we'd go to Los Angeles to pick up merchandise to sell. We would be in the car together a lot, and I just had this curiosity and I love stories. I think that's why I became an artist—because of my love for stories. I would always ask, "So, Dad, then what happened, then what happened?" etc.

He talked about having "multiple mothers," but I just thought that was part of an older Chinese culture that was common. When men came over from China to the United States, they would leave one family behind and they would start another, so I just thought he was talking about that. I never knew he was a paper son because he always acted with his brothers and sisters in a very cohesive way; you never felt that he was different from them. But during his funeral, it was the first time I ever saw his three brothers together, and when I saw them together, they were all the same size: five feet four inches. My dad was over six feet tall. And in my grieving process, I was still somehow able to look at my uncles and think, "What the hell? They're all short!" Then I went back to grieving, but you take that snapshot and you kind of store it away. When my older brother told me, I was, like, okay. Then there's other character-istics that made my father stand apart from his brothers and sisters, so it started to make a lot of sense that he was from a different family.

LK: How do you identify yourself?

RAL: I identify myself as a Chicano. At the same time, that's more of a political identification. That's also an ethnic identification as well. The term "Chicano" has become much more amplified for it not to be applied solely to Mexican Americans who have a particular ideological perspective, mostly leftist. Lots of people have been self-identifying as Chicano, and it's more of a pan-Latino identity. So we have people

born in México who call themselves "Chicano." I've seen white women who call themselves "Chicanas"; Puerto Ricans who grew up with Chicanos calling themselves "Chicanos." I've seen white guys growing up in the barrio calling themselves "Chicano." The notion of it has expanded beyond the historical point of 1970. And then, at the same time, it has lost its initial goals in regard to how relevant they are to the twenty-first century. For example, in El Plan Espiritual de Aztlan, one of the goals is for us to re-create a spot, but without seceding from the U.S. And how is that useful? We've moved away from that sort of nationalistic model to a different multifunctional model in how we participate in the larger Latino diaspora.

LK: Can you talk about your community or identity ties, specifically in the arts?

RAL: Even though I'm in Memphis, a lot of the lessons I've learned from growing up in the Southwest, and a lot of the sort of strategies and tactics that I've learned there, I've applied. But at the same time, I've had to be sensitive to a new history and a new community dynamic. Living in the Southwest, it's 90-some percent Mexican American, and in the South, it's more of a pan-Latino experience—lots of Cubans, Puertorriqueños, Dominicans, and then the newer wave of immigrants from Honduras and Guatemala. But still, because the Latino community in the United States is 70 percent of Mexican descent, there's still a huge Mexican–Mexican American community.

LK: Would you say your ties are primarily with a leftist Chicano community across the United States, or is it in a specific area?

RAL:: Well, it's both, because I'm always trying to "get home." I keep very close contact with my friends and allies across the United States. At the same time, I'm trying to work with the community where I'm presently living. There's a group of us who are working toward creating a cultural center here in Memphis.

LK: You mentioned that your father served in World War II. Do you remember where?

RAL: He was at the Battle of Guadalcanal and the Battle of Tarawa in 1943. He was in the Pacific theater. He was part of the occupational force in Tientsin because he spoke Mandarin, Cantonese, and Japanese as well as English. And his English was impeccable, and actually, *Stories on My Back* talks about that. I remember growing up, as a kid, I always wanted my father to teach us Chinese, but he would always say, "Who are you going to talk to?" And of course, when you're a kid, you're like, "Huh?" But the answer was, "Well, to you, my uncles and my aunts, and everybody else who's Chinese except us." Also, my uncles and aunts, they were 100 percent Chinese and since we were 50 percent, but not in my father's eyes, and I don't know if it was from us or subtle cues from our family or maybe it was just that they were just a little bit more clannish, but it always seemed like whenever we tried to interact with them that

we were thought of as being "less." In my other interactions with Asians, they'd kind of look at me and go, "Hey . . . you kinda look Asian." When I would say, "I'm Mexican-Chinese," most of the Chinese people or Korean or whatever, they would start laughing, and you kind of get used to it; otherwise you fight every day. Who wants to do that? It becomes very wearisome.

LK: Was there a real difference in the way you were accepted by other Mexicans versus Chinese?

RAL: Well, in the Mexican community, we were a little bit more accepted. But at the same time, growing up in Tijuana, there was this petition being passed around by our neighbors to get us kicked out of our neighborhood because we were half Chinese. That had its ups and downs, and kids taunted us for being Chinese. It was a purely racist thing because my father was the only Chinese in the whole neighborhood. They wouldn't let their kids play with us. My mom used to fight with everybody. I didn't know why she was fighting until I was thirty. I found out that she was fighting with everybody because we would come home crying—not that this was a daily occurrence—and she would find out what happened. She would go to the neighbor's house and say, "How come your kids don't want to play with my kids?" and then the mom or the dad would say, "Because . . . " And then that's when the fighting would start. And my father, when he came home from work, would always ask my mom, "Well, who did you fight with today?" It was kind of a joke at the same time.

LK: Can you tell me about *Stories on My Back* (2008) (plates 35a,b)?

RAL: It's an installation piece based on one of my father's stories. When he knew that he would have to come back to the United States, one of his teachers told him, "You're going to have to lose your accent if you want to succeed." His teacher told him that he should put pebbles in his mouth and go recite the alphabet and consonants out loud. When he came back to the United States, to northern Mississippi, he said he would go out to Moon Lake, which is really odd, because it sounds so "Chinese," but it's actually shaped like a moon, and he would recite the alphabet. His English was impeccable. The metaphor is about grinding away something that is potent to you, in other words, your identity. Getting rid of your Chineseness by losing your accent, it's like grinding away your face.

LK: The images on the four lanterns in the installation, are those your children?

RAL: Right. *Stories on My Back* means a couple of things. One is that these are my children's stories now. My father gave them to me, and I'm giving the stories to them. Now it's up to them to deal with, to learn from them or discard them or whatever. And then, also, my two older daughters, Gloria and Maricela, decided to put our family name on their backs. My brother, Robert, who grew up in the village, painted our name in Chinese character form, and the girls had them tattooed on their backs.

Stories on My Back comes from another story that I'm working on, too. They're all sort of interconnected somehow. The story is about my "supposed" grandfather coming to the United States. Before my father died, we started having children. Gloria is the oldest—she's named after my Aunt Gloria. The youngest three—Maricela, Magda, and Ming—all have a middle name that's some derivative of "Alejandro" because that's what my mom called my father as his immigrant name. My father had all these multiple identities. At work, he was called "Lou," because older Chinese people identify the family name first. He would present himself, "Oh hi, I'm Lou." In the United States, that's pretty common. "Oh, hi, Lou." At work, it would be "Lou." In the Chinese community, he was "Ming." And then in the Mexican community with my mom's family, he was called "Alejandro." I'm named Alexander, too; it was one of my mom's favorite middle names. The audio component in the installation is actually my four children telling the same story over and over again. It's broken up with Peking Opera.

Whether it's a war or some kind of incredibly racist immigration law or poverty that were very powerful factors for them, too, and how they responded to those factors is what brought all these people together.

LK: President Obama chose to select one box, African American/Black, on his 2010 census form. In the same way that you were talking about identifying as Chicano, President Obama seems to have been making a political motion of solidarity, rather than affirming the one-drop rule. Do you see Chicano identity as expansive and inclusive of all of your races and ethnicities, or are you asked to choose one identity?

RAL: It's my understanding, as a Chicano, that to claim 100 percent of anything is impossible because we're part of this larger mestizaje, which is another term for "hybrid" or "diaspora." And so it all depends who you're speaking to, but it's been my experience within the Chicano community that it was nice if you declared one way or another, but they didn't care. It was more about "What are you working on?" and "What are you doing to move our community forward?" in regards to participating in a march, dialogue, or work that you were doing, which presented other kinds of problems, too. Identifying themselves was not a very big issue for them. "Are you an ally or not?" was more overarching. "Do you see what we're doing? Can you provide? Are you with us?" When you look at the history of the Chicano Movement, we had Filipinos, Indians, and Sikhs; there were Chicano Sikhs from Fresno.

LK: Actually, I talked to Karen Leonard, who wrote *Making Ethnic Choices: California's Punjabi Mexican Americans*. I was really curious to learn more about that hybrid community, and she said that the people wouldn't use a term and frame themselves as "mixed," that they would either assimilate into one community or the other.

RAL: I didn't feel like I belonged in any particular place except in the Chicano

community, and it wasn't until I became much older [that] I felt "comfortable everywhere now." I've always felt like I was this outsider looking in, which comes from growing up as this mixed race child, not fitting in with my Chinese cousins because I was bigger, taller, and spoke Spanish and/or not fitting in with the Mexican community in México because I looked Chinese and we ate strange food.

Transcribed by Mario Cortes, 2010

Resources

Cullen, Deborah, ed. *Arte ≠ Vida: Actions by Artists of the Americas, 1960–2000.* New York: El Museo del Barrio, 2008.

Lacy, Suzanne. *Mapping the Terrain: New Genre Public Art.* Berkeley: University of California Press, 1995.

Stallings, Tyler, Ken Gonzales-Day, Amelia Jones, and David R. Roediger. *Whiteness: A Wayward Construction.* Laguna, CA: Laguna Art Museum, 2003.

Artificial Gems:
An Interview with Cristina Lei Rodriguez

Sculptor CRISTINA LEI RODRIGUEZ *is a Miami native, born in 1974 to an Okinawan mother from Hawai'i and a father from Cuba. After completing her undergraduate degree at Middlebury College in Vermont and living in Hawai'i and New York, she received her MFA degree in 2002 from the California College of Arts and Crafts (now California College of the Arts) in San Francisco. Her work has been shown nationally and internationally, including solo shows at the Oakland Museum of California, Galerie Emmanuel Perrotin and Vizcaya Museum and Gardens in Miami, and Team Gallery in New York as well as in group shows at Mary Boone Gallery, Leo Koenig, and Deitch Projects in New York and Blum and Poe in Los Angeles. Critic Lauren O'Neill-Butler of* Time Out New York *describes Rodriguez's work as "striking and grotesque, verdant and withering, seemingly real and manufactured all at once."*

Laura Kina spoke with Cristina Lei Rodriguez on the phone on May 28, 2010, about her assemblage sculptures Decadence (Opal), Decadence (Red Coral), *and* Forever *(2008).*

CRISTINA LEI RODRIGUEZ: My mom is second generation, born in the States. My great-grandparents came from Okinawa and went to Hawai'i to work on the pineapple plantations. My grandmother and my mom were both born in Hawai'i. I consider myself to be Japanese American. My dad is from Cuba. He came to the States in the '60s. My mom is a nurse and my dad is a doctor; they met working in a hospital in Jacksonville, Florida, in the late '60s. I was born in 1974. They got married in Miami. My mom was American, and I don't know if my dad was already an American citizen, but as a Cuban coming for political asylum, he was able to become a citizen rather quickly. My dad was in medical school when he left Cuba. For his own political reasons, he didn't want to finish school and graduate from school there. He was at the University of Havana, and he finished his medical schooling in Madrid. He was the first of his family to leave, and the rest of my dad's family came in the next ten years.

LAURA KINA: You mentioned earlier that you consider yourself Japanese American, but how do you identify yourself in terms of your ethnoracial identity?

CLR: I usually say I'm mixed. It's kind of an unusual combination, and I think that since my mom grew up in Hawai'i, it's a little bit different. If you ask my mom, she

thinks of herself as being from Hawai'i, first and foremost. When I was little, I thought my mom was Hawaiian, but then I thought, "Oh, that's not right . . . my mom's not Native Hawaiian." It's not that she's not aware of that, but being from Hawai'i and being second generation, there's a really big focus, because of the war, to become American. How I think of myself as my identity or my ethnicity depends on where I am. When I was growing up in Miami, I was more aware of the Asian part of me because it was more unusual and people saw that I looked different, that I looked Asian. But outside of Miami and when I went to school in Vermont, I definitely felt much more Cuban or Hispanic. In Miami, it's a little bit of a different history, because in Miami, being Hispanic is the majority.

LK: Do you find that you're part of a particular community?

CLR: I feel mostly connected to Miami and Miami's history of having so many people who have immigrated here to start a new life and culture. I feel connected to Miami as a place—that informs my practice. I am a mix, and my identity is complex and exists with contradictions.

LK: *Decadence (Red Coral)*, *Decadence (Opal)*, and *Forever* (2008) (plates 36–38)— what are they made out of? I remember you referring to them in terms of a "constructed paradise."

CLR: All my work is assemblage. Different objects are fused together with layers of pigmented resin and epoxy and paint and glue into a form. It really started in graduate school. I was thinking about the fantasy of an object—both my grandmother on my mom's side and on my dad's side were into making personal altars and had a relationship to objects that was very similar. They projected a lot into objects, and the altars had different found objects making a scene. *Forever* is very similar because it's a flower, and when you see a fake flower, it's always the flower that's perfectly in bloom. The idea that it's a frozen moment, an idealizing moment—it's something that can't die. It's always in its perfect moment of freshness and color.

LK: But in *Forever*, your flower is drooping forward and dripping down.

CLR: *Forever* is taking that idea of this perfect flower and then pushing it to look like it's in a process of decay and also growing. In graduate school, I was having discussions about identity politics and trying to conceptualize my work. At that time, there was a show called *Ultra Baroque*[: *Aspect of Post Latin American Art*, Museum of Contemporary Art San Diego, 2000–2001]. There's an essay about it, about imperfect beauty and the idea of the fantasy, of the exotic and the desire behind that, so I think that really connects to those ideas.

I was working on *Decadence (Red Coral)* and *Decadence (Opal)* around the time of the financial crisis in September of '08. I was thinking about things being excessive,

being more and more about eye candy, playing between what was realistic and what was artificial. At the time I titled those works, I wanted them to be "a relic of a moment for the future" that would be like this chunk of artificial gem. I was interested in how, if enough happens to an object, it starts to have a history. What I attempted to do was give the sculpture enough layers so that it fuses together like a sedimentary rock. Then it would be a gem but made out of fake jewelry and glitter. I worked on it with pigments while the epoxy was wet, so the surface settled slowly. The patterns on it are natural, kind of like the way a river can dry up and create a natural pattern. That's one of the things that I really like about that work, actually.

LK: When I initially saw those and you talked about your biography, I was reading them as like coral from Hawaiʻi or constructions of paradise. Was that a theme at all in terms of the relationship between Miami and Hawaiʻi?

CLR: It definitely was something I thought a lot about when I was trying to define what my work was about when I was in school. Both of my parents are from islands, and they both come from places that are exoticized. I think about that idea of "paradise," desire for fantasy and questions of what is that fantasy. When I was living in Hawaiʻi before going to graduate school, I could really see it as well. We lived relatively close to Waikiki, and it's such a fabricated experience; Miami is, too. When you think about the landscape in Miami and Hawaiʻi, the palm trees in Hawaiʻi—those plants are imported, not native. And the same thing with Miami. They have a tropical landscape that you relate to when you think about what a Miami landscape looks like, but it's really a landscape that was totally constructed. Miami was swamp before. That's something that's interesting to me and has a lot to do with my work investigating nature and it being artificial. Growing up in Miami, you experience nature in a way that is sanitized. In Hawaiʻi, too, there's something about it that's artificial. I can see it from my mom's family in Hawaiʻi and also from my dad's—there's part of wanting things to be new, wanting things to be shiny, wanting to latch on to this fantasy of your life being transformed or the possibility of something better. I don't want to sound only critical of the Hawaiian and Miami landscapes. They are beautiful places, and especially in Hawaiʻi, I have had so many intense moments of awe of the natural beauty there. The landscape is so magical and powerful—that has always stayed with me.

LK: Are there any particular associations that your family has with war?

CLR: My mom's dad, my grandfather, he was an engineer during World War II stationed out of Pearl Harbor. I think the main way it affects me is in the way my family and my mom really pushed to be American during that time and kind of how that affected my family's idea of culture. My grandfather passed away before I was

born, and I don't really have a personal experience or a strong experience with the war for them in that way. They have shells of bombs and things like that. It's like a souvenir, which is kind of in keeping with the way that Hawai'i is.

LK: What about in your father's personal narrative?

CLR: It's a big part of my dad's life, and it's something that still affects him and affects the Cuban community here just because he was essentially a student during the Cuban Revolution. There are things that infiltrate my works because they're a part of who I am and they're part of the way that I learned about life or that influences my father's perspective on the world. In terms of referencing it in my work, I think of it more as the effects of being displaced or being an immigrant in a new place. I feel it's about object. My dad's family—if you think about leaving everything behind— objects are so sentimental for him. He's like, "Oh, I remember that pen from that day when this and this and this when you gave it to me." It's just such a big part of the way that they think about objects that really influenced me becoming a sculptor. There's also an idea of women's work in terms of craft and making something special, making something important. Those things are tied with being displaced. I think of it as all being in the mix of my mind until it comes out in my work in that way. Especially lately, I've really wanted my work to come from an intuitive place where I'm thinking about my work being abstract or having an emotional feeling or being about a relationship. So those things all just exist in there.

Transcribed by Marco Cortes, 2010

Resources

Coetzee, Mark. "Mark Coetzee and Mark Clintberg Dialogue via SMS: The Work of Cristina Lei Rodriguez." *art.es*, no. 22: 34–38.

Birnbaum, Daniel, Gunner B. Kvarn, and Hans Ulrich Obrist. *Uncertain States of America: American Art in the 3rd Millennium*, 92–93, 164–65. Oslo: Astrup Fearnley Museet for Moderne Kunst, 2005.

Papaioannou, Dimitris, Zafos Xagoraris, Cay Sophie Rabinowitz, Diana Baldon, Chus Martínez, and Nadja Argyropoulou. *2nd Athens Biennale 2009: Heaven*. Athens: Athens Biennale, 2010.

Revolutions:
The Biracial Baby Boom and the Loving Day
and Marriage Equality Movements

The Biracial Baby Boom
and the Multiracial Millennium

CAMILLA FOJAS

AT THE HEIGHT of what Maria P. P. Root describes as the biracial baby boom and coinciding with the 1967 landmark Supreme Court decision in *Loving v. Virginia*, the classic interracial drama *Guess Who's Coming to Dinner* (1967) enjoyed box-office and critical success; it was nominated for eight Oscars and won two. Thirty-eight years later, the contemporary redux *Guess Who* (2005) inverts the racial dynamic so that outrage stems from an African American woman bringing her White boyfriend home to her disapproving parents. While it may seem that the new version is a sign of progress in racial relations, it may simply represent another layer of complexity in the racial dynamics of the post–Civil Rights era. After the biracial baby boom of the 1960s, babies who would be the fruit of the relationship between the protagonist couple of *Guess Who's Coming to Dinner* would bring forth a new era in the multiracial composition of the United States. This mixed race era gives rise to a new political awareness and understanding of race through the work of interracial and mixed race peoples. The mixed race political movement that came of age in the 1990s enabled a film like *Guess Who* to turn the racial tables and ask the eponymous question from the standpoint of the racialized family. By the 1990s and beyond, cultural productions about mixed race peoples and mixed race relations were becoming increasingly popular. The cultural and political changes from the 1960s to the millennium can, in part, be charted across the terrain of popular culture with the original and the remake of *Guess Who's Coming to Dinner* acting as symbolic bookends.

Films like *Guess Who's Coming to Dinner* and its remake are reminders of the potent cultural role of mixed race peoples and relations. For example, in war films, particularly those that take place in the Asian Pacific theater, intimacies between Asians and Anglos represented strategic alliances and political relationships to Asian nations—as in *Sayonara* (1957). These romances were typically between Anglo men and Asian women, in which the latter were viewed as the spoils of war.[1] Kent A. Ono writes of the special role of the biracial offspring of these relations in the film *Come See the Paradise* (1990). The biracial child symbolizes a potential neutralization of the

fraught political and social relations of Japanese Americans and Anglo Americans during the World War II incarceration of Japanese Americans.[2] The popular television show *The Courtship of Eddie's Father* (1969–72), about a Japanese housekeeper who takes care of a single Anglo father and his son, revisits the wartime fantasies about Asian caretaking of Anglo men. Popular culture has rarely lent insight into the complex issues faced by mixed race peoples and those in mixed race relations, relying instead on fantasy and stereotype. By the 1990s, mixed race activist organizing and academic work would change popular perceptions of interracial relations.

Naomi Zack, a scholar whose work focuses on issues related to the philosophical analysis of race and mixed race, uses her own experiences of the ambiguities and complexities of racial formation as a point of departure for her philosophical inquiries. She was raised in a single-parent home, by her Jewish mother, on New York's Lower East Side and in Greenwich Village and, until age sixteen, identified with her mother's heritage. At sixteen, she discovered that her father was mixed race—African American and Native American—which put her in a racially ambiguous position and instigated an identity crisis. *Race and Mixed Race* is the result of her personal inquiry into mixed race identity formation and became a major text of the mixed race movement.[3] Two years later, she extended this inquiry in an edited collection of essays, *American Mixed Race*.[4] In her work, she critiques the notion of race—and, by extension, mixed race—as a sign of difference not only for the bogus science of race but for the cultural meanings attached to race that are unfounded and "unfair."[5] Paul Gilroy makes similar claims in *Against Race* (2000), in which he rails against the concept of "race" as the primary organizing schema of social relations. However, Zack recants somewhat; she claims in the preface to *American Mixed Race* that she originally intended to close the volume with a "strong repudiation of all racial identity" but realized the strategic importance of mixed race identity formation.[6] She affirms the appropriateness of this hesitation by citing the consolidation, in the mid-1990s, of mixed race national organizations and other mixed race scholarship. By the early 1990s, mixed race organizations had gathered considerable force, evident in their successful lobbying of the U.S. government to change the way the census categorizes people in discrete racial categories, which led to changes in the 2000 census.[7] By the 1990s, when many of the mixed race baby boomers had come of age, the cultural politics of multiculturalism was in its heyday.

In 1990, in anticipation of the quincentenary of Columbus's voyage to the Americas, Lucy Lippard's book *Mixed Blessings* gathered a wide swath of mixed race artists and artists of color who represent what she calls "new art in a multicultural America."[8] She documents artists' attempts to engage new forms and new ways of imagining race within and across boundaries. This work raises questions about whether new ways of

understanding race challenge the norms and structures of visual culture. She explores the work of artists such as Jaw Ash Poitran, Joyce J. Scott, Adrian Piper, Daniel Tisdale, and Albert Chong. Lippard's work is a sign of how the mixed race 1990s coincided with the cultural politics and policies of "multiculturalism" as an effect of neoliberalism. The culture of neoliberalism promotes universalisms—for example, freedom and justice—over the particularities of race and racialized struggles for self-determination. Neoliberal multiculturalism was a reaction against political correctness and the supposed racial divisiveness of struggles by racialized groups to assert racial difference.[9] The mixed race person became a sign and a symbol of the multicultural, a figure that embodies two sides of racial conflict and its resolution. Much of the artwork cited by Lippard as a sign of the multicultural moment critiques neoliberal whitewashing of racial critique. For instance, Daniel Tisdale's *Paul Robeson* (1988), from his *Post-plantation Pop* series, features double photographs of Robeson, one untouched and the other Anglicized and "whitewashed."

While some artwork was critical of multiculturalism, Hollywood film and media culture of the 1990s tended to celebrate the mixed race figure and mixed race relations as signs of the successful eclipse of racial difference. One notable example is Keanu Reeves as Neo in *The Matrix* (1999); his racial ambiguity is key to the character's and the film's popularity and success.[10] The semi-independent lineage of Edward James Olmos's *American Me* (1992) enables a critical departure from the multicultural ethos of the day. The main character, played by Olmos, is a mixed Anglo and Mexican character whose parentage reflects a rape as well as the colonial history of U.S.-Mexican relations both internally, in the shifting boundaries of the United States, and externally. This film reflects how the mixing of races is the result of various kinds of migration, both forced and at will, and is the outcome of imperial expansion throughout the ages. *American Me* calls into question what it means to be "American" while exploring the racial dimension of nationalism. Many television shows of the 1990s point to the deracialization of "Americanness" being about racialized families embodying the "American" norm. Margaret Cho's short-lived sitcom about a Korean American family, *All-American Girl* (1994), is a key example of this cultural moment.

After the turn of the millennium, popular culture multiraciality is everywhere apparent. For example, Disney and ABC, both owned by the Disney Company, have many shows with multiracial casts, such as *Ugly Betty* (ABC, 2006–10), *Gray's Anatomy* (ABC, 2005–), *Desperate Housewives* (2004–), and *The Cheetah Girls* (Disney, 2003–). Angharad Valdivia has written of Disney's commitment to diversity as strategic, in fact, taking full advantage of an expanding market of multiracial viewers.[11] According to the 2000 census, 40 percent of the mixed race population was under the age of eighteen, and this growing and maturing population is the key to future markets.

Nonetheless, the ethnically ambiguous, multiracial person had become the symbol of U.S. culture—another sign of American exceptionalism—based on the erroneous notion that the United States is somehow more just and racially democratic than the rest of the monoracial world. Indeed, mixed race identity has become a sign of democracy. This trend was described in a much-cited article in the *New York Times*, "Generation E.A: Ethnically Ambiguous," in December 2003.

> Ad campaigns for Louis Vuitton, YSL Beauty and H&M stores have all purposely highlighted models with racially indeterminate features. "Today what's ethnically neutral, diverse or ambiguous has tremendous appeal," said Ron Berger, the chief executive of Euro RSCG MVBMS Partners in New York, an advertising agency and trend research company whose clients include Polaroid and Yahoo. "Both in the mainstream and at the high end of the marketplace, what is perceived as good, desirable, successful is often a face whose heritage is hard to pin down."[12]

I have argued, with Mary Beltrán, in *Mixed Race Hollywood*, that it is not the mystery associated with the racial heritage of the media figure but the very explicit coverage of this racial heritage—as in the case of Barack Obama—that marks a new era that might be called "generation mix / generation ethnic ambiguity."[13] This new generation is out about its mixed racial heritages and demands the same of others, especially major figures of popular culture. Lisa Nakamura writes of the practice of outing mixed race celebrities on the Internet, which not only "races" digital spheres but opens up new communities of users and sparks interracial dialogue.[14]

There is no doubt that the ethnically ambiguous multiracial actor or model or public figure is a desirable commodity in U.S. popular culture. The ethnically ambiguous person represents the special opportunities of interracial and cross-cultural contact that have never been explicitly valorized or part of public discourse in the United States. For example, the history of mixed race representation has been overwhelmingly negative or ambivalent in such Hollywood films and media as *Birth of a Nation* (1915), *Imitation of Life* (1934, 1959), *Duel in the Sun* (1946), *Pinky* (1949), *I Love Lucy* (CBS, 1951–57), and *Sayonara* (1957). The 1960s and the post-*Loving* mood brought films like *Guess Who's Coming to Dinner*, the 1970s ushered in an era of critical examination of interracial relationships in popular culture in shows such as *The Jeffersons* (CBS, 1975–85) and *Chico and the Man* (NBC, 1974–78), and the 1990s produced films such as *Jungle Fever* (1991) and, less critically, *Fools Rush In* (1997), *Save the Last Dance* (2001), and *O* (2001), to name a few. Now, the Hollywood film and media cultural standard seems to be multiraciality, but though this is a sign of a new

set of ideas about democratic culture, mixed race continues to be a sign that demands to be read and interpreted.

The publicity around mixed race figures has transformed the way that race is perceived in the United States and has also reshaped the way we perceive heritages that can be traced to other parts of the world. This is a generational shift; for example, Colin Powell, whose parents are Jamaican, is part of that generation who reads as African American, while Barack Obama, among the newer generation, includes all aspects of his heritage and cross-cultural experience in his public persona even though he makes a political choice to identify as African American. This shift holds the promise of a new direction in mixed race cultural studies that moves beyond the exceptionalism of the U.S. example, beyond the silos of distinct racialized and ethnic identities and analysis, to build a global perspective that does not privilege any one site or geographic region. But echoing the caution expressed by philosopher Naomi Zack, we should be critical of a "mixed race" identity for the ineluctable traces of the racial histories it contains but also open to the opportunities we might find under the rubric of "mixed race" to question what we know about racial formation and its political practices.

Loving Days:
Images of Marriage Equality Then and Now

STUART GAFFNEY AND KEN TANABE

Ideas of interracial marriages, mixed race identity, and same-sex marriages have all been constructed with a reliance on visual images. These images have had an impact on laws relevant to interracial and same-sex couples; the status of these marriages in the eyes of society and in the eyes of the law have also affected the identity formations of people of mixed heritage. An analysis of past and present-day visual portrayals of interracial marriages reveals the way in which attitudes toward such relationships have changed— and in some cases have remained the same—thus providing an important context for understanding the larger effects of antimiscegenation laws and anti-same-sex marriage laws. This conversation between STUART GAFFNEY, *of the Marriage Equality movement, and* KEN TANABE, *founder and president of Loving Day, explores these issues from their perspectives as artist-activists engaged with contemporary movements for social justice around marriage equality and the valuing of all kinds of families.*

Gaffney has been making films and videos about his Asian, Eurasian, and gay identities since 1994. He and his partner since 1987, John Lewis, were plaintiffs in the California lawsuit for equal marriage rights and legally married in 2008 after the California Supreme Court ruled in favor of the case.

Named after Loving v. Virginia, *the June 12, 1967, Supreme Court decision that legalized interracial marriage in the United States, Loving Day was founded in 2004 as a global day of celebration and education that focuses on the multiethnic-multicultural community. Along with the June 12 Loving Day Flagship Celebration in New York, Loving Day is celebrated by thousands of people in the United States and around the world and has been featured in major media, including* Time *magazine, National Public Radio, and* BBC World.

What started as a series of e-mail exchanges in summer and fall 2010 culminated in a roundtable discussion on November 6, 2010, facilitated by Wei Ming Dariotis, at the inaugural Critical Mixed Race Studies Conference in Chicago. The following is an edited compilation of these conversations.

KEN TANABE: We are both artists, Stuart a filmmaker and myself a designer, telling stories through visual media. These are very powerful and useful tools, especially when they are combined with the ability to share things online. A lot of our conversation had to do with questions like "How do you represent these communities? How do you represent the marriage equality movement? How do you represent the multiethnic community? What's the best way to do that?" That was the launching-off point. Both of us in our work have sought to represent those communities in a way that is compelling, tells a story, is accurate, and captures their energy.

STUART GAFFNEY: And it's been a way for us to connect with some of our personal stories that are involved in this project as well.

KT: Race is a complex topic, and representing a diverse community is not easy. Even as a full-time art director who teaches at Parsons The New School for Design in New York, I still think it's a challenge to create these images. I've seen the multiracial community portrayed using a wide range of images. Some were so beautiful that they changed my life. Others are stunningly cheesy. Many people—including my former self—use well-worn themes that focus on black-white contrast.

For example, in 1864, one L. Seaman wrote a pamphlet titled "What Miscegenation Is!: and What We Are to Expect Now that Mr. Lincoln is Re-elected" (fig. 32.1). On the cover, an engraving of a Black man kissing a white woman was clearly meant to shock. Fast-forward to June 4, 2010, on *ABC World News*: Diane Sawyer cited a Pew Research Center study that found that one in seven new marriages in the United States is interracial.[1] The image behind Sawyer was of a Black man with a white woman. Little has changed about the most common visual representations of multiracial community. We need to develop a better visual mixed heritage literacy that considers larger historical and social contexts. Those producing such images include Kip Fulbeck, author of *Part Asian, 100% Hapa* and *Mixed*, and Willie Davis, who has taken photos at the Loving Day Flagship Celebration in New York for three years.[2]

When people ask me how I was inspired to start Loving Day, I think they expect to hear a story about racial slurs on the playground. Did the other kids call me names? Yes. Did I feel like I didn't fit in sometimes? Yes. However, I wouldn't credit any of the above as the primary reason I got involved in the community.

As a teenager, I discovered the D.C. punk rock scene and cut my hair into a mohawk, much to my parents' dismay. Despite appearances, the scene was socially progressive, as most of the best concerts were also benefits for charities, even at three dollars to five dollars a ticket. From this, I learned that one could make a difference with minimal resources and lots of creative energy.

In 2002, I started my MFA at Parsons The New School for Design. Thanks to an accidental Google search result, I discovered *Loving v. Virginia*, the Supreme Court

WHAT MISCEGENATION IS!

—AND—

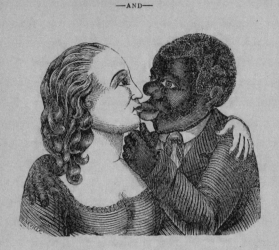

WHAT WE ARE TO EXPECT

Now that Mr. Lincoln is Re-elected.

By L. SEAMAN, LL. D.

WALLER & WILLETTS, Publishers,

NEW YORK.

Fig. 32.1. "What Miscegenation Is!: and What We Are to Expect Now that Mr. Lincoln is Re-elected," by L. Seaman, LL.D, 1864. Prints and Photographs Division, Library of Congress, LC-USZ62-32501.

case that legalized interracial marriage in the United States in 1967. I was inspired to use it as the core of my thesis. I wanted to teach the world about this civil rights milestone—but how? A film? A website? Martin Luther King, Jr., has a day. Black history has a month. Rosa Parks has a compelling story. Juneteenth, the oldest nationally celebrated commemoration of the ending of slavery in the United States, is not officially recognized but has brought thousands of people together for many years. The multiethnic community needed something like that. That's how Loving Day was born.

In 1868, the Fourteenth Amendment to the United States Constitution guaranteed "equal protection" under the law. It took ninety-nine years for the Supreme Court to grant that protection to Richard and Mildred Loving's marriage in *Loving v. Virginia*. When Richard and Mildred Loving, a white man and a Black woman, got married in 1958, a Gallup poll found that 94 percent of Americans disapproved of marriage between "whites and non-whites." Only 4 percent approved. That was the gut instinct in 1958.

SG: My parents met and married at the University of California, Berkeley, in 1952. My mother, who is Chinese American, was able to marry my father, who is English and Irish American, only because in 1948 California became the first state in the nation to overturn a ban on interracial couples marrying. After growing up in Hawaiʻi, my mom entered Berkeley at a time when it would have been illegal for her to marry my dad. My mother still remembers the day when one of her friends in the Chinese Students Club had to leave the state to marry her white fiancé a few years before the court's ruling. My mom's friend literally had to run from the law to marry the person she loved.

The marriage equality movement's visual depictions are as diverse as are couples hoping to get married, yet they share a basic commonality. When I look back at photographs and the words of Mildred and Richard Loving, I am struck by their earnestness. I believe this earnestness has its roots in the simplicity of a couple in love standing up for who they are, for each other, and for their family together. I see this same trait in the plaintiff couples in today's marriage equality lawsuits. These images might include two women with their children who want their kids to grow up with married moms or the surviving husband of a member of Congress who is denied pension and Social Security benefits because he married a man.

The visual portrayal of activism in opposition to both interracial marriages and contemporary marriage equality is strikingly similar. For example, a photograph of a Little Rock protest in 1959, where protesters were carrying American flags and signs reading "Race Mixing is Communism" and "Stop the Race Mixing March of the Anti-Christ," (fig. 32.2) is similar to photographs showing signs against marriage equality today: "Judge Mocks Christ" and "A Moral Wrong Cannot Be a Civil Right." Ulti-

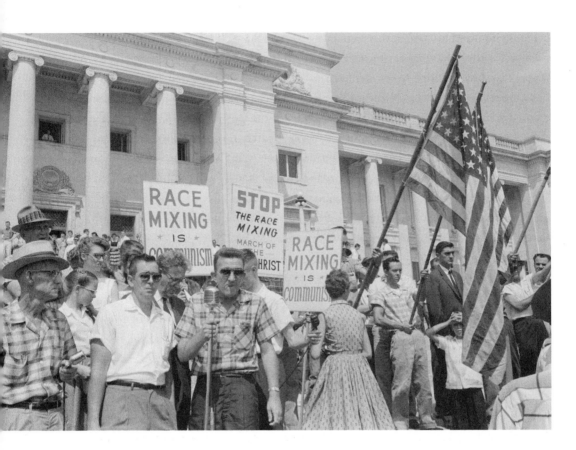

Fig. 32.2. Little Rock, Arkansas, August 20, 1959. Rally at state capitol, protesting the integration of Central High School. Protesters carry U.S. flags and signs reading "Race Mixing Is Communism" and "Stop the Race Mixing March of the Anti-Christ." Library of Congress, U.S. News & World Report Magazine Photograph Collection.

mately, the construction of mixed race marriages and same-sex marriages as both illegal and immoral through visual imagery also constructs mixed heritage people, queer folks, and their families as being outside social norms.

I know best how my own identity has been constructed. I grew up eating bratwurst and butterburgers in Whitefish Bay, Wisconsin, which people there jokingly refer to as "White Folks Bay." I was one of only three folks of color in my class, so I grew up thinking I looked incredibly Chinese—my classmates identified me as looking 100 percent Chinese. When I was little, my family flew from our home in Wisconsin to visit my mother's family in Hawai'i. Honolulu was a world away, and through a child's eyes, everything was different, strange and wonderful. The fact that my Chi-

nese cousins referred to my brother, sister, and me as "hapa" was just part of the landscape. They thought we looked pretty white, but they got that we were mixed. So it came as quite a shock to me when my mom and I moved to California, where I finished high school in the Central Valley, and my classmates there had no idea or didn't care what my race was. When it came up in conversation, they would guess random things like Mediterranean, Middle Eastern, mixed Latino, or other mixes. For the first time in my life, I had the experience of somebody calling me a liar when I said my mom was Chinese, which I couldn't fathom at first. They thought I was joking and I thought they were joking, but it was the beginning of the readjustment of my idea about what I must actually look like. I realized that history of being seen as Other was actually about Whitefish Bay, Wisconsin; it wasn't about me.

Many years later, my partner and I were thumbing through the catalog of the San Francisco Asian American Film Festival and saw a program of shorts titled *Don't Worry, Be Hapa*. As we watched the program with my family, I realized for the first time that stories like this mattered. These stories had a place, an audience, a community.

Sitting in that audience, I also realized that I could play a role on both sides of the screen. This is the first time I thought I could make art that mattered. By giving these stories a home, the film festival had also created community and identity—and possibilities.

KT: Mixed heritage identity begins with realizing that it is an option, because it's hard to choose something you've never heard of. Although Stuart heard the word "hapa" when he was a kid, I didn't hear it until I was in my mid-twenties.

I also feel that many are unwilling to choose something that others will not accept. For that reason, I feel that it is especially important for us to make sure that mixed heritage identity is an option for multiethnic individuals and for parents of multiethnic children. Perhaps things are a little easier now that we can point to the president of the United States as an example. In *The Audacity of Hope*, Barack Obama says, "I can't help but view the American experience through the lens of a Black man of mixed heritage, forever mindful of how generations of people who looked like me were subjugated and stigmatized, and the subtle and not so subtle ways that race and class continue to shape our lives."[3]

SG: My brother, sister, and I were born in three different states, and all of our birth certificates reflect our races differently. My brother was born first, in Oregon, and his birth certificate says his father is white, his mother is Chinese—and my brother is listed as "White-Chinese." Then my sister was born in North Carolina, and her birth certificate says she is the white child of two white parents (because in North Carolina at the time, "white" really meant "not Black"). Later, when I was born, in Wisconsin,

my birth certificate had no race indicated at all. Three children, one family—but our birth certificates tell three completely different stories. After my brother and sister were born, my parents moved to Missouri. Looking for a house, they were informed that their marriage was illegal in Missouri, where the law declared that "all marriages between whites and Negroes, and white and Mongolians are . . . absolutely void."[4] My father's first reaction was to say, "But I'm not married to a Mongolian!"

Attending summer camp in Wisconsin, I was immediately identified by the other boys in my cabin as "Chinese Stuart," despite being only half Chinese. I was used to this from my schoolmates, who were predominantly German and Polish American. Interestingly, they also started calling my bunkmate, Tom, who was Mexican American, "Chinese Tom." It was then that I realized that the word "Chinese" was being used to mean "outsider" and could come and go at will. Later, when the other boys decided I was cool, they dropped the "Chinese" and simply called me Stuart, while Tom remained an outsider and thus "Chinese Tom" until the end.[5]

KT: I can certainly relate to Stuart's story about being racially categorized. My mother registered me for kindergarten in a public school just outside of Washington, D.C. A woman asked questions about me, writing the answers on a standard form. Name? Age? Race? My mother, who was very far ahead of her time, said, "I am from Belgium and his father is from Japan, so that would make him Eurasian." The lady looked at me, looked at my mother, and said, "He looks pretty white to me" and marked "white" on the form. I thought of my mom—and of that lady—when I was finally able to check more than one box on the census form in 2000. I considered making use of the blank space labeled "some other race" to write in "Eurasian."

SG: John and I were on the steps of San Francisco City Hall on February 12, 2004, to attend a rally for Freedom to Marry Day. We had been together for seventeen years at that point and were becoming increasingly aware of the inequalities we faced growing older together without the rights and responsibilities that marriage provides. Then someone told us there was no need for a rally that day—instead, we could walk right through the doors of City Hall and get married! Mayor Gavin Newsom, in one of his first acts as mayor, had ordered the county clerk to stop discriminating in the provision of marriage licenses and give them to all loving couples regardless of race, gender, or sexual orientation. To get married, you just had to be two people. When John and I exchanged vows and heard the words "By virtue of the authority vested in me by the state of California, I now pronounce you spouses for life," it was the first time we felt our government was treating us as equal human beings, entitled to full citizenship under the law.

I began filmmaking as a personal response to stories I was hearing from friends with HIV/AIDS who were facing issues of death and dying at very young ages. It was

hard to know what to do with these heartbreaking and soul-searching stories, so I learned to make film and video in order to preserve and memorialize their thoughts and their lives. Later, I began addressing Asian American, queer, and mixed race identities in my work, and finally these themes intersect in a single film, *Muni to the Marriage* [2004] (fig. 32.3), which tells the parallel family stories of the marriage equality struggles faced by two generations in our family: that of my parents in the 1950s, and that of John and me today.

KT: Visualizing the many dimensions of mixed heritage experience is one of the important components of this art and activism. Loving Day contributes to this for the multiracial community. Megumi Nishikura, whose experience includes making films for the United Nations and codirecting, with Lana Perez Takagi, a feature film, *Hafu* [2011], filmed the Loving Day Celebration in New York in 2009. The production of strong visual media in a competitive visual landscape is important for the viability of the organization. Loving Day shares this work through every available channel: LovingDay.org, social networks, public exhibitions, and more.

Design is another important part of visually representing the community. The Legal Map on LovingDay.org visually summarizes hundreds of years of interracial marriage bans in a single interactive graphic. The map is far simpler than piles of legal documentation, so teachers can use the Legal Map as a teaching tool in their classrooms. The Loving Day logo (fig. 32.4) has been frosted on cakes and tattooed on a person, which signals the logo's success as a visual representation of an important idea: multiethnic community is important and valuable, and is personal to interracial couples and families and multiethnic individuals.

In 2009, Loving Day received the National Awareness Award from the Multiracial Americans of Southern California [MASC]. This was especially meaningful because MASC has been around since 1986. MASC, iPride, the Association of MultiEthnic Americans, MAVIN, Hapa Issues Forum, and other organizations inspired Loving Day. Today, they support Loving Day and host their own Loving Day Celebrations. They also contributed to the updated 2000 census, which allowed people to select more than one racial category, or write in their own, for the first time. This was one of the most visible signs of multiracial community progress.

Despite advances, the multiethnic community has yet to achieve major political influence. I believe this can be accomplished by building a more unified multiracial-multicultural community; Loving Day is an instrumental part of that process. Beyond building community, Loving Day educates about the history of interracial marriage as a crucial part of basic civil rights education. These efforts are especially relevant in the context of the marriage equality movement.

SG: In 1987, I met the man of my dreams but didn't dream we would ever be able

Fig. 32.3. Stuart Gaffney's parents, Mason Gaffney and Estelle Lau, on their wedding day in 1952. Video still from *Muni to the Marriage* (2004). Courtesy of the artist.

Synopsis: February 12, 2004, the day San Francisco made marriage history. A short ride to city hall suddenly turns partners of seventeen years into newlyweds. During the ride, the filmmaker reflects on the difficulties experienced more than fifty years ago by his Chinese American mother and white father, who were able to marry only when California's law against interracial marriage was overturned.

Fig. 32.4. Loving Day logo designed by Ken Tanabe in 2002. Photograph by Mauro Clerici; courtesy of Ken Tanabe.

to have a legal domestic partnership or civil union, much less full marriage equality. After all, the U.S. Supreme Court had upheld the constitutionality of sodomy laws one year earlier.

In 2004, John and I first exchanged vows in San Francisco City Hall during San Francisco's Winter of Love. Along with more than four thousand other newlyweds, we were pronounced "spouses for life" and told six months later that our marriage was legally null and void. This was an experience I never wanted to have in common with my parents—being told we had an illegal marriage. Along with other couples and organizations, we sued for equal marriage rights and began a four-year legal journey as one of the plaintiff couples in California's case for marriage equality.

In 2008, the California Supreme Court ruled in our favor. Surrounded by our friends and family, we exchanged vows once again and were legally married (fig. 32.5). My parents were present to witness the next generation in their family achieving marriage equality under the law.

In 2011, we celebrated our third wedding anniversary and toasted the first same-sex couple to legally marry in New York State—making history by exchanging vows before Niagara Falls illuminated in rainbow colors. Ten years from now, I hope this chapter of American history will be closed, and the time when some Americans could marry while others could not will be a relic of a bygone era to be studied in the history books.

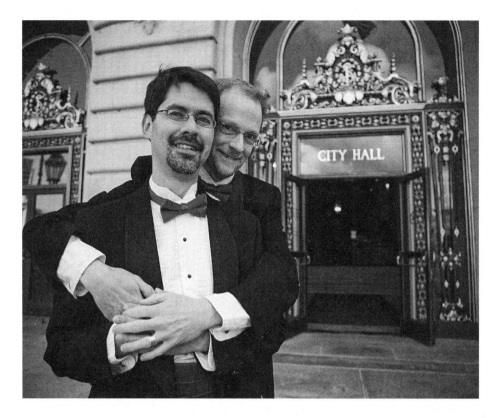

Fig. 32.5. After a four-year legal odyssey, Stuart and John legally married at San Francisco City Hall on June 15, 2008, after the California Supreme Court affirmed the right of same-sex couples to marry. Bella Pictures, courtesy of Stuart Gaffney and John Lewis.

KT: We should work to remember this history so that future instances of prejudice can be avoided. A much larger and more self-aware multiethnic community, commonly represented everywhere from popular media to official forms, should be part of this future vision. Ultimately, race is a social construct with no scientific basis. I believe that some of us see the world like this already. However, I believe that significant work must be accomplished before this idea becomes as familiar as the monoracial categories to which we are currently accustomed.

In the past seven years, Loving Day has connected diverse community groups and individuals, even across great distances. I hope that in the next ten years, Loving Day becomes a common, well-known annual tradition that is enjoyed by families, passed down between generations, shared among friends, and celebrated globally.

SG: On Loving Day in 2007, John and I flew with my mother to attend ceremonies in Washington, D.C., commemorating the fortieth anniversary of *Loving v. Virginia*.

The greatest anniversary gift of all came from Mildred Loving herself, who issued the following statement, titled "Loving for All":

> My generation was bitterly divided over something that should have been so clear and right. The majority believed what the judge said, that it was God's plan to keep people apart, and that government should discriminate against people in love. The older generation's fears and prejudice have given way, and today's young people realize that if someone loves someone they have a right to marry. I believe all Americans, no matter their race, no matter their sex, no matter their sexual orientation, should have that same freedom to marry.

That the woman whose name is synonymous with the struggle for interracial couples to achieve marriage equality could see the connections between her fight and that of same-sex couples is profoundly moving. Mildred Loving advocates that we move beyond bitterness and division toward freedom to marry as a fundamental right. Perhaps her words will help us conceive a new image—one that is no longer of only one couple standing together but rather of a whole community standing shoulder to shoulder fighting for social and legal justice in the context of marriage equality.[6]

Resources

Dariotis, Wei Ming. "'My Race, Too, Is Queer': Queer Mixed Heritage Chinese Americans Fight for Marriage Equality." *Chinese America: History and Perspectives—The Journal of the Chinese Historical Society of America*, 2007.

Dumesnil, Cheryl. *Hitched!: Wedding Stories from San Francisco City Hall.* Cambridge, MA: Da Capo Press, 2005.

Oishi, Eve. "Bad Asians, the Sequel: Continuing Trends in Queer API Film and Video." *Millennium Film Journal*, no. 41 (Fall 2003): 33–41.

Notes

Foreword

1. Stuart Hall, *Representation and the Media*, directed by Sut Jhally (Northampton, MA: Media Education Foundation, 1997); and Hall, *Cultural Representations and Signifying Practices* (London: Open University Press, 1997).

Preface

Across this manuscript, we use the term "mixed race" with no hyphen because we are looking at this idea as a social construct and not as a biological reality, which would be implied by the compound term "mixed-race." "Mixed race" specifically points to histories of racism, racialization, and the racial hierarchy. The term "mixed heritage," which is more expansive, includes transracial and international adoptees and cultural and ethnic blending more generally. Readers may also notice that we have not italicized foreign words. The English language, like the United States, is structured by and contains words borrowed from many other languages. Rather than mark some words as foreign, we chose to decolonize the text. You will thus find words italicized only for emphasis.

1. "What are you?" is the interrogative artist Kip Fulbeck uses to elicit handwritten responses that he pairs with portraits of his subjects in *Part Asian, 100% Hapa*.

2. Dariotis was first introduced to the word "Hapa" in "The World of Amerasians," a class at the University of California, Santa Barbara, taught by Teresa Williams-León in 1992. See Williams et al., "Being Different Together."

3. Definition in Pukui and Elbert, *New Pocket Hawaiian Dictionary*, 21; for an etymology of "hapa," see J. Kʻhaulani Kauanui, "Racialized Beneficiaries and Genealogical Descendants," in Kauanui, *Hawaiian Blood*, 56–57.

4. Wei Ming Dariotis, "Hapa: The Word of Power," Mixed Heritage Center, http://mixedheritagecenter.org/index.php?option=com_content&task=view&id=1259&Itemid=34.

5. We organized panels at both the 2008 and the 2009 Association of Asian American Studies conferences (Chicago and Honolulu, respectively) and at the 2011 Critical Ethnic Studies conference (University of California, Riverside); Mark Dean Johnson invited us in 2009 to organize a panel, "From Isamu Noguchi to Kip Fulbeck: Mixed Asian American Art," related to the exhibition *Asian/American/Modern Art: Shifting Currents, 1900–1970*, at the de Young Museum in San Francisco; we cohosted a discussion, "Miscegenating the Discourse: Mixed Race Asian American Art & Literature," with author Jessica Hagedorn at DePaul University on October 22, 2009; and we co-organized, with Camilla Fojas, the inaugural Critical Mixed Race Studies Conference "Emerging Paradigms in Critical Mixed Race Studies," held in 2010 at DePaul University in Chicago, at which a number of the artists in this book presented.

6. They include U.S. scholars such as Christine Ijiima Hall, George Kitahara Kich, Rebecca Chiyoko King-O'Riain, Stephen Murphy-Shigematsu, Cynthia L. Nakashima, Margo Okazawa Rey, Maria P. P. Root, Paul Spickard, and Teresa Williams-León and more recent work from U.K. scholars such as Jayne O. Ifekwunigwe (now in the United States), Suki Ali, Sarah Salih, Denise Williams, and Elaine Bauer.

7. "In the 1980s and 1990s, the research begins to center on the experience and identity of mixed race/multiracial individuals. Accordingly, there is a shift from studying this population simply as 'objects of analysis' to one in which they become 'subjects of analysis.' Previous research tended to examine mixed race/multiraciality within a monoracial framework and from a monoracial perspective. These new studies have included examining and giving voice to the actual perspectives of mixed race/multiracial–identified individuals. Moreover, they have articulated analyses surrounding the concept of 'critical' mixed race and multiraciality along with interrogating monoraciality and biological essentialism." G. Reginald Daniel, e-mail to Laura Kina, September 19, 2011. Examples of foundational work include ethnic studies scholars in Native American Studies and Asian American Studies (Jack Forbes, Teresa Williams-León, Terry Wilson); multidisciplinary social sciences (Marvin Arnold, Phillip Brown, G. Reginald Daniel, Christine Iijima Hall, George Kitahara-Kitch, Steven Murphy-Shigematsu, Carlos Poston, Maria P. P. Root, Michael Thornton, Francis Wardle); social history (Gary Nash, Paul Spickard); and philosophy (Naomi Zack).

8. Andrew Jolivette, "Critical Mixed Race Studies: New Directions in the Politics of Race and Representation," keynote address, "Emerging Paradigms in Critical Mixed Race Studies" conference, DePaul University, Chicago, November 5, 2010.

9. G. Reginald Daniel, e-mail message to Laura Kina, November 27, 2010.

10. Retreat organized by Eric Hamako (Hapa Issues Forum), Anthony Yuen (Hapa Issues Forum), Tarah Fleming (iPride), Farzana Nayani (MASC), and Elli Nagai-Rothe; attendees were an inspiring group of academics, activists, and artists.

11. For mixed race popular culture: Beltrán and Fojas, *Mixed Race Hollywood*; and DaCosta, *Making Multiracials*. For biracial art history: Elam, *Souls of Mixed Folk*; Smith, *Enacting Others*. For Asian American art history: Chang, *Envisioning Diaspora*; Chang, Johnson, and Karlstrom, *Asian American Art*; Hallmark, *Encyclopedia of Asian American Artists*; Machida, *Unsettled Visions*; See, *Decolonized Eye*.

Chapter 1. Miscegenating Discourses

1. Lowe, "Heterogeneity, Hybridity, Multiplicity," 60–83. The term "heritage" is wider than "race," encompassing people of mixed ethnicities as well as transracial adoptees. Though we are wary of reinscribing race, we use "mixed race Asian" in order to call attention to specific processes of racialization.

2. Root, *"The Biracial Baby Boom."*

3. U.S. Census Bureau, "2010 Census Shows America's Diversity," March 24, 2011, http://www.census.gov/newsroom/releases/archives/2010_census/cb11-cn125.html.

4. Pukui and Elbert's *New Pocket Hawaiian Dictionary* defines "hapa" as "Portion, fragment, part, fraction, installment; to be partial, less" and "Of mixed blood, person of mixed blood, as hapa Hawai'i, part Hawaiian."

5. Nakashima, "Asian American Studies," 112.

6. Ibid., 113.

7. Ibid., 114.

8. The dynamics of hair as a complex symbol of racialization for mixed race women, though it has a particular significance for women of mixed African heritage (from whence comes the notion of hair that is "good" [i.e., straighter, smoother, or more "white"] vs. bad [i.e., kinkier, nappier, or more Black]), also has meaning for women of other racialized mixes. See Sabrena Taylor, "Hair II," in "No Passing Zone: The Artistic and Discursive Voices of Asian Descent Multiracials," special issue, *Amerasia Journal* 23, no. 1 (1997): 163; and Ayana D. Byrd and Lori L. Tharps, *Hair Story: Untangling the Roots of Black Hair in America* (New York: St. Martin's Press, 2001).

9. Mequitta Ahuja, e-mail interview by Laura Kina, April 19, 2010.

10. DaCosta, *Making Multiracials*, 8.

11. Serene Ford says she does not use the historic term "Amerasian" (which refers to those fathered by U.S. military personnel during wars in Asia) to describe herself because of its negative connotation of illicit sex as her parents married for love. See the 1988 Amerasian Homecoming Act.

12. Serene Ford, interview by Laura Kina, Los Angeles, February 1, 2010. Digital recording.

13. Hannah Beech, "The Eurasian Invasion," *Time*, April 23, 2001, http://www.time.com/time/magazine/article/0,9171,106427,00.html.

14. Bhabha, *The Location of Culture*, 37.

15. Berssenbrugge, *I Love Artists*, 70.

16. Min, "The Last Asian American Exhibition," 35–36.

17. Anna Lang Kaye, "Hapa-palooza Origins Story," Hapa-Palooza, September 2011, http://hapapalooza.ca/hapa-palooza-origins-story/.

18. See the 1995 video *Doubles: Japan and America's Intercultural Children*, directed by Regge Life.

19. Margo Machida, address, College Art Association Conference, Los Angeles, February 27, 2009.

20. Machida, *Unsettled Visions*; Chang, *Envisioning Diaspora*; Chang, Johnson, and Karlstrom, *Asian American Art*.

21. Machida, *Unsettled Visions*, 8.

22. Duus, *The Life of Isamu Noguchi*; Brodsky, *Experiences of Passage*.

23. Art Spaces Archive Project Panel, "Oral Histories and the Archive," annual meeting of the College Art Association, New York, February 9, 2011.

24. Tam, "Is There an Asian American Aesthetics?" 629.

25. Bhabha, "In Conversation: Students with Homi K. Bhabha," roundtable at "Bodies and Borders: Symposium for Social Difference and Artistic Practice," Art Institute of Chicago, September 9, 2011.

26. See Laura Mulvey, "Visual Pleasure and Narrative Cinema," *Screen* 16.3 (Autumn 1975): 6–18.

27. "One Big Hapa Family: Synopsis" (Vancouver: Meditating Bunny Studio, 2010), http://web.me.com/jeffchibastearns/One_Big_Hapa_Family/About.html.

28. In the Canadian context, the Employment Equity Act of 2005 defines visible minorities

as "persons, other than aboriginal peoples, who are non-Caucasian in race or non-white in colour." http://www.statcan.gc.ca/concepts/definitions/minority-minorite1-eng.htm.

29. Paul Spickard, "Issues and Interpretations: Japanese, Americans," in *Mixed Blood*. For a transnational, including Canadian, perspective on this, see also Greg Robinson, *A Tragedy of Democracy: Japanese Confinement in North America* (New York: Columbia University Press, 2009).

30. Bhabha, *The Location of Culture*; Bhabha, "In Conversation."

31. Zia, *Asian American Dreams*, 109–35.

32. Ono, "The Biracial Subject as Passive Receptacle," 137. For a critical mixed race perspective on these issues, see also Velina Hasu Houston, "The Fallout Over 'Miss Saigon': It's Time to Overcome the Legacy of Racism in Theater," Counterpunch, *Los Angeles Times*, August 13, 1990, http://articles.latimes.com/1990-08-13/entertainment/ca-387_1_miss-saigon.

33. Murphy-Shigematsu, *When Half Is Whole*, 2. The author comments that he first began hearing the term used in this way in "the mid '80s when Lane Hirabayashi . . . declared it a term of self-definition. His assertion was prompted by the controversial meaning and use of the term, as some Japanese Americans were opposed to what they deemed a term with negative connotations as used in Hawaii."

34. Kristen D. Lee, *MiXeD mE*.

35. Lim, Tsutakawa, and Donnelly, *The Forbidden Stitch*, 20.

36. Mixed heritage West Asians face the same kind of interrogation encountered by other mixed Asian populations: How can we trust you?

37. Katie Roiphe, "'Love Child': How a Bastard Phrase Went Mainstream," *Slate*, May 24, 2011, http://www.slate.com/id/2295419/.

38. Before 1967, interracial marriage was not illegal in some states (more likely to be true above the Mason-Dixon Line). Antimiscegenation laws varied greatly and were structured in response to specific demographics, sociology, and politics.

39. The term "Middle East" is Eurocentric in origin, as it relates parts of Asia by their location relative to Europe, but the consensus of current scholarship has for the moment settled on MENA.

40. Chin, "Come All Ye Asian American Writers." He cautions that even apparently "positive" stereotypes have a negative effect, what he calls "racist love" or "the dream of being assimilated." The term "racial saviors" refers to a concept developed by Eric Hamako, "Monsters, Messiahs or Something Else? Representations of Mixed Race in Science Fiction Film," paper presented at the annual meeting of the American Literary Association, 2008. Julie S. Villegas, "The Racial Shadow in 20th Century American Literature," PhD diss., University of Washington, 1997.

41. Within the context of Asian American literary criticism and a critique of *Aiiieeeee!* and *Blu's Hanging*, Elda E. Tsou raises a similar concern over the use of racist terms to name a "new literary 'self' . . . if such a lesson can be drawn, [it] is not to dispense with such names, however painful, asymmetrical, but to attend, meticulously and persistently, to the figurative conditions of their emergence and reception." Elda E. Tsou, "Catachresis: *Blu's Hanging* and the Epistemology of the Given," *Journal of Asian American Studies* 14 (2011): 300.

42. Elam, *The Souls of Mixed Folk*, 33.

43. As Gerd Baumann and Andre Gingrich note, "The first is a special version of oriental-

ization in which the positive values associated with both self and other are normatively amalgamated, creating ideal representations of 'the best of both [indeed more] worlds'. Remaining a hegemonic operation, the second process that involves a self encompassment by elites may be less visible, but where it is absent, 'hyphenated identities' continue to be kept in such 'special' categories as are called 'halfies' by some and 'mixed race' by others." *Grammars of Identity/Alterity: A Structural Approach*, EASA Series (New York: Berghahn Books, 2004), 3:xi.

44. "Don't Worry . . . Be Hapa" T-shirt by Noe Yamabe, http://janmstore.com/2250x.html; Meghan Carlson, "'America's Next Top Model' Recap: Don't Worry, Be Hapa," BuddyTV, October 28, 2009, http://www.buddytv.com/articles/americas-next-top-model/americas-next-top-model-recap-32240.aspx.

45. Dariotis, "To Be 'Hapa'"; Tammy Conrad-Salvo, "Defending My Usage of 'Hapa,'" http://www.hapastories.com/hapastories.php?theme_id=COMMUNITY&story=28&pg=1; Nina Moon, "I Am Not Hapa," August 4, 2008, http://kimchimamas.typepad.com/kimchi_mamas/2008/08/i-am-not-hapa.html; various authors, "Talk:Hapa," *Wikipedia*, http://en.wikipedia.org/wiki/Talk%3AHapa#Edit_wars; various authors, discussion thread, "What Does 'Hapa' Mean?" HawaiiThreads.com, April 19, 2005.

46. DaCosta, *Making Multiracials*, 159–63.

47. Christina Lagdameo, deputy director of the White House Initiative on Asian Americans and Pacific Islanders, "Asian American Empire: Revisiting Pacific Island Studies and Pacific Islanders in Asian America/n Studies," plenary panel at "Association for Asian American Studies Annual Conference," Capital Hilton Hotel, Washington, DC, April 13, 2012.

48. J. Kʻhaulani Kauanui, "Where Are Native Hawaiians and Other Pacific Islanders in Higher Education?" Diverse Issues in Higher Education, September 8, 2008, http://diverseeducation.wordpress.com/author/kauanui/.

49. See Dariotis, "To Be 'Hapa.'"

50. Wah, *Faking It*, 58.

51. Mixed Asian Americans will inevitably continue to use the word "Hapa" in the process of constructing narratives and visual images about Asian Americans of mixed heritage. Mari Hara and Nora Okja Keller's anthology *Intersecting Circles: The Voices of Hapa Women in Poetry and Prose*, May Lee Chai's novel *Hapa Girl*, and Kip Fulbeck's fictional autobiography *Paper Bullets* use the word "Hapa" as a label of ethnic identity and as a way of connecting the mixed heritage Asian American community. Fulbeck's book of photos, *Part Asian, 100% Hapa*, and Laura Kina's *Hapa Soap Opera* oil painting series, in both their production and their execution, also center mixed heritage Asian American communities through the use of the word "Hapa."

52. Margo Machida, e-mail to the authors, September 4, 2011.

53. DaCosta, *Making Multiracials*, 8.

54. "Cherokee Nation Expels Descendants of Tribe's Black Slaves," *Huffington Post*, August 25, 2011, http://www.huffingtonpost.com/2011/08/25/cherokee-nations-expels-d_n_936930.html.

55. Samia Mirza, video interview by Laura Kina, Los Angeles, February 26, 2009. Mirza stated that since 1921, blood quantum laws have demanded at least 50 percent Hawaiian heritage in order to qualify for Hawaiian homestead benefits.

56. Kauanui, *Hawaiian Blood*, 14–15.

57. Jolivette, *Obama and the Biracial Factor*.

58. Kymberly Pinder, "Double Exposure" discussion, symposium at DePaul University in conjunction with the traveling exhibition *Double Exposure: African Americans before and behind the Camera*, Chicago, May 23, 2009.

59. Ytasha L. Womack, "'Post Black: How a New Generation is Redefining African American Identity,'" *Huffington Post*, March 18, 2010, http://www.huffingtonpost.com/ytasha-l-womack/post-black-how-a-new-gene_b_504590.html.

60. Lavie Raven, "Re-examining Bodies and Borders in Practice: Theory and Pragmatism," roundtable at "Bodies and Borders: Symposium for Social Difference and Artistic Practice," Art Institute of Chicago, September 9, 2011.

61. Mike Stuckey, "Multiracial Americans Surge in Number, Voice," MSNBC, May 5, 2008, http://www.msnbc.msn.com/id/24542138/.

62. Mequitta Ahuja, e-mail to Laura Kina and Wei Ming Dariotis, April 19, 2010.

63. Ibid.

64. Kip Fulbeck, e-mail to Wei Ming Dariotis, November 4, 2009.

65. Stuart Gaffney, e-mail to Wei Ming Dariotis, November 14, 2009.

66. Jane Jin Kaisen, interview by Laura Kina, Los Angeles, February 1, 2010.

67. Jenifer Wofford, "Artist Statement," Wofflehouse.com, May 6, 2010, http://wofflehouse.com/wofford/statement/.

68. Jenifer Wofford, e-mail to the authors, May 23, 2010.

69. Gina Osterloh, interview by Laura Kina, Los Angeles, February 1, 2010.

70. Barbara Marquand, "Philippine Nurses in the US—Yesterday and Today," Alloy Education, http://www.minoritynurse.com/filipino-philippine-nurses/philippine-nurses-us%E2%80%94yesterday-and-today.

71. For Punjabi Mexicans of California, see Karen Leonard, *Making Ethnic Choices: California's Punjabi Mexican Americans*, and Jayasri Majumdar Hart's documentary *Roots in the Sand*. For the Irish Chinese of New York, see Hall, *Tea That Burns*.

72. Rosa, "Coming of the Neo-Hawaiian American Race," 49–56.

Chapter 2. Skin Stories, Wars, and Remembering

Epigraph from Francisco, "The First Vietnam," 9.

1. Emiko Omori and Lisa Alteiri, *Skin Stories*.

2. Hauʻofa, "Our Sea of Islands," 152–54.

3. In Tagalog, the word for "to mark, stamp, or print" is "tatak," which is similar to the Polynesian word "tatau," from which the word "tattoo" originates. See Wilkin, *Filipino Tattoos*, 10–16; van Dinter, *The World of Tattoo*, 135–72. See also, in Roces, *Filipino Heritage*, vol. 3: Miguel A. Bernad, SJ, "A Booming Inter-Island Trade," 576–88; S. V. Epistola, "The Day the Chinese Came to Trade," 645–50; Cesar Adib Majul, "The Coming of Islam," 673–78; and E. P. Patanne, "Overseas Trade before Magellan," 767–69. See also Cesar Adib Majul, "The Shifting Winds of Change," in *Filipino Heritage*, ed. Roces, 5:1131–35; Scott, *Barangay*, 12–13; and J. Nicole Stevens, "The Austronesian Language Family," Department of Linguistics, Brigham Young University, http://linguistics.byu.edu/classes/ling450ch/reports/austronesian2.html.

4. Tan, "The Chinese Mestizos"; Wilkin, *Filipino Tattoos*.

5. Agoncillo, *History of the Filipino People*, 71–72; Laus, "The Search for Spice."

6. See Mercene, *Manila Men in the New World*, 1–11; Guevarra, "Filipinos in Nueva España"; and Schurz, *The Manila Galleon*.

7. Although many mestizos in the Philippines claim Spanish ancestors, the majority are a more complex racial blending. See Guevarra, "Filipinos in Nueva España."

8. Resurreccion, "Pockets of Revolts."

9. See Agoncillo, *History of the Filipino People*, 149–66; Arcilla, *An Introduction to Philippine History*, 84–91.

10. McCormick, *China Market*.

11. Brown, *Bury My Heart at Wounded Knee*; Churchill, *A Matter of Genocide*; Acuña, *Occupied America*, 1–134; Ignacio et al., *The Forbidden Book*, 7–11; and Miller, *Benevolent Assimilation*, 7–8.

12. Ignacio et al., *The Forbidden Book*, 9.

13. Silva, *Aloha Betrayed*; Lili'uokalani, *Hawaii's Story by Hawaii's Queen*; and Ignacio et al., *The Forbidden Book*, 8.

14. Ignacio et al., *The Forbidden Book*, 11.

15. Graff, *American Imperialism and the Philippine Insurrection*, 15–17.

16. Ignacio et al., *The Forbidden Book*, 12.

17. Ibid., 16; Kramer, *Blood of Government*, 87, 109.

18. Agoncillo, *History of the Filipino People*, 213–14; Kramer, *Blood of Government*, 108–10.

19. Francisco, *The First Vietnam*, 2–4.

20. Ibid., 4.

21. Ibid.

22. Kramer, *Blood of Government*, 87–158. On political cartoons, see Ignacio et al., *The Forbidden Book*.

23. See Ignacio et al., *The Forbidden Book*; Silva, *Aloha Betrayed*.

24. Linn, *The Philippine War, 1899–1902*, 322.

25. Karnow, *In Our Image*; Wolff, *Little Brown Brother*.

26. Ignacio et al., *The Forbidden Book*.

27. Bender, Brown, and Vazquez, *Savage Acts*; Ignacio et al., *The Forbidden Book*, 10, 20.

28. Rene G. Ontal, "'Fagen and Other Ghosts': African-Americans and the Philippine-American War," in Shaw and Francia, *Vestiges of War*, 118–33.

29. Francisco, *The First Vietnam*, 7.

30. Shaw and Francia, *Vestiges of War*, 13–15.

31. Francisco, *The First Vietnam*, 8; Linn, *The Philippine War, 1899–1902*, 310–12.

32. Francisco, *The First Vietnam*, 9.

33. See Rodríguez, "A Million Deaths?"; Kramer, *Blood of Government*, 157–58; Francisco, *The First Vietnam*, 14; Ignacio et al., *The Forbidden Book*, 109; and Shaw and Francia, *Vestiges of War*, 138.

34. Francisco, *The First Vietnam*, 10–14.

35. Reynaldo C. Ileto, "The Philippine-American War: Friendship and Forgetting," in Shaw and Francia, *Vestiges of War*, 18.

36. Ibid., 5; Kramer, *Blood of Government*, 168–70, 198–204.

37. Renato Constantino, "The Miseducation of the Filipino," in Shaw and Francia, *Vestiges of War*, 178.

38. Sucheng Chan, *Asian Americans*, 181.

39. Wilkin, *Filipino Tattoos*; van Dinter, *The World of Tattoo*, 85–93; Lars Krutak, "The Last Kalinga Tattoo Artist of the Philippines," http://www.larskrutak.com/articles/Philippines_/; Randolf Lagumbay Arguelles, "More Than Skin Deep," *A. Magazine* (April–May 1999): 19–20; and Mel Orpilla, "Mark of the Four Waves," *Filipinas Magazine* (February 2008): 32. For more on this, see Paul Morrow, "Baybayin: The Ancient Script of the Philippines," http://www.mts.net/~pmorrow/bayeng1.htm; Scott, *Prehispanic Source Materials for the Study of Philippine History*, 60, 213.

40. Rondilla, "The Filipino Question," 62–63.

Chapter 6. The Celtic Samurai

1. "*The Loneliest Brides in America.*"

2. *A More Perfect Union: Japanese Americans and the U.S. Constitution*, Smithsonian National Museum of American History, Behring Center, http://americanhistory.si.edu/perfectunion/experience/index.html (accessed October 14, 2011).

3. Ellen Clare Kennedy, "The Japanese-American Renunciants: Due Process and the Danger of Making Laws during Times of Fear," Japan Policy Research Institute Working Paper 110 (October 2006), http://www.jpri.org/publications/workingpapers/wp110.html (accessed October 14, 2011).

4. Renee Tawa, "Childhood Lost: the Orphans of Manzanar," *Los Angeles Times*, March 11, 1997, http://articles.latimes.com/1997-03-11/news/mn-37002_1_manzanar-orphans/2.

5. Robinson, *A Tragedy of Democracy*.

6. According to the 2010 U.S. Census, in the Japanese American population age 5–17, 74 percent were mixed in any combination, and for the under-5 population, 76.2 percent were mixed heritage. According to a 2011 University of Maryland–JACL study, "A Demographic Overview of Japanese Americans," as of 2009, Japanese American men and women continued to have the highest rates of outmarriage of any Asian ethnic group, with 35.4 percent of the men (24.1 percent of foreign-born and 42.6 percent of U.S.-born) and 54.3 percent of the women (57.8 percent of foreign-born and 49.7 percent of U.S.-born) marrying non-co-ethnic spouses. For Japanese Americans of a single race who engaged in intermarriage, 58 percent of the men and 42 percent of the women married non-Hispanic whites, equating to a staggering 77.5 percent of all Japanese American women with non-Japanese husbands marrying non-Hispanic whites.

7. Paul Yamada, e-mail to Laura Kina, July 22, 2011.

Chapter 7: Yonsei Hapa Uchinanchu

1. The Six-Day War, which took place June 5–10, 1967, involved a historically contested military attack by Israel on Syria, Jordan, and Egypt. Israel viewed the attack as a preemptive strike against an impending coordinated attack by surrounding Arab states. Arabs call it the 1967 War or an-Naksah (The Setback).

2. Lee, "Laura Kina," Foundation for Asian American Independent Media, http://www.faaim.org/visual/.

3. Lanny Silverman, panel moderator, "Fame and Fortune: Chicago Artists and the Politics of Reputation," DePaul Art Museum, September 17, 2011.

4. The first generation of picture brides who became sugarcane plantation workers found they had little use for their handwoven blue-patterned kimonos and repurposed the garments as work clothes.

5. The flumes consisted of a network of permanent wooden and temporary aluminum inclined channels that carried diverted stream water for floating sections of cane from the fields to the mills for processing.

6. Obon is the Buddhist summer festival honoring the spirits of one's ancestors.

Chapter 9. Gravity Always Wins

1. Laurel Nakadate, School of the Art Institute of Chicago, Parlor Room lecture, November 11, 2009.

2. Her grandfather's father, Bunichi Nakadate, emigrated from Yamanashi-ken, Japan, to Portland, Oregon, in the late 1890s. Her grandmother's father, Minejiro Marumoto, came from Wakayama-ken via Kobe, Japan, to Seattle, to farm. In 1913, Laurel's great-grandmother, Mariji Ashizawa (Nakadate), and grandmother, Hatsune Imoto (Marumoto), came to the United States through the picture bride system of arranged marriage. Laurel's mom is a "white cowgirl from Texas." Her parents met at the University of Texas at Austin in 1971.

Chapter 10. Producing Missing Persons

1. The misrecognition of adoptees whose socialization as "white" is at odds with their racialization as "Asian" is, following Judith Butler, an instance of disidentification—that is, an "uneasy sense of standing under a sign to which one does and does not belong" (Butler, *Bodies That Matter*, 219). Lisa Lowe describes disidentification as a "space in which alienations, in the cultural, political and economic sense, can be rearticulated in oppositional forms. . . . It allows for the exploration of alternative political and cultural subjectivities that emerge within the continuing effects of displacement" (Lowe, Immigrant Acts, 103–4). Adoptees' social practices can be seen as forms of disidentification with dominant narratives of race and nation, but they are arguably more multiple and shifting than those of other minority subjects, including mixed race individuals or hapas, not only because they are caught between homogenized "cultures" and "nations" but also because their racialized difference and national origins typically are not shared with either adoptive parent.

2. Eleana J. Kim, "Korean Adoptee Auto-ethnography," 43–70.

3. In 2001, reacting to the exclusion of adoptees from an exhibition of Korean diasporic art in Korea, she and kate hers began to network with other adoptee artists and diasporic Koreans through the publication *O.K.A.Y.: Overseas Korean Artists' Yearbook*.

4. Choy and Choy, "Transformative Terrains"; Choy and Choy, "What Lies Beneath"; Eng, *The Feeling of Kinship*; Eleana J. Kim, "Korean Adoptee Auto-ethnography"; Park Nelson, "'Loss Is More Than Sadness.'"

5. Naficy, *An Accented Cinema*.

6. Maya Weimer, e-mail to author, January 2006.

7. kate hers, phone conversation with author, October 2008.

Chapter 11. Crossfading the Gendered History of Militarism in Korea

1. Jane Jin Kaisen, "Act 3: The Faroe Islands," *Rethinking Nordic Colonialism: A Postcolonial Exhibition Project in Five Acts*, The Faroe Islands Art Museum, Tórshavn, http://www.rethinking-nordic-colonialism.org/files/grid/c3.htm#JJKTH.

2. During 1953–67, "servicemen's wives and adoptees were admitted to the United States under special considerations." In contrast, starting in 1968, the third wave of Korean immigration has been "marked by the passage of the 1965 immigration act," which "removed national origin as the basis of American immigration." "Korean American History," Korean American Museum, http://www.kamuseum.org/community/base.htm.

Chapter 12. Lost in Their "Fathers' Land"

Epigraph from Seth Mydans, "Vietnamese Find No Home Here in Their Fathers' Land," *New York Times*, May 28, 1991, http://www.nytimes.com/1991/05/28/us/vietnamese-find-no-home-here-in-their-fathers-land.html.

1. Boyne, *Air Warfare*, 362–63.

2. Shaw and Warnock, *The Cold War and Beyond*, 75.

3. The location shown in this image is consistently misidentified. The UPI Tokyo bureau originally claimed that the image was taken on the roof of the U.S. embassy.

4. Rogers, *Destiny's Landfall*, 253.

5. In the twentieth century, U.S. refugee policy has been dictated largely by failed campaigns abroad (with the exception of the 1948 Displaced Persons Act, which concerned refugees in nation-states that had fallen under Communist rule). For example, the 1966 Cuban Refugee Adjustment Act, like the 1975 Indochinese Refugee Act, was intended to facilitate the arrival of Cubans who had participated in the disastrous Bay of Pigs invasion in 1961.

6. Nguyen, *The Unwanted*, 343.

7. David Lamb, "Children of the Vietnam War," *Smithsonian*, June 2009, http://www.smithsonian.com.

8. Operation Babylift did not take place without controversy. Indeed, it was revealed at the time that not all the "orphans" were parentless.

9. Dolgin and Franco, *Daughter from Danang*.

10. This quote was taken from my adoption papers. In order to finalize the adoption, my biological mother was required to publicly provide a reason for relinquishing custody to the court.

11. Young, *The Vietnam Wars*, 319.

12. Wiest, *The Vietnam War*, 85.

13. Lamb, "Children of the Vietnam War."

14. Ibid.

15. Hedges, *War Is a Force*.

16. Caroline Kieu Linh Valverde, "Doing the Mixed-Race Dance: Negotiating Social Spaces Within the Multiracial Vietnamese American Class Typology," in Williams-León and Nakashima, *The Sum of Our Parts*, 136.

17. Lisa Belkin, "Children of 2 Lands in Search of Home," *New York Times*, May 19, 1998 http://www.nytimes.com/1988/05/19/us/children-of-2-lands-in-search-of-home.html/.

18. Lamb, "Children of the Vietnam War."

19. Ibid.

20. Ibid.

21. Chan, *Asian Americans*, 163–64. According to Chan, "Between 1982, when Vietnam's Orderly Departure Program was expanded to cover American Vietnamese, and the end of 1987, when Congress finally passed an Amerasian Homecoming Act, the only way such children could enter the United States was through the Orderly Departure Program. Approximately 4,500 of them did so during that five-year interval" (164).

22. Kay Johnson, "Children of the Dust," *Time*, May 13, 2002, http://www.time.com/time/printout/0,8816,2375,00.html. As Johnson argues, Vietnamese Amerasians have been exploited in Vietnam precisely because of the Homecoming Act. In particular, some Vietnamese intent on immigrating to the United States will bribe officials for documents attesting to a familial relationship with a Vietnamese Amerasian émigré.

23. "Amerasian Laws," Amerasia Foundation, http://amerasianfoundation.org/?page_id=9.

24. Ibid.

25. Maria. P. P. Root, "Factors Influencing the Variation of Racial and Ethnic Identity of Mixed-Race Heritage Persons of Asian Ancestry," in Williams-León and Nakashima, *The Sum of Our Parts*, 61.

Chapter 13. In Love in a Faraway Place

1. Serene Ford, August 10, 2010, follow-up e-mail interview with Laura Kina.

Chapter 14. Six Queens

1. Eileen McCann O'Brien, "University of Hawaii Beauty Queens," *Paradise of the Pacific*, December, 1948. *Paradise of the Pacific* was widely distributed in the United States, which may account for the lengths to which the editor went to explain the novelty of the contest.

2. The sociologist Romanzo Adams argued that even though the ordinary jealousy and competition existed between ethnic groups, interracial marriage in Hawai'i was evidence of a racial code that promoted ethnic harmony in order to preserve social peace. See Adams, *Interracial Marriage in Hawaii*.

3. Beth Bailey and David Farber coined this term to denote the sense of social displacement and alienation many American GIs felt once they arrived in Hawai'i. Estimates vary, but as many as three million military personnel lived in, passed through, or were deployed in Hawai'i during World War II. See Bailey and Farber, *The First Strange Place*.

4. Bailey and Farber estimate that between three thousand and seven thousand military personnel returned to Hawai'i as civilian residents after World War II. See ibid., 46.

5. There were few white female residents in Hawai'i until the arrival of Congregational missionaries in 1820. Most of the sailors aboard whalers and other commercial ships were working-class white men, but many were African American, Portuguese, Filipino, and Mexican.

6. Adams, *Interracial Marriage in Hawaii*, 21.

7. The total Hawaiian population declined from 71,000 in 1853 to around 40,000 at the end of the century. "Foreign" populations grew then from about 2,000 to more than 100,000. Growth in the sugar industry and the large number of workers—largely from Asia—who were imported to work on plantations accounted for most of the population increase. See Nordyke, *The Peopling of Hawai'i*.

8. See Schmitt, *Historical Statistics of Hawaii*.

9. Most famous, of course, was Princesses Kaiulani, niece of Queen Lili'uokalani and heir to the throne.

10. Amateur observers and professional sociologists alike were fascinated with the acceptance of interracial marriage in Hawai'i and considered it to be a barometer of racial harmony. The most astute analysis is Adams's *Interracial Marriage in Hawaii*, but others have attempted to explain the curious nature of race relations in Hawai'i to mainland readers, such as Sidney Gulick, *Mixing the Races in Hawaii: A Study of the New-Hawaiian American Race* (Honolulu: The Hawaiian Board Book Room, 1937), and William Freemont Blackman, *The Making of Hawaii: A Study in Social Evolution* (1899; repr., New York: The Macmillan Company, 1906).

11. Editorial, *Ka Leo 'O Hawaii*, May 23, 1923, 4.

Chapter 15. Remixing Metaphors

1. Here, I use the terms "Native Hawaiian" (abbreviated in the context of the essay as "Native") and "Hawaiian" interchangeably, to refer to indigenous peoples in Hawai'i and the Hawaiian diaspora.

2. See Lai and Arguelles, *New Face of Asian Pacific America*, 15.

3. "Hawaii Still Leads U.S. with Highest Rate of Mixed Marriages," *Honolulu Advertiser*, May 27, 2010, http://www.honoluluadvertiser.com/article/20100527/NEWS01/5270361/Hawaii-still-leads-US-with-highest-rate-of-mixed-marriages.

4. See "Applying for Hawaiian Homelands," Department of Hawaiian Home Lands, http://hawaii.gov/dhhl/applicants/appforms/applyhhl.

5. Anne Keala Kelly, interview with Laura Kina, February 12, 2010.

6. Kaili Chun, interview with the author, June 7, 2007. Chun is the product of multigenerational marriages between Native Hawaiians and other groups. Her father is of Hawaiian, Chinese, and European descent, and her mother is of Hawaiian and European ancestry.

7. According to the 2000 U.S. Census, Native Hawaiians and part–Native Hawaiian people constitute 20 percent of the total population in Hawai'i.

8. Kaili Chun, interview with the author, September 20, 2007.

9. Kaili Chun, interview with the author, May 22, 2010. For a detailed discussion of the concept of a "Hawaiian epistemology," see Manulani Aluli Meyer, "Native Hawaiian Epistemology: Contemporary Narratives (Unedited Doctoral Thesis)," in *Ho'oulu, Our Time of Becoming: Collected Early Writings of Manulani Meyer* (Honolulu: 'Ai P'haku Press, 2003).

10. Trask, *From a Native Daughter*, 1.

11. Meyer, "Native Hawaiian Epistemology," 82.

12. Sahlins, "Goodbye to *Tristes Tropes*," 387–88.

13. Adrienne Pao, e-mail to the author, May 18, 2010.

14. Pao, unpublished artist's statement.

15. Pao, interview with the author, May 20, 2010.

16. Pao, e-mail to the author, May 18, 2010.

17. Pao, interview with the author, May 20, 2010.

18. Pao, e-mail to the author, May 18, 2010.

19. Pao, interview with the author, May 20, 2010.

Chapter 16. Hawaiian Cover-ups

1. Pao spoke about this same series on a Pacific Islander Arts panel, "Views from the Continent: Art and the U.S. Pacific Diaspora," at the College Arts Association conference, February 12, 2010, in Chicago.

Chapter 17. I've Always Wanted Your Nose, Dad

1. Kamehameha Schools, Vision/Mission, http://www.ksbe.edu/about/.

2. In 1959, Hawai'i became the fiftieth state. For Kamehameha School's admissions policy, see http://www.ksbe.edu/admissions/admissions.php.

3. One of the requirements for being eligible to apply for a Hawaiian Home Lands lease is that one must be a Native Hawaiian, "defined as 'any descendant of not less than one-half part of the blood of the races inhabiting the Hawaiian Islands previous to 1778.' This means you must have a blood quantum of at least 50 percent Hawaiian. This requirement remains unchanged since the HHCA's passage in 1921." http://hawaii.gov/dhhl/applicants/appforms/applyhhl.

Chapter 18. Both Buffer and Cosmopolitan

Epigraph is from Meiqi Lee, *Being Eurasian*, 32.

1. Ulbe Bosma and Gijsbert Oonk, "Bombay Batavia: Parsi and Eurasian Variations on the Middlemen Theme," in Nico Randeraad, *Mediators between State and Society* (Rotterdam, Netherlands: Verloren Publishers in cooperation with Erasmus University Rotterdam, 1998), 17.

2. Meiqi Lee, *Being Eurasian*, 28, 30.

3. Somaiah and Zhuang, *Gateway to Singapore Culture*, 30.

4. Spivak, *A Critique of Postcolonial Reason*, 1.

5. Winant, *The New Politics of Race*, 133.

6. Ross and Lester, *Images That Injure*, 129.

7. Caplan, Children of Colonialism, 74; Hollander, Silenced Voices, 61; Yen Le Espiritu,

"Possibilities of a Multiracial Asian America," in Williams-León and Nakashima, *The Sum of Our Parts*, 29.

8. Lee, *Being Eurasian*, 16.

9. Hawes, *Poor Relations*, 56–72.

10. Bosma and Oonk, "Bombay Batavia," 20.

11. Fischer-Tiné and Gehrmann, *Empires and Boundaries*, 9.

12. Lee, *Being Eurasian*, 8.

13. Peters, *In Search of the Good Life*, 142.

14. Marchetti, *Romance and the "Yellow Peril,"* 69; Oyama, "Secret Asian Man," 83–84.

15. Oyama, "Secret Asian Man," 93.

16. Hawes, *Poor Relations*, 19.

17. Paul Spickard, "What Must I Be?: Asian Americans and the Question of Multiethnic Identity," in *Asian American Studies: A Reader*, ed. Jean Yu-wen Shen Wu and Min Song (Piscataway, NJ: Rutgers University Press, 2000), 267.

18. Winnifred Eaton has been critiqued for "faking" a Japanese identity during a time when Japanese were seen as an acceptable Asian Other and Chinese were a reviled and threatening "Yellow Peril." Edith Eaton, conversely, has been praised, most notably by Frank Chin, for choosing to identify as Chinese when she could have passed for white (Chan et al., *Aiiieeeee!* 12).

19. Founded by historian Jack Kuo Wei Tchen and activist Charles Lai.

20. Dariotis, "Teaching Edith Eaton," 1.

21. Chin, "Come All Ye Asian American Writers," 12.

22. Lippard, *Mixed Blessings*, 188.

23. Winther-Tamaki, *Art in the Encounter of Nations*, 118.

24. Chang, Johnson, and Karlstrom, *Asian American Art*, 124.

Chapter 19. Cosmopolitan Views

1. Brodsky, *Experiences of Passage*, 113.

2. Lin & Keng Gallery, *Inaugural Exhibition*, Beijing, April 21–July 7, 2007.

3. Lin & Keng Gallery, *Experiences of Passage: The Paintings of Yun Gee and Li-lan*, Beijing, November 15– December 16, 2008.

4. Jess Frost, *"Li-lan: Mystery, Meditation, and Technique,"* *East Hampton Star*, March 3, 2009, http://www.li-lan.com/texts/Li_lan_EHStar_09.

5. Li-lan, "Artist's Statement," http://www.li-lan.com/texts/li_lan_statement_07.

Chapter 20. 100% Hapa

1. Hapa Issues Forum started as a student group at the University of California, Berkeley, dedicated to supporting mixed race Asian Pacific American students and mixed race advocacy more generally. Founded in 1992 in response to the exclusion of multiracials in the Japanese American community, the multi-chapter organization disbanded in 2007. Dariotis cofounded the San Francisco chapter, with April Elkjer, in 1997 and served on the board of directors.

2. See Nakashima and Williams-León, *The Sum of Our Parts*; Spickard, *Mixed Blood*; and Daniel, *More Than Black?*

Chapter 22. Reappearing Home

Epigraph from "Tribal Enrollment Councils: Lessons on Law and Indian Identity," *Western Historical Quarterly*, Summer 2001: 176.

1. The terms "Native American" and "American Indian" are both used regularly within academia and colloquially, though members of these communities may also refer to themselves simply as "Native" or, depending on context, by their tribal and ethnic affiliations. The variation in usage is controversial, as the meanings are complex. See Roemer, introduction to *Cambridge Companion to Native American Literature*, 9–11.

2. Spickard and Daniel, *Racial Thinking in the United States*, 39, 221.

3. See Bier, *American Indian and African American People*; Jolivette, *Louisiana Creoles*; Forbes, *Africans and Native Americans*; Brooks, *Confounding the Color Line*; Julia Harris, "The Black-Indian Connection in Art: American Portraits, Soulscapes and Spirit Works," *International Review of African American Art* 17, no. 1 (2000): 2–40.

4. Robert Keith Collins, "What Is a Black Indian? Misplaced Expectations and Lived Realities," in *IndiVisible: African-Native American Lives in the Americas*, (Washington, DC: Smithsonian Institution's National Museum of the American Indian in association with the National Museum of African American History and Culture and the Smithsonian Institution Traveling Exhibition Service, 2009), 185.

5. Collins, "What Is a Black American?" 184.

6. Dismukes, *The Red-Black Connection*.

7. This is true for the Coast Miwok, who were federally recognized in 2000 after establishing a village center for cultural life in Point Reyes National Seashore. Jennifer Sokolove, Sally K. Fairfax, and Breena Holland, "Managing Place and Identity: The Marin Coast Miwok Experience," *Geographical Review* 92, no. 1 (January 2002): 35, http://0-www.jstor.org.opac.sfsu.edu/stable/414094938.

8. Cited in Preston Singletary, "Cultural Confluence at Wing Luke Museum through Sept. 18," posted on July 29, 2011, by Studio, http://www.prestonsingletary.com/2011/07/29/cultural-confluence-at-wing-luke-museum-through-sept-18/.

9. Preston Singletary, "Artist Statement," http://www.prestonsingletary.com/artist-statement/.

10. Walter Porter "A Spokesman of Culture," Tlinkimo.com, http://www.tlinkimo.com/home_page-right-column/a-spokesman-of-culture/.

11. Paul Chaat Smith, "No Fixed Destination," PaulChaatSmith.com, http://www.paulchaatsmith.com/no-fixed-destination.html.

12. Dariotis, "Crossing the Racial Frontier."

13. W. Richard West, Jr., "Lunar Exploration," in *James Luna: Emendatio*, by Lisbeth Haas, Truman Lowe, Paul Chaat Smith, and W. Richard West, Jr. (Washington, DC: Smithsonian National Museum of the American Indian, 2006).

14. Liestman, *Horizontal Inter-ethnic Relations*, 330.

15. Chinese Canadian Historical Society of British Columbia, *Chinese Canadians and First Nations: 150 Years of Shared Experience*, http://www.chinese-firstnations-relations.ca/index.html; Dariotis, "Developing a Kin-Aesthetic," 192, 188.

16. Liestman, *Horizontal Inter-ethnic Relations*, 348.

17. Ibid., 328.

18. Dariotis, "Developing a Kin-Aesthetic," 190.

19. Sokolove, Fairfax, and Holland, "Managing Place and Identity," 29.

20. Frances Cabahug argues, "Many of the characters in *Disappearing Moon Café* concern themselves with the preservation of the family bloodline, primarily as a reaction to the racist state policies, which restricted the number of Chinese workers and brides allowed to immigrate to Canada" ("Jumping the Helix: Genomics and the Next Generation of Chinese-Canadian Literature on the West Coast," *UFV Research Review: A Special Topics Journal from the University of the Fraser Valley* 3, no. 1: 138, *journals.ufv.ca/rr/RR31/article-PDFs/13-cabahug.pdf*).

21. Lucy Ostrander and Don Sellers, *Island Roots*, dir. Lucy Ostrander and Don Sellers, video (Bainbridge Island, WA: Stourwater Pictures, 2006).

22. Gina Corpuz, "The Value of a Small Story," in *"Island Roots": Curriculum for Engaged Learning through Film*, project managers, Katie Jennings, Pat Guild O'Rourke, and Kristin Poppo (Bainbridge Island, WA: IslandWood, 2009).

23. Lawrence, *"Real" Indians and Others*, 14.

Chapter 23. Walking in "Chindian" Shoes

1. Louie Gong, "Bio," Eighth Generation, http://www.eighthgeneration.com/index.php/content/bio/.

2. Tracy Rector, Longhouse Media, *Unreserved: The Work of Louie Gong*, YouTube, http://www.youtube.com/watch?v=YRgqhHVPQKg.

Chapter 25. What Used to Be a Footnote

1. Loewen, *The Mississippi Chinese*, 76–77.

2. Rhee, "In Black and White," 127.

3. Allison Varzally, "Romantic Crossings: Making Love, Family, and Non-Whiteness in California, 1930–1950," *Journal of American Ethnic History* (Fall 2003): 30.

4. Henry James Clark, ''Ière,' The Land of the Humming Bird, Being a Sketch of the Island of Trinidad* (Port-of-Spain: Government Printing Office, 1893), 52.

5. Lai, *Indentured Labor, Caribbean Sugar*, 209.

6. Lai, *Chinese in the West Indies*, 246.

7. Ibid., 250.

8. In the 1918 Anti-Chinese Riots, during an economic down period that particularly affected working-class Black Jamaicans, a number of Chinese small-business owners were attacked and their stores looted and destroyed. Aggression was again directed at Chinese business owners in 1938 following an economic depression and in 1965 after word got out that a Chinese bakery owner in Kingston had assaulted a Black female employee. See Bouknight-

Davis, "Chinese Economic Development." For an account of racially motivated attacks and riots against Chinese Americans, see Pfaelzer, *Driven Out*.

9. Ottley, *New World A-Coming*, 53–54.

10. His sister, Betty Wong Lem, was interviewed by Jean Wong on April 5, 1979.

11. Varzally, "Romantic Crossings," 9.

12. Houston and Houston, *Farewell to Manzanar*, 36.

13. Spickard, *Japanese Americans*, 98.

14. Matsumoto, *Farming the Home Place*, 129.

15. Alvarez, *The Power of the Zoot*, 85.

Chapter 26. Jamaican Hybridity within the "Bowels of Babylon"

1. Robert Lee is the director of the Asian American Arts Centre in New York.

2. Albert Chong, paper presented at the "Double Exposure: African Americans Before and Behind the Camera" symposium, DePaul University, Chicago, May 23, 2009.

3. As Kara Kelly Hallmark describes the series: "From 1980 to 1985, Chong created a series of self-portraits, I-Traits, where he used aspects of Rastafarianism as a lens to portray himself." Hallmark, *Encyclopedia of Asian American Artists*, 37.

Chapter 27. Automythography

1. On April 19, 2010, Mequitta Ahuja e-mailed Laura Kina this description of *Dream Region*, which appeared in "Portrait of an Artist," Smithsonian National Portrait Gallery, March 26, 2009, http://www.npg.si.edu/competition/site2/artist/mequitta-ahuja /04.html.

> *Dream Region* is actually an update of a piece titled *Night Emission* that I made while in residence at Blue Sky Project [in Dayton, Ohio] in collaboration with eight teenagers. We worked literally on top of each other; a couple of people working toward the bottom of the piece, others standing on stools. This pile of people resulted in a visual mix. I tried to bring it together in the end, but the piece was inevitably heterogeneous, which I think lent to its strength. To my surprise and delight, the piece was purchased by one of my artistic heroes, visual artist Nick Cave. Upon hearing about the sale, I started imagining what the piece must have looked like to him. In making *Dream Region*, I tried to amplify the aspects of *Night Emissions* I saw related to Cave's work. I began with the figure and moved into adornment, visual rhythm, pattern, and design.

Chapter 28. Revisiting Border Door
and Unearthing Anthropolocos' White-Fying Project

1. Minor White is an American photographer and cofounder of *Aperture* magazine.

2. "Carnalismo" means loyalty to and support for your community members.

3. Fusco, "Fantasies of Oppositionality," 62.

4. The Chicano term "rasquache" means "to make the most with the least."

5. Guisela Latorre, "Border Consciousness and Artivist Aesthetics: Richard Lou's Performance and Multimedia Artwork" (paper presented at Bielefeld University, Bielefeld, Germany, July 2009), 13.

Chapter 29. Journey of a "Chicanese"

1. Paper sons and paper daughters came to the United States after the 1906 earthquake and fire in San Francisco destroyed past records, allowing new Chinese immigrants to enter through Angel Island with papers claiming U.S. citizenship or blood ties to U.S. citizens. These ruses were used as a means of circumventing racist anti-Chinese immigration laws.

Chapter 31. The Biracial Baby Boom and the Multiracial Millennium

1. See Marchetti, *Romance and the "Yellow Peril."*

2. See Ono, "The Biracial Subject as Passive Receptacle."

3. Zack, *Race and Mixed Race.*

4. Zack, *American Mixed Race.*

5. Ibid., 305.

6. Ibid., x–xi.

7. By 2000, the census officially recognized racial diversity by allowing people to check more than one box, counting people in several categories in order to track individuals in relation to distinct racial categories.

8. Lippard, *Mixed Blessings.*

9. Michael Winant and Howard Omi, *Racial Formation in the United States: From the 1960s to the 1990s* (New York and London: Routledge, 1994), 147–48.

10. See LeiLani Nishime, "*The Matrix* Trilogy, Keanu Reeves, and Multiraciality at the End of Time," in Beltrán and Fojas, *Mixed Race Hollywood*, 290–312; and Jane Park, "Virtual Race: The Racially Ambiguous Action Hero in *The Matrix* and *Pitch Black*," in Beltrán and Fojas, *Mixed Race Hollywood*, 182–202.

11. Angharad Valdivia, "Mixed Race on the Disney Channel: From *Johnny Tsunami* through *Lizzie McGuire* and Ending with *The Cheetah Girls*," in Beltrán and Fojas, *Mixed Race Hollywood*, 269–89.

12. Ruth La Ferla, "Generation E.A.: Ethnically Ambiguous," *New York Times*, December 28, 2003.

13. Mary Beltrán and Camille Fojas, "Introduction: Mixed Race in Hollywood Film and Media Culture," in *Mixed Race Hollywood*, 1–20.

14. Lisa Nakamura, "Mixedfolks.com: 'Ethnic Ambiguity,' Celebrity Outing, and the Internet," in Beltrán and Fojas, *Mixed Race Hollywood*, 64–83.

Chapter 32. Loving Days

1. Jeffrey S. Passel et al., "One-in-Seven New U.S. Marriages is Interracial or Interethnic: Marrying Out," *Pew Research Center*, June 4, 2010, http://pewresearch.org. "A record 14.6% of all new marriages in the United States in 2008 were between spouses of a different race or ethnicity from one another. This includes marriages between a Hispanic and non-Hispanic (Hispanics are an ethnic group, not a race) as well as marriages between spouses of different races—be they white, black, Asian, American Indian or those who identify as being of multiple races or 'some other' race."

2. Davis's photos (and the option to upload your own) are available at LovingDay.org.

3. Obama, *The Audacity of Hope*, 10.

4. Missouri Statutes, 1949: Sec. 8020, "Certain marriages prohibited. All marriages between . . . white persons and negroes, white persons and Mongolians, are prohibited and declared absolutely void."

5. This was the inspiration for Stuart Gaffney's film *Chinese Tom* (2003).

6. On May 9, 2012, in an ABC News interview, President Obama stated, "I think same-sex couples should be able to get married." Stuart Gaffney reflected on this significant development in a follow-up phone conversation with Laura Kina on May 10, 2012: "It is unprecedented that a sitting president and vice president came out in full support of the freedom to marry for all couples, regardless of sexual orientation. I always thought, given the president's biracial background, that our families share so many parallels. But then I thought, why don't you fully support mine? Now he got it. And his daughters helped his position on marriage equality evolve, because of conversations they had around the dinner table talking about their friends who have two moms or two dads. This is a movement for social justice that is being propelled by personal stories and lived experience."

About the Authors

WEI MING DARIOTIS, PhD, is associate professor of Asian American studies at San Francisco State University. She has co-curated exhibits with Kearny Street Workshop and Galeria de la Raza. Dariotis has also served on the boards of Hapa Issues Forum, iPride, and the Asian American Theater Company and on the advisory boards of the Asian American Women Artists Association and Kearny Street Workshop. Her publications include "Hapas: The Emerging Community of Multiethnic and Multiracial APAs," in *The New Face of Asian Pacific America*; "Developing a Kin-Aesthetic: Mixed Heritage Characters in Asian and Native North American Literature," in *Mixed Race Literature*; and "Hapa: The World of Power," at the Mixed Heritage Center, an online resource. She is a member of the editorial board of the online journal *Asian American Literature: Discourses and Pedagogies*. She cofounded, with Camilla Fojas and Laura Kina, the Critical Mixed Race Studies conference. Dariotis is a founding and managing editor, along with G. Reginald Daniel, Laura Kina, Maria P. P. Root, and Paul Spickard, of the *Journal of Critical Mixed Race Studies*.

CAMILLA FOJAS is Vincent de Paul Professor of Latin American and Latino Studies and a member of the Global Asian Studies program at DePaul University, Chicago. Her books include *Cosmopolitanism in the Americas*, *Border Bandits: Hollywood on the Southern Frontier*, *Mixed Race Hollywood*, which she coedited with Mary Beltrán, and *Transnational Crossroads: Remapping the Americas and the Pacific*, which she coedited with Rudy P. Guevarra, Jr. Her most recent work is *Pop Imperialism: Island Frontiers of the U.S. Imaginary*.

STUART GAFFNEY is an independent filmmaker and marriage equality activist. The Solomon R. Guggenheim Museum has screened his videos as part of its "Fever in the Archive" program of AIDS activist videos. The "Stuart Gaffney Special" at the 13th International Festival of Gay and Lesbian Films in Torino, Italy, featured a wide variety of his short works. Gaffney is a leader in API Equality and is with Marriage Equality USA, where he is API outreach director.

RUDY P. GUEVARRA, JR., is assistant professor of Asian Pacific American studies, Arizona State University. His books include *Becoming Mexipino: Multiethnic Identities and Communities in San Diego*; *Transnational Crossroads: Remapping the Americas*

and the Pacific, coedited with Camilla Fojas; *Filipinos in San Diego*, coauthored with Judy Patacsil and Felix Tuyay; and *Crossing Lines: Race and Mixed Race Across the Geohistorical Divide*, coedited with Marc Coronado, Jeffrey Moniz, and Laura Furlan Szanto. He has also published articles in the *Journal of Asian American Studies, The Journal of San Diego History* and *MAVIN Magazine*.

ELEANA J. KIM is assistant professor of anthropology at the University of Rochester. She is the author of *Adopted Territory: Transnational Korean Adoptees and the Politics of Belonging*, an ethnographic study of the political, economic, and cultural dimensions of transnational adoption from South Korea to North America, Europe, and Australia. Her articles have appeared in *Social Text, Visual Anthropology Review, Anthropological Quarterly*, and a number of collected volumes, including *Cultures of Transnational Adoption* and *Fifty Years of International Korean Adoption*. She is on the selection committee for the International Symposium of Korean Adoption Studies and on the editorial board of the *Journal for Korean Adoption Studies*.

LAURA KINA, MFA, is associate professor of Art, Media, and Design, a Vincent de Paul Professor, and American Studies, Global Asian Studies, and Women's and Gender Studies affiliated faculty member at DePaul University, Chicago. She is a member of the Diasporic Asian Arts Network and the International Network for Diasporic Asian Art Research and has served on the boards of the MAVIN and the Japanese American Service Committee. Kina's artwork has been exhibited nationally and internationally and published in *Modeling Citizenship: Jewish and Asian American Writing; Other Tongues: Mixed-Race Women Speak Out; Embracing Ambiguity: Faces of the Future;* and *The New Authentics: Artists of the Post-Jewish Generation*. Her solo shows include *Sugar, a Many-Splendored Thing; Aloha Dreams; Hapa Soap Operas;* and *Loving*. She cofounded, with Wei Ming Dariotis and Camilla Fojas, the Critical Mixed Race Studies conference. Kina is a founding and managing editor, along with G. Reginald Daniel, Wei Ming Dariotis, Maria P. P. Root, and Paul Spickard, of the *Journal of Critical Mixed Race Studies*.

RICHARD A. LOU is a professor and the chair of the Department of Art at the University of Memphis. Known as a Chicano multidisciplinary artist of mixed Chicano and Chinese descent, Lou's work has been cited in such publications as *Postborder City: Cultural Spaces of Bajalta California*, edited by Michael Dear and Gustavo Leclerc; *Whiteness: A Wayward Construction;* and *Hecho en Califas: The Last Decade*, for which he curated the exhibition and wrote "The Secularization of the Chicano Visual Idiom: Diversifying the Iconography."

MARGO MACHIDA is associate professor of art history and Asian American studies, University of Connecticut, Storrs, and a scholar, independent curator, and cultural critic specializing in Asian American art and visual culture. Her most recent book is *Unsettled Visions: Contemporary Asian American Artists and the Social Imaginary*. She is also the coeditor, with Elaine H. Kim, Lisa Lowe, and Sharon Mizota, of *Fresh Talk / Daring Gazes: Conversations on Asian American Art*. Machida is currently working on a new book, *Resighting Hawai'i: Global Flows and Island Imaginaries in Asian American and Native Hawaiian Art*.

STEPHEN MURPHY-SHIGEMATSU is a consulting professor at the Stanford School of Medicine and the Center for Comparative Studies in Race and Ethnicity at Stanford University. He is a practicing psychologist, writer, and storyteller who performs *The Celtic Samurai: A Boy's Transcultural Journey*. His books include *When Half is Whole: Multiethnic Asian American Identities; Mixed Roots: Transnational and Multiethnic Asian-American Lives; Transcultural Japan: At the Borderlands of Race, Gender, and Identity; Multicultural Encounters: Case Narratives from a Counseling Practice*; and *Amerasian Children: An Unknown Minority Problem*.

KENT A. ONO is professor and chair of the Department of Communication at the University of Utah. He is the author of *Contemporary Media Culture and the Remnants of a Colonial Past*; coauthor of *Asian Americans and the Media* with Vincent Pham and *Shifting Borders: Rhetoric, Immigration, and California's Proposition 187* with John Sloop; editor of *Asian American Studies after Critical Mass* and *A Companion to Asian American Studies*; and coeditor of *Critical Rhetorics of Race* with Michael Lacy and *Enterprise Zones: Critical Positions on Star Trek* with Taylor Harrison, Sarah Projansky, and Elyce Helford. He coedits the book series *Critical Cultural Communication* with Sarah Banet-Weiser at New York University Press and also coedits the journal *Critical Studies in Media Communication* with Ronald L. Jackson II.

LORI PIERCE is associate professor of American studies at DePaul University, Chicago. Her research includes the study of the history of race and ethnicity in the United States before World War II, the history of Hawai'i before statehood, and Asian American studies. She is currently working on a book, *The Paradox of Primitivism: Race and Tourism in the Kingdom, Territory and State of Hawai'i*.

CATHY J. SCHLUND-VIALS is associate director of the Asian American Studies Institute and assistant professor of English and Asian American studies at the Univer-

sity of Connecticut, Storrs. She is the author of *Modeling Citizenship: Jewish and Asian American Writing* and the forthcoming book *War, Genocide, and Justice: Cambodian American Memory Work*. Schlund-Vials's academic projects are informed by the experiences of dislocation and migration and the crucial connections between history, memory, citizenship, and human rights.

KEN TANABE is an art director, graphic designer, and animator based in New York City. He founded Loving Day (www.lovingday.org) in 2004 and serves as its president. Tanabe has been a panelist and moderator at educational and community events at Harvard University, Columbia University, and New York University. He is a member of the adjunct faculty at Parsons School of Design, where he teaches graduate and undergraduate students.

WENDY THOMPSON TAIWO is an Andrew W. Mellon Fellow in African Studies at Bowdoin College who researches Chinese and African diaspora histories and communities, comparative African American and Asian American histories, contemporary African migrants and the informal economy in Asia, and mixed race identity. While a postdoctoral associate at the University of Minnesota, she began an ethnographic documentary project focused on African traders in China. She is currently working on *Guangzhou/Lagos*, a series of portraits of Yoruba men and women making a living in the informal economy shared by China and Nigeria.

Bibliography

Acuña, Rodolfo. *Occupied America: A History of Chicanos*. New York: HarperCollins, 1988.

Adams, Romanzo. *Interracial Marriage in Hawaii: A Study of the Mutually Conditioned Processes of Acculturation and Amalgamation*. New York: The Macmillan Company, 1937.

Adolfson, Nathan. *Passing Through: A Personal Diary Documentary*. Directed by Nathan Adolfson. Video. San Francisco: National Asian American Telecommunications Association, 1999.

Agoncillo, Teodoro A. *History of the Filipino People*. Quezon City, Philippines: Garotech Publishing, 1990.

Alvarez, Luis. *The Power of the Zoot: Youth Culture and Resistance during World War II*. Berkeley: University of California Press, 2008.

Arcilla, Jose S., SJ. *An Introduction to Philippine History*. Manila: Ateneo de Manila University Press, 1994.

Bailey, Beth, and David Farber. *The First Strange Place: Race and Sex in World War II*. Baltimore, MD: The Johns Hopkins University Press, 1994.

Beltrán, Mary, and Camilla Fojas, eds. *Mixed Race Hollywood*. New York: New York University Press, 2008.

Bender, Penee, Joshua Brown, and Andrea Ades Vasquez. *Savage Acts: Wars, Fairs and Empires, 1898–1904*. Directed by Penee Bender, Joshua Brown, and Andrea Ades Vasquez. DVD. New York: American Social History Project, 2006.

Berssenbrugge, Mei-mei. *I Love Artists: New and Selected Poems*. Berkeley: University of California Press, 2006.

Bhabha, Homi K. *The Location of Culture*. London: Routledge, 1994.

Bier, Lisa. *American Indian and African American People, Communities, and Interactions: An Annotated Bibliography*. Westport, CT: Praeger, 2004.

Bosma, Ulbe and Gijsbert Oonk, "Bombay Batavvia: Parsi and Eurasian Variations on the Middlemen Theme," in *Mediators Between State and Society*, edited by Nico Randeraad. Hilversum: Verloren, 1998.

Bouknight-Davis, Gail. "Chinese Economic Development and Ethnic Identity Formation in Jamaica." In *The Chinese in the Caribbean*, edited by Andrew R. Wilson, 69–90. Princeton, NJ: Markus Wiener Publishers, 2004.

Boyne, Walter L., ed. *Air Warfare: An International Encyclopedia (A–L)*. Santa Barbara, CA: ABC-CLIO, 2002.

Brodsky, Joyce. *Experiences of Passage: The Paintings of Yun Gee and Li-lan*. Seattle: University of Washington Press, 2008.

Brooks, James. *Confounding the Color Line: The Indian-Black Experience in North America*. Lincoln: University of Nebraska Press, 2002.

Brown, Dee. *Bury My Heart at Wounded Knee: An Indian History of the American West*. New York: Bantam Books, 1972.

Butler, Judith. *Bodies That Matter: On the Discursive Limits of "Sex."* New York: Routledge, 1993.

Caplan, Lionel. *Children of Colonialism: Anglo-Indians in a Postcolonial World*. Oxford: Berg Publishers, 2003.

Chai, May-Lee. *Hapa Girl: A Memoir*. Philadelphia: Temple University Press, 2008.

Chan, Jeffrey Paul, Frank Chin, Lawson Fusao Inada, and Shawn Wong. *Aiiieeeee! An Anthology of Asian American Writers*. Washington, DC: Howard University Press, 1974.

Chan, Sucheng. *Asian Americans: An Interpretive History*. New York: Twayne Publishers, 1991.

Chang, Alexandra. *Envisioning Diaspora: Asian American Visual Arts Collectives*. Hong Kong: Timezone 8, 2009.

Chang, Gordon, Mark Johnson, and Paul Karlstrom, eds. *Asian American Art: A History, 1850–1970*. Stanford, CA: Stanford University Press, 2008.

Chin, Frank. "Come All Ye Asian American Writers of the Real and the Fake." In *The Big Aiiieeeee!: An Anthology of Chinese American and Japanese American Literature*, edited by Jeffrey Paul Chan, Frank Chin, Lawson Fusao Inada, and Shawn Wong. New York: Meridian Publishing, 1991.

Chiu, Melissa, Karen Higa, and Susette S. Min, eds. *One Way or Another: Asian American Art Now*. New Haven, CT: Asia Society with Yale University Press, 2006.

Choy, Catherine Ceniza. *Empire of Care: Nursing and Migration in Filipino American History*. Durham, NC: Duke University Press, 2003.

Choy, Catherine Ceniza, and Gregory Paul Choy. "Transformative Terrains: Korean American Adoptees and the Social Constructions of an American Childhood." In *The American Child*, edited by Caroline Levander and Carol Singley, 262–79. New Brunswick, NJ: Rutgers University Press, 2003.

———. "What Lies Beneath: Reframing *Daughter from Danang*." In *Outsiders Within: Writing on Transracial Adoption*, edited by Jane Jeong Trenka, Julia Chinyere Oparah, and Sun Yung Shin, 221–31. Cambridge: South End Press, 2006.

Chuong, Chung Hoang, and Le Van. *The Amerasians from Vietnam: A California Study*.

Folsom, CA: Southeast Asia Community Resource Center, Folsom Cordova Unified School District, 1994.

Churchill, Ward. *A Matter of Genocide: Holocaust and Denial in the Americas, 1492 to the Present.* San Francisco: City Lights Publishers, 2001.

Cohen, Lucy M. *Chinese in the Post–Civil War South: A People without a History.* Baton Rouge: Louisiana State University Press, 1984.

Cornell, Daniel, and Mark Dean Johnson. *Asian / American / Modern Art: Shifting Currents, 1900–1970.* Berkeley: University of California Press, 2008.

DaCosta, Kimberly McClain. *Making Multiracials: State, Family, and Market in the Redrawing of the Color Line.* Stanford, CA: Stanford University Press, 2007.

Daniel, G. Reginald. *More Than Black? Multiracial Identity and the New Racial Order.* Philadelphia: Temple University Press, 2002.

Dariotis, Wei Ming. "Before the War." *580 Split*, no. 12 (Summer 2010).

———. "Crossing the Racial Frontier: *Star Trek* and Mixed Heritage Identities." In *A Science Fiction Phenomenon: Investigating the "Star Trek" Effect*, edited by Lincoln Geraghty 63+. Jefferson, NC: McFarland Publishing, 2008.

———. "Developing a Kin-Aesthetic: Multiraciality and Kinship in Asian and Native North American Literature." In *Mixed Race Literature*, edited by Jonathan Brennan, 177–99. Stanford, CA: Stanford University Press, 2002.

———. "Teaching Edith Eaton/Sui Sin Far: Multiple Approaches." *Asian American Literature: Discourses and Pedagogies* 1 (2010).

———. "To Be or Not to Be 'Hapa': What to Name Mixed Asian Americans?" In *At 40: Asian American Studies @ San Francisco State*. San Francisco: Asian American Studies, San Francisco State University, 2009.

Dismukes, Valena Broussard. *The Red-Black Connection: Contemporary Urban African Native Americans and Their Stories of Dual Identity.* Los Angeles: Grace Enterprises, 2007.

Dolgin, Gail, and Vicente Franco. *Daughter from Danang.* Directed by Gail Dolgin and Vicente Franco. Film. Waltham, MA: Balcony Releasing Pictures, 2002.

Duus, Masayo. *The Life of Isamu Noguchi: Journey without Borders.* Princeton, NJ: Princeton University Press, 2006.

Eisenman, Stephen F. *Gauguin's Skirt.* London: Thames & Hudson, 1999.

Elam, Michele. *The Souls of Mixed Folk: Race, Politics, and Aesthetics in the New Millennium.* Stanford, CA: Stanford University Press, 2011.

Elliston, Deborah A. "Geographies of Gender and Politics: The Place of Difference in Polynesian Nationalism." *Cultural Anthropology* 15 (2000): 171–216.

Eng, David. *The Feeling of Kinship: Queer Liberalism and the Racialization of Intimacy.* Durham, NC: Duke University Press, 2010.

Fischer-Tiné, Harald, and Susanne Gehrmann. *Empires and Boundaries: Rethinking Race, Class, and Gender in Colonial Settings.* New York: Routledge, 2008.

Fojas, Camilla, "New Frontiers of Asian and Latino America in Popular Culture: Mixed Race Intimacies and the Global Police State in Miami Vice and Rush Hour." *Journal of Asian American Studies.* 14:3 (2011): 417–34.

Fojas, Camilla, and Rudy P. Guevarra, Jr., eds. *Transnational Crossroads: Remapping the Americas and the Pacific.* Borderlands and Transcultural Studies Series. Lincoln: University of Nebraska Press, 2012.

Forbes, Jack D. *Africans and Native Americans: The Language of Race and the Evolution of Red-Black Peoples.* Champaign: University of Illinois Press, 1993.

Francisco, Luzviminda. "The First Vietnam: The U.S.-Philippine War of 1899." *Bulletin of Concerned Asian Scholars* 5, no. 4 (December 1973): 9.

Fujikane, Candace, and Jonathan Y. Okamura, eds. *Asian Settler Colonialism: From Local Governance to the Habits of Everyday Life in Hawaiʻi.* Honolulu: University of Hawaiʻi Press, 2008.

Fulbeck, Kip. *Banana Split.* Directed by Kip Fulbeck. Remastered DVD. Chicago: Video Data Bank, 2011.

———. *Mixed: Portraits of Multiracial Kids.* San Francisco: Chronicle Books, 2010.

———. *Paper Bullets: A Fictional Autobiography.* Seattle: University of Washington Press, 2001.

———. *Part Asian, 100% Hapa.* San Francisco: Chronicle Books, 2006.

———. *Selected Videos #1 & #2.* Directed by Kip Fulbeck. DVD. San Francisco: Center for Asian American Media, 2008.

Fusco, Coco. "Fantasies of Oppositionality." In *Art, Activism, & Oppositionality—Essays from Afterimage,* edited by Grant H. Kester, 62. Durham, NC: Duke University Press, 1998.

Graff, Henry F., ed. *American Imperialism and the Philippine Insurrection.* Boston: Little, Brown and Company, 1969.

Guevarra, Rudy P., Jr. "Filipinos in Nueva España: Filipino-Mexican Relations, Mestizaje, and Identity in Colonial and Contemporary Mexico." *Journal of Asian American Studies* (October 2011): 389–416.

———. "Mexipino: A History of Multiethnic Identity and the Formation of the Mexican and Filipino Communities of San Diego, 1900–1965." PhD diss., University of California, Santa Barbara, 2007.

Hall, Bruce. *Tea That Burns: A Family Memoir of Chinatown.* New York: Free Press, 1998.

Hallmark, Kara Kelly. *Encyclopedia of Asian American Artists: Artists of the American Mosaic.* Westport, CT: Greenwood Press, 2007.

Hara, Mari, and Nora Okja Keller. *Intersecting Circles: The Voices of Hapa Women in Poetry and Prose*. Honolulu: Bamboo Ridge Press, 1999.

Hart, Jayasri. *Roots in the Sand*. Directed by Jayasri Hart. Film. Montrose, CA: Hart Films, 2000.

Hau'ofa, Epeli. "Our Sea of Islands." *Contemporary Pacific* 6 (1994): 147–61.

Hawes, Christopher J. *Poor Relations: The Making of a Eurasian Community in British India, 1773–1833*. Richmond, Surrey, UK: Curzon Press, 1996.

Hedges, Christopher. *War Is a Force That Gives Us Meaning*. New York: Anchor, 2003.

Hickey, Dave. *Pagan America*. New York: Free Press, forthcoming.

Ho, Fred, and Bill V. Mullen, eds. *Afro Asia: Revolutionary Political and Cultural Connections between African Americans and Asian Americans*. Durham, NC: Duke University Press, 2008.

Hollander, Inez. *Silenced Voices: Uncovering a Family's Colonial History in Indonesia*. Athens: Ohio University Press, 2008.

Hollinger, David. *Postethnic America: Beyond Multiculturalism*. New York: Basic Books, 2000.

Houston, Jeanne Wakatsuki, and James D. Houston, *Farewell to Manzanar*. Reprint. Boston: Houghton Mifflin, 2002.

Ignacio, Abe, Enrique de la Cruz, Jorge Emmanuel, and Helen Toribio. *The Forbidden Book: The Philippine-American War in Political Cartoons*. San Francisco: T'Boli Publishing, 2004.

Ingram, David. *Rights, Democracy, and Fulfillment in the Era of Identity Politics: Principled Compromises in a Compromised World*. Lanham, MD: Rowman and Littlefield, 2004.

Jolivette, Andrew. *Louisiana Creoles: Cultural Recovery and Mixed-Race Native American Identity*. Lanham, MD: Lexington Books, 2007.

Kame'eleihiwa, Lilikal'. *Native Land and Foreign Desires: Pehea L' E Pono Ai?* Honolulu: Bishop Museum Press, 1992.

Karnow, Stanley. *In Our Image: America's Empire in the Philippines*. New York: Ballantine Books, 1989.

Kauanui, J. K'haulani. *Hawaiian Blood: Colonialism and the Politics of Sovereignty and Indigeneity*. Durham, NC: Duke University Press, 2008.

Kim, Elaine H., Margo Machida, Sharon Mizota, and Lisa Lowe. *Fresh Talk/Daring Gazes: Conversations on Asian American Art*. Berkeley: University of California Press, 2005.

Kim, Eleana J. *Adopted Territory: Transnational Korean Adoptees and the Politics of Belonging*. Durham, NC: Duke University Press, 2010.

———. "Korean Adoptee Auto-ethnography: Refashioning Self, Family, and Finding Community." *Visual Anthropology Review* 16 (2001): 43–70.

Kina, Laura. "Half Yella: Embracing Ethnoracial Ambiguity." In *Embracing Ambiguity: Faces of the Future*, edited by Jillian Nakornthap and Lynn Stromick, 5–10. Fullerton, CA: Main Art Gallery, Cal State University Fullerton, 2010.

Kramer, Paul A. *Blood of Government: Race, Empire, the United States, and the Philippines.* Chapel Hill: University of North Carolina Press, 2006.

Kurashige, Scott. *The Shifting Grounds of Race: Black and Japanese Americans in the Making of Multiethnic Los Angeles.* Princeton, NJ: Princeton University Press, 2010.

Kwan, SanSan, and Kenneth Speirs. *Mixing It Up: Multiracial Subjects.* Austin: University of Texas Press, 2004.

Lai, Eric, and Dennis Arguelles, eds. *The New Face of Asian Pacific America: Numbers, Diversity & Change in the 21st Century.* San Francisco: AsianWeek, 2003.

Lai, Walton Look. *Chinese in the West Indies, 1806–1995: A Documentary History.* Kingston: The Press University of the West Indies, 1998.

———. *Indentured Labor, Caribbean Sugar: Chinese and Indian Migrants to the British West Indies, 1838–1918.* Baltimore, MD: Johns Hopkins University Press, 1993.

Laus, Emiliano L. "The Search for Spice." In *Filipino Heritage: The Making of a Nation*, ed. Alfred R. Roces, 3:814–18. Manila: Lahing Pilipino Publishing, 1977–78.

Lawrence, Bonita. *"Real" Indians and Others: Mixed-Blood Urban Native Peoples and Indigenous Nationhood.* Lawrence: University of Nebraska Press, 2004.

Lee, Kristen D. *MiXeD mE.* Directed by Kristen D. Lee. Film. MFA thesis, University of California, Los Angeles, 2010.

Lee, Larry. "Laura Kina: A Many Splendored Thing." *15th Annual Asian American Showcase.* Chicago: Foundation for Asian American Independent Media, 2010. http://www.faaim.org/visual/.

Lee, Meiqi. *Being Eurasian: Memories across Racial Divides.* Hong Kong: Hong Kong University Press, 2004.

Leonard, Karen Isaksen. *Making Ethnic Choices: California's Punjabi Mexican Americans.* Philadelphia: Temple University Press, 1994.

Liem, Deann Borshay. *First Person Plural.* Directed by Deann Borshay Liem. Video. San Francisco: Independent Television Services and the National Asian American Telecommunications Association, 2000.

Liestman, Daniel. "Horizontal Inter-ethnic Relations: Chinese and American Indians in the Nineteenth-Century American West." *The Western Historical Quarterly* 30, no. 3 (1999): 327–49.

Life, Regge. *Doubles: Japan and America's Intercultural Children.* Directed by Regge Life. Video. Hohokus, NJ: Doubles Film Library, 1995.

Lili'uokalani. *Hawaii's Story by Hawaii's Queen.* Honolulu: Mutual Publishing, 1990.

Lim, Shirley Geok-lin, Mayumi Tsutakawa, and Margarita Donnelly, eds. *The Forbidden Stitch: An Asian American Women's Anthology.* Corvallis, OR: Calyx Books, 1989.

Ling, Amy. *Yellow Light: The Flowering of Asian American Arts.* Philadelphia: Temple University Press, 1999.

Linn, Brian McAllister. *The Philippine War, 1899–1902.* Lawrence: University Press of Kansas, 2000.

Lippard, Lucy R. *Mixed Blessings: New Art in a Multicultural America.* New York: The New Press, 2000.

Loewen, James W. *The Mississippi Chinese: Between Black and White.* 2nd ed. Long Grove, IL: Waveland Press, 1988.

"The Loneliest Brides in America." *Ebony*, January 1953: 17–24.

Lowe, Lisa. "Heterogeneity, Hybridity, Multiplicity: Asian American Differences." In *Immigrant Acts: On Asian American Cultural Politics*, 60–83. Durham, NC: Duke University Press, 1996.

———. *Immigrant Acts: On Asian American Cultural Politics.* Durham, NC: Duke University Press, 1996.

Lui, Mary Ting Yi. *The Chinatown Trunk Mystery: Murder, Miscegenation, and Other Dangerous Encounters in Turn-of-the-Century New York City.* Princeton, NJ: Princeton University Press, 2005.

Machida, Margo. "Convergent Conversations: Contemporary Art in Asian America." In *A Companion to Asian Art and Architecture*, edited by Rebecca M. Brown and Deborah S. Hutton, 264–89. Malden, MA: Blackwell, 2011.

———. "Icons of Presence: Three Chinese American Artists." In *Icons of Presence: Asian American Activist Art: Jim Dong, Nancy Hom, Leland Wong*, edited by Margo Machida. San Francisco: Chinese Culture Center, 2008.

———. "Out of Asia: Negotiating Contemporary Asian Identities in America." In *Asia/America: Identities in Contemporary Asian American Art*, edited by David Sternbach and Joseph N. Newland, 65–110. New York: The Asia Society Galleries and The New Press, 1994.

———. "Seeing 'Yellow': Asians and the American Mirror." In *The Decade Show: Frameworks of Identity in the 1980s*, edited by Louis Young, 108–27. New York: Museum of Contemporary Hispanic Art, The New Museum of Contemporary Art, and The Studio Museum in Harlem, 1990.

———. "Tomie Arai," "Bing Lee," and "Hanh Thi Pham." In *Grove Encyclopedia of American Art*, edited by Joan Marter. Oxford: Oxford University Press, 2011.

———. *Unsettled Visions: Contemporary Asian American Artists and the Social Imaginary*. Durham, NC: Duke University Press, 2009.

Marchetti, Gina. *Romance and the "Yellow Peril": Race, Sex, and Discursive Strategies in Hollywood Fiction*. Berkeley: University of California Press, 1993.

Matsumoto, Valerie J. *Farming the Home Place: A Japanese American Community in California, 1919–1982*. Ithaca, NY: Cornell University Press, 1993.

McCormick, Thomas J. *China Market: America's Quest for Informal Empire, 1893–1901*. Chicago: Elephant Paperbacks, 1990.

McFerson, Hazel M., ed. *Blacks and Asians: Crossings, Conflict and Commonality*. Durham, NC: Carolina Academic Press, 2005.

McKelvey, Robert. *The Dust of Life: America's Children Abandoned in Vietnam*. Seattle: University of Washington Press, 2000.

Mercene, Floro L. *Manila Men in the New World: Filipino Migration to Mexico and the Americas from the Sixteenth Century*. Quezon City: The University of the Philippines Press, 2007.

Meyer, Manulani Aluli. "Native Hawaiian Epistemology: Contemporary Narratives (Unedited Doctoral Thesis)." In *Hoʻoulu, Our Time of Becoming: Collected Early Writings of Manulani Meyer*. Honolulu: ʻAi Pʻhaku Press, 2003.

Miller, Stuart Creighton. *Benevolent Assimilation: The American Conquest of the Philippines, 1899–1903*. New Haven, CT: Yale University Press, 1982.

Min, Susette S. "The Last Asian American Exhibition in the Whole Entire World." In *One Way or Another: Asian American Art Now*, edited by Melissa Chiu, Karin Higa, and Susette S. Min, 34–41. New York: The Asia Society Museum, 2006.

Morgan, Charlie V. *Intermarriage across Race and Ethnicity among Immigrants: E Pluribus Unions*. El Paso, TX: LFB Scholarly Publishing, 2009.

Murphy-Shigematsu, Stephen L. H. *Amerajian no Kodomatchi: Shirarezaru Mainorito Mondai* [Amerasian Children: An Unknown Minority Problem]. Tokyo: Shueisha, 2002.

———. *Multicultural Encounters: Case Narratives from a Counseling Practice*. New York: Teachers College Press, 2002.

———. "Multiethnic Lives and Monolithic Myths: American-Japanese Amerasians in Japan." In *The Sum of Our Parts*, edited by Teresa Williams-León and Cynthia L. Nakashima, 207–16. Philadelphia: Temple University Press, 2001.

———. *The Voices of Amerasians: Ethnicity, Identity and Empowerment in Interracial Japanese Americans*. Doctoral diss., Harvard University, 1986.

———. *When Half Is Whole: Multiethnic Asian American Identities*. Stanford, CA: Stanford University Press, 2012.

Naficy, Hamid. *An Accented Cinema: Exilic and Diasporic Filmmaking*. Princeton, NJ: Princeton University Press, 2001.

Nakashima, Cynthia. "Asian American Studies through (Somewhat) Asian Eyes: Integrating 'Mixed Race' into the Asian American Discourse." In *Asian American Studies after Critical Mass*, edited by Kent Ono, 111–20. Hoboken, NJ: Wiley-Blackwell, 2005.

Nguyen, Kien. *The Unwanted: A Memoir of Childhood*. New York: Little, Brown and Company, 2001.

Nordyke, Eleanor C. *The Peopling of Hawai'i*. 2nd ed. Honolulu: East-West Center and University of Hawai'i Press, 1977.

Obama, Barack. *The Audacity of Hope: Thoughts on Reclaiming the American Dream*. New York: Random House, 2006.

Omori, Emiko, and Lisa Altieri. *Skin Stories*. Directed by Emiko Omori. DVD. Honolulu: Pacific Islanders in Communications, 2006.

Ono, Kent A. "The Biracial Subject as Passive Receptacle for Japanese American Memory in *Come See the Paradise*." In *Mixed Race Hollywood*, edited by Mary Beltrán and Camilla Fojas, 136–54. New York: New York University Press, 2008.

Ottley, Roi. *New World A-Coming: Inside Black America*. Boston: Houghton Mifflin Company, 1943.

Oyama, Misa. "Secret Asian Man and Other Invisible Asians: Race as Theater in *Miss Saigon*." In *Navigating Islands and Continents: Conversations and Contestations in and around the Pacific: Selected Essays*, edited by Cynthia Franklin, Ruth Hsu, and Suzanne Kosanke, 83–84. Honolulu: University of Hawai'i Press, 2000.

Park Nelson, Kim. "'Loss Is More Than Sadness': Reading Dissent in Transracial Adoption Melodrama." *The Language of Blood and First Person Plural: Adoption and Culture* 1, no. 1 (2007).

Peters, Rebecca Todd. *In Search of the Good Life: The Ethics of Globalization*. New York: Continuum International Publishing Group, 2006.

Pfaelzer, Jean. *Driven Out: The Forgotten War against Chinese Americans*. Berkeley: University of California Press, 2008.

Prashad, Vijay. *Everybody Was Kung Fu Fighting: Afro-Asian Connections and the Myth of Cultural Purity*. Boston: Beacon Press, 2001.

Pukui, Mary Kawena, and Samuel H. Elbert, eds. *New Pocket Hawaiian Dictionary*. 2nd ed. Honolulu: University of Hawai'i Press, 1992.

Quan, Robert Seto. *Lotus among the Magnolias: The Mississippi Chinese*. Jackson: University Press of Mississippi, 1982.

Raphael-Hernandez, Heike, and Shannon Steen, eds. *AfroAsian Encounters: Culture, History, Politics*. New York: New York University Press, 2006.

Resurreccion, Celedonio O. "Pockets of Revolts under the Spanish Shadow." In *Filipino Heritage: The Making of a Nation*, edited by Alfred R. Roces, 3:1211–17. Manila: Lahing Pilipino Publishing, 1977–78.

Rhee, Jeannie. "In Black and White: Chinese in the Mississippi Delta." *Journal of Supreme Court History: Yearbook of the Supreme Court Historical Society* 117 (1994): 117–32.

Robinson, Greg. *A Tragedy of Democracy: Japanese Confinement in North America*. New York: Columbia University Press, 2009.

Roces, Alfred R., ed. *Filipino Heritage: The Making of a Nation*. Vol. 3. Manila: Lahing Pilipino Publishing, 1977–78.

———. *Filipino Heritage: The Making of a Nation*. Vol. 5. Manila: Lahing Pilipino Publishing, 1977–78.

Rodríguez, Dylan. "A Million Deaths?: Genocide and the 'Filipino American' Condition of Possibility." In *Positively No Filipinos Allowed: Building Communities and Discourse*, edited by Antonio T. Tiongson, Jr., Ricardo Gutierrez, and Edgardo Gutierrez, 158–61. Philadelphia: Temple University Press, 2006.

Roemer, Kenneth M. *The Cambridge Companion to Native American Literature*. Cambridge: Cambridge University Press, 2005.

Rogers, Robert F. *Destiny's Landfall: A History of Guam*. Honolulu: University of Hawai'i Press, 1995.

Romero, Robert Chao. *The Chinese in Mexico, 1882–1940*. Tucson: University of Arizona Press, 2010.

Rondilla, Joanne L. "The Filipino Question in Asia and the Pacific: Rethinking Regional Origins in Diaspora." In *Pacific Diaspora: Island Peoples in the United States and across the Pacific*, edited by Paul Spickard, Joanne L. Rondilla, and Debbie Hippolite Wright. Honolulu: University of Hawai'i Press, 2002.

Root, Maria P. P. "The Biracial Baby Boom: Understanding Ecological Constructions of Racial Identity in the 21st Century." In *Racial, Ethnic, and Cultural Identity and Human Development: Implication*, edited by Rosa H. Sheets and Etta Hollins. Mahwah, NJ: Earlbaum, in press.

———. *Love's Revolution: Interracial Marriages*. Philadelphia: Temple University Press, 2001.

———. *Multiracial Experience: Racial Borders as the New Frontier*. Thousand Oaks, CA: Sage Publications, 1996.

———. *Racially Mixed People in America*. Thousand Oaks, CA: Sage Publications, 1992.

Ropp, Steven. "Do Multiracial Subjects Really Challenge Race? Mixed Race Asians in

the United States and the Caribbean." In *"Mixed Race" Studies: A Reader*, edited by Jayne O. Ifekwunigwe. New York: Routledge, 2004.

Rosa, John Chock. "The Coming of the Neo-Hawaiian American Race: Nationalism and Metaphors of the Melting Pot in Popular Accounts of Mixed-Race Individuals." In *Sum of Our Parts*, edited by Teresa Williams-León and Cynthia L. Nakashima, 49–56. Philadelphia: Temple University Press, 2001.

Ross, Susan Dente, and Paul Martin Lester. *Images That Injure: Pictorial Stereotypes in the Media*. Santa Barbara, CA: ABC-CLIO, 2011.

Sahlins, Marshall. "Goodbye to *Tristes Tropes*: Ethnography in the Context of Modern World History." In *Assessing Cultural Anthropology*, edited by Robert Borofsky, 387–88. New York: McGraw-Hill, 1994.

Salvesen, Britt. *Gauguin: Artists in Focus*. Chicago: The Art Institute of Chicago, 2001.

Schlund-Vials, Cathy J. *Modeling Citizenship: Jewish and Asian American Writing*. Philadelphia: Temple University Press, 2011.

Schmitt, Robert C. *Historical Statistics of Hawaii*. Honolulu: University Press of Hawaii, 1977.

Schrader-Villegas, Julie. "The Racial Shadow in 20th-Century American Literature." PhD diss., University of Washington, 1997.

Schurz, William Lytle. *The Manila Galleon*. New York: E. P. Dutton & Co., 1959.

Scott, William Henry. *Barangay: Sixteenth-Century Philippine Culture and Society*. Manila: Ateneo de Manila University Press, 1994.

———. *Prehispanic Source Materials for the Study of Philippine History*. Quezon City, Philippines: New Day Publishers, 1984.

See, Sarita Echavez. *The Decolonized Eye: Filipino American Art and Performance*. Minneapolis: University of Minnesota Press, 2009.

Shaw, Angel Velasco, and Luis H. Francia, eds. *Vestiges of War: The Philippine-American War and the Aftermath of an Imperial Dream, 1899–1999*. New York: New York University Press, 2002.

Shaw, Frederick J., Jr., and Timothy Warnock. *The Cold War and Beyond: Chronology of the United States Air Force, 1947–1997*. Maxwell Air Force Base, AL: Air Force History and Museum Program and Air University Press, 1997.

Silva, Noenoe K. *Aloha Betrayed: Native Hawaiian Resistance to American Colonialism*. Durham, NC: Duke University Press, 2004.

Smith, Cherise. *Enacting Others: Politics of Identity in Eleanor Antin, Nikki S. Lee, Adrian Piper, and Anna Deavere Smith*. Durham, NC: Duke University Press, 2011.

Smith, Earl, and Angela Hattery. *Interracial Relationships in the 21st Century*. Durham, NC: Carolina Academic Press, 2009.

Somaiah, Rosemarie, and Xinyan Zhuang. *Gateway to Singapore Culture.* Singapore: Asiapac Books Pte., 2004.

Spickard, Paul. *Japanese Americans: The Formation and Transformations of an Ethnic Group.* New Brunswick, NJ: Rutgers University Press, 2009.

Spickard, Paul R. *Mixed Blood: Intermarriage and Ethnic Identity in Twentieth-Century America.* Madison: University of Wisconsin Press, 1989.

Spickard, Paul, and G. Reginald Daniel. *Racial Thinking in the United States: Uncompleted Independence.* Notre Dame, IN: University of Notre Dame Press, 2004.

Spivak, Gayatri Chakravorty. *A Critique of Postcolonial Reason: Toward a History of the Vanishing Present.* Boston: Harvard University Press, 1999.

Tam, Augie, ed. "Is There an Asian American Aesthetics?" Translated by Gargi Chatterjee. In *Contemporary Asian America: A Multidisciplinary Reader*, edited by Min Zhou and James V. Gatewood, 627–35. 2nd ed. New York: New York University Press, 2007.

Tan, Antonio S. "The Chinese Mestizos and the Formation of the Filipino Nationality." *Asian Center Occasional Papers* 2, no. 2 (1984): 3–16.

Thornell, John. "Struggle for Identity in the Most Southern Place on Earth: The Chinese in the Mississippi Delta." *Chinese America: History & Perspectives*, January 2003: 63–70.

Thrum, Thos. G. *Hawaiian Almanac and Annual for 1902.* Ann Arbor: University of Michigan Press, 1901.

Trask, Haunani-Kay. *From a Native Daughter.* Monroe, ME: Common Courage Press, 1993.

van Dinter, Maarten Hesselt. *The World of Tattoo: An Illustrated History.* Amsterdam: KIT Publishers, 2005.

Varzally, Allison. *Making a Non-white America: Californians Coloring Outside Ethnic Lines, 1925–1955.* Berkeley: University of California Press, 2008.

Veneracion, Jaime B. "In the Line of Fire." *Filipinas*, March 1997: 49–51.

Wah, Fred. *Faking It: Poetics and Hybridity.* The Writer as Critic Series 7. Edmonton, Alberta, Canada: NeWest Press, 2000.

Wiest, Andrew. *The Vietnam War: 1956–1975.* New York: Routledge, 2002.

Wilkin, Lane. *Filipino Tattoos: Ancient to Modern.* Altglen, PA: Schiffer Publishing, 2010.

Williams, Teresa Kay, Cynthia L. Nakashima, George Kitahara Kich, and G. Reginald Daniel. "Being Different Together in the University Classroom: Multiracial Identity as Transgressive Education." In *The Multiracial Experience: Racial Borders as the New Frontier*, edited by Maria P. P. Root, 359–79. Thousand Oaks, CA: Sage, 1996.

Williams-León, Teresa, and Cynthia L. Nakashima. *The Sum of Our Parts: Mixed-Heritage Asian Americans*. Philadelphia: Temple University Press, 2001.

Willis, David Blake, and Stephen Murphy-Shigematsu, eds. *Transcultural Japan: At the Borderlands of Race, Gender, and Identity*. London: Routledge, 2008.

Wilson, Andrew R., ed. *Chinese in the Caribbean*. Princeton, NJ: Markus Wiener Publishers, 2004.

Winant, Howard. *The New Politics of Race: Globalism, Difference, Justice*. Minneapolis: University of Minnesota Press, 2004.

Winther-Tamaki, Bert. *Art in the Encounter of Nations: Japanese and American Artists in the Early Postwar Years*. Honolulu: University of Hawai'i Press, 2001.

Wolff, Leon. *Little Brown Brother: How the United States Purchased and Pacified the Philippine Islands at the Century's Turn*. Garden City, NY: Doubleday, 1961.

Yang, Alice, Jonathan Hay, and Mimi Young, eds. *Why Asia? Essays on Contemporary Asian and Asian American Art*. New York: New York University Press, 1998.

Yarborough, Trin. *Surviving Twice: Amerasian Children of the Vietnam War*. Dulles, VA: Potomac Books, 2005.

Young, Marilyn B. *The Vietnam Wars: 1945–1990*. New York: HarperCollins Publishers, 1991.

Yun, Lisa. *The Coolie Speaks: Chinese Indentured Laborers and African Slaves in Cuba*. Philadelphia: Temple University Press, 2008.

Zack, Naomi. *American Mixed Race*. New York: Rowman and Littlefield, 1995.

———. *Race and Mixed Race*. Philadelphia: Temple University Press, 1993.

Zhou, Min. "Are Asian Americans Becoming 'White'?" *Contexts* 3 (2003): 29–37.

Zia, Helen. *Asian American Dreams: Emergence of an American People*. New York: Farrar Straus and Giroux, 2000.

Index

Chai, May Lee, 247n51

Chakiris, George, 139

Chan, Sucheng, 99–100, 253n21

Chang, Diana, 140–41

Charlotte Sometimes (Byler), 11

Chiang Kai-shek, Madame, 150

Chiba Stearns, Jeff: *One Big Hapa Family*, 10

Chicanese identification, 205

Chicano exceptionalism, 210

Chicano Movement, 210, 215

"Children of 2 Lands in Search of Home" (Belkin), 99

Chin, Frank, 7, 140, 246n40

China: Hakka people from, 190; Japanese invasion of, 212; Li-lan in, 145; Opium Wars, 166

Chinaman's Chance: Views of the Chinese American Experience (Pacific Asia Museum), 157

"Chincano" as political and ethnic identification, 212–13

Chindian identification, 170

Chinese Americans: American Indian Women and Chinese Men, 166–67; Fulbeck interview, 149–53; Li-lan interview, 143–48; Ross-Ho interview, 154–59. *See also* Blasians (mixed Black Asians); *specific artists*

"Chinese" as "outsider," 236

"chino" label, 211

Chiu, Melissa, 70

Cho, Grace, 89

Cho, Margaret, 227

Chong, Albert: hybrid vision of self, 188; *Imagining the Past*, 193–94, 195, plate 31; *I-Traits*, 192–93; *Portrait of the Artist as a Victim of Colonial Mentality, 1979/2010*, 192, 195, plate 30; *The Sisters*, 191; *Throne* series, 193

Chu, Tammy, 89–90

Chun, Kaili: about, 116; *Nāu Ka Wae: The Choice Belongs to You*, 119, plate 17; themes, 117–19; untitled project, 119–20

citizenship: Native American tribal, 163, 170; Vietnamese Amerasians and, 100

Clark, H. J., 186

class and Eurasians, 139

Coast Miwok, 257n7

Coast Salish, 168, 171–72

Coast Salish Dragon (Gong), 166, 173, plate 27

Coconuts for Sale / Iwi Puniu Kapa (*Hawaiian Cover-ups*) (Pao), 121–22

Collapse (*Somewhere Tropical*) (Osterloh), 41–42, plate 9

Collins, Robert Keith, 163–64

colonialism, postcolonialism, and imperialism: Bhabha on stereotypes and, 10–11; colonial-postcolonial continuum, 137–38; Eurasians as middlemen and, 137–38; globalization and, 139; Hawaiian identification as anticolonial, 16; Native Americans, Black American Indians, and, 163–64; Pao on WWI iconography and, 126–27; Philippines and, 28–35; reversing, and reassignment of power, 209; Spanish, 28–29

Colorado River Relocation Center, 141

Colorless, the (Anthropolocos), 208–10

"Come All Ye Asian American Writers of the Real and the Fake" (Chin), 140

Come See the Paradise (film), 11, 225

"comfort" women, 88–91

commodification of Native American culture, 178

commodification of Native Hawaiian culture, 122

Constantino, Renato, 34

Copy Flat (Osterloh), 43

Corpuz, Gina, 168

cosmopolitan identity, 137–42, 146

The Courtship of Eddie's Father (TV), 226

Cox, Fanshen, 7

Crawford, Romi, 66

critical mixed race studies: fenestrated capillaries metaphor and, 6; history of, xiv, 244n7; womanist approach compared to, xiv–xv. *See also* mixed race

"Critical Mixed Race Studies: New Directions" (Jolivette), xiv–xv

Cuban Refugee Adjustment Act (1966), 252n5

Cultural Confluence: Urban People of Asian and Native American Heritages (Asian Pacific American Experience), 164–65

culture: Wofford on construct of, 45

Curio Shop (Singletary), 164–65

Curtis, Edward S., 9, 166, 178

127, 128, plate 20; *Sunset at Sunset Beach / Napoʻo ʻana o ka lʻ Kapa*, 128, plate 21

Hawaiʻi and mixed race Hawaiians: contemporary art and negotiation of multiracial positions, 116–23; contested site, Hawaii as, 13; cultural renaissance, 118; Discourse of Aloha, 114–15; evolving positions within mixed race heritages, 123; globalization and, 116–17; interracial marriage in harmony ideal in, 253n2, 254n10; Mirza interview, 129–32; Miss Ka Palapala beauty pageant, *110*, 111–12, 114–15; Pao interview, 124–28; Pearl Harbor, 126; population collapse and dynamics in, 113, 254n7; race and social status in, 113–14; racial diversity and anxiety in, 112; religion in, 129–30; rocks, cultural significance of, 131–32; skin color preferences in, 121–22; tourism and, 127–28; U.S. overthrow of, 29; World War II and social displacement in, 113, 253n3. *See also* Hapa/hapa; Hawaiians, Native

Hawaiian Homes Commission Act (1921), 117, 255n3

Hawaiians, Native: Black-white binary model and, 16; blood quantum and heritage rules, 117, 247n55, 255n3; Chun on survival of, 118–19; "Hapa" identity at expense of, 14–15; lineage and anticolonialism, 16; population collapse, 113

Hedges, Christopher, 99

Heir to Rice (Kay), plate 8

Hello Kitty Tipi (*Starry Sky*) (Yepa-Pappan), 166, 178, plate 29

heritage vs. race, 244n1

hers, kate, 84, 251n3

"He Wouldn't Take It Any Other Way" (Gillam), *32*

Higa, Karin, 70

Hirabayashi, Lane, 246n33

Hiyane, Makat Maehira Gibu, 58–59

Ho, Ruyell, 158–59

Hoar, George Frisbee, 31

Hollywood, history of mixed race portrayals by, 225–29

Homebase (Wong), 167

Honolulu Academy of Arts, 119

Houston, Jeanne Wakatsuki, 187

Houston, Velina Hasu, 8

humanitarianism narratives, international adoption and, 89

hybridity: Ahuja's *Spark* and, 5; Blasian artists and hybrid vision of self, 188; as border phenomenon, 204, 205; Hawaiian racial mixing, social status, and, 115; Jamaican, 190–95; Korean adoptees and, 81; as liminal discursive, 6. *See also* mestizaje; mixed race

identity, mixed race or mixed heritage: arts and development of, 7–8; body as sutured and fracture image, 9–10; external vs. internal, 40; history of, 4. See also *specific identities*

I Is for Indians (Yepa-Pappan), 177–78

Ileto, Reynaldo, 34

illegitimacy and "love child" stereotype, 13

Imagining the Past (Chong), 193–94, 195, plate 31

immigration laws: Amerasian Homecoming Act (1988), 12, 99–100, 253nn21–22; Immigration and Nationality Act (1965), 3, 252n2; paper sons and daughters and, 204, 212, 260n1; Public Law 97-359, 12

Imoto, Hatsune (Marumoto), 251n2

imperialism. See colonialism, postcolonialism, and imperialism

I'm the Girl Who Survived the War series (Ford), 5, 101, 104–7; *Ghost of a Girl*, 106, plate 2; *Mom*, 106–7, plate 3; *Mom Sleeping*, 107, plate 4

Indian Country Today (ICT), 173–74

Indian Relocation Programs, 171

Indipino identification, 167–68

Indochina Migration and Refugee Assistance Act (1975), 97

Inner City Portraits / Self Portraits (Lou), 204–5

insider/outsider status: Pao and, 124–25, 127

intermarriage: Asian and Native American, 167; Hawaiian racial harmony and, 253n2, 254n10; social equals and ethnicity as symbolic identification, 15; statistics on, 231, 261n1; visual images and, 230. *See also* antimiscegenation laws

International Adoptee Gathering Exhibition, Seoul, 86

Intersecting Circles (Hara and Keller), 247n51

heritage, 228, 229; election of, 13, 157; on same-sex marriage, 261n6

Oceania, 28

O.K.A.Y.: Overseas Korean Artists' Yearbook, 251n3

Okinawa, 61–62

Olmos, Edward James, 227

One Big Hapa Family (Chiba Stearns), 10

O'Neill-Butler, Lauren, 217

One Way or Another: Asian American Art Now (Asia Society in New York), 70

Ono, Kent A., 11, 225

Oonk, Gijbert, 138

Operation Babylift, 97, 252n8

Operation Frequent Wind campaign, 95–96

Operation New Life, 96

Orientalism, 140, 246n43

Orientity (Kaisen), 86

Osterloh, Gina: about, 39; *Burnt Out, Died, Got Some Rest #1* (*Somewhere Tropical*), 41, plate 10; *Collapse* (*Somewhere Tropical*), 41–42, plate 9; *Copy Flat*, 43; on identity, 19; interview with, 39–43; *Rapture* (*Somewhere Tropical*), 41–42, plate 11

Ostrander, Lucy, 167–68

Others. *See* alterity and the Other

outing of mixed race celebrities, 228

outmarriage in Chiba's *One Big Hapa Family,* 10

Out of the Archive (Asian American Arts Center, New York), 193

Oyama, Misa, 139

Pacific Islander Americans conflated with Asian Americans, 14

Pak, Greg: *Robot Stories,* 11

Pao, Adrienne: about, 116, 120, 124; *Auntie Winnie Wearing Hina Hina* (*Pele's Hair*) (*Family Portraits*), 122; *Coconuts for Sale / Iwi Puniu Kapa* (*Hawaiian Cover-ups*), 121–22; *Family Portraits* series, 122–23, 126; *Fishkin Blanket Amidst the Mokulua's / I'a Kapa* (*Hawaiian Cover-ups*), 121; *Hawaiian Cover-ups* series, 120–22, 125, 127–28; interview with, 124–28; *Lei Stand Protest / Lei Pua Kapa* (*Hawaiian Cover-ups*), 127, plate 19; *Searching for Roots at the Interna-*

tional Marketplace / A'a Kapa (*Hawaiian Cover-ups*), 127, 128, plate 20; *Sunset at Sunset Beach / Napo'o 'ana o ka I' Kapa* (*Hawaiian Cover-ups*), 128, plate 21; *The Three Cousins—Malia, Pohai, Leilani* (*Family Portraits*), 122–23; *Uncle Jeff and His Favorite Fighting Cock* (*Family Portraits*), 122, plate 18

Paper Bullets (Fulbeck), 247n51

paper sons and paper daughters, 204, 212, 260n1

Paradise of the Pacific, 110, 111–12

Part Asian, 100% Hapa (Fulbeck), 141, 243n1, 247n51

passing and not passing: Corpuz on, 168; in Japanese American internment camps, 187; Osterloh on, 40, 43

patriarchy: Korean adoptees and, 75–76; Korean culture and, 89; military sex workers and, 90–91

Paul Robeson (*Post-plantation Pop*) (Tisdale), 227

Pearl Harbor, 126

Peters, Rebecca, 139

Philippine-American War, 29, 30–33

Philippines: annexed by U.S., 30; colonial education and racism in, 33–34; MacArthur's beachhead scene at Leyte, 19, *46,* 46–47; Oceania, mestizaje, and, 28; revolution against Spain, 28–29. *See also* Filipina/o Americans

photography: Fulbeck on power dynamic in, 151–52; Gong on vision and, 195; Ross-Ho on veneer of, 156. See also *specific photographers*

picture brides, 61, 251n4

Pinder, Kymberly, 17

popular culture, mixed race in, 225–29

Porter, Walter, 165

Portrait of the Artist as a Victim of Colonial Mentality, 1979/2010 (Chong), 192, 195, plate 30

Portuguese colonialism, 138

Possibility of an Island, The (Rodriguez), plate 36

Post Black (Womack), 17

postcolonialism. *See* colonialism, postcolonialism, and imperialism